Contemporary British Art: An Introduction

The last few decades have been among the most dynamic within recent British cultural history. Artists across all genres and media have developed and refashioned their practice against a radically changing social and cultural landscape – both national and global.

This book takes a fresh look at some of the themes, ideas and directions that have informed British art since the later 1980s through to the first decade of the new millennium. In addition to discussing some iconic images and examples, it also looks more broadly at the contexts in which a new 'post-conceptual' generation of artists, those typically born since the late 1950s and 1960s, have approached and developed aspects of their professional practice.

Contemporary British Art has been written as an introduction to the field. To guide the reader, the book is organised around genres or related practices – painting; sculpture and installation; and film, video and performance. The first chapter explores aspects of the contemporary art market and some of the contexts within which art is made, supported and exhibited. The chapters that discuss various genres of art practice also mention books that may be useful to support further reading.

The book is extensively illustrated with a wide range of work (both known and less well known) from artists such as Chris Ofili, Rachel Whiteread, Damien Hirst, Banksy, Anthony Gormley, Jack Vettriano, Sam Taylor-Wood, Steve McQueen and Tracey Emin, and many more.

Grant Pooke is a Senior Lecturer in the School of Arts, University of Kent. He is the author of *Francis Klingender 1907–1955: A Marxist Art Historian Out of Time* (2008) and co-author of *Art History: The Basics* (2008).

Contemporary British Art

An Introduction

Grant Pooke

Routledge
Taylor & Francis Group

LONDON AND NEW YORK

First published 2011
by Routledge
2 Park Square, Milton Park, Abingdon, Oxon OX14 4RN

Simultaneously published in the USA and Canada
by Routledge
270 Madison Ave, New York, NY 10016

Routledge is an imprint of the Taylor & Francis Group, an informa business

Typeset in ITC New Baskerville by
Saxon Graphics Ltd, Derby

Printed and bound in Great Britain by
TJ International Ltd, Padstow, Cornwall

British Library Cataloguing in Publication Data

A catalogue record for this book is available from the British Library

Library of Congress Cataloging in Publication Data

A catalog record for this book has been requested

ISBN10: 0-415-38973-9 (hbk)
ISBN10: 0-415-38974-7 (pbk)

ISBN13: 978-0-415-38973-0 (hbk)
ISBN13: 978-0-415-38974-7 (pbk)

To
Daisy and Hollie

Look after the trees.

Contents

Illustrations

The images in this book have been reproduced with kind permission of the copyright holders. While every effort has been made to trace copyright holders and obtain permission, this has not been possible in all cases. Any omissions brought to our attention will be remedied in future editions.

PLATES

The plate section can be located between pages 162 and 163.

Acknowledgements

Books are ultimately the consequence of collective endeavour, and this publication is no exception. I should especially like to thank Natalie Foster, senior editor at Routledge, for her encouragement and patience in respect of this venture. My thanks also to Charlie Wood, senior editorial assistant, Routledge, for her good-humoured support with the manuscript and with the permissions process. Appreciation to David Koloszyc for researching and securing many of the permissions required for the reproduction of images used within this book and to Rob Brown and James Benefield for their editorial work. Dr Diana Newall provided technical support and guidance, without which producing this manuscript would have been a far more onerous process. Many thanks to Jane Powell, Dr Graham Whitham and also to Susan Curran for copy-editing this manuscript.

Several artists and colleagues kindly gave of their time to discuss work (and broader perceptions of the art world), either directly through formal interview, informal discussion or correspondence, or by presenting their approach and practice through lecture and seminar contributions to the University of Kent's Fine Art MA programme (2008–09). Sincere thanks and appreciation to Clio Barnard, Colin Booth, Adam Chodzko, Nigel Cooke, Ken Currie, Peter Kennard, Pil and Galia Kollectiv, Cat Picton Phillipps, Angus Pryor, Kira O'Reilly and Jack Vettriano.

Sincere thanks to all the galleries and arts organisations that have assisted with enquiries and that have agreed permissions: in particular, the Alan Cristea Gallery, Andrea Rosen Gallery, Anthony Reynolds Gallery, Artangel, the Art Fund, the BALTIC Centre for Contemporary Art, Carnegie Museum of Art, David Chipperfield Architects, Flowers East Gallery, Frith Street Gallery, Gagosian Gallery, the Imperial War Museum, James Cohan Gallery, Manuel Vason, Maureen Paley, the Saatchi Gallery, Stuart Shave/Modern Art Gallery, Tate Modern Bankside, Thomas Dane Gallery, Timothy Taylor Gallery, Turner Contemporary, Margate, Victoria Miro Gallery, White Cube Gallery, Whitechapel Gallery, the Wilkinson Gallery and the 303 Gallery New York.

Many thanks to the following in particular for assisting with images and

interviews: Philip Absolon, Alice Boff, Ruth Busby, Gordon Cheung, Steve Cotton, Karen Eslea of Turner Contemporary, Hugo Glendinning, Gary Hume, Jimi Lee, James Lingwood, Jennifer Mallery, Martin Maloney, Nathalie Martin, Tim Noble and Sue Webster, David Roberts, Paul Rooney, Hanna Sorrell, Kathy Stephenson, Joanna Thornberry, Dr Graham Whitham and Stephen White.

My thanks to Peter McMaster for his views and perceptions of the work and legacy of the late British art critic, Peter Fuller, and to Elizabeth Tophill for conversations relating to her film practice and to recent trends in docu-fiction.

Grant Pooke

Introduction

Cool Britannia, Contemporary Art and the Altermodern

Between 1996 and 1997 'Cool Britannia' entered the United Kingdom's style lexicon. New Labour seized upon its association with youth culture and musical celebrity as part of that year's election campaign. D:ream's 1994 chart hit 'Things can only get better' became New Labour's anthem, promising a jaded electorate hope and social regeneration. Keen for young votes, Tony Blair lavished attention on rock bands Blur and Oasis, which paralleled a sudden interest in major league football teams and their players. As the commentator Jim Claven has noted, popular culture became an important tool in selling the New Labour project to young swing voters and their lifestyle aspirations.[1]

Vanity Fair's iconic 'Cool Britannia' issue was a sharp and convenient piece of branding, crystallising a particular cultural moment and the aspirations of a new political administration. Although these narratives unwound in the years that followed (the political and economic ones spectacularly so), both underscored broader and irrevocable transformations within the country's cultural and social economy, the origins of which had been the radical free-market Thatcherism of the previous decade.

Culturally, the most visible shift was the heightened metropolitan prominence of London and a landscape of new art, design and fashion. Dealers and collectors such as Jay Jopling, Victoria Miro, Charles Saatchi and Karsten Schubert had become associated with the promotion of work by a new generation of artists, the so-called YBAs ('Young British Artists'), many of whom had come to mainstream public notice with the Royal Academy's 1997 *Sensation* exhibition.[2] But the origin of that tendency was *Freeze*, a series of three artist-led shows, the first of which was co-curated in 1988 by Damien Hirst and Carl Freedman, in a disused London Port Authority building. The brash self-promotion of a noticeably entrepreneurial 'Brit Art' generation was seen by commentators as symptomatic of a new and self-confident visual culture, analogous to New Labour's ideological re-definition and its embrace of the free market.[3]

Unsurprisingly, this cultural moment and the visual art with which it became associated have provided the basis and focus for several books, and as various authors have ruefully pointed out, a kind of self-perpetuating mythology. *High Art Lite: British Art in the 1990s* by the art historian and curator, Julian Stallabrass (1999, revised edition 2006), was a closely argued and acutely articulated polemic which explored the genesis, character and contradictions of Brit Art. For Stallabrass, by and large, the YBAs melded some of the 'high art' qualities and appearances of a Minimalist aesthetic with subject matter and a sense of spectacle culled from mass culture. The apparent populism and cultural accessibility of YBA practice were largely interpreted as attempts to conceal an underlying critical vacuity and complicity with the institutions, patrons and imperatives of the art market.[4]

Shark Infested Waters: The Saatchi Collection of British Art in the 1990s (1994) by Sarah Kent profiled work by thirty-five contemporary British artists.[5] Based on studio visits and interviews, it was a sympathetic and affirmative survey which explored the ideas and subject matter that characterised a tranche of artists whose work was collected or promoted by Charles Saatchi. Kent eschewed making critical value judgements, describing her task as akin to that of a cultural anthropologist who recorded, compared and described what they encountered. The explicit relativism of Kent's account foregrounded similar ambiguities and deferrals in much of the work it discussed, a point not missed by other commentators.[6]

Sensation: Young British Artists from the Saatchi Collection (Adams et al.) was the collaboratively authored catalogue which accompanied the Royal Academy's exhibition of that name in 1997.[7] It included a range of essays by Brooks Adams, Lisa Jardine, Martin Maloney, Norman Rosenthal and Richard Shone. The catalogue provided an account and a critical context for the work of some of the forty-two artists exhibited at the group show. It included essays on contemporary British art patronage (Jardine); the reception of the YBAs in the United States (Adams) and an account of the early exhibition history of the YBAs (Shone).

Blimey! From Bohemia to Britpop: The London Artworld from Francis Bacon to Damien Hirst (1997) and *Art Crazy Nation: The Post-Blimey! Art World* (2001) were both authored by Matthew Collings, a practising painter (Byam Shaw and Goldsmiths College).[8] His breathless prose acutely captured the zeitgeist of the 1990s, offering a personal take on contemporary artists and the gallery scene. The first-person narrative and diary style used by Collings may also have influenced Gregor Muir's *Lucky Kunst: The Rise and Fall of Young British Art* (2009).[9] Muir had curated two group shows which involved artists associated with the YBAs: *Lucky Kunst* (1993) and *Liar* (1994). The book is an account of Muir's professional involvement with the art world, and provides a personal take on some of the personalities and the gallery scene of the time.

Some of the major personalities associated with the British art scene in

these years provided the basis for two readable and accessible volumes by curator and commentator Louisa Buck: *Moving Targets: A User's Guide to British Art Now* (1997) and *Moving Targets 2: A User's Guide to British Art Now* (2000).[10] While the first volume showcased and introduced some of the personalities, curators and gallerists associated with the British art scene of the 1990s, the second recognised the consolidation and passing of that moment by introducing names from a post-YBA generation at the start of the new millennium. A similar sense of historical retrospection is evident in Richard Shone's chapter 'Freeze and its Aftermath' in *Blast to Freeze: British Art in the 20th Century* (2002), the catalogue and anthology of essays which accompanied the international touring exhibition of that name.[11] Shone concluded his essay on Brit Art with the observation that it would fit a 'neat characterisation' as an end-of-century phenomenon which successfully 'grafted post-modern practice onto the long British tradition of poetic realism'.[12]

A sense of critical distance and emerging perspective is appreciable in *The History of British Art 1870–Now* (2008) edited by Chris Stephens, the fourth volume of the series. As David Bindman's introduction makes clear, the project, initiated by Tate Britain and the Yale Centre for British Art, aims to sketch out some of 'the broader concerns of scholars' working in the area and to indicate future 'directions' for research.[13] Chapters 4 and 5 include a range of long and short essays, surveying trends in art education (Paul Wood), developments in photography (Emma Dexter), installation art (Gill Perry), visual arts activity in the 1980s (Eddie Chambers) and developments since the millennium (Nicolas Bourriaud).

Sex & Violence, Death & Silence: Encounters with Recent Art (2009) was an anthology of reviews and collected ephemera by the late novelist and critic Gordon Burn, with a foreword by Damien Hirst and David Peace.[14] Although not exclusively concerned with British art (the texts consider some of the major US artists from the 1950s onwards), the anthology contains a range of reviews and recollections of the London art scene and some of its dealers. Of the various composite text sections which comprise material on several of the YBAs, the longest entry by far is on Damien Hirst, of whom Burn was a good friend. The anthology includes some acute observations which situate work by Richard Billingham, Michael Landy and Sarah Lucas. As he conceded, Burn came to the British art scene in the early 1990s as something of an outsider, but his reviews and observations combine descriptive economy with lyrical exposition. One of the last texts in the anthology is an evocative and cogently observed survey of the contexts and landscapes that have influenced the practice of the figurative painter George Shaw.

Critical attention has also been given to some of the personalities associated with the art scene of the last twenty years. *Supercollector. A Critique of Charles Saatchi* by Rita Hatton and John A. Walker (1999) is a sociologically detailed and sceptical treatment of its subject. In a broader sense, it is an

excoriating study of how unregulated markets can be used to add value to art as a commodity, and what this reveals about the social and political ethos of contemporary capitalism. In their introduction, its authors note:

> The story of Charles Saatchi … is instructive because of the light it throws on the history of British politics and society since the 1990s, in particular the shift of power from the Left to the Right and from the public domain to the private sector which occurred during the 18 years of Tory rule (1979–97).[15]

In looking at the broader dynamic of the British art market and the social polity of which it is part, Hatton and Walker argued that the election of Labour's 'social democratic' administration in 1997, merely consolidated the changes of the previous Conservative administrations, and that little change could be anticipated.

The above is an incomplete and highly partial survey, omitting, for example, the extensive coverage and material in specialist art journals like *Art Monthly*, *Frieze* and *Parkett*, and attempts at defining the period's zeitgeist in publications such as *Third Text* and *New Left Review*. But what it does suggest is the extent to which, at one particular time, widely read accounts of British art appear to have become conflated with, and subsumed by, narratives associated with the YBAs. While the reasons for this are probably apparent, one of its consequences was to elide or obscure the contributions of those whose practice may not have had particular affiliations with this tendency, but whose work simply shared a similar geographical location and time.

For example, while it has become fashionable to discuss the 'political and affective turn' of recent art practice in the face of accelerating globalisation, an engagement with the contexts, audiences and constraints of cultural production, and with the defining political and social events of recent decades, has remained a central subject within British art.[16] An entire generation has reached maturity since the late 1990s, developing perspectives and directions within a rapidly globalising, late modernity. Equally, a generation of artists working before and since the middle years of the 1980s continued to be engaged in technically innovative and politicised practice – across all genres.

This book has been written as a general introduction to British art from the late 1980s through to the first decade of the new millennium. It has been authored for the general reader and interested student, and does not assume any particular or specific knowledge of the subject. In scope and focus, it is angled towards exposition and description, with the aim of offering a point of purchase and context for what has been one of the most diverse and innovative periods within recent British art history.

Contemporary British Art: An Introduction is not a history of the YBAs, a subject which has already received ample media attention and critical

discussion elsewhere.[17] However, in discussing developments relating to patronage and the art market (Chapter 1), it would have been unhistorical to have passed over the associated meeting of art, spectacle and celebrity, symptomatic as it was of such a visible cultural sensibility. Similarly, there are some well-known art works that have been included here; to have edited out some iconic examples of British art of the last twenty years would have been unrepresentative. Other examples of art practice reproduced here are perhaps less well known, or at least more recently known.

With a few exceptions, most of the art practice discussed in this book was either completed or exhibited between 1987 and 2007 – a small tranche of time in the scheme of things, but one of the most culturally and socially dynamic periods in recent British history. The material and coverage in the initial chapter, 'Perspectives on the Contemporary Art Market and its Institutions', does range beyond 2007, not least because it seemed necessary to follow the financial meltdown and its immediate aftermath. In the United Kingdom at least, this has offered some distance from which to make observations on what might now be called the last British art boom which finally petered out in 2008, although its origins were in the speculative and investment-led buying appreciable from the middle years of the 1990s.

As a subject introduction and to provide a basis for further exploration, chapters have been organised around specific genres or related practices: painting, sculpture and installation, photography, video and the performative. While this is not intended as a pre-determined and prescriptive reading of practice, it is designed to offer an interpretative framework which might be expanded, re-ordered or revised in the light of reader experience or developing subject interest.

Each chapter opens with a brief historical mapping of the genre, with mention of some of the issues explored and discussed by commentators and academics. Such coverage cannot be exhaustive, but it is designed to offer a point of orientation and context for further reading. The text then explores examples of how particular practitioners have approached themes, issues or subjects within their chosen medium or genre. Some of the subjects and ideas explored naturally cross a variety of media (and chapters), while others appear more specific and experientially related to the concerns of particular practitioners or groups of artists.

At a time when recent and contemporary practice appears increasingly interdisciplinary, and British art no less so, with many artists working across several genres concurrently, medium-oriented chapters may seem unusual. In some ways, genres are arbitrary and historically contingent categories; a structure could equally have foregrounded themes, chronologies or subject matter. Besides, in the course of a career or a series of commissions, artists may switch from one medium to another. Increasingly, within the 'expanded field' of cultural production and proximities, artists hybridise styles, formats and media.

For example, documentary film practice, once seemingly distinct, appears to have merged with specific trends within video, installation, conceptual and performance art. Sculpture and installation have been redefined and expanded – literally and symbolically by the contested and complementary spaces between them. Some of the tableaux pieces created by Jake and Dinos Chapman employ conventions associated with the historically based 'distinctness' of sculpture, while creating spatial environments and immersive experiences typically identified with larger-scale installations.

However, the conviction behind this introductory book is that genres can provide an intelligible and generally recognisable framework within which art making takes place as a material, aesthetic, conceptual and ultimately as an institutionally-based practice. The choice of genre(s) foregrounds the materiality or immateriality of the object, image, idea, performance or constructed environment. Genres are also informative in other ways, signifying shifts in culture and intellectual fashion. For example, installation art in various forms has become the default aesthetic in recent years, as photography and video appeared to be in the 1980s and performance and conceptual practice were in the 1960s and 1970s. Before then, the genre of painting, mediated through gestural and colour-field abstraction, delineated the Modernist hegemony of the 1950s and early 1960s.

While simplifications, the conventions of genre-based art have their own narratives and cultural histories. For instance, performance, conceptual practice and land art historically indexed the countercultures of the 1960s and 1970s, and what Lucy Lippard has described as the 'de-materialisation of the art object'.[18] But for what might be called a 'post-conceptual generation' of artists – those born in the later 1950s, 1960s and 1970s – these associations may be more historic, rather than of determining and ongoing interest. The term 'post-Conceptual painting' has been used to identify trends which opposed the artistic conservatism associated with the genre in the early 1980s.[19] However, it can be applied to a wide range of subsequent painting-based practice which has extended and developed the techniques and subject matter associated with the medium. While examples of performance and environmental art remain widespread, they tend to be explored with a different generational, cultural or theoretical inflexion. The resurgence of interest in the photographic was to some extent premised on responses to a particular kind of painting and its ascendant cultural status. The object-based practice of the 1990s was itself symptomatic of a range of concerns which, in retrospect, were more representative of the particular fashions of the time and the particularities of the Anglo-American art markets.

Chapter 1 surveys aspects of the British art market and some of its related institutions, practices and awards. To what extent have private collecting and corporate patronage eclipsed State involvement in supporting recent and contemporary British art? What are some of the implications for public

art and for the awards and prizes which increasingly typify the contemporary art landscape? Is it possible to identify recent trends in commissioning, collecting, and in how artists approach the development of their own professional careers and practice?

Chapter 2 explores the continuing durability and contribution of painting as a contemporary art medium, taking a selection of examples by British artists from the later 1980s onwards. How have a generation of practitioners, many of whom were born in the 1950s, 1960s and 1970s, approached and engaged with the medium? Is it possible to identify distinct or emerging themes from a selection of artists active within this period?

For example, while critical attention has explored the response to the Modernism sponsored by the American art critic Clement Greenberg in the 1950s and 1960s, what of those for whom such debates are comparatively remote cultural history? Chapter 2, and this book more broadly, employs the term 'post-conceptual' both in a generational sense to situate the range of practitioners noted above, but also to characterise a more pragmatic and pervasive engagement with various forms of conceptual art – performance, installation, photography, video and environmental practice – as cultural givens. In relation to painting, it suggests an open and expansive approach to the possibilities of the medium and how it might be used to develop new themes, ideas and directions.

Chapter 3 explores the increasingly mainstream genres of installation and sculpture. How might we identify and describe what appears to be such a porous and expanding category of cultural practice, and why has it become so popular? What are its connections to spectacle and to institutional patronage? How have artists outside the gallery used other environments and locations to develop the genre and to explore new ideas and subject matter?

Chapter 4 considers some of the various forms and formats of the moving image and its mediation through a range of photographic, film, video and documentary-based approaches and technologies. It also explores the closely related genre of performance art itself. What are the trends, developments and themes that might characterise these genres of British art practice in recent decades? The book closes with some concluding remarks concerning broader and identifiable developments within recent and contemporary art practice and patronage.

Overall, the selection of images used to illustrate this book has remained a largely personal one, although the intention has also been to include a demonstrative range and variety of practice. In each case, the aim has been to include material that is suggestive of an artist's particular priorities and subject matter, or that typifies trends and concerns which are more generally apparent within or across genres.

Contemporary British Art: An Introduction covers a period of just over two decades, one of the most eventful within British and European post-war

history. The collapse of the Berlin Wall in 1989, the disintegration of the former Eastern Bloc and the Soviet Union, formally ended the Cold War and began a series of economic and geo-political step-changes. Discussing this period the curator and writer Okwui Enwezor has recently noted:

> we have passed through two endings of modernity: first, with the collapse of communism and the fall of the Berlin Wall, we bore witness to the demise of a Marxist vision of modernity; and secondly, after September 11, 2001, came the dissolution of its liberal counterpoint.[20]

Enwezor concludes the observation by suggesting that 'modernity is a spectre that hangs over the global collective consciousness', but that cultural futures remain open and contested. In the early 1990s, politicians touted the idea of a post-Cold War 'peace dividend' in recognition of the new era, although the disintegration of the former Yugoslavia into warring regimes sponsoring ethnically motivated genocide and the first Gulf War were indications of a different kind. In the decade that followed, Brazil, China, India and Russia emerged as the new engines of global economic growth, and as countries and regions with increasing political and international influence.

Within the last twenty years, Britain has witnessed two cycles of boom and bust. In 1979, a Conservative administration inaugurated a period of sustained financial de-regulation and privatisation throughout the City of London and the wider economy of the United Kingdom. Three successive electoral wins and eighteen years in power consolidated a project of laissez-faire conservatism and the shift towards a service-based economy, from one that had been historically defined by the manufacturing and engineering hinterlands of the Midlands and the North East.

The emasculation of the British trades unions, emblematic in the outcome of the miners' strike of 1984–5 and the political marginalisation of the Left more generally, can be contrasted with the increasing role of business, both formally through lobby groups and private finance initiatives, and informally in the development of social and economic policy. These directions have continued, informing the policy framework of New Labour after Tony Blair's election victory in 1997. In the areas of arts subsidy and cultural infrastructure, the ideological direction has been one of increasing support for business sponsorship or corporate giving, and in real terms, a long-term decline in direct government-based support for the arts.

Culturally, there seemed to be some consensus that a new moment had also been reached. An essay by the social and economic historian Francis Fukuyama, 'The end of history?' which subsequently became the premise of his widely read book, *The End of History and the Last Man* (1992), was published in an American international affairs journal just before the fall of the Berlin Wall in 1989. Its thesis was that liberal democracy and the free

market were the logical culmination and end points of the west's Enlightenment project, providing the template the rest of the developing world would follow and emulate.

Fukuyama's thesis was widely welcomed by American neo-conservatives as an apparent confirmation of the virtues and supremacy of free market capitalism. As the journalist John Rentoul has observed, Fukuyama's argument proved attractive to the hawks within the Bush administration, 'making them feel the wind of "historical inevitability" at their backs when they went into Iraq' in 2003.[21] Elsewhere, there were more domestic variations which asserted the triumph of free market ideas. In the United Kingdom, the idea of the 'Third Way' became culturally fashionable, symbolising the pragmatic melding of Tony Blair's New Labour ideology with social democratic and conservative thinking.[22]

The events of America's 9/11 in 2001, the Madrid train bombing and the UK's own 7/7 inaugurated the 'War on Terror' and prompted shifts in foreign and domestic policy. Most noticeably, these have included the unprecedented expansion of laws designed to restrict civil liberties and to extend civil surveillance throughout the United Kingdom. At the time of writing, the United Kingdom and United States are fighting insurgents in Afghanistan and have begun the drawdown of operational forces in Iraq, after an earlier invasion by an American and British-led coalition, on the premise that Iraq harboured 'weapons of mass destruction'. Following de facto accommodations with several Sunni and Shi-ite militias and their tribal sponsors, efforts are being made to extricate the western-led coalition from Iraq and Afghanistan and to stem, in particular, the ongoing political damage arising from the losses of coalition troops in both counter-insurgency campaigns.

Between 2007 and 2009, much of the globe's economic, banking and regulatory system came close to meltdown, with the biggest contraction in the UK economy since the Great Depression of the 1930s. In order to avoid a run on the banks, the British government through the Bank of England, was forced to inject billions of pounds into the banking and private finance system. In the immediate aftermath, China emerged as the largest holder of the dollar currency, effectively underwriting the economic deficit of the United States. At one point in 2009, economic forecasts suggested that the UK budget deficit, incurred from supporting financial and banking losses, would come close to the country's Gross Domestic Product (GDP) for the first time.

This book's coverage extends into the first decade of the new millennium, a hiatus which acknowledged the waning of the YBA 'effect' and an expectation of new directions and cultural possibilities. A sense of cultural disengagement was evident in some of the press coverage of the Momart fire of May 2004. In what was believed to be arson connected with an adjoining break-in, fire spread to an industrial storage facility in Leyton,

East London, which was sublet to Momart, the major shipping, handling and art storage company.

Over fifty artists, collectors and galleries were subsequently reported as having sued the company, with multi-million pound claims for the loss of work stored. Plaintiffs included Charles Saatchi (who was reported to have lost around 140 works), Axa Art Insurance, the Royal Academy and the Thyssen-Bornemisza Contemporary Art Foundation. Other claimants included Gillian Ayres, Sadie Coles, Anthony d'Offay, Barry Flanagan, Damien Hirst, Victoria Miro and Leslie Waddington.[23] Also lost were fifty works by Patrick Heron and several by Helen Chadwick, in addition to Jake and Dinos Chapman's major tableau-based installation, *Hell* (1998–2000), Tracey Emin's appliquéd tent, *Everyone I Have Ever Slept With* (1995), Chris Ofili's *Afrobluff* (1996) and Gary Hume's *Dolphin Painting No. 1* (1990–1). Major tranches of work were lost by Jason Brooks, Martin Maloney, Michael Craig-Martin, Fiona Rae, Paula Rego and Rebecca Warren.

Although coverage by correspondents in some of the broadsheet papers was more objective, reportage elsewhere, including the tone of letters from readers published through various newspaper columns, was less forgiving, implying a sense of schadenfreude, suggesting that the apparent hubris and hunger for celebrity of some of the YBAs had been rewarded by bad chance and misadventure.[24]

Reflections on the direction of British art and the role of celebrity and the market within cultural life were also apparent in some of the work selected for the following year's Beck's Futures awards. The preface to the 2005 catalogue was authored by curator and ICA director of exhibitions Jens Hoffmann, who took the opportunity to make some broader observations on the 'sensation-dependent UK art scene' and the spirit of 'entrepreneurship and ambition' which it compelled artists to demonstrate. In what appeared a calculated attempt to underline the differences between Beck's Futures and the ethos of the Turner Prize (and its past choice of nominees), he continued:

> The ability to perform within this system is lauded as acuity, in particular in the UK which has witnessed the most profoundly disturbing alignment between art and commerce in the market-affirming, object-based practice of the YBAs – at the time when artistic practice elsewhere was turning in the direction of the performative or relational.[25]

Hoffmann concluded by asserting that what remained important was the principle that such prizes crucially provided new and emerging artists with platforms and support for the display and exhibition of their work.

Chris Townsend's *New Art from London* (2006) was one of the first surveys to sample this post-YBA moment, exploring new developments within recent British art. Townsend situates contemporary art practice within a

global network of cultural production, hybridity and exchange.[26] These trends had already been explicitly recognised in the *British Art Show 6* (September 2005–September 2006). As the co-curators Alex Farquharson and Andrea Schlieker noted, the cultural diversity of contemporary British art could no longer be 'attributed to the post-colonial diaspora alone', but to the intersecting dynamic of globalisation.[27]

These accelerating shifts have prompted the idea of a 'global altermodernity' – the premise behind Tate Britain's *Fourth Triennial Exhibition* (February–April 2009), a 'state of the art' overview offered by the curator and critic Nicolas Bourriaud. His manifesto stated:

> Altermodernity is characterised by translation, unlike the modernism of the twentieth century which spoke the abstract language of the colonial west, and postmodernism, which encloses artistic phenomena in origins and identities.[28]

Like the suggestive periodisation of the postmodern, the idea of the altermodern registers a new form of modernity, but one in which contemporary cultural practice is informed by hybridity, mobility and translation. According to this characterisation, the artist experiences this flux as a 'traveller' responding to, and informing, different stylistic and cultural idioms. Temporality and heterogeneity are integral parts of the altermodern:

> Altermodern art is thus read as a hypertext; artists translate and transcode information from one format to another, and wander in geography as well as in history. This gives rise to practices which might be referred to as 'time-specific', in response to the 'site-specific' work of the 1960s.[29]

These ideas accent earlier concerns explored by Bourriaud in *Relational Aesthetics* (2002) and *Postproduction* (2007). In the former, he characterised the trend towards the 'relational' – 'taking as its theoretical horizon the realm of human interaction and its social context' rather than the closed off and largely symbolic realm associated with Modernism.[30] For Bourriaud, the origin of this development is in the 'growing urbanization of the artistic experiment' and an intensification of integration arising through consumer culture.[31] In *Postproduction*, he described the proliferation of that technique – the re-use and recycling of earlier styles and innovations as a central component to the art produced since the early 1990s.[32] Although pastiche and appropriation are hardly new within late modern art, these recent trends are seen as reflexive and pervasive responses to cultural production within an increasingly internationalised and technologically integrated world order.

Some of the characteristics that Bourriaud appears to celebrate as part of the altermodern – mobility, heterogeneity, transmission and hybridities

– had already been recognised, as critics and commentators have noted, by post-colonial theorists Michael Hardt and Antonio Negri. In their book *Empire* (2000) they assert that these attributes are equally attractive to the interests of corporate capital in developing and integrating global markets for products and in colonising new audiences for their goods. As a corollary to this argument, they note that 'Postmodernism is indeed the logic by which global capital operates'.[33]

It remains to be seen whether, like its postmodern precursor, the altermodern will come to be used with what one art historian describes as a 'bad conscience'.[34] It is also unclear what the 'translation' alluded to as part of the altermodern will actually mean in relation to present and future visual practice, either in the United Kingdom or internationally. As other post-colonial theorists like Sarat Maharaj have acknowledged, there are limits to the transparency of cultural 'translation', and hybridities which cannot be fully adapted as a bridge between western and non-western cultures, without the risk of becoming refashioned in the process as a 'one dimensional, reductive term … an overcoming of the untranslatable … the mirror image of purity'.[35] He continues:

> Meaning is not a readymade portable thing that can be 'carried over' the divide. The translator is obliged to construct meaning in the source language and then to figure and fashion it a second time round in the materials of the language into which he or she is rendering it.[36]

Such untranslatability remains one of the subtleties associated with hybridisation, and what Enwezor describes in a similar context as the 'terrible nearness of distant places' – the apparent collapsing of geographical and cultural distance by the imperatives of globalisation and technological integration.[37]

In the face of increasingly connected (and fractured) global economies, the idea that cultural and ethnic identities are somehow determined by national borders is risible. Nowhere is the ideological impoverishment and deficit of contemporary British politics clearer than in the regressive and confused government policy and parliamentary debates concerning cultural identity. John Major's homily on warm beer and cricket, New Labour policy drafts and Foreign Office booklets on 'Britishness' underscore the hegemonic rhetoric of class, gender and generational perspective which passes for 'debate' on complex issues of identity, ethnicity, allegiance and nationhood. The growth of multi-faith communities, federalism, transnational corporations and accelerating global integration (and conflict) have rendered the nation state of academic interest only.[38]

It is axiomatic that to be British is to be from somewhere else. As Alex Farquharson and Andrea Schlieker noted in their introduction to *British Art Show 6*, London is a city of émigrés.[39] This book therefore includes examples

of work, or includes mention of such, produced or exhibited by artists living or working in the United Kingdom, or by British artists living abroad.

Grant Pooke
School of Arts, University of Kent

Notes

1 See Jim Claven, *The Centre is Mine: Tony Blair, New Labour and the Future of Electoral Politics*,(Pluto Australia, 2000).

2 Originated by Charles Saatchi, this term is used principally because it has become a widespread shorthand for identifying a particular tranche of British artists who came to prominence in the 1990s. See Julian Stallabrass, *High Art Lite: British Art in the 1990s*, (Verso, 1999), pp. 2–3.

3 Richard Shone, 'From 'Freeze' to House: 1988–94', in *Sensation: Young British Artists from the Saatchi Collection*, (Thames & Hudson in association with the Royal Academy of Arts, 1997), p. 17.

4 Stallabrass, *High Art Lite*, pp. 60–6, 273–95.

5 Sarah Kent (with Jenny Blyth), *Shark Infested Waters: The Saatchi Collection of British Art in the 1990s*, (Zwemmer, 1994).

6 See for example Rita Hatton and John A. Walker, *Supercollector: A Critique of Charles Saatchi*, (Institute of Artology, 2003), pp. 105–6.

7 Brooks Adams, Lisa Jardine, Martin Maloney, Norman Rosenthal and Richard Shone, *Sensation: Young British Artists from the Saatchi Collection*, (Thames & Hudson, 1997).

8 Matthew Collings, *Blimey! From Bohemia to Britpop: The London Artworld from Francis Bacon to Damien Hirst*, (21 Publishing Ltd., 1997) and *Art Crazy Nation: The Post-Blimey! Artworld*, (21 Publishing Ltd., 2000).

9 Gregor Muir, *Lucky Kunst: The Rise and Fall of Young British Art*, (Aurum Press, 2009).

10 Louisa Buck, *Moving Targets: A User's Guide to British Art Now*, (Tate Gallery Publishing, 1997) and *Moving Targets 2: A User's Guide to British, Art Now*, (Tate Gallery Publishing, 2000).

11 Andrew Causey, Richard Cork, David Curtis, Penelope Curtis et al., *Blast to Freeze: British Art in the 20th Century*, (Hatje Cantz, 2002).

12 Richard Shone, 'Freeze and its Aftermath', in *Blast to Freeze: British Art in the 20th Century*, p. 295.

13 Chris Stephens (ed.), *The History of British Art 1870 – Now*, (Tate Publishing and the Yale Center for British Art, 2008).

14 Gordon Burn, *Sex & Violence, Death & Silence: Encounters with Recent Art*, Foreword by Damien Hirst and David Peace, (Faber & Faber, 2009).

15 Hatton and Walker, *Supercollector. A Critique of Charles Saatchi*, p. 10. The first edition was in 1999, with revisions in 2003 and 2005.

16 See for example Alex Farquharson and Andrea Schlieker's brief section introduction, 'Love and War: Geopolitics and the Camera', in *British Art Show 6*, (Hayward Gallery Publishing, 2005), pp. 144–5.

17 For purposes of general recognition the collective term Young British Artists (YBAs) has been retained for this book. Despite the evident semantic and generational implications that Julian Stallabrass and others have acknowledged with its usage, it remains a broadly recognisable short form within the trade and more general press coverage.

18 See Lucy Lippard, *Six Years: The Dematerialization of the Art Object from 1966 to 1972*, (University of California Press, 1997).

19 See 'The state of painting', Charles Harrison and Paul Wood, in *Modernism in Dispute: Art Since the Forties*, (Yale University Press, 1993), p. 232.

20 Okwui Enwezor, 'Bio-politics, human rights, and the figure of "truth" in contemporary art', in Maria Lind and Hito Steyerl (eds), *Reconsidering the Documentary and Contemporary Art #1*, (Sternberg Press, 2008), p. 65.

21 John Rentoul, 'The End of History Man', feature article, *Independent on Sunday*, 25 March 2006.

22 For a sociological exposition of these ideas see Anthony Giddens, *The Third Way: The Renewal of Social Democracy*, (Polity Press, 1998).

23 Reported by Martin Bailey, 'Artists sue Momart for £20 million', *The Art Newspaper* No. 160 (July–August 2005), p. 10.

24 For a sampling of some of the coverage see Jacques Peretti's 'Burning shame', *Guardian*, 5 June 2004.

25 Jens Hoffmann, 'Back to the Future', *Beck's Future's 2005*, (ICA Publications, 2005), p. 9.

26 Farquharson and Schlieker, *British Art Show 6*, p. 12.

27 Nicolas Bourriaud, *Altermodern Manifesto: Postmodernism is Dead*, http://www.tate.org.uk/britain/exhibitions/altermodern/manifesto.shtm (accessed August 2009).

28 Ibid.

29 Nicolas Bourriaud, *Relational Aesthetics*, (Les Presses du réel, 2002), p. 14.

30 Ibid., pp. 14–15.

31 Ibid., pp. 14–15.

32 http://www.tate.org.uk/britain/exhibitions/altermodern/manifesto.shtm (accessed August 2009).

33 Michael Hardt and Antonio Negri, *Empire*, (Harvard University Press, 2000), p. 151.

34 Paul Wood, 'Inside the whale: an introduction to postmodernist art', in Gillian Perry and Paul Wood (eds), *Themes in Contemporary Art*, (Yale University Press, 2004), p. 16.

35 See Sarat Maharaj, 'Perfidious fidelity: the untranslatability of the other', in Jean Fisher (ed.), *Global Visions: Towards a New Internationalism in the Visual Arts*, (Kala Press/Iniva 1994). pp. 28–36.
36 Ibid., pp. 28–36.
37 See Okwui Enwezor's 'The Black Box,' extract reprinted in Jason Gaiger and Paul Wood (eds), *Art of the Twentieth Century. A Reader*, (Yale University Press, 2003), pp. 319–26.
38 See for example the recommendations made in the report by the Commission on the Future of Multi-Ethnic Britain, co-ordinated by the Runnymede Trust, 2000, in Bhikhu C. Parekh, *The Future of Multi-Ethnic Britain: Report of the Commission on the Future of Multi-Ethnic Britain*, (Profile Books, 2000).
39 Farquharson and Schlieker, *British Art Show 6*, p. 12.

I

Perspectives on the Contemporary Art Market and its Institutions

Introduction

> I don't see what else you can spend your money on. If you want to own things, art is a pretty good bet. Buy art, build a museum, put your name on it, let people in for free. That's as close as you can get to immortality.
> (Damien Hirst, 2007)[1]

In the summer of 2007, just before the onset of the global financial meltdown, London was the centre of a stratospheric international art boom. Although commentators throughout the specialist trade press and broadsheet arts correspondents had been calling the top of the market for some months, speculative buying had driven auction prizes to new heights. One recent estimate suggested that in the six years since 2002, the British art market had grown by 600 per cent, to an estimated worth of £4.2 billion.[2] One anonymous collector interviewed by *The Art Newspaper* noted:

> The insides of the auction houses have started to remind me of casinos – art has become monetised. But it is frightened money. If all of a sudden two or three lots fail to get sold, it wouldn't take much for people to decide that some of this stuff is no longer a repository for serious money.[3]

A few examples associated with Damien Hirst (b. 1965), one of the iconic Young British Artists (YBAs) whose professional reputations were established in the 1990s, convey the sentiment of a frenetic art boom. Hirst's *Lullaby Spring* (2002), from a series of four themed installations, comprises a stainless steel medicine cabinet with razor blade shelving on which there are an array of brightly coloured tablets, pills and capsules. The series draws upon the metaphors, contrasts and associations of the four seasons, with *Lullaby Winter* featuring predominantly off-white pills. *Lullaby Spring* was sold at auction for a record-making price of £9.65 million.

The disposal briefly established Hirst as the world's most highly priced living artist, before the auction in New York of *Hanging Heart* (*Magenta and Gold*) by Jeff Koons for £11.3 million in November of that year. A telephone bidding war for a Francis Bacon *Self-portrait* (1978) resulted in a final sale price of £21.58 million. As *The Times* arts correspondent Dalya Alberge noted, in four days of auctions at Sotheby's and Christie's, buyers had spent over £414 million on art. The amount broke all previous records for London-based sales.[4]

In 2007 Hirst's *For the Love of God*, a platinum cast of a human skull encrusted with diamonds, was sold to a consortium for a stated £50 million. The art division of Hiscox insurers described it as the most intrinsically valuable piece of art of the last hundred years by virtue of its 8,601 flawless or near-flawless diamonds and the 2,156 grams of platinum used for the cast.[5] The work had been carried out by Bond Street silversmiths Bentley & Skinner. According to art trade rumours, during earlier sale negotiations the price for the piece had fallen to £38 million, a figure robustly denied by Hirst's business manager, Frank Dunphy. The sale price the piece finally secured is unknown since the transaction was private and cash based, although *The Art Newspaper* subsequently identified Hirst himself as one of the members of the purchasing consortium.[6]

The following September, Hirst mounted his own two-day art sale, bypassing professional art dealers by directly selling 218 art works. The disposal, the biggest such sale by a living artist, raised a record £111 million, and was widely seen as a challenge to the hegemony of the dealer system as well as a conceptual art 'joke' at their expense. It also exposed the more nuanced interdependencies that exist between established artists and their dealers. Had work not reached its stated reserve, it would have damaged Hirst's value for his dealers (Jay Jopling and Larry Gagosian) and their existing holdings, a consideration which underpinned their reported bidding interest in the disposal.[7] In any event, the record outcome suggested that in particular circumstances, auction houses historically concerned with the secondary market could cut out contemporary galleries and dealers in bringing new and recent work to the market.

In 2007 a long bull market in equities, property and commodities of all kinds finally began to unravel. In September 2008, just after a market high and Hirst's major disposal of recent work, the merchant bank Lehman Brothers Holding Inc. collapsed and the world's financial markets went into meltdown. Even before this there had been trade speculation that some auction houses had been helping to keep the art market artificially buoyant, effectively acting as private brokers for high-profile pieces, which in garnering media attention would conceal the wider softening of prices (and sentiment) across the market.

In May 2008 Ian Peck, chief executive of the Art Capital group, alleged that such practices had been ongoing for some time as a means of concealing

the weakening prospects for mid-range disposals.[8] But this was not the first time that insiders had identified apparent irregularities within the art market. During the art boom of 1988–90, the then recently established trade publication *The Art Newspaper*, ran reports alleging that illicit profits, money laundering and tax evasion ploys from businesses in Japan and Italy had effectively driven the market.[9]

It was in these years that the idea of art as a speculative investment gained popularity, particularly among international collectors and buyers. This trend developed throughout the 1990s, with the contemporary art market in particular being driven by investment-based buying from a new demographic, the phenomenon of the super-rich: those with multi-million-dollar fortunes accrued from share brokerage, derivatives, hedge-fund management, property, private equity and portfolios across all asset classes. Although the City of London had become the engine room of the art market, the profile of those investing – principally in the post-war and contemporary period – was international, underlining the globalisation of the market in art. Throughout this period, auction houses reported brisk business from Russian oligarchs and a spread of overseas investors and buyers from Brazil, China, India and the Middle East. According to market analysis by the database service Artprice, between 2003 and 2007 global auction sales of contemporary art grew more than eightfold.[10]

Art, entirely commodified, was being referred to routinely as an 'asset class'. A former Christie's finance director, Philip Hoffman, who set up the Fine Art Fund, the UK's first art-based hedge fund, was explicit about the venture's rationale and the driver for trading practice: 'Our focus is purely profit. Passion doesn't come into it. I have bought a piece for £70,000 which we sold for £300,000 two and a half years later, and I loathe it'.[11]

Two years later, after the market crash and major slide in the value of contemporary art, Hoffman and a syndicate of buyers were reported to be in firesale negotiations with the corporate owners of two major art collections with an estimated value of £40 million. As collectors scrambled to liquidate their stock, art being one of the less divisible of assets, areas of speculative buying shifted to the market in India which was also perceived to be undervalued.

The contemporary art market

The Modernist American art critic and theorist Clement Greenberg (1909–1994), memorably described the patronal relationship between the avant-garde and the power elites which have traditionally commissioned and collected their work as akin to an 'umbilical cord of gold'.[12] Greenberg's shade would doubtless recognise the acquisitive and competitive dimension to contemporary art patronage, which has driven both British and international markets in recent decades, as it might the attractions of

ownership – social cachet and status, aesthetic interest, financial pragmatism, and for those who establish public collections and foundations, a desire for recognition and remembrance. Others have argued that the act of collecting conceals a fundamental vacuity, both personal and existential.[13]

The art trade is among the last major unregulated markets, its dynamic largely a consequence of historically liberalised and open trading arrangements. There is scant regulatory framework for the purchase and sale of art, although dealers and auctioneers are subject to legislation, depending upon jurisdiction and location.[14] Unlike other commodities, there is no comprehensive and auditable registry and history of sales for works of art, although subscription-based index and market information services provide partial windows on quoted market prices for particular artists' works. Of these, online services such as Artnet.com provide market information on the prices for art sold at auction, although caveats remain more generally about the use and reliability of index information on declared transactions.[15]

Insider trading, which is illegal and subject to punitive measures in other commodity-based markets, remains a distinctive feature of the British and international art markets. Although less centralised and more diverse than was the case in the 1980s, the UK's art trade is still geographically clustered. Its artists, dealers, collectors, buyers and curators still represent a largely socially homogeneous demographic within which the distinction between business, networking and socialising, provided through private views, fairs and auction previews, is typically opaque.

As elsewhere in the international art market, the UK's art trade operates informal protocols. Collectors can be discouraged by dealers from offloading work they have acquired through gallery purchase onto the secondary auction market because of what is perceived to be the negative effect on prices of other work by the same artist(s). Exceptionally, Hirst's profile and financial status as an artist and international collector enabled the direct disposal of work mentioned earlier, effectively insulating him from some of these pressures. However, anecdotally it is not unknown for smaller-scale collectors and buyers to be ostracised by the handling galleries of artists whose work they have sold at auction.

The sensitivity that underpins the relationship between collector, gallery and artist was demonstrated by an earlier, if somewhat smaller-scale disposal by the art dealer and collector Charles Saatchi, of six canvases by the Italian neo-expressionist painter Sandro Chia in 1985. The artist alleged that the 'dispersal' had subsequently affected gallery and critical interest in his work. The British painter Sean Scully also saw eleven of his paintings traded to a Swedish dealer in 1991.[16] Saatchi has generally disposed of work by living artists through both dealers and the secondary market, although like Hirst, he has sufficient power and status within the art market to be largely immune from the consequences of such disposals or censure within the art trade.

Although major dealers and sellers may have gallery space where work is formally displayed, the greatest volume of secondary trade business is now conducted from dealer back offices circulating jpegs of works to prospective buyers and clients. Since the mid-1990s, both private galleries and public museums have started to develop an online presence, realising in the internet a means of establishing a global reach and an international audience. The inauguration of virtual galleries, handling online sales of art, has been one of the market's more recent and distinctive developments.[17]

An important and indicative market maker for the status and value of an artist's oeuvre is promotion by a major mid-career retrospective hosted by a leading museum or gallery. The selection and planning process, decided upon by trustees, management and members of acquisitions committees (some of whom may have related commercial interests as buyers or collectors in their own right), is not usually subject to any formal or enforceable embargo. Potentially sensitive market information arising from informal decisions and discussions tends to pass across the art trade before formal or public announcements are even made. At the very least this allows for the prospect of trade insiders hedging or securing commercial interest(s) in a particular artist or their oeuvre.[18] One London-based dealer, Kenny Schachter, is on record in describing his initial response to this particular aspect of the art world ethos:

> There's so much insider trading around these retrospectives. Galleries call their top two or three collectors as soon as they find out and let them in on the deal. In commodities trading where I used to work this was called 'front running' and it's illegal. I remember when I first stumbled into the art world, I was shocked that it could be run in such an archaic manner.[19]

Schachter's concerns are illustrated by instances in which art-related institutions (major galleries are typically registered as charities for commercial and liability reasons), have been involved in perceived conflicts of interest. The Tate has been embroiled in various cases, three of which have involved artists as acting trustees: Jeremy Deller, Peter Doig and Chris Ofili. In Deller's case, it has been established that after his appointment as a trustee, he voluntarily absented himself from several meetings where the acquisition of his work and proposed exhibitions were discussed (and agreed).

In 2006, the UK's Charity Commission ruled that the Tate Modern had contravened the law through its acquisition of *The Upper Room* (1998–2002), a series of thirteen canvases by Ofili, who was also a serving trustee. Under existing legislation, trustees of charities cannot receive monetary benefit from their work, unless they have cleared permission through the Charity Commission. In Ofili's case, confirmation and disclosure of the gallery's

actions was only secured through requests made under the Freedom of Information Act.[20] However, despite the technical contravention of the law, the Charity Commission was eventually persuaded that the Tate Modern had acted in the public interest, since an estimated 250,000 members of the public had seen the works while they were on display in 2005–06.[21]

Recognising the contemporary art market's opacity, attempts have been made to regulate aspects of its conduct and operation. In formal hearings concerning the art trade made to Parliament's Culture, Media and Sport Committee in 2005, *The Art Newspaper* reported politicians' frank 'amazement' at the market's opacity and 'predominant absence of written contracts'.[22] But recommendations that an art code be established to ensure greater transparency within the market was rejected by the then arts minister, Estelle Morris, as being 'too regulatory'.[23] While the various sections of the art trade, as with other economic and cultural sectors, may operate according to a code of ethics, such self-regulation is, as the academic David Bellingham has noted, 'the lightest in [the] hierarchy of codes, being mainly aspirational and using light coercion to encourage members'. He continues, 'Arguably … the code of ethics of an art dealer or museum is more concerned with the creation of a politically correct public image than with religious adherence to a set of stone-inscribed commandments'.[24]

One major issue has concerned the intellectual property or resale rights of living artists within the secondary or tertiary market. The most controversial piece of legislation to affect the UK and European art market in recent years has been the right of artists to secure a percentage of their work's value when sold on the secondary market – the so called 'droit de suite' or 'right to follow'. The concept was initially introduced in France in 1920 as a means of supporting artists and to enable them to make some provision for their families and dependants. The legal principle was progressively recognised and adopted in other European countries, although its enforcement varied, prompting the European Commission to harmonise practice within the European Union's member states.

As introduced in the United Kingdom and Europe, the Artist's Resale Right is a statute which entitles artists and their beneficiaries whose work is covered by copyright, to claim a percentage of their art work's price each time it is offered for resale at auction, or by a gallery or dealer. The payment of these royalties is designed to acknowledge the artist's intellectual and creative ownership of work(s) being resold. One obvious point of comparison might be with the publishing or music industry, in which writers, performers or their estates already derive benefit from the sale or republishing of their work through royalties on each copy sold. But by definition, within the visual arts sector, a far higher percentage of the work made can be described as one-off originals, rather than mass produced as with books or music CDs. As Joanna Cave notes of the ethical dimension to

the legislation, 'by creating an ongoing link with the professional artist, this new legislation also serves to remind art market professionals, buyers and sellers, who created the art in the first place'.[25]

The Artist's Resale Right was only formally secured in January 2006 after protracted legal battles, although several countries sought postponement from implementing the European Union directive which sought to harmonise practice within its jurisdiction.[26] In the United Kingdom there had been particularly strong resistance and art trade representations, principally because of the concern that business would shift to markets excluded from the agreement, including those in the United States and Switzerland. Other trade concerns related to the extent and scope of the liability faced by both dealer and seller.[27]

In February 2006, the British government surprised the art market by setting the lower liability for resale payment at US$1,200 (€1,000) rather than the $3,600 (€3,000) expected. After the deduction of administrative costs, artists can expect to receive a percentage on a sliding scale of from 0.5 to 4 per cent, with the maximum capped at $15,000. A prominent group of British artists and trade figures including Peter Blake, Tracey Emin and Arts Council visual arts director, Marjorie Allthorpe-Guyton, had argued for the lower liability on the basis that a large percentage of visual artists 'subsisted on less than £5,000 per year'.[28] After 2010 (with scope to 2012 if submissions are made which justify an extension of the exemption), the arrangement will extend to the estate of deceased artists up to a limit of seventy years. Within the United Kingdom, the Design and Artists Copyright Society (DACS) is one of the main bodies charged with collecting and distributing the royalties on behalf of artists, although other organisations such as the Artists' Collecting Society (ACS) also oversee resale rights for subscribing members.

At the time of writing, the legislation's ramifications and how it might be consistently implemented and policed across the secondary art market remain ongoing issues. As Cave has mentioned, the legislation's narrow definition of works of art ('original works of graphic and plastic art'), including prints and photographs, has the potential to disadvantage those working in the areas of installation, performance and film, although precedents under law appear yet to be tested in these areas.[29] Despite concerns within the art market, widely reported in the trade press, that a mandatory 'droit de suite' would result in lost business and trade going to non-regulated jurisdictions, sales volumes in the UK's secondary art market appear to be unaffected. More broadly, the directive's implementation might be interpreted as underlining wider shifts in the art market, in which forms of support for working artists are delivered, if at all, through the operation of the open market, rather than through State-based subsidy for the production of visual practice.

Contemporary art, celebrity and private collecting

The gap between art and the celebrity-driven worlds of fashion, music and top-division football have narrowed in recent decades. In 1984 the French jewellery and watch brand Cartier launched its Art Foundation, followed in 1993 by the Italian fashion label Prada. In some instances artists have been directly commissioned by corporate brands, most notably the mixed-media practitioner Takashi Murakami, who has developed a long-standing and widely publicised association with the international French fashion house Louis Vuitton.

As the art commentator Louisa Buck has noted, the relationship between contemporary British art and music has been particularly symbiotic. In the 1990s Elton John and his partner David Furnish became significant buyers of art, with collections also amassed by David Bowie, Jarvis Cocker, Brian Eno, Madonna, Sir Timothy Sainsbury, Kevin Spacey and Dave Stewart.[30] Elton John and David Furnish have established a private gallery at Windsor to house their major collections of twentieth-century and contemporary photography, the first airing of which was an exhibition at the Baltic Centre for Contemporary Art. The singer George Michael and his partner launched the Goss-Michael Foundation in Dallas in 2007 with major holdings of work by celebrity YBA Tracey Emin.

Suggesting that brand identification and the enhancement of commercial value and subject profile work both ways, British artists have also tackled sporting, media and musical celebrity. Examples include Sam Taylor-Wood's one hour-long video work of footballer David Beckham sleeping (*David*, 2004) and Manchester-based artist Michael J. Browne's *The Art of the Game* (1997), in which Eric Cantona replaces Christ in a pastiche of Piero della Francesca's painting *The Resurrection* (c. 1463). The sleeping soldiers at the base of the tomb included other leading footballers David Beckham, Nicky Butt and Phillip Neville. In music and performance, Neil Tennant of the Pet Shop Boys duo, commissioned a video projection piece for the show *Somewhere Live at the Savoy* (1997). Through the sale of work, YBAs including Emin, Hirst and Marc Quinn have also supported the licensed brand Product Red, set up by U2 frontman Bono and Bobby Shriver, through which designated companies donate a percentage of their profits to fighting disease in the developing world.

In the 1990s Hirst extended the celebrity associations of contemporary art through various co-ventures into the concept-restaurant and bar business: Quo Vadis (Soho) and Pharmacy (Notting Hill) melded Brit Art with celebrity and enterprise. Hirst pulled out of the first enterprise, although he initially provided his art collection to adorn its walls and interior spaces. Pharmacy, which opened on New Year's Eve 1997 and ran for six years, was dubbed by one journalist as 'Cool Britannia's Canteen'.[31] A high-concept restaurant, co-directed with Hirst's then business partner,

PR consultant Matthew Freud, it symbolised the social and cultural pretensions of the decade, popularising the branding of fine cuisine with high fashion and contemporary art. When the venture closed in 2003 everything from the art on the walls to the customised ashtrays, glasses and plates was auctioned at Sotheby's.

In the past decade, private collections have become a far more visible part of the UK's art infrastructure, a trend started by Charles Saatchi's Boundary Road exhibition space, St John's Wood, in 1985. The self-made millionaire and collector Frank Cohen opened his Wolverhampton-based collection in January 2007 with a series of exhibitions featuring work by Hirst and Jake and Dinos Chapman, although his first acquisitions of work by British artists date to the early 1970s.

Among the UK's biggest collectors of contemporary art are Anita Zabludowicz and her property dealing husband, Poju. Their gallery, Project Space 176, opened in 2007 in a converted Methodist chapel in Chalk Farm, North London. Their collection of over 1,200 pieces includes work by established names such as Sigmar Polke and Albert Oehlen. The collection's curator, Lizzie Neilson, sees the purpose of the gallery as providing a 'platform' for artists on the 'emerging end of the market'.[32] In a variation on the formula of the private foundation, the intention is to show three exhibitions per year, including one based on the owner's private collection, another concerned with an 'emerging contemporary artist', and the third similarly hosted by an 'up-and coming young curator'.[33]

The practice of private art foundations opening their doors recalls the gestures of earlier American art collecting dynasties such as the Guggenheim and the Getty families. These collections were instrumental in popularising earlier European avant-garde art and in helping to establish Abstract Expressionism as the definitive Modernist aesthetic in the 1950s and 1960s. The purpose behind some of these more recent collections by the super-rich seems to be that of making a personal statement and establishing a cultural legacy identifiable by name or association.

Some of these motivations are apparent in the private collection that Damien Hirst has been amassing since 2003. It includes over 1,000 pieces of art, including work by Francis Bacon, Jeff Koons, Richard Prince and Andy Warhol. The collection, titled 'Murderme' (referencing its owner's apparent pre-occupation with death – both as a theme within art and as an existential concern), also contains work by Hirst's YBA contemporaries, including Angus Fairhurst, Gary Hume and Sarah Lucas, and images by the anonymous graffiti artist Banksy.

In 2005, Hirst purchased a 300-room neo-gothic manor house in the Cotswolds for a reputed £3 million. In a ten-year project in partnership with English Heritage, Toddington Manor will undergo conversion to a museum in order to house Hirst's collection, which will then be opened to the public.[34] As with other private and recently developed collections, a selection

of the works held have been placed on public display. In Hirst's case, London's Serpentine Gallery hosted an exhibition titled *In the Darkest Hour There May be Light* (2006–7), which showcased some of the pieces from the developing collection.

Perspectives on contemporary art patronage

Since the later 1980s the principal art market shift in the United Kingdom has been the decline of direct State support and its hybridisation with an expanded network of private and corporate patronage. Although this is a structural trend that has accelerated in the last decade, it might be qualified to some extent, as Julian Stallabrass has noted, by the direct and informal State support made via the payment of social security benefits to those whose choice of profession has dictated a lengthy 'low-paid' apprenticeship.[35]

Some high-profile examples of corporate patronage from companies with UK-based operations, include the major collaborative venture between the Deutsche Bank and Berlin's Guggenheim Museum (1993) and the dedicated art space set up by the financial systems and international news and data company, Bloomberg, for its European headquarters in London (2002). This was fashioned not just to be a static space for the display of their corporate art collection, but as a public venue for temporary exhibitions, and a vehicle for directly commissioning new artists and projects.

The accelerating shift towards private and corporate patronage has been particularly noticeable in the budgets available to national and regional galleries in comparison with the purchasing power of private individuals and businesses, which are typically called upon to assist with acquisitions or to sponsor exhibitions and capital projects. As Chin-tao Wu's major study, *Privatising Culture: Corporate Art Intervention since the 1980s* (2002) recognises, these developments have been international and systemic, with contemporary art increasingly signifying 'both material and symbolic value for corporations'.[36]

Some of these shifts in patronage and the acquisitions budgets available to public museums and galleries are graphically illustrated in the work undertaken by the UK's independent art charity, the Art Fund. Established in 1903, it has in the last decade increasingly intervened with major benefactions to prevent the export of examples of art judged to have particular historic or cultural value. Regardless of the cultural politics or (de)merits of art being exported, as the organisation's manifesto makes clear, its aim is to support the UK's galleries and museums with acquisitions, because of their diminished ability to compete with the prices demanded by a globalised art market. In recent years the Art Fund has outspent the National Lottery and the Heritage Memorial Fund, providing around £4 million in annual grants to British museums and galleries for this purpose.[37]

The trend towards the dominance of private and corporate philanthropy can be illustrated with other forms of benefaction, specifically the examples of two major UK collectors and dealers. Anthony d'Offay closed his gallery in 2001 and is now a private dealer. During a career which began in the mid-1960s, he became one of London's most important and successful dealers in international contemporary art, representing at various times artists such as Joseph Beuys, Gilbert & George, Jeff Koons, Andy Warhol and Rachel Whiteread.

In 2008, d'Offay made the art world's largest benefaction of 725 contemporary and post-war works of art to the major public galleries of the Tate and the National Galleries of Scotland. The collection, priced by the salerooms at around £125 million, was gifted as a concession to the receiving institutions at its original acquisition price of £26.6 million. The deal was only sealed after extensive negotiations between Westminster, the Inland Revenue and the devolved Scottish Parliament at Holyrood, which resulted in the waiving of d'Offay's estimated £14 million tax bill.[38]

The exchange was the first part of an ambitious scheme known as 'Artist Rooms', with items from the collection subsequently exhibited and circulated across the UK's major and less well-known public museums. Starting with the Scottish National Gallery of Modern Art and Tate Britain, institutions and public museums of all sizes can request the loan of particular works for exhibit and then trade or exchange them for others in the collection. One of the caveats that came with the transfer was that each work exhibited had to be shown in a room on its own. If the substantial price reduction had not been offered and the collection had been auctioned on the open market, the Treasury would have been unable to match interest from private buyers and bidders. D'Offay's historic benefaction, the largest since that of the sugar baron Henry Tate, underlined some of the positive dimensions to private art philanthropy, while equally demonstrating the State's diminished and dependent role as sponsor within the UK's contemporary art market.

The name of the second art world collector and tastemaker has become synonymous with the narrative of the YBAs and the popularisation of particular forms of contemporary art practice – the dealer and patron Charles Saatchi. Saatchi has been dubbed by one commentator a 'supercollector', by virtue of his international profile and influence on the art market, in addition to the scope, range and extent of his acquisitions and patronage. For commentator Jane Allen, the other defining features are a multi-million-pound capital base, which in Saatchi's case comes from a family-run international advertising business, and a record of establishing art institutions and hiring curators to operate them.[39] In the established traditions of art dealing and an entirely monetised art market, he has typically purchased and promoted the work of emerging artists, buying low and selling on. The regular disposal of more established names to make

space for new acquisitions has been one of the distinctive features of Saatchi's collecting ethos since the 1980s.

In 1983 Saatchi purchased what was to become his first commercial art gallery space, a single-storey paint storage facility at 98a Boundary Road, St John's Wood, West London. Opened in 1985, the cavernous white-cube space became a showcase for an expanding contemporary art collection. It also marked what Rita Hatton and John Walker identified as the 'shift from public to private support for the visual arts' which came to characterise the British art market of the 1980s – although the Boundary Road space was a 'hybrid phenomenon: partly private, partly public'.[40] When the Saatchi Gallery opened there was, with the possible exception of the South London Gallery, no comparably sized, dedicated space for the exhibition of contemporary art in London, a situation only remedied with the opening of the Tate Modern at Bankside in 2000, and latterly with the renovated and extended Whitechapel Gallery in London's East End.

Even hostile critics acknowledge that Saatchi has played a major part in shaping the character of the British art market, and more particularly, in promoting, sponsoring and ultimately helping to institutionalise the YBAs and the work with which they have became associated. The exhibition *Sensation: Young British Artists from the Saatchi Collection* (1997), organised in collaboration with the Royal Academy's exhibitions secretary, Norman Rosenthal, was widely judged a commercial and critical success. The vandalism and protests attracted by Marcus Harvey's *Portrait of Myra* (page 73) and the scatological spectacle of several pieces by Jake and Dinos Chapman and work by Ofili, maximised media coverage and public exposure.

Securing initial space for the touring show within a perceived bastion of cultural conservatism provided both the institution and those exhibiting with immediate cachet – as well as consolidating market demand for their work. In retrospect, *Sensation* will probably be seen as the highpoint of Saatchi's influence on contemporary British art, a show which was instrumental in bringing artists such as the Chapmans, Tracey Emin, Sarah Lucas, Ron Mueck, Chris Ofili, Gavin Turk and Rachel Whiteread to wider public notice.

Despite a reclusive reputation, Saatchi has nevertheless been innovative in exploring new media and formats for identifying rising art school talents and popularising their work.[41] In 2007, the Saatchi Gallery Online in collaboration with Channel 4 set up '4 New Sensations', an annual art prize open to students completing UK-based BA or MA Fine Art programmes. Four finalists were selected by a panel of art professionals, and each was given £1,000 to create a work of art as well as some promotional space to air their work and ideas during the annual Frieze Art Fair.

A similar formula was subsequently adapted for 'Saatchi's Best of British', a reality TV show scheduled for BBC2 which was designed to showcase emerging art talent, with applicants working in all media required to apply

online. The selection criteria required that prospective contestants had to be over eighteen years of age, UK-based and without a representing gallery. The six appearing candidates were duly selected from a shortlist of twelve by a panel of judges including the critic and broadcaster Matthew Collings, the collector Frank Cohen, the gallerist Kate Bush and Tracey Emin. The winning contestant was invited to participate in the Saatchi group show *Newspeak: British Art Now* at the Hermitage, St Petersburg and in London (2009–10). The formula of both ventures, based on other franchised reality TV shows, made explicit the extent to which part of the YBA legacy has been to fashion the perception of contemporary British art as a branded consumer spectacle. Equally, the ventures underlined the inventive hybridity of private philanthropy and the broadcasting media in responding to unprecedented levels of public fascination with contemporary art and celebrity culture.

However, some of Saatchi's subsequent professional judgements appear to have lacked such sureness of touch. An example was the relocation of his collection to the leased premises of County Hall on London's Embankment in 2003. Although situated in an excellent location with high tourist footfall, the Edwardian building's configuration of small rooms, oak panelling and decorative fixtures could not be changed because of the structure's listed status. The collection's arrangement and curation did little justice to the art, which appeared cramped and contingent to the historical curiosity of the space itself.[42] There were subsequent disputes with the building's owner and its landlord, Cadogan Leisure Investments, over alleged breach of lease arrangements arising from the gallery's operation. This resulted in a widely publicised High Court case which Saatchi lost, resulting in the gallery's closure in October 2005.[43] In a quoted extract from the autobiographical work, *My Name is Charles Saatchi and I Am an Artoholic* (2009), trailed in the *Observer* in advance of its publication, he candidly conceded the misjudgement in moving the art collection:

> I wanted to introduce new art to as wide a public as possible and I went for somewhere with a much bigger footfall I gave up the airy lightness of Boundary Road for small oak-panelled rooms and nobody liked it. I saw it as a challenge, but one which I clearly wasn't up to.[44]

The contemporary British art style of New Neurotic Realism, an apparent successor to the work of the YBAs, was the subject of Dick Price's book of that name, published by the Saatchi Gallery in 1998 and promoted in association with the artist and curator Martin Maloney. Although supported by a series of exhibitions featuring work by a range of contemporary painters, sculptors and photographers, including Cecily Brown, Martin Maloney and David Falconer, the attempt at cultural branding was widely perceived as lacking either critical credibility or visual coherence. Subsequent press

coverage of the three-stage show, *The Triumph of Painting* (2005–6), was mixed, with reviews suggesting that some of the work shown lacked the conviction promised by the exhibition's title.[45]

Following a three-year search, the new Saatchi Gallery opened at the Duke of York's Headquarters, a former Territorial Army building on King's Road, Chelsea, in London's West End in 2008. The new gallery's white-cube idiom, top-lit galleries and neoclassical architecture were a studied and purposeful contrast to the County Hall interior. The opening exhibition, *The Revolution Continues*, featured a selection of contemporary art from China, although it was criticised for its extreme selectivity and received mixed reviews. Rachel Campbell-Johnston suggested that the featuring of installations and hyperreal sculptures seemed to replay the object-based aesthetic of Brit Art. She concluded:

> the works that Saatchi offers seem ... commercially unadventurous. He is not setting a new course with this opening show. He is offering a slick fake with lots of funds thrown in. It is as if Merchant Ivory had tackled a martial arts movie.[46]

By contrast, *Sensation* had been emblematic of a carefully judged and presented exhibition which correctly identified that decade's zeitgeist, and press appetite for the spectacular and the flamboyant. Widely reviewed and reported, *Sensation* established Saatchi's status as a leading tastemaker and patron within the contemporary art scene.

As these two examples of collecting practice suggest, the influence of private and corporate philanthropy on contemporary British art has developed simultaneously on various levels: through exhibitions, commissions, benefactions and acquisitions, and via the sponsoring of major exhibitions, awards and the proliferation of competitions and residences. The UK's leading art galleries and collections, including the British Museum, the National Portrait Gallery, the Tate Galleries, the Victoria and Albert Museum and the Serpentine, are increasingly dependent upon international corporate sponsors like BP, Deutsche Bank, Sainsbury, Shell, Texaco and Unilever. A former chief executive of British Petroleum (BP), Lord Browne of Madingley, was appointed chairman of the Tate in 2009. The major re-installation and re-configuration of Tate Modern's collection in 2005 (using the themes of Abstract Expressionism, Cubism, Minimalism and Surrealism) was sponsored by the UBS banking group.

Some of these shifts were recognised by *Art Review*'s annual 'Power 100' list which records influential artists, curators, art fair organisers, collectors and gallerists. In 2006 it allocated twenty-five entries to British figures, as against forty from the United States.[47] Particularly emblematic was the inclusion of major sponsors – the Swiss investment bank UBS (49th) and Deutsche Bank (50th).

The corporate sponsorship of galleries and cultural institutions typically involves a medium to longer-term association, including not just the branding of 'blockbuster shows' but, in some cases, contributions to the recurrent capital costs of running and maintaining permanent collections and the associated overheads. Cultural commentators have characterised this increasingly close and symbiotic brand relationship as one of 'deep ownership'. As Stallabrass has noted, there are various advantages for the sponsoring, commercial interest:

> they associate their name with a form of philanthropy and cultural distinction (and those with troublesome images – those dealing in oil or arms or tobacco, for instance – are keen to do that); they get an impressive venue for corporate hospitality; and they get the chance to display their name before a distinguished group of consumers, notably wealthier and better educated than the average public.[48]

It can also be argued that as prospective 'consumers' have become more sophisticated, they have also become, as one commentator puts it, 'inured to the banalities of traditional advertising', encouraging corporations to develop more nuanced strategies for projecting their image and communicating their values 'using the cachet of art' to do so.[49]

But there remain tangible and pragmatic benefits for the sponsored institution. Private patronage offers the prospect of financial assistance which is not subject to the restrictions, bureaucratic controls and quality assurance protocols that increasingly characterise forms of State patronage. Private and commercial support is not typically subject to changing political agendas, although corporations (and sponsoring individuals) do have political interests and are sensitive to media coverage or the kinds of association into which they enter. More prosaically, some senior State employees with careers in managing major public galleries and museums that are able to demonstrate reduced reliance on direct forms of publicly funded support (and by implication secure extra private or business patronage), do accrue kudos in the eyes of politicians within relevant government departments. With such recognition comes the enhanced possibility of honours-based preferment on or near retirement.

Operationally, the marketing and business acumen of the private and commercial sector can have tangible benefits for major galleries and museums facing the realities of a financial and cultural landscape in which direct State support continues to decline. The trend towards shops and merchandising activities apparent within major museums and galleries is symptomatic of the contemporary expectation that arts institutions should engage in enterprise activities to make up shortfalls in direct funding or subsidy. Implicit is the consensus across the mainstream political parties that such State support as there is for the visual arts should continue, but

with the expectation of increasing involvement from the private and commercial sector.

Despite some of the appreciable benefits of private and corporate patronage, there remain significant downsides. One criticism relates to the homogeneity of motive which can accompany corporate or commercial interest in the visual arts and its apparent philanthropy. As the gallerist and former art journalist Nick Hackworth puts it:

> There is a cultural crudity about corporations because their bottom line is always money. Kings, aristocrats, oligarchs, plutocrats, popes, bishops, dictators and even democratic states tend, at least, to have more personal, complicated reasons to align themselves with art and artists.[50]

Hackworth's observation is not one of moralising nostalgia for the feudal or State commissioning of art, although his choice of example suggests a belief in the continuity of association which was more appreciable within earlier periods of social history. But it does recognise how the vagaries and idiosyncrasies of personal taste, individual judgement or just sheer chance may offer sufficient conditions for supporting creativity, or at least may make a durable contribution towards the development of a meaningful visual culture. These considerations are probably the most visible with powerful private collectors and dealers, although even in these instances, choices can be inflected by professional and commercial, as well as genuinely personal, motivations. One further drawback of reliance on the private sector is that the effects of downturns in the economic cycle are far more pronounced, since non-profit-based associations are typically the first items to be cut on the corporate balance sheet.

Equally, the commissioning or supporting of art and museums by State committees and quangos has, like corporate commissioning, attendant and inherent forms of instability. For example, the UK National Lottery Fund is one of the major public sponsors of galleries, museums and archives, in addition to supporting much smaller arts and cultural organisations across the country. Since the announcement of London's successful bid to host the 2012 Olympics, there have been repeated and wide-ranging concerns relating to the use of money earmarked for the Heritage Fund being diverted to cover the increasing budget for hosting the Games, originally set at £9 billion. These instabilities create their own uncertainties which percolate down to State-dependent arts venues and institutions – locally, regionally and nationally.

In 2007, the Heritage Fund faced losses in excess of £160 million, with gallery chiefs and curators warnings that London could face the prospect of museum closures and restrictions on service.[51] Concerns have also been raised more generally that with private sponsors being approached by the

London Organising Committee of the Olympic Games, there would be a proportionate reduction in private support for the arts, an effect magnified by the collapse of the financial markets in 2007–08.

The political drivers of public funding for the arts, and the need to divert money to support lost tax, business and employment revenues, demonstrate that State sources of funding also fluctuate with the wider fortunes of the UK's economy. In September 2009 the national press picked up a story that the Department for Culture, Media and Sport (DCMS) was considering reneging on the £50 million originally pledged for Tate Modern's planned extension.[52] Despite the apparent shortfall, media reports at the time suggested that the Tate would go ahead with the project, on the expectation that the capital deficit would be supported by private donors, encouraged by rallies on the financial markets.

If these examples suggest anything, it is that arguments for private and corporate support or public and State patronage for the cultural sector are rarely clear cut, but that both are increasingly inter-dependent within and across the United Kingdom. All forms of patronage and sponsorship bring tangible benefits and distortions – in relation to the art commissioned, its public visibility and even any longer-term durability and significance that it may be perceived to have.

In the United Kingdom the increasing hybridity of patronage between the public and private sectors is emblematic of contemporary art's commodity status, a trend which has accelerated and followed developments in the United States, in particular, the critically and institutionally-supported Modernism associated with the abstract painting of the 1950s and early 1960s. At the time of the Royal Academy's *Sensation* exhibition, some commentators noted the links between the two. The academic and journalist John Molyneux suggested that the 'crude nationalism' associated with the YBA phenomenon was not dissimilar to the American 'chauvinism' that had accompanied the promotion of Abstract Expressionism.[53] The cultural resonance of both tendencies related in no small way to the perceived marketability and commercial attractiveness of the work on display.

But more generally, contemporary attitudes towards the funding of the UK's visual arts sector continue to mirror the orientation towards the free market which has been such a distinctive feature of British national politics since the late 1970s. Even the recognition that widespread deregulation was among the causes of the massive and protracted meltdown that struck the developed world's finance, banking and housing sectors in 2007–8 does not appear to have prompted any significant change in ideological direction, and certainly not in relation to political perceptions of the role of private money in supporting the cultural sector. It remains to be seen what the longer-term repercussions will be of such dependence on private philanthropy, both on the art that is made and the contexts in which it is displayed and promoted. In the short to medium term, it is unclear whether

increased commercial sponsorship will encourage greater or less institutional self-scrutiny on the part of the receiving museum or gallery.

The interface between museums and corporate culture, and the accompanying risks of self-censorship, have long informed the work and interventions of the painter and activist Hans Haacke (b. 1936). He is also known for having proposed exhibitions cancelled by the host museum, including a solo show at the Guggenheim Museum in 1971 after one of the installations threatened to expose the questionable dealings of several New York-based companies.[54] In what has become a famous catalogue statement which accompanied the exhibition *Art into Society – Society into Art* held at the Institute of Contemporary Arts, London in 1974, Haacke made the observation that all museums are inherently 'political' institutions by virtue of their cultural agency and influence. He continued:

> The question of public or private funding does not affect this axiom … the decisions of museum officials … follow the boundaries set by their employers. These boundaries need not be expressly stated to be operative. Frequently, museum officials have internalized them to make the 'right' decision.[55]

In 1985, after his solo exhibition at London's Tate Gallery, lawyers acting for the Mobil oil company contacted the gallery alleging copyright infringement in the exhibition catalogue, which was subsequently withdrawn from circulation. The catalogue later went on sale after the Tate received advice from government solicitors.[56] Although this was an extreme example, prompted by Haacke's exposure of apparent corporate hypocrisy arising from the alleged sale by its subsidiaries of fuel to South Africa's apartheid regime, such instances suggest the commercial sensitivities and interests that can encourage more subtle forms of self-censorship and selection.

Aside from the National Lottery (established to support the arts, sport and heritage), State patronage for art in the United Kingdom is channelled through the devolved structures of the Arts Council and the British Council. The latter, established in 1934 to promote and extend British culture overseas, with grant aid from the Foreign and Commonwealth Office, has a history of buying work from emerging artists, although its collection of just under 9,000 works is under-recognised. The organisation is probably better known for its curation of the British Pavilion at the Venice Biennale.

In 2007 the British Council ended its overseas exhibiting of work by younger British artists, a decision widely criticised by art world figures including Anthony Caro, Anthony Gormley and Richard Wentworth, who argued that it was an overtly managerial response to government pressure. Michael Craig-Martin, one of the Goldsmiths College mentors who tutored the YBAs and a conceptual artist in his own right, described it as a decision that had lead to the 'diminution of the arts' in the United Kingdom and

overseas. It was also reported that there were attempts to close the departments of film, design and visual arts, although these proposals were not carried through.

The overseas exhibitions programme had been a long-running commitment, instrumental in establishing the reputations of artists such as Peter Doig, Gilbert & George, Damien Hirst, Chris Ofili, Sarah Lucas and Rachel Whiteread. The British Council was also central in internationalising the reputation of artists from previous generations, including the British modernists Henry Moore, Paul Nash and Bridget Riley.

The Council's director of arts, Rebecca Walton, subsequently conceded that cuts had gone 'too far' and had left the organisation insufficiently 'responsive to the creative sector'.[57] It was reported that the rationale had been to focus on building cultural relations with Asia and the Middle East as part of an attempt to tackle the perceived alienation of young Muslims arising from Britain's foreign policy. In a comment that raised concerns about the British Council's direction and heavy-handed government control, Anthony Gormley stated that:

> We're looking at the politicization of an organization that dealt with the exporting of creative values and processes to a wider world. We're seeing the British Council being turned into a political tool more concerned with teaching English and creating business links. It's now seen as another arm of the Foreign Office.[58]

While the British Council has publicly pledged to put its house in order and to reverse some of the consequences of funding cuts, this example illustrates how public support and patronage, exercised by government, for contemporary art are equally subject to pressures and agendas both commercial and political.

The Arts Council's Per Cent for Art scheme

The UK's Arts Council is the national development agency for the arts, supporting the full spectrum of practice, from literature, dance, music and theatre through to carnival and the visual arts in all forms. In addition to assisting arts-based projects and initiatives, the Arts Council also supports artists through an acquisitions and purchasing fund. Established in 1945, it was reorganised in 1994 into a more devolved structure, with separate councils for England, Scotland and Wales, and coverage reflecting the constituent regions of each country. The Arts Council is also responsible for distributing lottery funds, having subsumed the regional arts boards in 2003.[59]

Among the Arts Council's most important contributions to the context for contemporary art making and commissioning in the United Kingdom

has been its campaign for a statutory arts funding policy. In March 1988 the organisation pledged itself to a national 'Percent for Art' scheme under which a proportion of the capital costs of building and environmental initiatives could be set aside for commissions to artists and craftspeople. In the mid-1990s, following a mixed response to the original scheme, the Arts Council relaunched and redefined its policy on public art. Discussing the initiative, senior visual arts officer Andrew Wheatley said at the time, 'Percent for Art was always a mechanism. It was never a philosophy, but only a means to ensure that contemporary art had a role in the built environment'.[60]

This pragmatic approach to policy development has helped the Arts Council to establish and support a sea-change within the United Kingdom towards the commissioning of contemporary art within the built environment. Across public and private commercial developments, variations of the Per Cent for Art formula are now commonplace, with 1 per cent of the capital build costs typically set aside for the commissioning of art as part of the final scheme. Under section 106 of the Town and County Planning Act, there is also an obligation between the developer and local authority to provide appropriate infrastructure and community-based facilities as part of any new build scheme. These provisions have been used to incorporate and finance art-based projects covered by the Per Cent for Art scheme.

The profile of regionally based development projects has been accompanied by further shifts in Arts Council policy. In 2005, Arts Council England launched a major review of the presentation of contemporary visual arts. Among its findings was that provision of contemporary art was 'uneven' across the country, and that there was a lack of 'specialist curators' especially in photography, new media and performance. Unveiling its ten-year strategy, Turning Point, for the visual arts sector in 2006, the Arts Council identified greater collaboration with business and enterprise as important drivers of urban regeneration, and the need to provide sustainable portfolio careers which characterise the professional lives of working artists. The Arts Council also formally recognised the need to expand and target visual arts support into rural areas previously sidelined in favour of large urban conurbations and infrastructure projects.[61]

Contexts for public art and other commissioning organisations

In the United Kingdom, non-profit-making real estate organisations like the Urban Land Institute (ULI) have been set up to promote and develop best practice across the commercial and public sectors and to encourage innovative approaches to commissioning art projects among business sponsors and developers. State-funded organisations within the sector such as the Contemporary Art Society (CAS), originally established to promote

and select art for the UK's museums, have developed a complementary role which now includes providing a client-based advisory service that covers art acquisition, site-specific commissions and corporate image-making.

Corporate art patronage within the workplace or the built environment was once memorably described by the architect Norman Foster, as just 'lipstick on the face of the gorilla'.[62] Attitudes within the commercial sector to the role and value of art vary, with some recognising it as a marginal addition to overheads which is justified or tolerated by the opportunity to 'add value'. But in the United Kingdom over the past two decades there has been increasing awareness of the broader social and public value in humanising the built environment in ways which are both tangible and less directly quantifiable, rather than just creating what Cher Krause Knight describes as 'aesthetic band-aids providing modest amenities and moralist platitudes'.[63]

Professor Chris Wainwright, head of the Camberwell, Chelsea and Wimbledon art colleges, has underlined the desirability of commissioning public art installations which signify as subversive and 'restless objects which refuse to give up their meanings easily'. This was counterposed to the default commissioning of safe, inoffensive, decorative installations which blandly meld into the background of design-led or architecturally-led projects.[64] Aside from the conceptual and aesthetic preferences evident from the observation, Wainwright's perspective also mediates the institutional interests of British art schools and their role as creative brokers in supporting graduates in the development of careers and the pursuit of commissions.

While British art schools have traditionally cherished their institutional independence, a key theme that has emerged and driven curricula over the past decade has been that of 'connectivity' – the relationship between the institution and the public domain. But throughout the commissioning and design stages, graduates and artists contracted by developers and planners are inevitably involved in pragmatic negotiations and accommodations, both aesthetic and practical.

The role, value, quality and profile of British public art has been the subject of increasing debate in both the specialist art press and the wider media in recent years. Homogenised to its broadest category of memorial sculpture, its defenders see it as a means of making visible, shared and communal spaces within a consumer culture which appears increasingly fragmented and socially disparate. Dave Beech, an artist and writer, has recently considered its paradoxical status within contemporary culture:

> Public art has never had a truly public role – and no wonder, given its emergence at the point at which art severed its links with church and state. Its key social roles today lie with town planning and property development, which are dominated not by the public good but by commerce.[65]

Rather than the conventional and formal siting of memorial objects in squares and shopping malls, he calls for the redefinition of the genre which takes account of the 'performative' dimension to public space and the specificities and contradictions of what is actually meant by 'public'.[66] For Beech, it is the possibility of public art's receptivity to diverse and possibly antagonistic audiences and social discourse that might justify its description as 'new genre public art'.[67]

The immediate context for Beech's essay was the recently unveiled Hyde Park sculpture to the victims of the 7/7 bombing in London, with each of its fifty-two stainless steel columns corresponding to one of those killed in the 2005 terrorist attack. Discussing the hegemonic associations of public statues and monuments, Beech continued, 'the ideological critique of monuments and public art is not enough by itself if it suggests merely that the content of public art needs to change, not its forms, formats, social relations and everything else that constitute it'.[68]

The inauguration of Trafalgar Square's vacant fourth plinth as a forum for the display of public art underlines both the adaptability of sculpture as a genre, and the prospect that ceremonial public spaces might be redefined in some of the more reflexive ways that Beech suggests. Described as London's 'most famous empty site', Trafalgar Square's fourth plinth, originally designed in 1841 for an equestrian statue of William IV, has become one of the most eagerly contested venues for showcasing contemporary sculpture and installation projects. The collaborative scheme, initially launched in 1999 by the Royal Society of Arts (RSA) and the arts commissioning charity, the Cass Sculpture Foundation, subsequently passed to London's Mayor's Office and the Greater London Authority (GLA), which assumed promotional and organisational roles.

As commentators have noted, submissions for the north-east plinth (which looks across to the spire of St Martin in the Fields) have tended to emphasise the 'anti-monumental' as a foil to the site's imperial history and the colonial or regal character of the personalities represented by adjacent statues. Trafalgar Square was designed by Charles Barry and John Nash and completed in 1845. The other three corners of the square host traditional commemorative statues; one of George IV and the other two of military figures, General Napier and Sir Henry Havelock. Despite the success and profile of initial exhibits, the fourth plinth was empty for three years after 2001, prompting speculation that the commissioning authorities were divided over the use and profile of the space. Widespread press coverage and apparent public interest during the hiatus indirectly underlined the extent to which the fourth plinth had become a highly 'active' space within the public domain, rather than a moribund sculpture mausoleum.

Some of the temporary installations have been more reflexive of the site, and by implication the challenges faced by public art, than others. The scheme's inaugural sculpture was Mark Wallinger's (b. 1959) near life-size,

white marble resin *Ecce Homo* (1999). The sculpture's title, Latin for 'behold the man', uses the words allegedly spoken by Pontius Pilate when Christ was presented before the crowd for judgement. Contravening the central placement and bombast of ceremonial sculpture, *Ecce Homo* was positioned on the plinth's front edge, a pose both diffident and expansive – suggesting the extension of the sculptural space to the surrounding cityscape.

Wallinger's poignant representation of Christ, with his wrists bound and garlanded with the crown of thorns before torture, crucifixion and death, has been interpreted as an allegory of the political prisoner, reprising a prominent theme within post-war public and civic sculpture. Reflecting on this broader theme and the sculpture's symbolic siting, Wallinger has described *Ecce Homo* as a reminder that 'Democracy is about the right of minorities to have free expression, not the majority to browbeat and maginalise'.[69]

David Burrows has discussed the very different critical resonance of *Ecce Homo* in relation to issues of 'belief and duration' conventionally associated with ceremonial public sculpture. Typically the monumentality and longevity of such sculpture makes claim to particular world views or ideologies which 'repress' any sense that such ideas might eventually become obsolete or irrelevant. The historic figures and lives commemorated on the adjoining plinths, and Nelson's Column itself, imply various feudal, colonial and militaristic ideologies. The durability and relevance of such ideas has become increasingly problematic, contested as they are by the 'near symmetries' of post-colonialism and the more complex interdependencies of globalisation, gender, class and multi-faith societies.

By contrast *Ecce Homo*, one of four copies, was a temporary exhibit and was taken down soon after the new millennium celebrations were over. The conditions of its display made explicit Wallinger's sensitivity towards the legitimacy and durability of highly visible public sculpture. Burrows notes:

> *Ecce Homo* subtly raises these issues, through the depiction of an ordinary man about to die, but whom one may or may not believe will live forever (in Spirit at least) … . In this sense, the persecuted and tortured figure of *Ecce Homo* was a question mark that punctuated Trafalgar Square's stone and bronze figures embodying the beliefs of a nation.[70]

Rather than recreating a mausoleum to compliant generals and statesmen, Wallinger's subject for the empty plinth mobilised Trafalgar Square's history as a place of political dissent and refusal. As Ian Hunt noted of the location's history, 'a connection was being affirmed, in the traditional focus for protest and public marches, to both the Christian nonconformist contribution to radical social movements, and simultaneously to the suppressed Catholic aesthetic of statuary in public places'.[71]

Wallinger's receptivity to the plurality of audience, to the historical ambiguity of location and the deliberate siting of the sculpture as a

temporary intervention, suggest that *Ecce Homo*, at least, has met some of the performative criteria for what has been termed 'new genre' public sculpture.[72] But working within such an iconic site, Wallinger was also responsive to the more established paradigms for public art: its role as monument, portraiture, commemoration and memorial, and the conflicting expectations of the open-ended audiences that viewed it while it was in situ.

Rachel Whiteread's (b. 1963) *Monument,* an up-ended mirror image of a large granite plinth, cast in two sections of clear resin, was installed on the fourth plinth in the summer of 2001. Evident with Whiteread's commission, which its maker described as 'a pause … a quiet moment', was its refusal of the condition of monumentality, a theme which the artist had explored in the Holocaust Memorial sculpture previously completed for Vienna's Judenplatz (2000). The transparency of *Monument* made it appear receptive to the changing conditions of light and atmosphere, suggesting a sense of mutability rather than just the bland exteriority associated with more conventional memorial sculpture. Describing the piece at the time of its installation as 'severe and rhetorical', the art critic Adrian Searle continued, 'Whiteread's piece is always a sculpture about tragedy, as much as it is a sculptural game with the physical world, a game with weight, and evanescence, abstraction and physicality. A plangent image of the metaphorical possibilities of repetition and endlessness'.[73]

A critical revision of some of the conventions and exclusions routinely exercised in public forums of art display underpinned Marc Quinn's (b. 1964) alabaster portrait, *Alison Lapper Pregnant,* which was unveiled on the fourth plinth in September 2005. Lapper (b. 1965), a British artist, was born with phocomelia, a rare chromosomal disorder which left her without arms and with shortened legs. The idea for the choice of subject came from the fragments of classical statuary, historically venerated as part of the western classical tradition, which Quinn had encountered in the British Museum and the Louvre. Similarly fractured, yet whole, Lapper's form was conceived as being 'like' the existing statues in Trafalgar Square. Although completed in marble and suggesting their smooth exteriority, Lapper's gender, physical and maternal condition collectively subverted the ideas and objectified pretensions of the surrounding statuary. Discussing the memorialising and historicised purposes of earlier public sculpture, Quinn said of the work:

> most public sculpture is about the past. It is writing or rewriting history: it tells us who won. This is one of the reasons why I thought *Alison Lapper Pregnant* would work in Trafalgar Square: the fact that she is pregnant means the sculpture is a monument to the future of humanity and not its past.[74]

A re-appraisal of earlier traditions of public and commemorative sculpture

has been central to work by Quinn. *Alison Lapper Pregnant* was among a group of life-size sculptures which Quinn had previously exhibited at Tate Liverpool in 2002. In these, he had explored the representation of sitters with physical disabilities using a medium and genre, marble sculpture, historically associated with depicting perfection and the heroic male body. The British Museum's classical marble portrait busts and sculptures, frequently incomplete, provided Quinn with an example of how aesthetic fragmentation had become accepted through custom and usage.

In size and in its figurative style, *Alison Lapper Pregnant* recalls the academic traditions of representing principally heroic male subjects from Britain's imperial and colonising past, examples of which surround Westminster and Pall Mall. Issues of physical impairment and disability, or more generally the representation of a female sitter, were not part of the classical ideal upon which earlier examples of academic or memorial sculpture were based. Interviewed by Sarah Whitfield for the Liverpool retrospective, Quinn explained how he literally and metaphorically wished to use the 'weight' of this academic tradition in order to subvert it. He continued, 'Heroes in ancient times went out and conquered worlds. Heroes nowadays conquer themselves. And they conquer public opinion. Even though they [the sculptures] came from a conceit about fragmentation they become about wholeness and humanity'.[75]

As Quinn conceded at the time, these sculptures arose from a 'quick and unquestioning' act of assimilation, but they also resist the bland exteriority and homogeneity associated with traditional ceremonial sculpture, what Rosalind Krauss has termed 'the logic of the monument'. Like Wallinger's *Ecce Homo* and Whiteread's *Monument*, Quinn's sculpture demonstrated a responsive sensitivity to location, recognising the inclusive commonality of public space and its debasement through advertising and the incursions of the culture industry. As he noted:

> In a city where the most visible and prolific form of public art are billboards with the slogans of advertisers, it's time to claim back this space for art and revitalise it. Neither dead generals nor mobile phone ads will do. It's time to raise the Lazarus of public art and transform it – and ourselves.[76]

The inclusive aspirations of Quinn's sculpture were given a more literal interpretation by Anthony Gormley's (b. 1950) *One & Another,* which gave 2,400 members of the public one hour each on top of the plinth, assisted by a team of six curators, for 100 days between 6 July and 14 October 2008. Each participant was invited to use the time in whatever way or manner they chose. As Gormley noted of the lottery-based invitation to prospective 'plinthers' to take part, 'We need the body builder but we also need the paraplegic, the naturalist, the Shakespearean actor …'.[77] The work was welcomed by some as

a celebratory and populist gesture and decried by others as a debased aesthetic, a gratuitous exercise in voyeurism. Gormley suggested of *One & Another* that it afforded the public as 'living sculptures' the opportunity 'to occupy … a space normally reserved for statues of Kings and Generals … an image of themselves and a representation of the whole of humanity'.[78]

Reviewing Gormley's 'highly idealistic' and 'political' perspective on the project, curator and commentator Simon Wilson continued, 'It's breathtakingly simple, but thinks outside the box of what constitutes current notions of public sculpture … . It is above all the most complete realization of the holy grail of progressive art, the public participation work'.[79]

In aspiration, Gormley's example suggests the 'relational' and discursive impulse recently popularised by the curator and theorist Nicolas Bourriaud. Although, like the other transient interventions, it left unchanged Trafalgar Square's other memorials to Empire. More practically *One & Another* suffered from the difficulty of actually seeing and hearing the messages and contributions of its various participants, becoming a mildly diversionary and largely overlooked spectacle after the initial media attention, following its launch, had subsided. The only privileged view was that provided by Sky Art's online flat screen monitors positioned around the corner at the National Portrait Gallery. As the art journalist Patricia Bickers acutely (and cryptically) noted of the corporate association, 'whose work is this anyway? Sky Arts is listed as "partner" with Anthony Gormley, so perhaps the "other" of the title *One & Another* refers to the media giant'.[80]

Gormley's participative work, and the other fourth plinth examples briefly discussed here, suggest a broader trend towards the performative and the discursive 'anti-monument' within public art commissions of the past decade. This also underlines the spectrum of sculptural practice in public spaces; from discrete, contingent objects, to composite assemblages and more complex installations. Unlike many of the other examples of memorial sculpture situated around Westminster, successive fourth plinth commissions have suggested a more discursive and critical engagement with location and a greater sensitivity to audience and historical narratives.

Nelson's Ship in a Bottle (2008), a 5 m scale replica model of the flagship *HMS Victory*, set with batik sails and placed in a giant glass bottle, by Yinka Shonibare MBE (b. 1962), was the winning fourth plinth entry for 2010–12. Following the announcement of the entry, Shonibare stated, 'For me it's a celebration of London's immense ethnic wealth, giving expression to and honouring the many cultures and ethnicities that are still breathing precious wind into the sails of the UK'.[81] Although clearly celebratory of the present, Shonibare's installation, placed in the shadow of Nelson's Column, also looks askance at the legacy of British imperialism, the slavery which paid for it and the hubris of Empire.

Other examples of recent and high-profile public art have also been used more instrumentally as fundraisers for particular charities. Simon

Gudgeon's (b. 1958) stylised and minimalist *Isis*, a large figurative sculpture inspired by the ancient Egyptian cult of the ibis, was unveiled in Hyde Park in 2009. Following an agreement between the Royal Parks Foundation, the Royal Parks Agency and Halcyon Gallery, Bruton Street, *Isis* will be surrounded by a series of 1,000 donor plaques, each of which can be inscribed and dedicated for £1,000. The proceeds will go towards the park's 'Look Out Education Centre Project' which provides opportunities for community engagement and for encouraging children to take an interest in wildlife and the environment.[82] *Isis* will contribute to the £1.8 million fundraising initiative to assist with the building of a new, eco-friendly education centre, constructed using sustainable materials.

The Hyde Park project, and the involvement of other private charitable foundations with it, instances a collaborative public and private partnership model, imported from the United States, where there are far more favourable tax breaks than in the United Kingdom for charitable giving and incentives for businesses to assist and contribute to projects which have a manifest social or public benefit. While the United Kingdom has yet to develop the kind of tax incentive structure that would benefit corporate or charitable giving on the scale undertaken in the United States, the various trends outlined here suggest that the onus for arts funding and public, arts-related projects, will increasingly encompass a mixed economy of public, private and voluntary giving.

A distinctive trend in British public art has been towards self-curated and site-specific installations and projects, including for example, the plinth for Birmingham's renovated Ikon Gallery (1997) by Tania Kovats; Michael Landy's *Break Down* (2001) and Jeremy Deller's film and performance work, *The Battle of Orgreave* (2001). The latter two (see pages 128 and 210), also share a further point of connection since both were commissioned by Artangel. One of the most innovative commissioning organisations to have emerged in the United Kingdom in recent decades, Artangel was originally established in 1985 as a non-profit-making concern. In 1991 James Lingwood and Michael Morris became co-directors with an aspiration to develop a 'fluid' and flexible organisation able to commission work in different sites, spaces and contexts beyond those typically associated with 'white cube gallery spaces'.

A London-based registered charity, its commissioned projects have included work by Francis Alÿs, Jeremy Deller, Douglas Gordon, Roni Horn, Michael Landy, Steve McQueen, Rachel Whiteread and Catherine Yass. As James Lingwood has noted, Artangel's approach to commissioning has arisen from a 'mixed economy of private patronage and public support' which has provided the flexibility to pursue projects of varied scales and expenditure. The organisation now works across the United Kingdom and internationally on visual arts and performance projects, with links to film and broadcasting media.

Initial invitations for Artangel commissions generally come from one of the co-directors, but from that moment on the process is 'discursive' rather than 'prescriptive', the idea for the work arising from a dialogue and conversation with the artist from which the project arises.[83] Arguably such an artist-led approach has helped to produce some iconic works of British art history in recent decades, including Landy's *Break Down*, Rachel Whiteread's *House* (page 44) and Deller's *The Battle of Orgreave*. In these three examples, artists produced work which, aside from a commitment to process, making and technique, also explored broader ideas of identity, community and belonging. Although Artangel has no agenda to commission or encourage particular types or forms of art, as Lingwood acknowledges, art is frequently 'entangled' with broader contexts, sites and situations, interconnections which emerge as the commissioned project develops. Discussing some of these examples and the open and discursive process of their origination, Lingwood noted, 'We have never genuinely been able to predict when a project crosses from the discourse of art to the discussion of a broader culture'.[84]

Rachel Whiteread's (b. 1963) *House*, a sculpture made from poured concrete and cast from a condemned terraced house in East London, was commissioned in 1993. (Figure 1.1). It is probably Artangel's most well-known project, the successful completion of which underlined Whiteread's increasingly international reputation, helping her to secure the award of the Turner Prize in that year. A graduate of the Slade School of Fine Art, before *House* (at the time her most ambitious project), Whiteread had explored a wide range of objects and spatial dynamics, using direct casts of plaster, resin and rubber.

Ghost (1990) was a negative cast of an entire room interior from a Victorian house, complete with the pattern of marks left by the door to the room. Taken from a condemned house at 486 Archway Road, North London, Whiteread meticulously made casts from each section of the room's enclosed space, before reassembling the plaster moulds within a customised steel frame. The spectral exteriority of *Ghost, House* and the Holocaust Memorial at Vienna's Judenplatz (2000) have since become artistic signatures of Whiteread's aesthetic.

One observation that several commentators have made is that her aesthetic is not about the solidification of space, but rather its absence. Introducing the first substantial showing of Whiteread's practice in the United Kingdom, the retrospective offered by the Tate Liverpool in 1997, the curator Fiona Bradley noted:

> Central to her work, however, is that its materiality is also an index of absence. In the casting process the original, the recognisable object which the work seems to be 'about' is lost. What is left is a residue or reminder, a space of oscillation between presence and absence.[85]

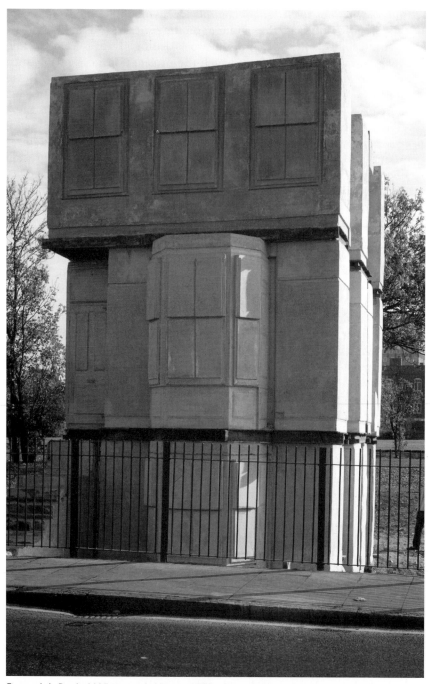

Figure 1.1 Rachel Whiteread, *House*, 1993. Commissioned and produced by Artangel.

The completion and subsequent demolition of *House* prompted wide-ranging debate regarding the purpose and durability of memorial sculpture, and also on wider issues of urban displacement, diaspora and gentrification. Discussing the completed cast as a memorial, the art critic Stuart Morgan noted:

> The result was a monument which served to show how few monuments fulfil their true function: to call to mind, to pacify, to promote reverie, to act as a replacement, however wretched, for what has been lost. A point in time and space, it stopped visitors in their tracks to remind them of larger, deeper, simpler issues of life.[86]

Artangel receives about a third of its financial support from public grants and contributions; a similar amount from co-production, charitable trusts and foundations, and the balance from private patronage arising from a tiered membership scheme to which contributors make a subscription and a pledge concerning length of commitment – important for assisting with capital flows and identifying what resource will be available for commissioned projects which may span several years. In common with moves by galleries, collectors and the major public art museums, Artangel is extending its online presence and platform, which is envisaged as both a 'documentary resource and a site for critical exchange'. At the time of writing, Artangel has commissioned over seventy projects across a range of formats and media.

British art awards and prizes

Corporate patrons, educational interests and some of the UK's major art institutions support a range of national and international art competitions and prizes, a trend which has developed apace in recent years. In addition to providing crucial support to artists and platforms for the display of their practice, such prizes also provide opportunities to gauge the direction and themes of contemporary art. Equally, such awards emphasise the connection between art, money, spectacle and corporate largesse. Writing the introduction to the *Beck's Futures 2005* catalogue, Jens Hoffmann noted some of the distorting consequences and assumptions behind art award shows, principally their gearing towards 'a rhetoric of sensation' and the annual identification and reliance upon the discovery of the 'new' or the 'novel'. He continued:

> Many artists' work simply does not adhere to the demands of such a media-driven event: it is too discrete, opaque or conceptual … . Nor is there any real choice about the decision to participate: to refuse to do so … risks the danger of marginalisation without the benefit of exposure.[87]

Implicit in Hoffmann's sober analysis is how prizes may clarify and deaden some forms of aesthetic practice through the simplifying logic of the market, while at the same time threatening to distort what is produced and how. But in their support, awards more generally extend audiences for art, providing exposure for artists and the prospect of financial support and recognition for their work at what may be critical early points in their professional careers.

As Hoffmann concluded, of awards where the winner does not take all, such prizes might be understood as a 'platform for the support of artists' rather than a competition with 'winners and losers'.[88] It is recognition of some of these effects and consequences that has encouraged galleries, museums and sponsors alike to vary their award formats, making increasingly explicit the eligibility criteria and target demographic, in addition to the allocation and weighting of actual prizes between those eventually selected and shortlisted.

Of contemporary art prizes, the Turner Prize remains the UK's most prestigious visual arts award. With its remit to recognise exceptional contributions to British art, to 'raise awareness of contemporary art and to encourage critical discourse', it was launched by the Patrons of the New Art in 1984.[89] The Turner's prominence within the art world is shared with the Deutsche Börse Photography Prize and the Jerwood Prizes. The Turner Prize offers £40,000 to the winner selected from the shortlist of four artists, with the runners-up each receiving £5,000. It is named after a bequest left by the British landscape painter, J. M. W. Turner (1775–1851). Briefly suspended in 1990 after the prize's then business sponsor, the American investment company Drexel Burnham Lambert, went bankrupt, its relaunch and sponsorship by Channel 4 a year later established what Louisa Buck has described as a 'clear and consistent format' which has been the event's signature ever since.[90] Designed to maximise media interest and public exposure, the selection process runs in three parts throughout the year, from the posting of the shortlist, through to the exhibition of work by those nominated, with the final announcement and televising of the actual awards ceremony held each December.

Since 2004 the prize's main commercial sponsor has been Gordon's Gin, one of the brands owned by UK-based drinks company Diageo, although Channel 4 still provides media coverage. Of comparable value to the cash prize is the press exposure that selection or even shortlisting invariably brings. For example, although both Tracey Emin and Jake and Dinos Chapman have not been awarded the prize (they were respectively runners-up in 1999 and 2003), the profile, status and the marketability of their work has undoubtedly been enhanced through past nominee status alone. The selection jury of five, the deliberations of which are held in private, comprises writers and curators (both UK and internationally based), and is chaired by the director of the Tate. As Sir Nicholas Serota,

Tate director, has conceded, in any one year the result 'depends on the chemistry' of the jurors. He commented, 'In the end it is not a lottery, because closely argued opinions win the day, but in any one year it is highly subjective'.[91]

Given that the jurors' deliberations are not publicised or subject to external scrutiny, Serota's assertion of the selection procedure's essential probity has to be taken on trust.[92] Since its inauguration, the Turner Prize has become a major institution in its own right, having been accorded a retrospective at Tate Britain in 2007. Even concerted critics have largely acknowledged that it has made an important contribution to internationalising the profile of British art and to the UK's standing as a centre of innovative contemporary practice. But the Turner Prize's opaque selection procedure, with the question of how precisely competing and comparative judgements across different media, themes and practices can be made (and consistently weighted or compared), has led to accusations that it has entrenched the influence – and highly subjective aesthetic preferences – of a largely exclusive and self-appointed coterie of art world insiders.

Despite the prominence that it now enjoys, the authority and critical standing of the Turner Prize has fluctuated. In its initial years, there was a marked tendency to recognise an older, established generation of artists, with early awards going to the US-based Malcolm Morley (1984), Howard Hodgkin (1985) and Gilbert & George (1986). The pattern continued, with subsequent winners belonging to a similar generation: Richard Deacon (1987), Tony Cragg (1988) and Richard Long (1989), although as Tom Morton has noted, these accolades to the 'high priesthood of post-war British art' omitted several major figures, including Peter Blake, Anthony Caro, David Hockney and Philip King.[93]

In 1991 the upper age limit for consideration became fifty, and the prize's orientation was designed to reflect more clearly the Tate's cultural mission as a museum, which included strengthening 'the support for the gallery from individuals, trusts, foundations and companies'.[94] In 1994, the Turner Prize remit was clarified to include British-born artists and those born overseas but who were living or working in the United Kingdom. Throughout its history, there has been an ongoing gender imbalance in both winners and shortlisted artists. Between 1987 and 2007, only three female artists were awarded the prize: Rachel Whiteread (1993), Gillian Wearing (1997) and Tomma Abts (2006). With the exception of the all-female shortlist in 1997 which, in addition to Wearing, featured Christine Borland, Angela Bulloch and Cornelia Parker, it has been unusual for any of the shortlists to include more female than male artists.[95]

Although the annual award ceremony and its nominees still receive significant media coverage, commentators have generally noted the increased competition and profile from other prizes, competitions and art

fairs, initially from the Beck's Futures award (1999–2006), but more recently from the Frieze and Zoo art fairs. Additionally, the more diffuse and expansive market of new galleries, dealers, curators and networks concerned with contemporary art has provided a broader and arguably more heterogeneous window onto recent practice which has challenged both the distinctness and primacy that the Turner Prize had previously enjoyed. But as its defenders regularly note, the media circus that still surrounds it has been influential in bringing contemporary British art from the periphery into mainstream visual culture and popular consciousness. As Tate Britain director and chair of the judges, Stephen Deuchar, observed in 2008, after that year's award had been made to Mark Leckey for his film, video and collage art, 'To be frank, if through the Turner Prize we're able to bring more than one artist to new public attention, then we're doing a good job'.[96]

The Beck's Futures award was launched in 1999 in association with the Institute of Contemporary Arts (ICA) at Pall Mall, then under the directorship of Philip Dodd. The German beer manufacturer already had a record of art sponsorship dating back to the mid-1980s, including collaborative projects with Artangel such as Whiteread's *House* and work by Douglas Gordon and Tony Oursler. The company's YBA-branded bottle series was a highly visible marketing exercise, the collectability of which ironically outlived the prize itself.

Widely perceived as a challenge to the primacy of the Turner Prize, the overall, headline prize amount of £65,000 made the Beck's Futures the most lucrative British art award, although this was divided between the winning nominee and the three runners-up, with £5,000 given to the Student Prize for Film and Video. This was subsequently whittled down to a seemingly arbitrary £38,000. In what Dodd pointedly described as a gesture to 'break the "winner-takes-all" frame of mind of most prizes', all those shortlisted received some financial help as well as the opportunity to tour work in major urban centres outside London, such as Glasgow and Sheffield.[97] Initially the Beck's Futures award solicited open nominations from critics and curators around the country, although this was later changed to a closed system consistent with Turner Prize practice.

Its ambition was to support and recognise 'promising but unknown artists' working across the media of painting, sculpture, video, film and photography. The prize organiser's ambivalence towards London's dominance of the British art scene and an interest in the regions outside the capital appeared to recognise the more stylistically eclectic and geographically decentred contemporary art environment, which became more apparent in the hiatus after the Royal Academy's *Sensation* show in 1997. This commitment to a 'larger national canvas on which to display the work of selected artists' became more explicit in 2006, when the exhibition of shortlisted artists took place in three cities – London (ICA), Glasgow (CCA) and Bristol (Arnolfini Gallery).[98] In a further development, the 2006

catalogue also included details of those artists longlisted, in addition to the thirteen selected artists.

One of the prize's most critically interesting shortlists was drawn up in 2005, in what was to prove its penultimate year. Submissions exhibited included documentary footage by Luke Fowler (b. 1978), a Glaswegian film-maker and musician, which explored the subject of the Scottish psychiatrist R. D. Laing. Fowler's *What You See Is Where You're At* (2001) spliced interviews with fraught audience scenes and the infamous Kingsley Hall experiment in which Laing applied some of his 'freeform' ideas to the treatment and medication of his patients' addictions and disorders. Laura Cumming described the effects of the crafting of the footage when it was included in Fowler's solo show at the Serpentine Gallery:

> The film has been so subtly treated, fractionally slowed, seamlessly jump-cut, spliced with television footage, interspersed with stills, distanced ... that one loses a firm grasp of time and reality.[99]

Fowler subsequently won the inaugural Derek Jarman Award in 2008. Another artist whose work was given a platform by the Beck's Futures was artist and writer Donald Urquhart (b. 1963), whose evocative mixed-media installation *Another Graveyard* (2005) included a red rose floral arrangement in the form of a funeral wreath, spelling the words 'So Life Goes On'. Urquhart has subsequently become more widely known for his pen and ink drawings depicting erotic subcultures and fetish characters, with solo shows in New York and Cologne.

Other submissions included Ryan Gander's (b. 1976) *Bauhaus Revisited* (2003), an installation of heaped chess pieces based on a design by Josef Hartwig, and made from blacklisted zebra-wood from the African rainforest. Gander's work was subsequently included in the 2006 Tate Triennial, and he has had solo exhibitions in Paris and Switzerland. Daria Martin (b. 1973), known for some of her 16 mm film tableaux which meld performance and a consciousness of the artificiality of her chosen medium, was another of the nominees. Her film *Closeup Gallery* (2003) (Plate 1), presented against a pop music soundtrack, depicted a card magician and his assistant who exchanged card tricks and displays on a rotating, transparent card table. Against an elaborate and opulent setting, the actors stepped outside of their roles to make occasional mistakes, undermining straightforward readings of the narrative, and making explicit the simulated nature of the choreography and the instability of visual representation.

In 2006 the *Tate Triennial of New British Art* featured her film short *Wintergarden*, based loosely on the mythological theme of the abduction of Persephone by Hades, which was performed within the restored modernist setting of Bexhill-on-Sea's De La Warr Pavilion, East Sussex. Elegantly choreographed in contemporary dress, *Wintergarden* was screened entirely

without dialogue, with the Norwegian classical musician Maja Ratkje providing the voiceover, comprising early melodies and occasional spoken words.

Ironically, in what was to be its last year, the selecting panel of 2006 was almost entirely composed of YBAs – Jake and Dinos Chapman, Martin Creed, Cornelia Parker, Yinka Shonibare and Gillian Wearing. The award went to Matt Stokes (b. 1974) for his video film piece on northern soul dance, *Long After Tonight*. Other notable nominees have included the film-makers Oliver Payne (b. 1977) and Nick Relph (b. 1979), painters Dan Perfect (b. 1965), Tim Stoner (b. 1970), Toby Paterson (b. 1974), and Dutch-born video artist Sakia Olde Wolbern (b. 1971).

In 2004 among those shortlisted was Brazilian-born Tonico Lemos Auad (b. 1968). Auad gained widespread media coverage for his *Drawing on Bananas (Portrait)*, a tattooed image made by pin-pricks, the shape of which only emerged on the surface of the banana when the fruit began to rot. His other noted explorations of the liminal and the overlooked included *Fleeting Luck* (2004), a small sculpture comprising carpet scraps and fluff held together with hairspray and static.

In February 2007 the *Evening Standard* ran a news story reporting that the prize was about to be replaced by a music award, judged by a new management team to be more 'fashionable' than contemporary art.[100] In the event, Beck's and the ICA collaborated on a music and arts project which celebrated the gallery's sixtieth anniversary, although the Beck's Futures awards were subsequently dropped. Although critical opinion was divided on the overall merits of the prize's relatively brief run (the 2005 award to Christine Mackie generated a lot of negative media coverage, including a scathing review by the *Guardian*'s Jonathan Jones), its cessation underlined the attendant sensitivities of private art prize sponsorship and the instabilities of commercial brand association, especially when that 'association' was no longer judged to be of optimal value to the brand.

There had already been a foretaste of corporate brio in 2003 when Beck's publicised the sponsored event with the poster strapline, 'If corporate sponsorship is killing art, want to come to a funeral?' Commenting on the perverse irony of the provocation, the art critic J.J. Charlesworth noted:

> in our anti-globalisation, no logo culture, corporations are blamed for pretty much everything. So the PR people at Beck's have decided that the way to look ethically responsible with their target market ... is to own up to corrupting culture before anyone's thought of accusing them. Even corporate guilt can, it seems, be re-branded.[101]

Given some of the negative press coverage that attended subsequent shortlists (and what appeared an impromptu closing of the Beck's award), the copy probably came back to haunt the sponsors.

Another high-profile contemporary art award is the Jerwood Contemporary Painters, which replaced the Jerwood Painting Prize, last awarded in 2003. A team of three selectors agree an exhibiting shortlist of work by contemporary artists working within the medium. Typically, contenders are relatively new artists rather than established names, a distinction which attracted speculative buying interest in the expectation of rising prices and reputations. In order to give the annual exhibition balance, selected works are chosen by genres and styles, such as landscape painting, portraiture, still life, abstraction, spray painting and works on paper etc.[102] Although a single prize is not awarded, each participant receives £1,000 and the opportunity to display and sell their work. The entries are initially exhibited at the Jerwood Space, at London's Bankside, before touring nationally.

The Photographers' Gallery, Ramillies Street, West London, is the largest public gallery dedicated to the medium in the United Kingdom. In 2005 the Deutsche Börse Group became the title sponsor of the annual Photography Prize that is associated with the gallery (under the former aegis of the Citigroup Private Bank since 1997, it had become one of the most prestigious international arts awards). The Photography Prize is awarded annually to a contemporary photographer who is judged to have made an outstanding contribution to the medium in the previous year. Previous winners include Richard Billingham (1997), Andreas Gursky (1998), Rineke Dijkstra (1999) and Paul Graham (2009).

The creative economy and cultural regeneration

The prominence of the institutionally-based art prizes and awards, some of the major examples of which have been briefly surveyed here, is underlined by the key involvement of commercial sponsors and backers who, in various ways, wish to be associated with the contemporary art 'brand'. But another aspect to the UK's profile as a centre of innovation in visual arts practice concerns the equally pragmatic interests of policy makers and economic forecasters.

One of the significant drivers that have underpinned political attitudes towards domestic British cultural policy since the late 1980s has been the recognition of the financial value of the creative sector in supporting urban and cultural redevelopment projects in which arts-led regeneration has played a central part. Although figures vary, one estimate from the UK's Department of Culture, Media and Sport (DCMS) suggests that the creative economy is considered to generate just under 8 per cent of the country's gross domestic product (GDP).[103] Using figures from 2001, John Hartley has suggested that in financial terms, this equated to the creative industries having generated around £112.5 billion in revenue, with an estimated 1.3 million people employed in the sector.[104]

In relation to the knowledge-based economies of the developed world, policy makers increasingly understand the enterprise and innovation associated with the creative industries as offering a new paradigm for economic and social development, one which moves away from the manufacturing-based ethos of previous decades. The concept of 'creative industries' started in Australia in the 1990s and was then adapted by New Labour, which established the Creative Industries Unit and Task Force under the auspices of the DCMS.[105]

New Labour's invocation of 'Cool Britannia' was an early attempt to brand and revitalise the United Kingdom through its creative sector, although, as Jinna Tay, has noted, its instigators had not necessarily consulted those who actually worked within the sector.[106] But implicit in the gesture, and the new administration's metropolitan bias, was the recognition of London's disproportionate influence as the UK's largest, most cosmopolitan city and its potential as an international, creative hub. London is judged to have around 40 per cent of the UK's arts infrastructure, with an estimation of around 700,000 people working within its creative industries. Geographically and culturally, successive waves of domestic and continental migration through the centuries have 'replenished' the city's reservoirs of talent and its receptivity to change and innovation, a profile that also applies to many of the UK's other major conurbations.[107]

London and its boroughs have seen a swathe of major redevelopment projects and proposals, of which the largest in recent decades was the conversion and refashioning of the Port of London's old docks and their immediate hinterland. Re-designated an enterprise zone with tax exemptions and allowances, the area was extensively redeveloped throughout the 1980s and 1990s for commercial, light industrial and residential use. The first of the YBA *Freeze* exhibitions, curated by Damien Hirst and Carl Freedman in 1988 in a then disused Port of London Authority building, shared this moment of post-industrial reinvention. Docklands is now the City of London's financial hub, with some of the highest real estate values and most exclusive residential addresses in the capital. The redevelopment of London's old port area into a prime residential and commercial sector has also provided the impetus for the planned development of the Greenwich peninsula and the Thames Gateway. Similar projects have been instrumental in refashioning port areas in cities such as Edinburgh, Glasgow, Liverpool, Gateshead and Newcastle. These initiatives have also been supported at a pan-European level with the European Union-sponsored Capitals of Culture scheme (2005–11), which has identified areas for extensive regeneration and redevelopment projects involving the creative industries.

Since the late 1980s and 1990s, gentrification and urban displacement have defined the City of London's demographic, as they have that of post-unification Berlin and New York's Harlem and Bowery districts. In London,

these dislocations were the result of the economic recession of the early 1990s which effectively restructured the art market. At the start of the 1980s, the UK's art market was largely clustered around London's West End, with private dealers and galleries centred around Cork Street, Old Bond Street and New Bond Street.

With the onset of the recession, long-established galleries faced a flat market and punitive overheads; some closed, others relocated to South London or the capital's East End, a trend anticipated by Interim Art and Matts Gallery, which had been involved in the East End since the 1980s. The previously working-class areas around Bethnal Green, Brick Lane, Hackney, Hoxton, Shoreditch, Southwark, Spitalfields and Old Street were colonised by successive diasporas of artists and dealers, who brought with them the infrastructure of gentrification: cafés, wine bars and residential redevelopment. The lottery-funded expansion and re-opening of the Whitechapel Gallery and the increasing prominence of the South London Gallery have since underlined the shift of much of the capital's art scene away from London's West End.

Areas further out from the City of London such as Mile End and Stratford have witnessed new influxes of artists and urban professionals. More recently Deptford, Camberwell, Fulham and Peckham have developed established enclaves, including artist-run collectives and self-curation projects. The regeneration of these areas is also, in part, a consequence of the property price pressures of London's inner boroughs and the planned Olympics, placing a premium on space costs and travel time into the City. As these newly colonised areas have become fashionable, with higher rents and living costs, their existing resident populations have gradually been forced out, feeding the classic pattern of urban gentrification.

These pressures are long-standing, and previous attempts have been made to provide affordable artists' spaces through initiatives such as Acme and Space Studios, the latter established by Bridget Riley, Peter Sedgley and Peter Townsend in 1968. Legislative changes which mean that landlords incur rateable charges on empty premises (waived if they register as a charity), have also helped extend the availability of studio space in parts of the capital, as has the increase in unused commercial warehouse and office space arising from the economic downturn.

One of the more recent strategic shifts in the UK's arts and cultural policy has been the emphasis on enhancing approaches to supporting and enhancing a visual arts infrastructure across the country, recognising the dominance of London and other major conurbations such as Glasgow, Liverpool and Manchester. The Renaissance in the Regions Programme was devised as a project to promote and develop art institutions outside London. Described by the Visual Arts and Galleries Association's (VAGA) website as the 'UK government's most important intervention in English non-national museums since the Museum Act of 1845', by 2011 £300 million

will have been invested, with an 18 per cent increase in visitors to 'hub museums' since 2002–3.[108]

As part of the push towards greater regional coverage and more inclusive social engagement, 2009 saw a major review of the initiative, with a raft of published recommendations, including calls for British museums to develop partnerships both within and outside the cultural sector, in addition to developing an ethos of 'innovation, risk, commercial and social entrepreneurship'. The DCMS was also called upon to make the initiative a central part of a National Strategy for Museums.

A string of cities and regions, all of which faced the prospect of long-term post-industrial decline, have been the focus of major civic regeneration schemes, including Middlesbrough, Gateshead, Glasgow and Liverpool – the 2008 City of Culture. The Baltic Centre for Contemporary Art (Figure 1.2) opened in Gateshead in 2002 in a former flour mill, has since become the central visual arts venue for the North East. This paralleled the redevelopment of the port and quayside areas into prime commercial and

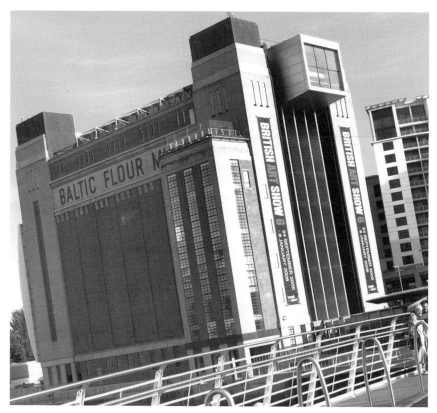

Figure 1.2 BALTIC Centre for Contemporary Art. Image © Colin Davison. Courtesy of BALTIC.

residential quarters, which have enhanced the attractiveness of the social environment, stemming the previously high levels of urban depopulation.

In February 2007 Middlesbrough's Institute of Modern Art (MIMA), a £19.2 million gallery dedicated to contemporary art, opened its doors on the site of a former car park. Its interior consists of a series of five interconnected gallery spaces. The building was designed by the Dutch company Erick van Egeraat (EEA), which has made extensive use of glass to construct the façade and the sloping terrace roof. The culmination of a five-year project, MIMA was planned to cater to the regional Teesside catchment area and also to develop a national profile through temporary loans of work, exhibitions and a permanent collection of British art which spans the twentieth century. In a pattern which increasingly informs other major arts infrastructure projects in the United Kingdom, its funding was provided through a mix of public and private partnership, involving the National Lottery, the Northern Rock Foundation and European development support.

MIMA's inaugural exhibition, *Draw*, featured work by Ceal Floyer, Damien Hirst, Chantal Joffe, David Musgrave, Chris Ofili, D. J. Simpson and Gavin Turk, which was paired with iconic modern images by artists such as Francis Bacon, Joseph Beuys, Jackson Pollock and Andy Warhol. The intention was to demonstrate differences and similarities in the approach to media, technique and subject, and to provide new visitors with a sense of the 'similarities' and 'tensions' between iconic modern art and more recent practice.[109]

In other venues outside of London, major cultural redevelopment projects have been supported by both central and local government funding. At the time of writing, Turner Contemporary is a major flagship project under construction at Margate, a seaside resort on the South East coast (Figures 1.3 and 1.4). Arts Council England and the South East England Development Agency (SEEDA) have provided £8.1 million towards the project, which is expected to be completed in 2011. Designed by David Chipperfield Architects, winners of the 2007 RIBA Stirling Prize for Architecture, the plinth-based two-storey building will feature naturally lit galleries with panoramic views of the coastal skyscape and Margate Bay.

The building will be clad in opaque recycled glass, with a double-height ground-floor gallery space available for installing and displaying new commissions. It will feature an external terrace and a cantilevered balcony area to maximise the building's location and floor space. In recognition of the project's expected contribution to the social and economic redevelopment of the surrounding area (Thanet is among the most deprived areas in the South East), the district council has provided the land on which the gallery will stand. Although many in the locality and the wider region have welcomed the investment in the town's infrastructure, the area continues to face systemic problems of high unemployment, older housing stock and under-investment in local services and the transport infrastructure.

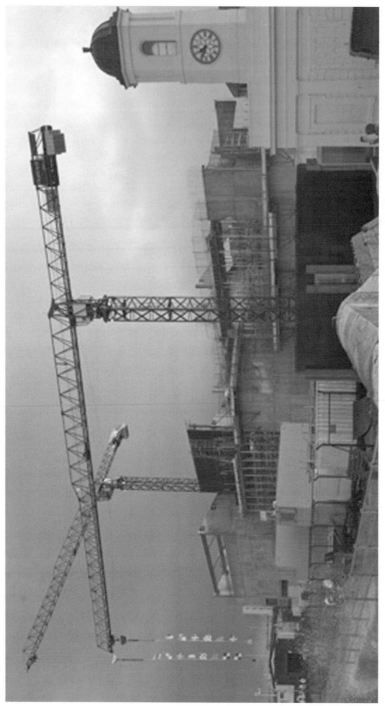

Figure 1.3 Turner Contemporary: building in progress. The gallery will open in 2011. Designed by David Chipperfield Architects. © David Chipperfield Architects. Image supplied courtesy of Turner Contemporary, 2009.

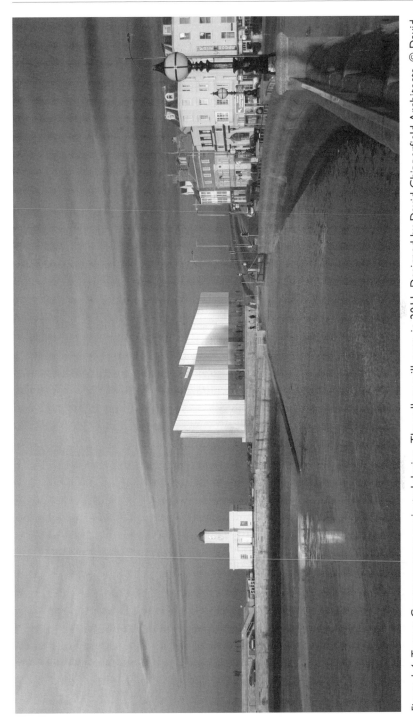

Figure 1.4 Turner Contemporary: projected design. The gallery will open in 2011. Designed by David Chipperfield Architects. © David Chipperfield Architects. Image supplied courtesy of Turner Contemporary, 2009.

In recognition of some of these underlying issues, and the need to tackle regeneration as an integrated social issue, Margate's Renewal Partnership has been set up with a budget of £35 million. Margate's Old Town, the historic centre of the town's fishing community and the area adjacent to the Pier and Turner Contemporary, is being redeveloped as part of a new cultural quarter. Other major landmark sites such as the Winter Gardens, the Lido, the former Dreamland park site and buildings within the High Street, are to be renovated and redeveloped with the aim of establishing a visible impact across the town's fabric and environment.[110]

Further along the South East coast, other arts infrastructure projects have involved the re-zoning and redevelopment of specific areas within towns, such as the establishment of an artists' quarter around Folkestone's old harbour and the decision to establish regular cultural showcases there such as the Triennial. Introducing the inaugural event in 2008, the curator Andrea Schlieker noted the concomitant shift in the role of the artist in these urban projects: 'The past decade or two have seen a shift from the single "auteur" working alone in the studio, towards the artist as collaborator, producer or service provider'.[111]

In recognition of the need to extend and develop opportunities for artists, writers and performers outside London and the other major conurbations, Arts Council England established the 'Escalator Talent' programme in 2004. In collaboration with Commissions East, the visual arts development agency for the East of England, it developed Escalator Visual Arts East to assist and develop young, talented artists in the region. Selected artists, chosen through the involvement of curators based in the region, are offered financial and career development support in addition to the opportunity to show their work in new venues and to new audiences. The first such project was to design a temporary site-specific work for a show to be hosted at the Great Eastern Hotel, adjacent to Liverpool Street Station, London.[112]

The Arts Council's regionalised structure and approach to funding has helped to support events such as Contemporary Art Norwich, which is an international contemporary art and culture festival held during July and August. It is the result of a multi-partner collaboration including the Sainsbury Centre for Visual Arts, EAST International at the Norwich School of Art and Design (now Norwich University College for the Arts), Norwich Arts Centre and the Norwich Castle Museum and Art Gallery. EAST International, an annual submissions-based exhibition, was established in 1991 by writer and curator Lynda Morris. Unlike some of the other UK-based art awards, there are no restrictions on age, medium or subject matter, although the judging or selecting panel comprises two members, usually a practising artist and a critic or curator. In 2005, Gustav Metzger, known for his auto-destructive art works, was invited as to be a selector, with previous selectors including Jeremy Deller, Peter Doig and Roy Arden. Describing EAST's ethos, Morris stated: 'There are three kinds of art institutions: museums, commercial galleries and

the art schools, and each has their idea of the artists that matter. EAST is the annual voice of the art schools'.[113]

Tate Modern, the UK's national gallery of international modern and contemporary art, at Southwark, opposite St Paul's Cathedral, has been the most ambitious cultural infrastructure project of the last decade (Figure 1.5). While visibly signifying the idea of the visual arts as a driver of cultural redevelopment and reconstruction in the centre of the capital, it also demonstrated an innovative and imaginative design concept of re-using and refashioning a previously derelict industrial space.

Swiss architects Jacques Herzog and Pierre de Meuron were commissioned in 1995 to renovate the decommissioned Bankside Power Station, a large brick and concrete structure designed by architect Giles Gilbert Scott in 1947 and operational into the 1960s. In a concept-based approach described

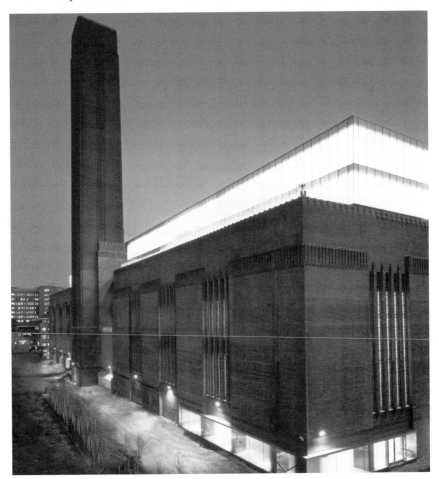

Figure 1.5 Tate Modern, *Bankside*, London. © Tate, London, 2010.

as 'open, flexible and pragmatic', the architects worked with the existing building shell, retaining the large internal space of the Turbine Hall, which has become the gallery's signature space for the exhibition of major installations and for showcasing other site-specific commissioned projects.

The galleries, housed within a five-floor structure, retain the high ceilings and horizontal windows of the original power station. The most visible external addition was a two-storey, glass-fronted horizontal beam, running the building's entire length, designed as a counter to the chimney's vertical mass and the solidity of the façade's crenellated brickwork.[114] Tate Modern was formally opened on 11 May 2000, with footfall more than doubling expectations (over 5 million visitors recorded in the first year, with 30 million in the first eight years), making it one of the world's most popular international art venues.

Tate Modern 2 will see a £125 million publicly and privately funded extension to the main gallery, to be opened in 2012. With the final closure of the remaining electricity switching station, the development will convert the three large underground reserve oil chambers, previously used by the power station on the gallery's south side, to performance and gallery spaces. The existing space enclosed by these structures will form the basement of an irregular tower of perforated brick which will become the visible extension to the main gallery building, providing a 60 per cent increase in public facilities and floor space available at the site.

Aside from the physical extension of the Tate Modern's infrastructure, the intention is to develop public spaces and a land-print which, in the words of the Tate's director Sir Nicholas Serota, prevents the gallery from being 'hemmed in' by adjacent new-build commercial and residential projects arising from the area's gentrification.[115] Associated and successful features designed to enhance the gallery's appeal to visitors and tourists include the 'Tate Boat' service which connects Tate Modern with Tate Britain at Millbank. As a further part of the extension of the Tate 'brand', the gallery's website is conceived by the trustees and director as 'effectively the fifth site', designed to further internationalise the gallery's reach and audience. This ambition is also reflected in the Tate's expansive lending record – more than 1,000 works to 261 ventures, over half of which are overseas.[116]

More recently, the UK's Cultural Olympiad, designed to showcase British culture and the arts to accompany the 2012 Olympics, has had particular resonance for the contemporary art market. The five Olympic boroughs (Greenwich, Hackney, Waltham Forest, Newham and Tower Hamlets) are among the most deprived in London, and include some of the highest concentrations of artists. The artistic director of Tate St Ives, Martin Clark, and other leading figures associated with the visual arts, have called for initiatives which would make a more durable contribution to social and urban regeneration within these areas, but without losing the communities that have sustained their identity.[117]

The trend towards self-curation and artist-run collectives, initially identified closely with the YBAs, has become increasingly recognisable since the late 1980s. Famous examples have included the renting of a former taxi office in Waterloo by Sarah Lucas and Tracey Emin, and Michael Landy's performance and installation work *Break Down*, self-curated and dismantled in the ironic location of a major West End department store.

With the market downturn in 2008 and an increasingly uncertain economic landscape, the trend towards self-curation and (self) professionalisation among art college graduates and early career artists looks set to increase. In 2009 nine universities contributed to *Inside Out*, a festival curated by the London Centre for Arts and Cultural Exchange (LCACE), with events which emphasised the increasingly vocational and pragmatic bias that informs British art colleges. As LCACE director Sally Taylor noted of more recent art students, 'They know they have to set themselves apart – and launch themselves fully formed into the job market. Many of the students in London art colleges do other things to support their art'.[118]

Although the sharing of studio spaces is nothing new, the production of e-zines and online publishing ventures, artist-run consultancies, freelance curation and professionally related networking sites, has been enabled by the impact of new technologies on the present generation of art college graduates. For example, one fine art graduate who left college with a textiles degree in 2007 established a business partnership with a fellow student which toured final degree college shows, selecting possible work for curation with a small commission taken from any work sold.[119]

Some of these shifts might be seen, in part, as an extension of the entrepreneurial and pragmatic ethos which typified the experience of some of the YBAs in the late 1980s and early 1990s. In response to these changes, some galleries have recognised the benefit of sub-leasing space for the direct marketing of work by the artists themselves. Islington's Candid Arts Galleries recently started its own weekend art market, encouraging artists to sell their own work from the gallery's ground floor.

The ethos of the funding projects outlined above and the government embrace of the creative industries have provided the context for a new generation of artists and practitioners. The more coercive dimension to these ideological shifts was among the subjects explored in *Art Incorporated: The Story of Contemporary Art* by Julian Stallabrass (2004). More recently, the consequences of contemporary art's apparent commodification (and responses to it) were explored by the ICA-sponsored symposium, Art & Post-Fordism. As the ICA bulletin put it:

> the culture industry has capitalised on the work ethic of the art world – its ever youthful energy, allure of freedom, flexible working hours, short-term or lack of contracts – and converted it into a standard production model ... governments have also been keen to embrace this

post-Henry Ford work model and link it to the global neoliberal market economy.[120]

In addition to sociologists and academics, the discussion panel included Pil and Galia Kollectiv, artists, writers, lecturers and curators working in collaboration, whose expansive range of shared practice provides one critical response to, and mediation of, the same post-Fordist ethos (see page 246).

Beyond the corporate patronage discussed earlier, collective business sponsorship has played a major part in large UK-based, high-profile social infrastructure projects. The redevelopment and regeneration of the area between and to the north of King's Cross and St Pancras railway stations by a consortium is one of the largest urban redevelopment projects in Europe. The 67 acre site includes twenty heritage buildings and projections for fifty new builds, and is scheduled for completion ahead of the 2012 London Olympics. A central part of the project hinges around the involvement of thirty arts organisations, including the University of the Arts, London (UAL), which encompasses several art colleges including Camberwell, Chelsea, Wimbledon and Central St Martins College of Art and Design.

In 2011 the Central St Martins College of Art and Design will be moving from its site in Charing Cross Road to a purpose-built space at King's Cross, with its graduates expected to play a significant role in the provision and development of art and design-related projects for what is envisaged as a major new civic quarter and international transport hub. As Roger Madelin, joint chief executive of the Argen Group plc and one of the major stakeholders, succinctly put it, 'We want to stuff King's Cross full of art'.[121]

One of the themes emphasised by the corporate sponsors of the King's Cross and St Pancras Project is the importance of commissions that have some linkage with locality or place, a characteristic of other successful public and privately funded art commissions. Reuben Kench, a former fine artist and head of culture and leisure at Stockton on Tees Borough Council, has suggested that the most successful public art has a 'specificity' linking it to location and place.

In the case of Anthony Gormley's iconic *Angel of the North* (1994–8) (Plate 2), this was demonstrated through the sourcing of the Corten weather-resistant steel from the Tyneside shipyards. The elaborate pre-installation work and the excavation of deep foundations alongside Gateshead's A1 were not just practical architectural steps determined by the mass and scale of the 20 m tall statue, but were metaphors for the embedding of a major installation within the landscape and geographical region of the North East.[122] The subsequent decking out of Gormley's installation in a giant replica of Alan Shearer's number 9 shirt by Newcastle United fans in 1998 was recognition that a sense of regional ownership had been acknowledged and reciprocated.

Contemporary art fairs and biennales

In the last decade, international art fairs have become a distinctive feature of the British contemporary art scene just as they have the global market, with the major events including Art Basel, the Venice Biennale and the Kassel Documenta.

London's first international art fair dedicated to contemporary art, the Frieze Art Fair, opened for business in Regent's Park in 2003. Since its launch in October 2003 by Matthew Slotover and Amanda Sharp (publishers of *Frieze* magazine), it has become the capital's major art event, driving the annual calendar of the UK's contemporary art market. One of its early consequences was the 'repackaging' of events by the main auction houses, in order to benefit from the presence and volume of international buyers in London. In 2005 it was reported that Sotheby's and Christie's had doubled their 'mid-season' sales.[123]

The Frieze Art Fair is heavily reliant upon corporate sponsorship, the major supporters being Deutsche Bank, BMW and Cartier. Its structure is also emblematic of the cross-over and increasing indistinctness between public and private forms of patronage. The Frieze Art Fair is a commercial organisation while the Frieze Foundation is a non-profit making entity, partly funded by the European Union and the Arts Council, which oversees the commissioning associated with the event, and the related programme of daily talks, panel discussions and educational provision. As Jens Hoffmann has noted, the close partnership between the public and the private or commercial is a trend that the EU report *European Cultural Politics 2015* expects to become the paradigm for the coming decades.[124]

The Frieze Art Fair through its foundation has also become the only such event to directly commission artists' projects. Discussing its rationale, Frieze curator Neville Wakefield stated:

> The ambition of Frieze Projects is to engage with these conditions [the trends of art making], whether by throwing sand into the vaseline-slick commercial presentation of art, or by taking the spectacle of art out of the white space empyrean and into the forgotten back-lots of the city.[125]

In 2007–8, supported projects included installations by Richard Prince and Elín Hansdóttir, a brief sound performance by Kris Martin (calling for a minute's silence), and printed announcements by Janice Kerbel. In various ways, these works were chosen to mediate the experience and specificity of the art fair itself, the aim being to promote reflexivity about the effects of such events, beyond the more narrowly defined commercial purpose.

The Zoo Art Fair (its name is derived from the site of its initial venue, the bear pavilion at Regent's Park Zoo) started in 2004 as a satellite non-profit-making event to the Frieze Art Fair. Since its launch, and funded by various

sponsors including the Arts Council, private advertisers, publishers and commercial galleries, it has established a reputation for showcasing new and innovative contemporary British art. It is now held behind the Royal Academy of Arts building at Burlington Gardens, and is associated with a younger demographic of artists and visitors. Between its inaugural exhibition and 2007, Zoo's exhibitor numbers had doubled to fifty-one. In recognition of its changing status as a smaller alternative to Frieze, it has also developed a formal application process for exhibitors and a selection committee.[126]

The Affordable Art Fair, launched in 1999 by Will Ramsay, underlined the art trade's response to changing consumer demographics, and in particular the appeal to prospective buyers who wished to make relatively modest art purchases, but not necessarily within the secondary market of the auction house or dealer's gallery space. Held annually in Battersea Park, London, it showcases a wide range of contemporary art, including exhibitions of work by recent graduates, with galleries, dealers and studio groups attending from both the United Kingdom and abroad. The response to changing patterns of art collecting and collectors has also seen the proliferation of online art merchandising and dealing. In some cases, artists have established their own online web presence as a means of directly contacting interested or prospective buyers of their work.

Another imaginative and growing response to the collecting and purchase of contemporary art has been through private buying collectives which pool an acquisitions budget and rotate art purchases among participating members of the group. An idea that originally started in London in 2001 has since spread to Birmingham, Bristol and Cambridge, with the Arts Council and the Contemporary Art Society using the example to develop and extend the idea of collective buying and patronage.[127]

This chapter has attempted an introductory survey and overview of some of the appreciable shifts and evolving contexts in UK-based art patronage and sponsorship in recent years. One of the most significant developments has been the increasingly hybrid character of public and private funding for the visual arts and of the creative industries more generally. Implicit in this have been the clear limits on the capability (or political motivation) of successive governments to fund large-scale arts infrastructure projects (or even the acquisition of individual works of art), without the partnership of the private, business or the voluntary and charitable sector.

At the level of politics, this approach has been driven by pragmatic and instrumentally-based policies which see the case for the support of the creative industries as one based on broadly quantifiable economic and social benefits. It has also been determined by a recognition of the perceived limits of State power, a situation underlined by the dependence of the nation state on the international workings of corporate capital – even when, as in recent years, this has been proven to be little more than an exercise in financial speculation.

The increasingly global and international character of cultural production, assisted through biennales, art fairs and some of the awards and large infrastructure projects mentioned earlier, is both a cause and an effect of this changing cultural and financial landscape. Discussing the evolving character of contemporary art making, and two of the most significant trends that have recently disrupted the 'hierarchy' of cultural production, Anthony Gross, co-founder of the art space 'temporarycontemporary', has noted the proliferation of 'artist-run' spaces which have accompanied the 'immediate professionalisation of the artist'. Secondly, he identifies the practice of the 'institution operating at a grass-roots level of cultural production'.[128] Discussing the possibilities for circumventing the commercial galleries, Gross concludes:

> Maybe the roles of the artist-run space and the institution will eventually swap altogether ... if an artist collective can self-organise and self-represent at a professional level, and if the institution can become a site for nurturing experimentation then there will be a whole new form of the roles of the artist and the public.[129]

In one sense, this is a statement of aspiration in which the artist as practitioner might regain a sense of personal and critical agency. Similarly, the idea that major galleries should become sites for ongoing cultural experimentation with a responsive sense of locality and public engagement has become widespread practice, appreciable in the design and development of projects such as the Baltic Exchange, Gateshead, Middlesbrough's Institute of Modern Art (MIMA) and the Turner Contemporary at Margate. But it also rationalises and turns to advantage the commercial and pragmatic landscape within which new forms of art practice, and immanent critique might be fashioned and realised.

Notes

1 Damien Hirst quoted by Ben Macintyre and Ben Hoyle, feature article, 'The Super-rich', *The Times*, 23 June 2007.
2 Quoted by Joanna Cave, 'Celebrating the artist's resale right', in Iain Robertson and Derrick Chong (eds), *The Art Business*, (Routledge, 2008), p. 155.
3 Quoted by Stefanie Marsh, 'Painting by numbers', auction news, *The Times*, 12 October 2007.
4 Dalya Alberge, art market report, *The Times*, 22 June 2007.
5 Reported by Jack Malvern, '£50 million for Hirst's diamond geezer', *news item, The Times*, 2 June 2007.
6 Reported by Marsh, 'Painting by numbers' (2007).

7 See: Ben Hoyle, 'Hirst brings £65m of his wares to market', news item, *The Times*, 29 July 2008.

8 Quoted by Andrew Johnson, 'Is the art market heading for a crash?' news feature, *Independent on Sunday*, 11 May 2008.

9 See for example 'Fifteen years reporting the international art world' editorial and commentary, *The Art Newspaper*, no. 164 (December 2005), p. 29.

10 Quoted by Philip Inman, 'Art syndicate hopes to snare £40m bargain', news item, *Observer*, 17 May 2009.

11 Quoted in Stefanie Marsh, 'Painting by numbers' (2007), art market news, *The Times*, 12 October 2007.

12 Clement Greenberg, 'Avant-garde and Kitsch', (1939), reprinted in Charles Harrison and Paul Wood (eds), *Art in Theory 1900–2000: An Anthology of Changing Ideas*, (Blackwell, 2003), p. 542.

13 For some examples of collectors' motivations see: Aurelia Voltz, Simone Menegoi, Lillian Davies and Cecilia Alemani, *Collecting Contemporary Art* (JRP Ringier, 2008). For a specifically behavioural and acquisitive explanation see Robin Wight, 'The peacock's tail and the reputation reflex', Arts & Business lecture, 2008.

14 For a survey of art market dynamics and a sociological exploration of variations between auction and gallery prices see Olav Velthuis, *Talking Pictures*, (Princeton University Press, 2005).

15 See for example Guido Guerzoni, 'Analysing the price of art: what the indices do not tell you', feature article, *The Art Newspaper*, no. 157 (April 2005), p. 54.

16 See Rita Hatton and John A Walker, *Supercollector: A Critique of Charles Saatchi*, (Institute of Artology, London, 2003), pp. 118–21.

17 For a discussion of how galleries and museums have responded to this, and to the wider phenomenon of online art, see 'The art institutions', in Julian Stallabrass, *Internet Art: The Online Clash of Culture and Commerce*, (Tate Publishing, 2003), pp. 114–37.

18 The dynamics of the art market and some of its associated institutions and personalities have been among the ongoing concerns of the periodical *The Jackdaw: A Newsletter for the Visual Arts*, edited by David Lee, 2000–.

19 Quoted by Marc Spiegler, *The Art Newspaper*, no. 159 (June 2005), p. 34.

20 Reported by Dalya Alberge, 'Tate embroiled in new conflict of interest row', *The Times*, 15 February 2008.

21 David Bellingham, 'Ethics and the art market', in Robertson and Chong, *The Art Business* (2008), p. 190.

22 Quoted by Marc Spiegler, *The Art Newspaper*, no. 159 (June 2005), p. 34.

23 Quoted by Georgina Adam, 'Parliamentary report backs "art code"', *The Art Newspaper*, no. 158 (May 2005), p. 55.

24 David Bellingham, 'Ethics and the art market', in Robertson and Chong, *The Art Business* (2008), p. 177.

25 Cave, 'Celebrating the artist's resale right', in Robertson and Chong, *The Art Business* (2008), p. 154.

26 See Georgina Adams, 'British Government dithers over art levy', *The Art Newspaper,* no. 164 (December 2005), p. 55.

27 Georgina Adams, 'Government U-turn shocks art trade', *The Art Newspaper,* no. 166 (February 2006), p. 43.

28 Ibid.

29 Cave, 'Celebrating the artist's resale right', in Robertson and Chong, *The Art Business,* (2008), p. 161.

30 Louisa Buck, *Moving Targets 2: A User's Guide to British Art Now,* (Tate Publishing, 2000), p. 186.

31 Quoted by Anthony Haden-Guest, 'Pills and thrills', *Observer Magazine,* 19 September 2004.

32 Quoted by Andrew Johnson, *Independent on Sunday,* 15 July 2007.

33 Lizzie Neilson, quoted in *Art World,* issue 1 (October/November 2007), p. 19.

34 Hirst's intention was recorded by Stuart Jeffries, *Guardian,* 14 November 2006.

35 Julian Stallabrass, *High Art Lite: British Art in the 1990s,* (Verso, 2001), p. 289.

36 Chin-tao Wu, *Privatising Culture: Corporate Art Intervention since the 1980s* (Verso, 2002), p. 6.

37 See the Art Fund website: http://www.artfund.org (accessed September 2009).

38 Laura Cumming, 'Give them some personal space', *Observer,* 15 March 2009.

39 See Jane Allen, 'Wheelers, dealers and supercollectors: where are they taking the art market?' *New Art Examiner,* vol. 13, no. 10 (June 1986), pp. 22–7.

40 Hatton and Walker, *Supercollector* (2003), p. 103.

41 Saatchi's self-authored *My Name is Charles Saatchi and I am an Artaholic* (Phaidon 2009) was profiled on the arts review programme *Front Row,* presented by John Wilson, broadcast on 9 September 2009. Since Saatchi had refused to give an interview, book extracts were presented by voiceovers from actors.

42 For one characteristic review, see Adrian Searle's 'The Trophy Room', *Guardian* G2, 15 April 2003. The design and architecture critic Deyan Sudjic provided a more upbeat commentary in the *Observer* sponsored and produced booklet *Saatchi: The Definitive Guide to the New Thameside Gallery,* which accompanied the gallery's opening in 2003 (pp. 18–19).

43 Martin Bailey, *The Art Newspaper,* no. 163 (November 2005), p. 8. The same press item noted the highly positive footfall which the South

Bank location and its exhibition had attracted. Figures provided by the gallery's press spokesperson placed numbers at 750,000 visitors to June 2004 – an estimated 50,000 per month. Given the £9 admission fee, such popularity was judged to be impressive.

44 See '30 things about art and life as explained by Charles Saatchi', *Observer Review*, 30 August 2009.

45 See for example Rachel Campbell-Johnston's review 'Sensation! It's paint on canvas', *Times2*, 26 January 2005.

46 Rachel Campbell-Johnston, 'Saatchi's old favourites – made in China', *The Times*, 7 October 2008.

47 Quoted by Louise Jury, *Independent*, 14 October 2006, p. 15.

48 Stallabrass, *High Art Lite* (1999), p. 174.

49 Nick Hackworth, 'The art of flogging cars', *Times Review*, 25 June 2005.

50 Ibid.

51 Reported by Jill Sherman, 'Stop plundering arts cash to pay for Games, urge MPs', *The Times*, 25 June 2007.

52 Ben Hoyle, 'Here's the financial picture: the super rich are back', *The Times*, 18 September 2009.

53 John Molyneux, 'State of the art', *International Socialism*, issue 79 (July 1998). See: http://pubs.socialistreviewindex.org.uk/isj79/contents. htm (accessed January 2010).

54 Sandy Nairne with Geoff Dunlop and John Wyver, *State of the Art: Ideas and Images in the 1980s*, (Chatto & Windus, 1987), p. 177.

55 See Hans Haacke's quote in John C. Welchmann (ed.), *Institutional Critique and After*, (JRP Ringier, 2006), pp. 53–5.

56 Nairne et al., *State of the Art* (1987), p. 178.

57 Quoted by David Smith, 'Young British talent betrayed', *Observer*, 29 March 2009.

58 Anthony Gormley quoted by David Smith, *Observer*, 29 March 2009.

59 See the Arts Council website: http://www.artscouncil.org.uk (accessed September 2009).

60 Quoted in Grant Pooke, 'Culture change' (Premises and Facilities Management, IML Group plc, September 1994), p. 33.

61 See the Arts Council England *Turning Point* policy document: http://www.arts.council.org.uk/our-work/turning-point-network/ (accessed July 2008).

62 Quoted by Jonathan Glancey in 'Magic to stir men's blood', *Guardian*, 12 December 2002.

63 Cher Krause Knight, *Public Art: Theory, Practice and Populism*, (Wiley Blackwell, 2008), p. 99.

64 Both sentiments were expressed at a ULI Seminar, Chelsea College of Art, 24 June 2008.

65 Dave Beech, 'Inside out: the fall of public art', *Art Monthly*, Issue 329 (September 2009), p. 3.

66 See for example the discussion of some of the contradictions and assumptions concerning what the 'public' is understood to be in Malcolm Miles, *Art, Space and the City: Public Art and Urban Futures*, (Routledge, 1997), pp. 84–103.

67 Suzanne Lacy quoted by Beech in 'Inside out' (2009), p. 4.

68 Beech, 'Inside out' (2009), p. 2.

69 Mark Wallinger quoted by Ian Hunt in 'Protesting innocence', in *Mark Wallinger: Credo*, (Tate Liverpool catalogue, 2000), p. 16.

70 David Burrows, 'Mark Wallinger's *Ecce Homo*', in *Mark Wallinger: Credo* (2000), p. 36.

71 Hunt, 'Protesting innocence', in *Mark Wallinger: Credo* (2000), p. 16.

72 For a discussion of this concept see Suzanne Lacy (ed.), *Mapping The Terrain: New Public Genre Art*, (Bay Press, 1995).

73 Adrian Searle, *Arts Guardian*, 5 June 2001.

74 Marc Quinn, 'Putting the future on a pedestal', *Times2*, 7 September 2005.

75 Marc Quinn, interviewed by Sarah Whitfield in *Marc Quinn*, (Tate Liverpool catalogue, 2002).

76 Quinn, 'Putting the future on a pedestal' (2005).

77 Anthony Gormley quoted by Dalya Alberge and Jack Malvern, 'Trafalgar Square volunteers will be offered the chance to put themselves on a pedestal', *The Times*, 24 June 2008.

78 Anthony Gormley quoted by Godfrey Barker, 'From marbles to mazes', *Art Times*, 5 September 2009.

79 Simon Wilson, 'A delicate balance', *Royal Academy of Arts Magazine*, no. 103 (Summer 2009), p. 33.

80 Patricia Bickers, editorial, *Art Monthly*, Issue 329 (September 2009), p. 12.

81 See: http://www.london.gov.uk/fourthplinth/shonibare.jsp (accessed February 2010).

82 See: http://www.royalparks.org.uk/learning/ (accessed September 2009).

83 All quotes from author interview with James Lingwood, 15 September 2009.

84 Author interview with James Lingwood, 15 September 2009.

85 Fiona Bradley, 'Introduction', in Rachel Whiteread, Rosalind Krauss and Fiona Bradley, *Rachel Whiteread: Shedding Life*, (Thames & Hudson, 1997), p. 8.

86 Stuart Morgan 'Rachel Whiteread', in Whiteread et al., *Shedding Life* (1997), p. 26.

87 Jens Hoffman, 'Back to the future', *Beck's Futures 2005* (ICA Exhibitions, 2005), pp. 8–10.

88 Ibid., p. 10.

89 Vicky Hughes, 'Foreword', in *Turner Prize 08*, (Tate Publishing, 2008).

90 Louisa Buck, 'The Tate, the Turner Prize and the Art World', in

Katharine Stout and Lizzie Carey-Thomas (eds), *The Turner Prize and British Art, 2007* (Tate Publishing, 2007), p. 18.

91 Nicholas Serota, 'Foreword', in Stout and Carey-Thomas, *The Turner Prize and British Art*, (2007), p. 10.

92 For a personal account of being on the selecting jury, see Louisa Buck's 'The Turner Prize: a judge's view', *The Art Newspaper*, no. 165 (January 2006), p. 30.

93 Tom Morton, 'Tomorrow never knows', in Stout and Carey-Thomas, *The Turner Prize and British Art*, (2007), p. 64.

94 Trustees' Foreword from *Aims of The Gallery: The Tate Gallery Biennial Report, 1988*, quoted by Louisa Buck in Stout and Carey-Thomas, *The Turner Prize and British Art*, (2007), pp. 17–18.

95 Taking the twenty-year run between 1987 and 2007 (and noting the prize's temporary suspension in 1990), there have been seven instances where women have either balanced out the male nominees or exceeded them. See 'Shortlisted artists and selecting jurors' in Stout and Carey-Thomas, *The Turner Prize and British Art*, (2007), pp. 101–7.

96 Quoted by Alexa Baracaia, 'Prize and prejudice', *thelondonpaper*, 2 December 2008.

97 Philip Dodd, 'Preface', *Beck's Futures 2002 Catalogue*, (ICA Publications, 2002).

98 Ekow Eshun, Francis McKee and Tom Trevor, 'Preface', *Beck's Futures 2006 Catalogue*.

99 Laura Cumming, *Observer*, 10 May 2009.

100 Tom Teodorczuk, 'No future for Beck's art prize', *Evening Standard*, 2 February 2007.

101 J. J. Charlesworth, quoted by Hatton and Walker, *Supercollector*, (2003), p. 227.

102 Elizabeth Magill (2007 selector) interviewed by Virginia Blackburn, 'In search of the next big thing', *The Times*, 19 March 2007.

103 Quoted in *Creative Industries: Economic Estimates* (Department of Culture, Media and Sport, 2001), p. 12. See: http://www.culture.gov. uk/creative/mapping.html (accessed September 2009).

104 John Hartley, 'Creative industries', in John Hartley (ed.), *Creative Industries*, (Blackwell, 2008), p. 2.

105 John Howkins, 'The Mayor's Commission on the Creative Industries', in Hartley, *Creative Industries*, (2008), p. 118.

106 Jinna Tay, 'Creative cities', in Hartley, *Creative Industries*, (2008), pp. 224–5.

107 Charles Landry, in Hartley, *Creative Industries*, (2008), p. 236.

108 Visual Arts & Galleries Association website: http://www.vaga.co.uk (accessed September 2009).

109 See Sophie Leris, 'The art of the Tees', *Independent on Sunday*, 28 January 2007.
110 See Margate Renewal Partnership website: http://www. margatetownpartnership.org.uk/margate_regeneration.html (accessed November 2009).
111 Andrea Schlieker, 'Tales of time and space', in *Folkestone Triennial: Tales of Time and Space*, (Henry Moore Foundation and Folkestone Estate, 2008), p. 13.
112 Commission East press release, 2 February 2005.
113 Lynda Phillips, quoted by Jessica Lack, *The Great Art Hunt*, (Contemporary Art Norwich Guide, 2007), p. 2.
114 Michael Craig-Martin, 'Towards Tate Modern', in Iwona Blazwick and Simon Wilson (eds), *Tate Modern: The Handbook*, (Tate Publishing, 2000), p. 18.
115 Sir Nicholas Serota interviewed and quoted in *Transforming Tate Modern*, a Tate Modern promotional video, Verity Sharp (narrator), (Tate Media, 2008).
116 Quoted by Ben Hoyle, 'Here's the financial picture: the super rich are black', *The Times*, 18 September 2009.
117 An observation quoted in an interview by Hugh Montgomery and Emily Stokes to stand up John Tusa's commentary piece, 'A Cultural Olympiad? Great idea – now give us the money', *Observer Review*, 5 August 2007.
118 Sally Taylor quoted by Liz Hoggard, *Evening Standard*, 15 October 2009.
119 Jessica Shepherd, 'Paint it black', *Guardian*, 13 January 2009.
120 Art and Post-Fordism, discussion panel at the ICA, 8 December 2009. Text from the *ICA Bulletin*.
121 Quoted from a presentation given at the ULI Seminar, Chelsea College of Art, 24 June 2008.
122 Reuben Kench, speech to the ULI Seminar, 24 June 2008.
123 Reported by Georgina Adam, 'How Frieze affected the auctions', *The Art Newspaper*, no. 164 (December 2005), p. 54.
124 Jens Hoffmann, 'The curatorialization of institutional critique', in John C. Welchman (ed.), *Institutional Critique and After*, (JRP Ringier, 2006), p. 328.
125 Neville Wakefield, 'Frieze commissions, talks and film 2007', *Frieze Art Fair Yearbook 2007/8*, (Frieze Publications, 2007).
126 Melanie Gerlis and Louisa Buck, 'Zoo's move out of the zoo is a success', *The Art Newspaper/Frieze Art Fair Daily*, 12 October 2007, p. 4.
127 Laura Stott, *Times2*, 5 March 2010.
128 Anthony Gross, 'Index Metropolis', in Anthony Gross and Jen Wu (eds), *Metropolis Rise: New Art from London*, (Article Press, 2006), p. 6.
129 Ibid., p. 9.

Post-Conceptual British Painting

Introduction

> Painting ... has no fixed conceptual concerns, or conceptual limits either. Nor is it a language in any simple sense. More a loose collection of vague and continuously evolving quasi-linguistic possibilities at work against an historical and social background which is, itself, characteristically unstable.
>
> (Jon Thompson, 2004)[1]

Marcus Harvey's (b. 1963) portrait of the Moors murderer Myra Hindley, *Myra* (1995) (Figure 2.1), provoked a media storm during its display at the Royal Academy's exhibition *Sensation: Young British Artists from the Saatchi Collection* in 1997. Based on the widely circulated police photograph taken shortly after Hindley's arrest with Ian Brady in 1965, *Myra* was vandalised during the exhibition and had to be taken down. The painting's monochrome, billboard-sized surface had been made using the pixillated handprints of hundreds of small children.

In making the painting, Harvey's principal interest had been the ubiquity and the reproducibility of the original black and white photograph. In the decades since Hindley's incarceration, the original mugshot, accentuating the harsh angles of its subject's then juvenile face, had been endlessly reprinted by the tabloid press as an icon of infanticide. As media controversy grew, Harvey went on the record several times to clarify the intention behind the painting:

> The whole point of the painting is the photograph. That photograph. The iconic power that has come to it as a result of years of obsessive media reproduction. And I don't want to get beyond that.[2]

Ironically, in the decade since, Harvey's image has assumed something of the infamy of the original photograph. Orchestrating the collision of mass culture with the conventions of high art defined the YBAs (the 'Young

Figure 2.1 Marcus Harvey, *Myra*, 1995. Acrylic on canvas, 156 x 126 inches. © the artist. Photo: Stephen White. Courtesy of White Cube.

British Artists'), making the careers of several of Harvey's contemporaries, including Tracey Emin, Angus Fairhurst, Damien Hirst, Gary Hume and Sarah Lucas. Harvey's stylistic signature was the mixing of the vaguely pornographic with the 'high art' conventions of gestural painting. In canvases titled *Proud of his Wife* (1994) and *Julie from Hull* (1994), he foregrounded the schematised images of the soft porn industry and its associated literature, in what art critic Sarah Kent described as the 'debased public language that makes inadequate reference to the private domain of desire'.[3]

The monumentality and stark referentiality of Harvey's *Myra* encouraged a reading through the use of medium to the portrait depicted. Discussions of process were largely submerged under arguments concerning the photographic context of the original and the justification, or otherwise, for the choice of subject matter. But Harvey's iconic portrait and the emotive disjuncture of its surface remain a stark reminder of painting's visceral power as a practice of mark making. From the opposite vantage point, Damien Hirst's household gloss spin paintings, conceded at various times by the artist as forms of aesthetic affliction, seemed to parody the very specificity of painting and its claims to cultural durability as a gestural and expressionistic practice.

Discussing the apparent dilemma faced by contemporary painters, curator Jaime Stapleton has succinctly noted, 'How does one move beyond the perception that all serious painting is merely a footnote to the endgame of abstraction'?[4] Likewise, addressing the genre's broader cultural status, the art historian Griselda Pollock has questioned whether painting actually occupies anything other than 'critical limbo', having been superseded by a plurality of more recent cultural forms such as video, photo-documentary and installation.[5]

Despite such critical reservations, the ongoing prominence of major awards geared to painting – the John Moores, Jerwood and the Celeste art prizes, are institutional reminders of the genre's standing, recognition and purchase within contemporary art. Painting practice has retained a stubborn, if sometimes residual, presence among nominees and eventual winners of the Turner Prize. With a few exceptions since its inauguration in 1984, painters have repeatedly featured in the annual notification of the Turner Prize nomination lists. Of the twenty-three awards made between 1984 and 2007, seven have been to either painters or artists who include the medium within their range of professional practice.[6]

In the face of such polarised readings, this chapter considers some of the ideas and themes adopted by British painters over the two decades leading up to 2010. Several of the artists discussed here have developed a dialogue with a formalist Modernism, or with narratives associated with earlier and marginalised modernist practice. Some have adapted and used these idioms to explore the symbolism of mass culture or to address specific social and political issues. Other painters have undertaken intense explorations of the

relevance of place, landscape, memory or even the discourse of painting itself, to the idea of the contemporary. But all the examples noted in this chapter suggest open and expansive possibilities for what painting as a genre might be – and what it might become.

Painting: histories, ideas and contexts

Painting is a reflexive and meditative practice which dramatises an ongoing tension between the materiality of the actual pigment and the fictive depth or space it represents. For example, with an abstract painting, we can suspend recognition of the flat, literal surface and the reality of stretcher, binder and pigment. We may perceive and intuit the shapes and compositional forms as part of a dreamscape, or an indexical fragment of an identifiable object. As the art critic and commentator Adrian Searle noted in the preface to the Hayward exhibition *Unbound: Possibilities in Painting* (1994):

> A painting is an object – of a rather peculiar sort – which refers both to itself, and to things outside itself. It is never only an object, and never only an image.[7]

This continual instability as to what painting is or might be necessarily renders any encounter with the medium a discursive and ultimately open-ended one. When the formalist art critic and theorist Clement Greenberg (1909–1994) famously said of abstract painting that it didn't have a 'score', he was not only describing the intuitive dimension to aesthetic experience, but also attempting to articulate what he perceived as the medium's intrinsic opacity.[8]

The origins of painting in mark making are primordial, but freed in recent decades from the straightjacket of abstract Modernism, it can, as Jon Thompson's opening observation suggests, explore renewal and self-invention.[9] If the physical craft of making a painting has not really changed – the mixing, handling and application of pigment to canvas, board or panel, using oil, acrylic, gloss, emulsion or enamels, the context of its making has.

As a medium and practice it is not value free; of all the genres, painting carries the greatest accumulation of social and cultural baggage. Its historically dominant position, from the sixteenth century through to the later avant-garde refusals of Édouard Manet and Gustave Courbet, arose from the hegemony of the western European art academies. The avant-gardes of the early twentieth century such as early Cubism, Expressionism and Surrealism variously exploited the medium's tactility and cultural status, although conventions of size and subject matter still broadly signified the easel tradition and the salons of the previous century. By the mid-twentieth century Abstract Expressionism, supported by prescriptive Modernist theory and the loss of Europe's cultural dominance, had become

the definitive genre on both sides of the Atlantic. As Greenberg observed in his essay of 1948, 'The Decline of Cubism':

> the main premises of Western art have at last migrated to the United States, along with the center of gravity of industrial production and political power. Not all the premises have reached this shore ... but enough have abandoned Paris to permit us to abandon our chronic, and hitherto justified pessimism about the prospects of American art.[10]

For Greenberg, America's economic power, supported by a European diaspora of avant-garde artists, offered a secure basis for the further development and refinement of Modernist painting. Discussing the tradition of abstract practice, Yve-Alain Bois in 'Painting: the task of mourning' suggests that it was defined by two principles. First, abstract painting was 'historicist' – suggesting an understanding of history and cultural development as linear processes – and second, it was essentialist – the belief that painting had an 'essence' which was somehow locatable and achievable.[11]

While such claims have been complicated by critical theory, the context in which they were originally formulated should be kept in mind. Both characterisations were closely related to the legacies of photography and mass culture, which not only challenged the status of painting, but also compelled its practitioners to assert the 'exceptional nature' or distinctness of their chosen medium.[12] These observations identify a particular and highly specific painterly tradition – abstract Modernism and the claim to a broader consensus about culture and aesthetic value which it represented.

Throughout this period, and aside from wartime disruption, painting had remained a highly desirable, cultural commodity within a rapidly internationalising and increasingly integrated art market.[13] Practically, paintings are a relatively saleable artistic form – they are flat, portable and can be sized according to the room-based conventions of the easel tradition. Even the panoramic and earlier historic exceptions – the large history and landscape paintings of the eighteenth and nineteenth centuries – were made with a presumption that they would fit an institutional or grand domestic space of some kind.

But by the 1960s and 1970s, the emergence of newer neo-avant-garde art forms – photography, performance, conceptualism and land art – were variously defined by their critical distance from, and opposition to, abstract and representational forms of painting, and especially the former's institutionalised status. By the late 1960s, painting had lost its privileged and hegemonic position, becoming just one of several practices available to artists. As Terry Smith, the British artist and member of Art & Language, noted in 1971:

> they [its practitioners] no longer have to carry the whole weight of artistic change and are more free to explore the infinite options still

open with painting. However, they can no longer claim for painting a special status, nor any special concessions. A painting now has to be good/interesting as art before it is of any interest as painting.[14]

Since Smith's comment, painters have continued to explore the limits, legacies and possibilities of their medium, albeit in the context of an increasingly hybridised and global visual culture. The 1980s saw an upswing in figurative and abstract painting practice, emblematic of which was the survey exhibition, *A New Spirit in Painting* (January–March 1981). Team curated by the Berlin-based art critic Christos Joachimides, Nicholas Serota, then director of the Whitechapel Art Gallery, and the Royal Academy's exhibitions secretary Norman Rosenthal, it featured selected work by thirty-eight painters across three generations. In the catalogue essay, Joachimides suggested that for all its 'apparent conservatism' the act of painting was one of 'resistance' in the face of a debased and homogenised commodity culture.[15] Asserting the genre's universality, the catalogue preface noted:

> it is surely unthinkable that the representation of human experiences, in other words people and their emotions, landscapes and still-lives could forever be excluded from painting.[16]

The exhibition's rationale was that expressive and gestural painting conveyed an authentic human dimension, a subjectivity which had sustained the best post-war practice and which had underlined the medium's inter-generational appeal. However, both claims were diminished by the exclusively male line-up of those whose paintings were shown and by the stylistic range of the images chosen for exhibition.

Notwithstanding the 1980s vogue for 'neo-expressionism', an earlier generation of painters had continued to work in oils, including Francis Bacon, Frank Auerbach, Lucian Freud and Leon Kossoff (unexhibited). The last three painters, associated with the School of London, had refused the options of a modified social realism or an American-led Modernism in favour of close, observational attention to subject or motif.[17] Although generally sidelined in the 1970s by the move towards conceptual art, photography and performance, the medium had remained central to the practice of a younger generation of acclaimed practitioners, including Michael Andrews, Gillian Ayres, Ken Currie, David Hockney, Howard Hodgkin, R. B. Kitaj, Thérèse Oulton, Paula Rego and Sean Scully.

The premise of *A New Spirit in Painting* was that certain forms of practice could make a privileged claim to authenticity, and that the medium's direct expressivity underlined the durability of painting as a genre. Its curators claimed that after the typically anti-pictorial and conceptual work of the later 1960s and 1970s, neo-expressionist painting offered universal perspectives which directly reflected human experience and emotions.

Such claims cited evidence that the upswing in painting was not limited to the United Kingdom alone, but was an international phenomenon. In the United States, Julian Schnabel was making large gestural canvases which parodied historic themes and subject matter, while in Italy, Sandro Chia, Francesco Clemente and Carlo Mariani were heralded as part of a new 'trans-avant-garde' for their own stylised and neo-figurative work.

As the art critic and theorist Hal Foster has argued, claims that painting is a direct and unmediated form of expression are philosophically problematic since all meaning is filtered through language, convention, and the experience of the viewing subject.[18] But despite the weakness of its premise and evident gender bias, *A New Spirit in Painting* appeared to some to offer a persuasive fit with broader narratives, situating the practice and medium of paint as expressive, mythic and ultimately nostalgic at a time of political conservatism and social retrenchment in both the United Kingdom and the United States.

Margaret Thatcher had been the UK prime minister for two years and was pursuing policies of robust privatisation and financial deregulation. In the United States, the Republican President Ronald Reagan supported a similar ideological agenda. Both leaders articulated a belief in national self-interest framed by free market principles, the basis upon which they made common cause against their Cold War enemies, the Soviet Union and its Eastern Bloc allies. As the art historian Julian Stallabrass has noted, the 'grandiose' and 'ironic' sentiment of German and American neo-expressionism fitted the 'victorious period of neo-liberalism' and the economic boom which it heralded.[19] Similarly, in relation to the dynamic of the contemporary art market, commentators have linked the success of several neo-expressionist artists with the more acquisitive and speculative forms of private patronage, which replaced public galleries and State funding as the main drivers of the international art market during these years.[20]

Twenty years on from *A New Spirit in Painting*, the viability and status of painting was among the concerns of *Hybrids: International Contemporary Painting*, hosted by Tate Liverpool and curated by Simon Wallis (2001). The exhibition showcased work by eight artists from Brazil, Germany, North America and the United Kingdom, exploring how different painters had engaged with the medium in response to national cultures and emerging technologies. Central to the exhibition's concerns and its linked conference were the aesthetic and conceptual outcomes of these interactions and fusions with painting understood as an increasingly hybridised cultural practice.

As David Green, one of the contributors to the associated anthology of essays, noted, the juxtaposition of these terms was itself paradoxical. While the idea of painting was associated with the 'singularity, specificity and autonomy' of Modernist art, hybridity had postmodern connotations of 'heterogeneity intertextuality and contingency'.[21] In discussing the unattainability of a pure and autonomous painting, a principle asserted by

Greenberg, Green suggested that the genre could not be somehow hermetically sealed off from a wider culture, other visual technologies and practices. Rather, it was implicated with everything else in a 'dialectical relationship'.[22] For the art historian Jonathan Harris, these and other internal complexities underlined the '*ontological insecurity* [his italics] of certain 'painting now" – a characteristic which, in the hands of contemporary practitioners such as David Reed and Gerhard Richter, demonstrated the medium's potential for criticality and its ongoing relevance to cultural politics more generally.[23]

At the start of a new millennium, the *Hybrids* exhibition mapped examples of contemporary painting as discursive and expansive interventions within a globalised cultural economy. Almost twenty years before, the neo-expressionism sponsored by *A New Spirit in Painting* had heralded a very different, conservative and reactionary aesthetic. The stylistic signature of these artists suggested a return to what the cultural theorist Walter Benjamin had called the 'aura' – the ersatz traditionalism associated with the cult of the 'masterpiece'. By contrast, the *Hybrids* exhibition surveyed more fluid and expansive identities for post-conceptual painting and the directions it might take.

Aside from the examples just noted, other influential UK-based survey exhibitions merit mention. *Unbound: Possibilities in Painting* (Hayward Gallery 1994) profiled practice by fourteen artists from fourteen territories. Curated by Adrian Searle, it included work by several UK-based practitioners, Peter Doig, Gary Hume, Fiona Rae, Paula Rego and Luc Tuymans. The premise of *Unbound* was that painting, understood as a discursive and pluralistic practice, occupied a new critical and cultural space:

> While there is no longer a dominant trend or direction in painting, the idea that it is a closed option, that everything has already been done is no more than a myth. *Unbound* is not about a revival of the fortunes of painting, but about its continuation ... about different orders, different values.[24]

The variety of practice that the Hayward Gallery exhibition demonstrated was also apparent in *Real Art, A New Modernism: British Reflexive Painters in the 1990s* (Southampton City Art Gallery, 1995), which explored the responses to a formalist Modernism across a new generation of British painters, as it did trends suggesting an increasing self-referentiality within painting more widely. In the same year, *From Here* (Waddington Galleries and Karsten Schubert Gallery) noted some of the generational continuities within British practice. More recently, *New British Painting I & II* (2004) considered the latitude and international purchase of a medium freed from the constraints of a formalist Modernism, while *The John Moores Painting 24* (Liverpool 2006) mapped a new generation of talent.

The New Neurotic Realism (1998) was an attempt by the collector and curator Charles Saatchi to confect a new style based on a series of exhibitions in which sculpture and painting were prominent; Cecily Brown, Dan Coombs, David Falconer and Martin Maloney were among thirty-four practitioners judged to be central to this new direction. The theme of new directions in painting was explored again in *The Triumph of Painting*, three group shows organised by Saatchi in 2005, which all traded off claims to the genre's cultural legitimacy. In addition to some of these more open, survey-oriented examples, other group exhibitions were curated around specific trends. One of the first major museum surveys of its kind, *The Painting of Modern Life* (Hayward Gallery 2007), explored how a range of conceptual and pop artists had used and translated photographic imagery in the history of contemporary painting. Curated by Ralph Rugoff, it underlined the medium's increasing critical prominence and its resonance as a conceptual practice in its own right. In 2009 two shows, *Sean Scully: Paintings from the 80s* (Timothy Taylor Gallery) and *UBS Paintings: Paintings from the 1980s* (Tate Modern) linked their subject matter (and medium) to the zeitgeist of an earlier decade.

This sample of exhibitions is clearly selective, but it does attempt to sketch some of the changing cultural contexts in which recent painting practice has taken place, and shows an increasing responsiveness to the medium. Although largely eclipsed since the 1960s, the ideas and values associated with Modernism – painting as an autonomous, self-critical and principally abstract practice – still provide a hinterland to the medium, and a point of reference for a range of contemporary British painters. Similarly, the ideas and debates associated with the conceptual art practices of the 1960s and 1970s have provided the genre with a range of possibilities and priorities that have extended the medium's critical impetus and durability.

Aside from the fashion for neo-expressionism, the tradition of painting had continued as a focus of serious critical attention. The grouping of artists and theorists ranged around the journal *Art-Language*, including the late British art historian and theorist Charles Harrison, had argued that painting could be recovered and reclaimed in the light of conceptual practice, and that it could become 'as complex in the receiving and describing as in the making'.[25] An artist who has been emblematic of such an exploration (and a point of reference for several of the post-conceptual British artists mentioned in this chapter) is the German painter Gerhard Richter (b. 1932).

Much of Richter's work has been informed by the use of photography and themes taken from mass culture, although the visceral and tactile qualities of the painted medium have continued to situate his practice. By basing his 'photopaintings' on photographic images – some found, others with family connections, or just examples taken from subject matter within contemporary culture – Richter has explored issues of appropriation, translation and transcription (conventionally associated with conceptual

practice), while referencing characteristically Modernist themes of flatness, facture, pigment and the opacity of the medium itself. Hybridising the mechanical effects of the photographic and the immediate with the craft-based and 'worked' qualities associated with paintings has resulted in work which challenges the perceived limitations of both mediums. As the art historian Jason Gaiger notes:

> Even the humble snapshot acquires a different status … . It is accorded a singularity that such images are usually denied, creating a space for critical examination and reflection that is often truncated or compressed by the sheer quantity of visual information that surrounds us.[26]

Richter's paintings 'make strange' the ubiquity of the photographic, while extending the range, versatility and relevance of painting as a contemporary medium. For a post-conceptual generation of painters – of which British practitioners remain emblematic – Richter, and other contemporaries such as the late Sigmar Polke, have provided the medium with a discursive range while often retaining notionally representative subject matter. The emphasis on the medium's particularity and its specific attributes, together with a criticality and responsiveness to other cultural forms, has provided a younger generation of practitioners with a new range of possibilities.

British painting: cultural politics, dissent and other narratives

In 1996 Mark Wallinger (b. 1961) remade the Union Jack in the colours of the Irish tricolour. Titled *Oxymoron*, the work explored the meaning of British identity and nationhood. What was the status and affiliation of Ulster Unionists, or the position of expatriate communities living in mainland Britain? How did post-colonial powers negotiate their relationships with former colonies and protectorates? How did all of these narratives end? As one critic noted, Wallinger's piece was an 'uncomfortable condensation of colonial history and current dilemma'.[27]

Globalisation has frequently been associated with the imposition of westernised corporate power and the relocation of jobs and services to countries with cheaper labour and poor conditions of employment. The closely associated, but more specific, term 'post-colonial' concerns the bias and manipulation of western European and American colonial and imperial enterprises. Post-colonialism has been characterised as the struggles of colonised peoples for 'material and cultural well-being' against the context of past and present colonial and imperial impositions.[28] What points of connection might there be between the genre of painting, with its institutionalised past as the preferred genre of the European art academies, and the cultural politics of the post-colonial?

The experience of cultural difference (understood as the mediation and definition of identity through culture, language and history), and the negotiation of post-colonial histories have become recurrent and ongoing concerns within British art and diaspora aesthetics. In 1989 the Hayward Gallery hosted a major exhibition curated by Rasheed Araeen (b. 1935), a practising artist and founding editor of the journal *Third Text*. *The Other Story: Afro-Asian Artists in Post-War Britain*, was an exhibition of work by artists who had come to Britain from Commonwealth countries in the post-war years. It included paintings by the Guyanese artist Frank Bowling (b. 1932) and the writer and painter Francis Newton Souza (1924–2002). Souza, a founder member of the Bombay Progressive Artists' Group, had left India for the United Kingdom in 1949 and was the first artist from India to achieve recognition in the west after that country's independence.[29] Both he and Bowling belonged to a generation that had formerly been part of the British Empire's forgotten 'other'. As Commonwealth migrants their mixed experience in the 'mother' country identified some of the contradictions that had accompanied Britain's recognition of its post-colonial and increasingly peripheral economic status within the post-war global order.

Araeen's exhibition drew criticism from various quarters, including the insufficient coverage given to various crafts and to work by Asian and African women, and for what some perceived as its 'separatist' agenda.[30] Although *The Other Story* was not intended to be medium-specific, painting and sculpture dominated, suggesting a curatorial privileging of such genres in mediating the experience of diaspora and difference. Regardless of the exhibition's exclusions and format, Araeen had drawn attention to important issues of hybridity, translation, marginality and what Homi Bhabha described as the 'anxiety of influence'.[31]

Over two decades on from the particular post-war diaspora which themed Araeen's exhibition, Britain is a diverse and multi-ethnic society. Black, Asian and African artists living and working in Britain are prominent across the visual arts. In 1999 Steve McQueen won the Turner Prize. In 2003 Chris Ofili represented Britain at the 50th Venice Biennale, having won the Turner Prize in 1998. British artists including Sonia Boyce, Sutapa Biswas, Lubaina Himid, Isaac Julien, Chris Ofili, Keith Piper and Yinka Shonibare have attained international reputations, while organisations such as the photographic agency Autograph ABP, the Institute of International Visual Arts (Iniva) and the cross-arts centre Rich Mix have contributed to a diverse and increasingly inclusive cultural agenda.

But as the sociologist Stuart Hall has noted, the positive dimensions to post-colonial diaspora conceal complex and conflictual interactions within developed and emergent economies, with contemporary Britain no exception. The regressive definitions of Britishness and the superficial debates on identity noted in this book's introduction gloss over tangible cultural differences and tensions within, and between, both recent and

longstanding migrants and indigenous communities. As well as contributing to one of the most vibrant and innovative contemporary visual cultures in the world, Britain's contemporary multi-ethnicity has made the country's political, financial and judicial culture, still largely white, secular and middle class, all the more apparent.

Some of these issues have been further complicated by the consequences and decisions of British foreign policy over recent decades and its impact upon the UK's constituent communities. To take one case in point, the various appeals made directly by government ministers in recent years to the UK's resident Muslim communities in relation to the so-called 'War on Terror' has treated them as if they were some reified 'other' – outside and beyond, rather than part of, the same mainstream electoral community that defines the spectrum of values and opinions within British society as a whole. Looking back to the mid and late 1980s, similarly polarised perspectives characterised the labelling and marginalisation of the so-called 'enemy within' of trades unionists, leftists, feminists, community activists and others judged by the Establishment as beyond the pale.

The murder of Stephen Lawrence, a black teenager, by a racist gang at a bus stop near his Eltham home in southeast London in April 1993 underlined the social and urban experience faced by many, but barely given official recognition. Despite the Lawrence family's protracted campaign for justice, his suspected killers have never been convicted. The public inquiry chaired by a former High Court judge, Sir William Macpherson, into the handling of the crime scene and the investigation, concluded that the Metropolitan Police was 'institutionally racist'. The report, described as a 'watershed in British race relations', made seventy recommendations.

Chris Ofili's (b. 1968) *No Woman, No Cry*, 1998 (Plate 3), titled after the 1974 Bob Marley song, was a tribute to the fortitude and grief of Doreen Lawrence; a statuesque black woman sheds tears, each of which holds a miniature, collaged portrait of Stephen Lawrence. *No Woman, No Cry* is a powerful and emblematic painting which combines the decorative with the stylised formality of a memorial. Discussing the image and the time of its making, Ofili recalled, 'I thought it might say something. Not change anything, but maybe just say something'.[32] The statuesque figure has an angled profile reminiscent of an icon. As succinctly described by the curator Judith Nesbitt:

> Ofili's image of maternal grief is composed with the taut control of a Renaissance portrait and invested with the aura of a votive object.[33]

No Woman, No Cry, as with other paintings by Ofili, was exhibited resting on two dried and varnished pieces of elephant dung, pieces of which are used to form the necklace of the grieving woman. Although dung has been used by the African-American artist David Hammons (b. 1943), for Ofili, it

references a broader cultural politics and the admixture of African, Australian and African-American practice in his own work. As the curator and commentator Okwui Enwezor observes, regardless of its 'scatological symbolism' and the 'retail clichés' of Africa which it evokes, elephant dung references a range of 'metaphysical, conceptual and sculptural possibilities' within Ofili's work. It is used as 'a spiritual signifier of a connection to Africa, especially between nature and culture, between Great Zimbabwe and London'.[34]

Ofili was born and raised in Manchester to Nigerian parents who had moved from Lagos in 1965. A graduate of the Chelsea College of Art (1988–91) and the Royal College of Art (1991–93), he moved to Trinidad in 2005, where he now lives and works. Aspects of Ofili's early practice were associated with the cultural provocation which characterised work by some of the YBAs in the early 1990s. In 1993 he staged a Brick Lane 'Shit Sale' of elephant dung shaped to look like hashish. As well as articulating personal anger and disaffection, Ofili was making a broader point concerning ethnic stereotyping and the social marginalisation of black people in the United Kingdom. As noted at interview, his aesthetic practice parodied that misreading:

> It's what people really want from black artists, we're the voodoo king, the voodoo queen, the witch doctor, the drug dealer. I'm giving them all that.[35]

Paintings such as *Afrodizzia*, *The Holy Virgin Mary* and *Afrobluff* (all 1996) animate their surfaces through the combination of paper collage, map pins, glitter and brilliant beads of colour. Describing Ofili's use of decorative abstraction, Martin Maloney writes:

> Playful in realisation, brash in materials, they have a patched-together, homemade look … . Ofili found a way of shifting the art of identity to an apparently neutral form – decorative abstraction, which had not previously been used to discuss issues of racial difference.[36]

In the use of iconography and emotive symbolism, Ofili has also broached broader, historic themes. In 2002 the Victoria Miro Gallery hosted *Freedom One Day*, his first major show since winning the Turner Prize in 1998. The exhibition's signature piece, *The Upper Room* (1999–2002), was an installation of thirteen paintings exhibited in a purpose-built chapel-like space designed by the architect David Adjaye. In a configuration which referenced Christ's Last Supper with the Apostles, twelve colour-themed paintings, each depicting a rhesus macaque monkey against a verdant and tropical jungle background, flanked a larger, central canvas depicting an elephant.

The exhibition's signage described the highly social and adaptable rhesus

monkey as having previously been 'venerated' for its qualities. As the art critic Richard Dorment noted, *The Upper Room* adapted a western, Christian theme, as though an 'African or Indian storyteller had transposed the events in the New Testament into his own imaginative world'.[37] It has also been described as an 'introspective' piece which in exploring the Christian sacrament 'invoked mystery rather than confrontation'.[38] But the installation and its iconography can be read differently, as a specific, if indirect comment, on the post-colonial and the experience of 'otherness', understood here as the history and experience of 'subject' peoples under the rule and hegemony of empire.

Although Christian ideas were rationalised as part of the civilising 'mission' of empire, they were widely used to colonise and make compliant its non-white subjects. But by substituting monkeys for white Apostles, Ofili possibly parodies and makes explicit the act of cultural appropriation and the ethnic stereotyping through which it was rationalised. Like the trappings of white religious colonisation, the choreography of *The Upper Room* was highly decorative. Its walnut panelling providing the aura of history and legitimacy associated with the sanctified space of a protestant chapel or church. Ofili's paintings mediated an awareness of British colonial history, understood as a pervasive process of cultural translation and appropriation.

The portrait of the murdered teenager Stephen Lawrence broached a subject which had already become politicised, but British painting's potential, in parallel with other media, to articulate more direct dissent and social commentary, had been the subject of an exhibition in 1987, two years before Araeen's *The Other Story*. As a complement to a major retrospective of work by the Mexican muralist painter Diego Rivera, nine artists had been invited to make large-scale works on 'subjects of their own choosing' which referred to events or issues 'affecting contemporary life in Britain'.[39]

The exhibition, *Art History: Artists Look at Contemporary Britain*, at the Hayward Gallery, showcased the resulting work. Four submissions were paintings by Ken Currie, R. B. Kitaj, Alain Miller and Keith Piper; two were charcoal on canvas or paper drawings by Peter de Francia and Michael Sandle; one was a light-projected triptych exploring social insecurity and dispossession by Helen Chadwick; Terry Setch submitted a mixed-media collage with found objects, and Paul Graham included three colour photographs exploring the 'preponderance of black workers in fast-food restaurants'.[40] In the catalogue's preface, Richard Cork contrasted the optimistic context of Rivera's political murals with the tenor of these commissioned works, noting:

> None of the artists in the present exhibition feels justified in sharing that faith, and their otherwise diverse contributions are marked by a pervasive sense of foreboding about Britain's future.[41]

Art History: Artists Look at Contemporary Britain mediated perspectives on the UK's social and political landscape after close to a decade of free market social experiment and widespread economic deregulation. What remains striking about this exhibition was the prominence of narrative painting, and its use to articulate cogent social and political critique, perspectives shared across the exhibition's other media – collage and photography. The themes explored included the casualisation and displacement of labour (Paul Graham and Helen Chadwick), and like *The Other Story*, the experience of diaspora and migrant identities and their contribution towards a culture, parts of which were beginning to look out beyond the boundaries of the nation state. Painters such as Ken Currie and R. B. Kitaj explored the legacy of sectarian politics, cultural identity and millenarian hope, whilst Keith Piper and Alain Miller directly engaged with the politics of the personality cult and increasingly coercive structures of government and State.

The selection of canvases referencing the genres of narrative history painting and portraiture contained the exhibition's most prominent submissions. R. B. Kitaj's figurative painting *The Londonist* (1987) depicted London's cosmopolitan and migrant identity through the monumental image of an 'alien, original, thinker-cabbie'. Alain Miller's *Untitled* (1987) was a dual work, with an emblematic portrait of Margaret Thatcher divided by Marcel Duchamp's copy of the *Mona Lisa*. Discussing the piece for the exhibition catalogue, Richard Cork drew attention to the reproduction's documentary objectivity, suggesting that the three yellow globes (the moon reproduced above the *Mona Lisa* and the prime minister's earrings) referenced the traditional iconography of the pawnbroker, in turn suggesting the economic consequences of Thatcherism.[42] Another reading might be to interpret the globes as oblique references to the 'palle' or balls which were part of the Medici family's coat of arms; either interpretation suggests emblematic forms associated with dynastic or ideological hegemony.

Artist, curator and academic Keith Piper (b. 1960), submitted a billboard-sized painting, *Nanny of the Nation Gathers Her Flock* (1987). It depicts the Conservative prime minister, Margaret Thatcher, then in her second term of office, as a nuclear-missile-bedecked 'colossus' with arms outstretched, embracing a patrimony of admiring business supporters on her left and ranks of uniformed police officers to her right. In the background, and continuing the martial theme, Piper painted a montage of Boudicca in her war chariot (one of the statues near the Houses of Parliament), and on the left a female warrior and line motif that had been taken from the Victoria Memorial outside Buckingham Palace.

Piper's use of iconography and the billboard dimensions of his canvas parodied the personality cult of an authoritarian prime minister, recalling some of the dominant political events and social protests of the 1980s: the breaking of the miners' strike in 1984–5 and the introduction of anti-trades

union legislation; the Greenham Common protests against American nuclear missiles; widespread privatisation and policies geared towards the deregulation of public services. Referencing the revolutionary zeal of the Puritan Commonwealth and an earlier period of civil conflict, Piper included a quote from Milton as a dominant strapline at the top of the composition: 'Methinks I see a noble & puissant Nation rousing like a strong man after sleep & shaking her Invincible locks'. It was taken from the *Areopagitica* (1644), Milton's treatise conceived and authored as a protest against the re-establishment of press and literary censorship, a reference Piper reframed for the abrasive realpolitik of the late 1980s.

Piper offers a pastiche on monumental propaganda images, a theme taken up by Ken Currie (b. 1960) but with a different inflexion. His allegorical painting *In the City Bar* (1987) (Figure 2.2) recalls the academic and naturalistic painting style of Soviet Socialist Realism, although it is deployed to depict the collapse and re-definition of community within the urban landscape of a Glasgow city bar. Like Jörg Immendorff's *Café Deutschland* series, which Currie admired, the activities of its denizens suggest dislocation, political sectarianism and millenarian hope.

On the left, a loyalist group restrain a vested man, while one of them tattoos his arm with a Union Jack emblem. Behind this sectarian group, a couple grimly dance to the country and western tune of a tartan-wearing accordion player. The stars and stripes and the native American motif on the drum suggests Scotland's receptivity to American culture, and its historic role as a country which fed the British Empire and a nascent North America with migrant labour and entrepreneurial know-how.

As the original catalogue text noted, Currie's vision of late 1980s Glasgow was not the regenerating 'City of Culture', but an underbelly which did not feature in the optimistic civic rebranding.[43] To the right, an elderly and despairing worker downs another pint, while Currie has represented himself as the artist rolling up his maps of plans and designs for the future. The single point of hope is in a young girl who, like a member of the Komsomol, the youth cadres depicted in optimistic and sunny Soviet State propaganda images, strides purposefully to the exit – and a future.

Currie looks to a narrative and didactic painterly tradition derived from several sources. As the artist has acknowledged, the *Neue Sachlichkeit* school, the avant-garde painting associated with the Weimar Republic, was a 'profound influence' on the painting's subject and style. Currie recalled that when he was a student, his tutor Alexander Moffat (b. 1943) introduced him to some of these works, an influence that was further developed through visits to Germany's museums. Rather than the restrained modernism of the School of London, the Glasgow School owed much to Moffat's own stylised portrait-based aesthetic, which mediated a range of international influences, including the neo-realism of the German painter Max Beckmann.[44] As Currie recalled:

Figure 2.2 Kenneth Currie, *In the City Bar*, 1987. Oil on canvas, 84 × 144 inches. Collection of Susan Kasen Summer and Robert Summer. Courtesy of Flowers Gallery.

My paintings from that time were very stylised – mannered even – and very much ... in the spirit of [Otto] Dix whose savage and melancholy social commentary on Weimar Germany seemed to resonate with my own concerns on the streets of my home city of Glasgow – a city utterly ravaged by Thatcherism.[45]

Although *In the City Bar* collectively references the styles of George Grosz, John Heartfield and Otto Dix, its principal influence is that of Max Beckmann, whose multi-layered and allegorical painting style is implicitly referenced through the political ambivalence and melancholy of Currie's own canvas. More generally, the didacticism of Currie's painting suggests the politically inspired murals of Diego Riviera and José Orozco, which had influenced work by a generation of Glasgow-based artists. The tradition of socially engaged avant-garde painting practice with its roots in the Popular Front period of the 1930s was not among the influences that featured in the Royal Academy's 1981 zeitgeist show noted earlier. The figurative and painterly aesthetic associated with Currie also typifies paintings by Steven Campbell (1953–2007), Stephen Conroy (b. 1964), Peter Howson (b. 1958) and Adrian Wiszniewski (b. 1958).

Art History: Artists Look at Contemporary Britain is instructive because it identified a robust paradigm for British narrative painting as social and political critique, a tradition that has remained highly relevant in the decades that have followed. With the formal ending of the Cold War in 1989, promises of a new 'peace dividend' proved illusory. Regional and local conflicts proliferated in the former Yugoslavia and the Soviet Union. Figurative painters such as Peter Howson, John Keane and Gerald Laing have been prominent in recording recent conflicts in Bosnia and Iraq, either as officially sanctioned war artists, or as in the case of Laing, offering personal perspectives on the widely televised news coverage of associated events.

Gerald Laing (b. 1936), a British pop artist and former soldier, employed montage techniques in his *Iraq War Paintings* series. In *Study for Capriccio* (2005), his subject was the widely televised photographs that recorded the mistreatment of detainees by some of their American guards at the Abu Ghraib prison in Iraq. The subject, a hooded detainee, is shown with wires extending from his fingers, a reference to the administering of electric shocks. The painting's title comes from the Italian word for fantasy or imaginative invention, which also obliquely references a series of etchings by Goya and his incredulity at the actions and behaviour of a supposedly post-Enlightenment society. Describing the image, Laing notes:

The painting is full of paradox and ambiguity ... it becomes possible to avoid thinking about the surreal arrangement of the human figures and the internal life of the prisoner. Formal concerns become a sort of anaesthetic, or at least a way of re-composing the reality of Abu Ghraib.[46]

Laing's painting combines pop art pastiche with photographic reportage which, as he suggests, partly neutralises and anaesthetises us to the full horror of what is actually being depicted. The detainee stands on a Brillo box, a double-coded reference both to Andy Warhol's installation of 1964 and to the art critic Arthur Danto, who has cited the installation as confirmation of the demise of art, understood as a primarily pictorial, rather than a conceptually driven, activity.[47] The American and consumer-based iconography provides an acute shorthand for globalisation, understood here as the de facto imposition of western values and norms.

The tangible repercussions of British foreign policy, particularly the interventions in Iraq, have provided subject matter for John Keane (b. 1954). His politically engaged impasto paintings have also taken as central themes post-colonial exploitation of the developing world as well as events in Northern Ireland, the miners' strike of 1984–5 and US involvement in South and Latin America. By personal admission, Keane was initially politicised by the Falklands War (1982), which became a 'turning point from the detached and ironic' work that he had previously made.[48]

But it was his appointment in the run-up to the first Gulf War as 'official recorder' in 1991 by the Imperial War Museum (IWM) – the title of 'war artist' was discouraged until the conflict began – that brought Keane to public attention. As Mark Lawson has noted, exceptionally within recent British art history, it was this association that resulted in Keane becoming the subject of an editorial in the tabloid daily *The Sun*. Several months after the Iraqi army invaded the oil-rich country of Kuwait, the United States and Britain led an international coalition which liberated Kuwait and invaded Iraq.

Although since overshadowed by subsequent and ongoing conflicts in Afghanistan and a second coalition intervention in Iraq, the first Gulf War had been the largest military intervention that Britain had undertaken as a post-colonial power. Keane's paintings, depicting the aftermath and debris of war, arose from time he spent in Kuwait City following the liberation and from time spent around the Basra Road, along which the Iraqi army had retreated under heavy coalition bombing. The carnage of the Basra retreat was the subsequent subject of a cycle of nine paintings, three titled *Ashes to Ashes* and six titled *The Road to Hell*.

Using a camcorder, colour photography and notebook, Keane collected material which resulted in the thirty-five canvases displayed at *Gulf*, the IWM exhibition held in the spring of 1992. As Lawson notes, in a literal irony, Keane produced 'oil paintings of a war fought for oil'.[49] In many of his canvases, and aside from wax crayon and PVA, Keane incorporated other media to underline the war's geo-political context: newspaper collages, pages from the Koran and the Bible; sand and US dollar bills.

In these paintings, Keane adopted a heavy 'old master' impasto technique, transposing the technique to the dissociated and schizophrenic experience

of war. His Gulf War paintings are by turns bleak, humorous and provocative. *Mickey Mouse at the Front 1991* (1991) (Plate 4) was one of two acquired by the Records Committee for the IWM's permanent collection. The painting's title is from the debris of an amusement arcade ride which is surrounded by the detritus of war and looting; on the left a broken shopping trolley holding munitions which pins a Kuwaiti flag to the ground (Iraqi troops had used a supermarket as a munitions dump), and human excrement – an amusement arcade had been used as a latrine. The grinning Mickey Mouse on a white pedestal had been a child's ride in the wrecked arcade. On the right, Keane depicts a blasted palm tree, while the distant horizon shows the skyscrapers of Kuwait City and barbed wire which frames the coastline. The shattered palm tree has been read as an allusion to the blasted landscape of *The Menin Road* by Paul Nash, one of a generation of British war artists who documented the First World War.

Leading on a heavily cropped photograph of *Mickey Mouse at the Front 1991* and misinterpreting aspects of the painting, *The Sun* newspaper denigrated Keane for his alleged lack of respect and patriotism for those fighting in the conflict. But the various tabloid attacks entirely missed the painting as a metaphor and allegory which Keane had particularised in its staging. Recalling the media campaign and the use of the Mickey Mouse figure, Keane notes:

> I was thinking of the American influence on Kuwait ... on the 'Mickey Mouse' defences of the Iraqis against an invasion from the sea which never came. But, above all, it was just a startling image that I had witnessed in the arcade.[50]

Keane's paintings frequently have carefully framed 'polemical' and 'editorial' titles. The title of *Mickey Mouse at the Front 1991*, as well as a literal reference to the Disney icon it depicts, can be read as an allusion to an earlier episode in American history. In 1943 as part of the war effort and to support morale, Disney Corporation's merchandising arm licensed the production of a comic-style newspaper titled *Mickey Mouse on the Home Front*. Although the venture was short-lived and ultimately unsuccessful, Keane's painting obliquely references this earlier conflict and use of commercial branding as a parallel to the Gulf War's co-option as consumer spectacle.

Some of Keane's Gulf paintings mediate the disassociation of war and its anaesthetised media presentation as spectacle. In *Every Time We Say Goodbye* (1991), a military jet releases two laser-guided missiles as it prepares to bank right. The painting's coolly ironic title is taken from Cole Porter's 1944 lyric of lovers parting, scored for the Second World War-era show *Seven Lively Arts*. The painting's border is fringed with miniature black and white satellite images showing the jet's distant ground target. Keane's inclusion of satellite images, which were routinely relayed through MTV and terrestrial

television networks, references Jean Baudrillard's description of the Gulf War as a 'virtual' event, simulated for Western audiences by satellite images of remote 'smart' bombs hitting their targets. The disjuncture of Keane's textured paint with schematic satellite photographs signifies the human agency and apparent remoteness of war in the late modern age.

Describing painting as 'essentially a reflective form, not an observational record', Keane foregrounds its ongoing relevance as a medium of reportage in a digital age. As Lawson notes in *Conflicts of Interest*:

> Keane's Gulf pictures make an eloquent case for their existence in the age of CNN. Canvases they are saying can capture the ambiguities, the mess, the chaos, the surrealism of war in a way that the camera never can. [51]

Given the ubiquity of satellite-based broadcasting technology, digital recorders, and increasingly the use of personal cell phones to record and document events, it could be argued that painting as a personal and deliberate form of mark making carries a 'distinctness' and cultural formality in memorialising such events. Rather than mitigating and distancing the actuality of conflict, Keane's work visualises its aftermath in ways which are both visceral and reflective.

The conflicts in Korea, Vietnam and the Falklands were recorded primarily through the media of photojournalism – still photography and film. Although this trend has continued with Steve McQueen's photographic installation *Queen and Country* (see pages 230 to 231) and with work by Peter Kennard and Cat Picton Phillipps (*Photo-Op*, Plate 20), British painters like Keane and Peter Howson, albeit supported by photographic and video record, have been emblematic in recording Britain's post-imperial interventions in the former Yugoslavia and Iraq. While the prominence of painting may in part reflect the traditional expectations of those who commission its practitioners on behalf of the State or its institutions, it also suggests the medium's durability and critical relevance within an increasingly fractured global modernity.

Oblique social commentary and allegory can also be seen in work by more recent painters. Martin Maloney (b. 1961) has achieved a reputation for a faux-naïve figurative style which melds a decorative Modernism with parody, pastiche and a compendium of classical influences. A graduate of Sussex University, St Martins College of Art and Goldsmiths College, Maloney exhibited at the Royal Academy's *Sensation* exhibition, and has been credited with encouraging Charles Saatchi to turn his attention to a younger generation of painters and sculptors, a trend showcased in *Die Young Stay Pretty* (ICA, 1999) and also the jointly curated exhibition *New Neurotic Realism* (1998).

In *Rave (after Poussin's Triumph of Pan)* (1997), Maloney transposes the

carnivalesque procession of the original composition to a contemporary, grungy gathering of ten partygoers. Semi-clothed revellers appear to gyrate, dance and grope each other against a purple and black backdrop which provides a foil to the flesh tones and lurid clothing of the participants. Maloney's choice of image and artist is a deliberate one – Poussin elevated the landscape genre's traditionally low cultural status, achieving a central reputation within the western academic tradition. He was also admired by modernist painters such as Cézanne and Picasso, for the composition and apparent order that he brought to the genre.

Maloney's subject matter might be read as suggestive of broader historical and cultural ambiguity. For instance, the chronology and meaning of Poussin's work have attracted divergent readings, most famously between the art historians and connoisseurs Anthony Blunt and Denis Mahon, who both asserted divergent interpretations of his personality (stoic versus hedonist) and the chronology of some of his paintings. Maloney's use of parody and his appropriation of the artist's iconography, identify historical re-interpretation as an ongoing and pervasive cultural process.

His solo exhibition, *Actress Slash Model* (Timothy Taylor Gallery, 2008), brought a more literal meaning to cultural recycling and Modernist re-appropriation, with paintings comprising collaged scraps of old or discarded canvases. In examples like *Actress/Model *9 'Paris & Roma'* (2007) (Plate 5), Maloney's subject matter is the semi-nude models routinely featured in tabloid newspapers and magazines, with the half profile of the two figures indicative of the angled photographic shot typical of opportunistic paparazzi. The composition's linear, angular style and subject matter are suggestive of avant-garde work by Max Beckmann and his evocation of a decadent, cosmopolitan demi-monde. But Maloney's technique of collage directly references the experimentation of synthetic Cubism, principally the variation into montage and decoration practised by its followers Juan Gris and Fernand Léger.

In the retrospective essay 'The Pasted-Paper Revolution' (1958), Greenberg explored the use of collage, not as a literal means of signifying modernity, but as a means of accenting the physicality of the picture plane and the pictorial surface. In identifying collage's pivotal role in the re-definition of Cubism (and hence of modern art), Greenberg had differentiated its conceptual rigour in the hands of Picasso and Braque from the deployment of collage for more ornamental pictorial effect by artists such as Gris. Discussing the latter's work, Greenberg noted:

> he almost always sealed the flatness inside the illusion of depth by placing images rendered with sculptural vividness on the nearest plane of the picture … .They [his paintings] have about them something of the closed-off presence of the traditional easel picture.[52]

Compositionally, *Actress/Model *9 'Paris & Roma'* shares some of these characteristics, arising from the placement of figures on the 'nearest plane of the picture'.[53] Intentionally or otherwise, the decorative exteriority of Maloney's collaged forms, prominent colouring and the equivalence given to technical process and stylised subject matter suggest a dialogue with the legacy of salon Cubists like Gris and Léger. But more contextually-based readings may also account for Maloney's apparently atomised presentation of motifs.

The academic conference *Allegory, Repression and a Future for Modernism* (Manchester Metropolitan University, 2007) considered the possibilities for contemporary painting offered by earlier modernisms, examples of which had been marginalised by the post-war dominance of Greenberg's prescriptive support of Modernist abstraction. In one paper framed by earlier critical interpretations, Alice Coggins discussed alternative readings of modernism with the aim of exploring new critical platforms for contemporary painting.

One of the references that framed her paper was Matthew Biro's essay, 'Allegorical Modernism: Carl Einstein on Otto Dix' (2000).[54] The critic and art theorist Einstein had discussed work by the German modernist painter Otto Dix, and had employed Walter Benjamin's theory of allegory – understood as a literal and symbolic representation of subject matter that depicts the present and future by referring to, or appropriating, the past. For Einstein, Dix's use of allegory indexed the Weimar Republic's cultural turmoil and political chaos. Transposing this allegorical reading, Coggins suggested that paintings like Maloney's *Rave* with their juxtaposition of past and present might be read as representations of the 'banality' and disconnection of contemporary social life. The line-up of disparate, blank faces underlines a vacuous and reified society in which sexual couplings are clumsily mechanistic and comic. Blank anonymity is also apparent in the stylised portraiture of other paintings by Maloney such as *Equal Opportunities* (1999) and *Slade Gardens, SW9, 1995* (2001). Coggins notes:

> Both Dix and Maloney's pictures show human interaction on a superficial level. Both are pictures of the artist's contemporary urban culture and both speak of something uncomfortable, something missing.[55]

Approached in this way, Maloney's use of collage and the mixing of art-historical motifs with subject matter taken from contemporary culture can be read as a deliberate referencing of earlier allegorical and socially critical forms of modernism. As Coggins acknowledged, applying readings from one radically dissimilar context to another is not necessarily straightforward, but in foregrounding historical associations through canvas titles, Maloney invites a deliberate instability into his images. In making explicit an awareness of painting's historical connection to earlier avant-garde traditions and to the lexicon of a critical modernism, Maloney provides a

point of connection appreciable in representational practice by other recent and contemporary British painters.

In a monumental series of life paintings, Jenny Saville (b. 1970) has used the traditional academic categories of the nude and the portrait to depict the self-transformation and self-realisation of transgender subjects through cosmetic surgery. As John Gray has noted, Saville's depiction of human bodies does not illustrate humanist belief or religious affirmation; rather, it 'point(s) to areas of sensation that ordinary experience struggles to close off, but which can never be wholly banished'.[56] Saville's interest in the abject (explored by other artists in relation to performance and installation – see pages 196 to 202 and 174 to 179 respectively), extends to the imprint of violence, burns and trauma on her subjects, and how these might be described and communicated through the visceral qualities of paint and pigment.

A graduate of the Glasgow School of Art (1988–92) and the Slade, she was among the contributors to the Royal Academy's *Sensation* exhibition in 1997 and *Young British Artists III* (1994). Saville has since established herself as a leading figurative painter concerned with challenging historical representations and constructions of the female body. Her large canvases, which feature tactile and highly worked surfaces, are informed by a close interest in contemporary feminist theory, and have been compared to work by a generation of modernist painters, including Frank Auerbach, Francis Bacon, Lucian Freud and Willem de Kooning.

In *Closed Contact* (2002), a collaboration with the fashion photographer and filmmaker Glen Luchford, Saville sat for a series of photoshoots, but with a difference. Instead of the customary glamour shots of the naked female body, she positioned herself on a large pane of plate glass. Luchford then photographed her naked body from underneath the glass. The resulting images of Saville's squashed, distorted form and splayed skin defamiliarised her body, a process which parodied the extent to which consumer culture and the fashion industry notates and objectifies the female body as commodity and spectacle.

Saville has worked principally from photographs of models, pathology textbooks and images of serious burns and injuries. More recently, she has explored aspects of cosmetic surgery and gender reassignment, enabling her to examine issues of gender identity and prevailing cults of beauty. In *Plan* (1993), Saville depicts a nude upon which lines and contours have been made – part of the preliminary and preparatory process for cosmetic alteration. She has recalled the tensions of vulnerability, strength and power evident within the figure's posture, the low viewing point which suggests reflexive self-examination and appraisal. The head of the figure is actually the artist's, as is the idea for the body. In composing the image and subject, Saville was acutely aware of the dynamics of the gaze and the complicity which arises from the act of looking. In discussing *Plan* with the late critic David Sylvester, Saville noted:

> I don't like the idea of just being the person looking. I want to be the person. Because women have been so involved in being the subject-object, it's quite important to take that on board and not be just the person looking and examining. You're the artist but you're also the model. I want it to be a constant exchange all the time.[57]

The painting *Passage* (2004–5) (Plate 6) depicts a transvestite with real male genitalia and false, silicone breasts. Interviewed by Simon Schama, Saville explains that she was interested in exploring the instability of gender suggested by the transsexual body:

> I was searching for a body that was between genders ... the idea of a floating gender that is not fixed. Thirty or forty years ago this body couldn't have existed and I was looking for a kind of contemporary architecture of the body. I wanted to paint a visual passage through gender – a sort of gender landscape.[58]

Although Saville is interested in exploring the 'space between abstraction and realism', she is committed to a realistic, painterly aesthetic which conveys the physicality of the body, using the paint in a constructive, almost sculptural way. Although produced using a conventional oil-based medium, *Passage* underlines the inadequacy of binary male/female distinctions, historically underpinned and objectified by the category of the painted nude.

Saville's painterly aesthetic mediates contemporary approaches to gender and sexuality understood as fluid and performative – that is, negotiated through lived and actual experience. *Passage* is less about gender difference as such, but about the instability of gender itself. In other paintings such as *Torso 2* (2004–5), a headless and partially delimbed animal carcass in the manner of Francis Bacon, she implies the abstract equivalence of the human and the animal as just so much animated flesh. The point is cogently made through the visceral and tactile qualities of the medium historically used by the academies to frame the specificity and distinctness of the human.

Place, entropy and the imaginary in contemporary painting

Recent representational painting has also foregrounded concerns traceable to earlier examples of British modernism. The depiction of highly specific locations and topographies was a defining aspect of work by Stanley Spencer, who used the Berkshire village of Cookham as the backdrop to his canvases; Paul Nash explored the landscapes around Wittersham, Iden and the Kent Coast as metaphors for memory and the transcendent. Graham Sutherland painted the rugged Pembrokeshire coastline, and artists such as Peter Lanyon and Roger Hilton are indelibly associated with Cornwall and St Ives.

An intense identification with place and location also situated earlier painterly traditions associated with John Constable, Samuel Palmer and J. M. W. Turner.

The resonance of place and landscape within British painting and culture was a central concern of the late British art critic and theorist Peter Fuller (1947–1990). Fuller was also the founder of the art magazine *Modern Painters*, the title a homage to John Ruskin's eulogy to Turner. His last book, *Theoria: Art and the Absence of Grace* (1988), explored the impact of scientific rationalism and Darwinism upon the Victorian belief in the divine order revealed through nature. The 'Theoria' of Fuller's title came from what Ruskin had believed was a moral response to beauty, as opposed to that of mere 'Aesthesis' – the sensual response to beauty as a phenomenon. Authored from a culturally conservative position, *Theoria* was both a platform for Fuller's views on the cultural and biological relationship between humankind and landscape, and a refusal of postmodern theory and practice. More speculatively, it was perhaps an attempt to relocate the spiritual and transcendent, or at least its possibility, within a painterly aesthetic after the loss of faith in Marxist, socialist and psychoanalytic ideas.[59]

Jean Baudrillard's *Simulacra and Simulation* (1994) was authored from a very different perspective. A philosopher and sociologist, Baudrillard identified the 'simulacrum' or copy of a lost original, as a means of addressing the 'hyper-reality' of contemporary culture, understood as a seamless web of technological and consumer spectacle. Applied to successive developments within cultural history, the concept and practice of art becomes increasingly divorced from what it represents. In the first order of the simulacra, the painter attempts to represent a basic reality by using the naturalism of a still life painting. In the second order, the image as commodity may illustrate narratives taken from historical or mythological subject matter (such as *The Judgement of Paris*). In the third order of the simulacrum, art actually conceals the 'absence of a basic reality'.

Within late modernity, for example, the principal source of the visual is no longer art, but a simulated culture of television and computer images driven by technology and consumer demand. Like Warhol's multiple silkscreen images, art merges with brand advertising, commodity production and a globalised electronic media. To illustrate the fourth and final order of the simulacra, Baudrillard employs the example of Disneyland as a wholly fabricated present in which images cease to have any relationship with anything other than their own simulation. According to this account, late modern culture begins to resemble a complete imaginary landscape, like the cityscapes of Los Angeles and Las Vegas.[60]

Some commentators have questioned the apparent pessimism of Baudrillard's characterisations, suggesting that they deny human agency while exaggerating the power of a commodity culture driven by corporate interest. But the model of successive simulacra culminating in a complete

and dystopic 'imaginary' and Fuller's conviction that place and landscape remain reservoirs for memory and the idea of the transcendent, provide extreme points from which we might consider representations of place, landscape and the imaginary within more recent British painting. Artists as diverse as Gillian Carnegie, Nigel Cooke, Gordon Cheung, Graham Crowley, Peter Doig, Stanley Donwood, Thérèse Oulton, Richard Patterson, Dan Perfect, George Shaw and Clare Woods are among those who have explored contemporary, but very different, representations of landscape and place and what both might signify.

In words that evoke Baudrillard's virtual imaginary, Gordon Cheung (b. 1975) has described his landscapes as examples of the 'techno Sublime'. In paintings titled *Skyscraper* (2004) and *Brueghel's Highway* (2004) (Figure 2.3), Cheung employs stock market data from the *Financial Times* and computer printouts as an all-over collaged background of newsprint on which he arranges computer-generated imagery using acrylic gel and spray paint. His apocalyptic vistas framed with collaged commodity and share price data dramatise the effects of global dependency on international finance, what Cheung refers to as a 'dream-world where investors chase after promises of fortune that affect all our lives'.[61]

In the aftermath of the near collapse of the global financial system, the subject matter of *Brueghel's Highway* is compelling and prescient. The wrecked bridge over the yawning, boulder-strewn chasm alludes to the promises of the information superhighway and related assumptions concerning the seamless flow of financial and other market data across the globe. The entire centre ground of the image is a collaged mass of tabulated market and share price information from the *Financial Times*. Precipitous mountains frame the backdrop to the image and brooding skies give the vista an apocalyptic feel. The title's reference is to the painter Pieter Brueghel the Elder known for his allegories of vice, virtue and the depiction of human folly. In particular, Cheung had in mind Brueghel's painting *The Fall of Icarus* (c.1555–8), a parable on hubris and human vanity.

The Sublime, understood as a terrifying of the subject, meets grim humour in Stanley Donwood's post-apocalyptic landscape, *If You Lived Here, You'd Be Home By Now* (2007). Donwood is the pen name for Dan Rickwood, who is more widely known for the album cover designs and artwork for the rock band Radiohead. The image's title came from his second solo exhibition of paintings and large-scale photographic etchings at the Lazarides Gallery in Soho, London. Small, stick figure silhouettes are lost and engulfed by a scenic Armageddon – a lurid orange and red backdrop. The homely-sounding vernacular of the painting's title is undone by the choreography of the composition, which suggests the virtual and simulated environment of the games console which has superseded lived reality.

In a Baudrillardesque coincidence, the title was taken from a sign advertising new zoning for a housing scheme which Donwood drove past

Figure 2.3 Gordon Cheung, *Brueghel's Highway*, 2004. *Financial Times*, ink, gloss paint, acrylic spray and gel on canvas, 165 x 220 cm. © Gordon Cheung. Courtesy of The Alan Cristea Gallery, London.

one day as he was leaving Los Angeles. Interviewed about the inspiration behind the work, he recalled:

> It's an exploration of my thoughts and fears about the suburban experiment. The whole thing is predicated on the assumption that there's going to be cheap oil forever. But prices will get higher and suburbia will become the slums of the future. Humans have built really brilliant places to live in the past. We seem to have lost the knack.[62]

If You Lived Here, You'd Be Home By Now parodies the bland homilies and advertising blandishments of suburban utopia as just one more spectacular deception in the imaginary landscapes of late modernity. The sense of social displacement and disorientation is underlined by Donwood's use of anonymous stick-like forms; in such a dystopian landscape, human subjectivity is pared down and interchangeable.

Landscape as a metaphor for entropy – the slowing down and eventual stasis of human life is a theme shared by Nigel Cooke (b. 1973), who came to prominence in the mid-1990s with surreal, flatline vistas which seem to reference the work of Caspar David Friedrich. His signature format – monochromatic backgrounds with low horizons and flat frontal baselines – has been compared to theatrical spaces and backdrops. If the philosophical category of the Sublime is understood as a terrifying negation of the subject, Cooke re-presents this through combinations of the banal with dislocated dreamscapes. Paintings like *Vomiting Monkey* (2002), *Smokestack in the Sun's Eye* (2003), *Black Zenith* (2004) and *The Dead* (2005) present wasted and denuded vistas in which severed heads, graffiti and random juxtapositions of objects, animals and foliage provide images of a surreal, post-apocalyptic world.

In *The Dead* (2005), this instability of reference extends to depictions of pumpkins which are given schematic human features. Illustrating the human tendency to anthropomorphise, Cooke's iconography identifies it as a defensive and infantile co-option of an indifferent natural world. In making these minutely detailed and rendered micro-environments, he uses the devices and effects of conventional, allegorical landscapes to direct the viewer's eye around the canvas in order to catch the weighted motifs of each painting. At interview Cooke noted:

> The thing to avoid is a kind of dwindling vista, like a Claude Lorrain, because in my work that presents the viewer with too much free contemplation space and associations of romance and reverie.[63]

The permutation and ordering of objects within his landscapes pose phenomenological questions: how and in what ways do we communicate and gain meaning from sense perception? What happens if what is seen and

experienced is dislocated and reordered? Can we make sense of seemingly illogical phenomena? Readings of Cooke's aesthetic have suggested the use of Surrealist techniques of dream compression, displacement and condensation as rhetorical devices to present and raise these questions. Noting the connection to the practice of Salvador Dali and Max Ernst, Darian Leader writes:

> Unreality was simply an effect of the transmission of information. To get through, it could only articulate itself in scenes which could never occur empirically, and which had an absurd aspect.[64]

Cooke uses recurrent graffiti inscriptions within his landscapes and on his surfaces as a 'painting mechanism', a means of mark making which, like painting, is a broader metaphor for language, rhetoric and communication. Asserting the importance of 'keeping the conversation about painting going within painting', the subject matter of Cooke's work is ultimately the medium's ontology:

> in a way my idea is always about expanding the terms of painting within the work, in that these paintings are theatrical allegories of the problems of the history of 20th century painting. It's not a material thing, but a visual and conceptual thing. They make a performance of the self-questioning and self-deprecating features of 20th painting, playing it out in this thing that builds and defaces itself.[65]

What is described as 'multi-temporality' attempts to chart the histories of painting; its meaning, interpretation and reception through the compendium of objects and details within his landscapes. In fifteen paintings exhibited under the title *New Accursed Art Club* (Stuart Shave/ Modern Art, April–May 2008), Cooke explored the conflicts, challenges and identities associated with painting. The exhibition underlined this central concern with the specificity of mark making as part of a broader conceptual process of what painting is or might be. Cooke notes:

> Painting puts you at odds with your own brain. The men in these paintings are this process made flesh – bearded, clownish and desolate. They paint themselves, and are painted. They are the beret-wearing answer to the question 'who is painting'.[66]

In the title canvas, *New Accursed Art Club* (2007) (Plate 7), artists and monkeymen, paint, urinate, drink, read or gaze into the middle distance in a typically denuded and post-apocalyptic landscape. Strands of spermazoa swim across the front of the canvas while in the background a brutalist concrete bunker, partly obscured by mist or smoke, brings a sense of

menace to the vista. The dissociated figures, described by the artist as 'grandiose bums', reference both the stereotypical artist as an introspective dreamer and the sublimation inherent within creative practice. Cooke's entropic landscapes objectify the complex narratives around what it means to paint, sustaining the medium's contemporary relevance within a post-conceptual environment – 'connecting painting to a wider world at large'.

The empirical and factual character of a previous tradition within British landscape painting was mentioned earlier. An emphatic sense of place defines work by George Shaw (b. 1966), in this case memories evoked by a post-war council housing estate in Coventry. Shaw is on record as having taken over 10,000 photographs of the Tile Hill area where he spent a 1970s childhood. Like many other 1950s Coventry housing estates, it once provided the labour for the region's main employer: the motor industry. Hit by the downturn in manufacturing that took hold in the 1980s, Tile Hill now ranks among the most disadvantaged estates in the area.[67]

Shaw's archive of images is the documentary basis for his meticulous recording of the estate's houses, bus stops, playing fields, garages and schools. The evocation and resonance of childhood continues with the choice of bright Humbrol enamel paints used by generations of children for Airfix models and soldiers. As the writer Chris Townsend has observed of Shaw's work, 'the medium itself is the memory'.[68] In these hyper-real canvases there are no people or cars, just suburban buildings, garages, woods, bus stops and the liminal spaces in between, prompting comparisons to the melancholic and mesmerising vistas of Edward Hopper. Describing his work as a form of therapeutic or personal archaeology, Shaw recalls a poignant verse line by Philip Larkin, an acknowledged literary influence:

> I'm looking for evidence. I'm not sure of what. Perhaps that I was here. These paintings come out of a mourning for the person I used to be – a passionate teenager, who read art books and novels and poems and biographies, watched films and TV and listened to music.[69]

Like much of Larkin's verse, Shaw's work articulates a sense of loss, displacement and exteriority which is located in those meticulously recorded spaces between the houses, shops and garages of Tile Hill. The cultural and social aspirations which made the housing estate and a thousand places like it belongs not just to time past, but to another world. Particularly in *Scenes from the Passion* and the meticulously recorded series of canvases such as *Ash Wednesday 8.00 a.m.* (2004–5) (Figure 2.4), one feels the cadences of a personal history and voice, spectres of which live on through buildings and places. The titles of these paintings suggest pilgrimage, remembrance, and more speculatively perhaps atonement, gained through the ritual act of painting itself.

In George Orwell's nostalgic and evocative novel *Coming Up for Air* (1939),

Figure 2.4 George Shaw, Ash Wednesday 8.00 a.m. 2004–2005. Humbrol enamel on board, 91 × 121 cm. © the artist. Courtesy of Anthony Wilkinson Gallery, London.

the principal character and narrator George Bowling returns to Lower Binfield, the village of his boyhood which he left on the outbreak of war in 1914. On the cusp of another conflict twenty-five years later, the journey only brings disillusionment and frustration at what has changed. In one sense, Shaw's paintings share this melancholic excavation of memory, imaging a loss and reinvention of place. Describing Tile Hill's location (a half-hour drive from Stratford's theatres), Shaw notes:

> I like the idea that this place was carved out of the Forest of Arden: Shakespeare's forest. And I love the way that planners left a few trees dotted about the estate.[70]

Looking at Shaw's images of Tile Hill, one is reminded of an observation made by Peter Fuller. Discussing what he perceived as the failure of contemporary artists to resolve the 'spiritual' and 'aesthetic' malaise of their time, and in a cadence reminiscent of Matthew Arnold's lyric poem, 'Dover Beach', he suggested that we (collectively) 'stood on the shore of a collapsed modernity'.[71] The vestigial, communal enclaves and spaces of planned suburbia, the blank windows and empty streets of Shaw's canvases seem to capture this absence, whilst sustaining a search for personal authentication through recollection and memory.

Remodernism, Stuckism and film noir nostalgia

A sense of locality and a vernacular idiom have informed the figurative aesthetic of the Stuckists, an art group originally co-founded in 1999 by Billy Childish and Charles Thomson. A career poet and artist, Thomson (b. 1953) took a foundation art course at Thurrock Technical College (1973–75) and attended Maidstone College of Art (1975–79). Childish studied at the Medway College of Art and Design (1977–78) before an abortive period at St Martins College of Art (1977–1980/1). The group label allegedly arose from a comment made to Childish by his ex-girlfriend Tracey Emin, who told him that his art was 'Stuck'.[72]

Trenchantly opposed to all forms of conceptual art, the Stuckists have described their work, specifically painting (although a photographic grouping was established in 2003), as a form of 'Remodernism' – understood as a return to the 'original principles of modernism' and a refusal of the ideas and theories associated with late modernity. Thomson and Childish were concerned to 'endorse painting as the most viable contemporary art form and [to] restore values of authenticity, content, meaning and communication in art'.[73] Supported by David Lee, editor of the independent visual arts journal *The Jackdaw*, they have opposed the celebrity culture associated with the YBAs and the perceived bias towards conceptualism apparent in art institutions such as the Turner Prize.

The Stuckists came to public notice with a series of group shows including *Stuck! Stuck! Stuck!* (September–October 1999), and a touring group exhibition, *The Resignation of Sir Nicholas Serota* (March 2000), both at Gallery 108, Hoxton EC2, then run by Joe Crompton. Stuckist demonstrations outside the Tate Britain over the Turner Prize have since become annual media events. A major group retrospective, *The Stuckists Punk Victorian*, was hosted by the Walker Art Gallery as part of the 2004 Liverpool Biennial.

In an open letter sent to Sir Nicholas Serota, director of the Tate Gallery in March 2000, Childish and Thomson denigrated what they claimed was Brit Art's 'superficial, lazy and gimmicky nature', alleging that relative critical and curatorial values had sanctioned a cynical and vacuous avant-garde practice. The text continued:

> Painting, with its translation of inner experience into accessible and recognisable images, has a depth of resonance and mystery that is essential to the human psyche. It brings us to an immediate confrontation, recognition and emotional engagement with our potentials and limitations.[74]

The direct association of figurative painting with humanistic ideas replayed some of the claims made by the curators of *A New Spirit in Painting*, noted earlier in this chapter. Like the Stuckists, its curators, which had included a younger Nicholas Serota, had claimed painting as 'one of the highest and most eloquent forms of artistic expression'.[75] In a further parallel, both the Stuckist manifesto and *A New Spirit in Painting* had referenced a similar line-up of formative, northern Expressionist influences, including Van Gogh, Ludwig Kirchner, Edvard Munch and Max Beckmann.

With some exceptions, several of the painters associated with the group at the time of its launch either originated from Kent, the Medway Poets, or had studied in the county at some stage in their professional careers. In addition to Childish and Thomson, several had taken foundation courses at the Medway College of Art and Design: Philip Absolon (b. 1960), Sheila Clark (b. 1960), Sanchia Lewis (b. 1960), Bill Lewis (b. 1953) and Charles Williams (b. 1965). Frances Castle (b. 1966) attended Richmond College before taking a HND in illustration at Lincoln. Eamon Everall (b. 1948) attended Folkestone School of Art before moving on to a postgraduate printmaking course at Wimbledon School of Art. Joe Crompton (b. 1974), Wolf Howard (b. 1968), Joe Machine (b. 1973) and Sexton Ming (b. 1961) are listed as self-taught and as not having attended art school. The other painter listed with the group, Ella Guru (b. 1966), was born in Ohio, USA and attended Columbus College of Art and Design.

The canvases by artist, writer and musician Billy Childish (b. 1959) are expressionistic in the use of impasto brushwork. His subjects are stylised and rapidly executed, with a concern to find what he describes as the

'vulnerability and truth of [the] subject ... believing in a direct access to the unconscious'.[76] He works in oils rather than acrylic binder, using primer rather than emulsion to prepare canvases. A listing of painting advice, 'handy hints' and the names of artists recommended for study, authored by Childish, follows the Stuckists' manifesto statement. The practical tenor of the advice underlines the conviction that painting is fundamentally a matter of learned craft rather than conceptual technique. In 2010 Childish was accorded a major retrospective at the ICA.

Wry social observation and bleak humour are appreciable in work by other Stuckist painters. Philip Absolon (b. 1960), a descendent of the Victorian watercolourist John Absolon, was among the group's founder members and met co-Stuckists Childish and Lewis whilst at Medway College of Art and Design before attending Epsom College of Art (1979–82). Absolon's *Job Club* (1997) (Plate 8) presents the skeletal living-dead as metaphors of the hopelessness and alienation of unemployment. He recalls:

> They were all real people on a government unemployed scheme. They were builders apart from me, and they didn't want to be there. We'd all been doing it so long that we thought we would end up dead still doing it. I also disguised them because I didn't want to get beaten up. They're all portraits. I'm the middle one.[77]

Other Stuckist painters have also chosen unusual ideas for composition. A smiling slaughterman complete with bloodied overalls and pug dog is the macabre subject of *Home from the Abattoir* (1993–94) by Charles Williams (b. 1965). The painting arose from what Williams describes as serious reflection on 'the discomfort of life we walk through'. He adds:

> I was thinking about dying and the last few moments of life – which are the most important. We are all oblivious of the blood we're covered in.[78]

Stuckism has received mixed critical and press coverage. Its members have, to some extent, self-consciously cultivated the identity of maverick outsiders and a sensibility that understands painting principally as a matter of experientially developed craft and personal technique. As Paul O'Keeffe notes, Stuckism was principally conceived as an 'Anti-Establishment movement in reaction to the YBA dominance of contemporary art and the hegemony of its state and private sponsors'.[79] Rather than a conceptual identity based around an art school ethos (Goldsmiths College or the Royal College of Art), many of the founder members of Stuckism share a distinct regional identity and affiliation, although unlike the generation of YBAs, the medium specificity of painting has underpinned their practice.

Stuckism's figurative aesthetic and its 'Remodernist' agenda assert claims to the local, the personal and the particular in the face of what is judged an

administered visual culture operated by a perceived coterie of dealers, gallerists and patrons. Although it remains to be seen whether the impetus and broad homogeneity of style which has characterised the group's aesthetic will continue, Stuckism registers one response to accelerating cultural change and a belief in the deployment of painting as a matter of craft and personal conviction.

A figurative and narrative painting style has also characterised work by the self-taught painter Jack Vettriano (b. 1951). Born in Fife, he initially worked in the Scottish coalfields before coming to wider public notice in 1988 with work submitted to the Royal Scottish Academy's Summer Exhibition. Since his first solo exhibition, *Chimes at Midnight* (1994), a sell-out success with London's Portland Gallery, Vettriano has become the UK's most popular contemporary painter with widely reproduced images such as *Mad Dogs and Englishmen* (1991), *The Singing Butler* (1992) and *Dance Me to the End of Love* (1998). The commercial and popular success of his work underscores the continuing gulf between broader public taste and art establishment judgement; with the exception of two donated canvases held by Kirkcaldy Art Gallery and Museum, there are no other works by Vettriano held in public collections. But more recently there has been formal recognition of his achievements; Vettriano was awarded an honorary doctorate from the University of St. Andrews in 2003 and an OBE for his contribution to the art world and his charitable work. Canvases by Vettriano were also extensively featured at New York's Twentieth Century International Art Fair.

Vettriano's compositions are typically takes on film noir subject matter and the associated milieu of the 1940s and 1950s. The narrative and anecdotal character of his paintings suggest homages to the journalistic reportage of James Ellroy and his depiction of the Los Angeles demi-monde, made famous in films like *LA Confidential* and *The Black Dahlia*. The narratives of Vettriano's paintings are frequently implied, with typical subjects depicting assignations and meetings between louche men and vampish women. The late critic and playwright W. Gordon Smith characterised what he believed to be the attraction of the painter's work:

> Passion, desire, threat, seduction and betrayal stalk boundaries between virtue and vice. There is an adoration of women and an indulgence of men, an acknowledgement of weakness and corruption, but neither censure nor approval.[80]

Critics have frequently dismissed such work as Art Deco erotica, kitsch or simply badly painted. The journalist Duncan Macmillan has described the artist's depiction of:

> People ... mutually indifferent, repetitively at right angles, never interacting with each other or with us, not even exchanging a glance and often seen from behind.[81]

But the exteriority and flatness of Vettriano's compositions might equally be read as evocations of a fragmented late modernity and metaphors for the transactional relationships evoked in novels by Michel Houellebecq and Angela Carter. This milieu is explicit in paintings like *Master of Ceremonies* or *Scarlet Ribbons* which explore fetishistic and sado-masochistic subject matter.

Vettriano's paintings are linear; flat in texture and typically composed in shallow pictorial space. Stylistically, he does not build up glazes and, unless over-painting or changing a composition, only applies a single layer of paint. The meditative Edinburgh studio portraits *Valentine Rose* and *Yesterday's Dreams* (1994) (Plate 10), partly derived from posed photographs, typify his approach and choice of subject matter; both paintings evoke a wistful moment or quiet introspection. Minimal interiors, backlit windows and motifs like fire hearths lend formality and structure; bold areas of colour are used dramatically to highlight a motif like a rose or an item of clothing. Describing *Yesterday's Dreams* (the title taken from a Four Tops song), Vettriano comments:

> How often have we stood at a window and we are actually not looking at anything. We are standing there and thinking about something else. We choose to look at a landscape or a townscape rather than at a wall. We go and stand at windows.[82]

In form and content his aesthetic has evoked comparison to work by the American modernist painter Edward Hopper and the British post-Impressionist Walter Sickert. Both frequently depicted atmospheric interior scenes with isolated figures or couples, suggesting introspection, loneliness or melancholy. Vettriano became aware of these precedents only after his own style had developed through a self-apprenticeship of copying from manuals and from older figurative styles. As he openly acknowledges, this approach arose from a compendium of influences:

> My style of painting came about through pure alchemy. It was an accident. I taught myself to paint by copying. I painted anyone I could get my hands on that I liked. That pleases me immensely, that I've got such a distinctive style and it has come about purely by chance.[83]

The observation places Vettriano securely within a late modern orbit of pastiche and appropriation, whilst the tangible nostalgia of his canvases and the pragmatic assimilation of other styles links his aesthetic with broader tendencies and trends apparent within recent and contemporary art.

The varied representational styles of painting mentioned so far have been responses to specific political or cultural environments. In the case of work by Howson, Keane or Laing, it has been commissioned and conceived in the context of war and overseas intervention. Practitioners have adapted or mobilised the conventions of portraiture (Harvey, Ofili and Saville) history or genre subjects (Absolon, Currie, Maloney, Piper and Vettriano) or landscape painting (Donwood, Cheung, Cooke, Oulton and Shaw). Groupings of artists with shared affiliations such as the Stuckists have ranged across all the existing genres, although their subject matter has tended to identify everyday subject matter and portraiture as categories of choice. Although a small selection, these examples point to the durability of traditional painting genres and an imaginative adaptation of subject matter to contemporary concerns and issues.

Gestural and geometric British painting: modernisms revisited

For its critics in the 1950s and 1960s, abstract Modernist painting had come to symbolise a paradigm of high culture. Greenberg's early essay 'Avant-Garde and Kitsch' (1939) defined it in elite opposition to the blandishments of an inauthentic mass culture derived from corporate advertising and the movie industry. Critical theory and the disciplines of anthropology and sociology have subsequently provided more nuanced and less polarised definitions of what 'culture' might signify. For example, the social theorist and lexicographer Raymond Williams suggested a more anthropological and performative dimension to culture – it was what people 'did' – whether making art, pigeon racing or gardening. 'Culture' was understood more as an affirmation of shared values, ideas and affiliations realised through practice and repetition.

A post-conceptual generation of practitioners has taken more open and pragmatic approaches to the use and combination of media. The genres of painting and sculpture have ceased to have exclusively Modernist connotations, although its decorative and formal dimensions have provided points of departure and exploration for a range of British artists. Other artists have looked to earlier traditions of avant-garde, modernist practice which were overtaken by the emphasis on formalist abstraction.

Allegorical subject matter which, in paintings by Maloney, themes earlier directions within avant-garde modernism, can also be seen in the work of Gillian Carnegie (b. 1971). Carnegie has in turn explored painting's ambivalent status within contemporary culture through the historic genres of landscape, still life and portraiture. A graduate of Camberwell College of Art, she studied at the Royal College of Art (1996–98), and was among the artists featured at *Surfacing* (ICA, 1998), with subsequent solo exhibitions in London and New York. Carnegie's work was included in the Tate Triennial

Exhibition of Contemporary British Art 2003. A nomination for the Turner Prize in 2005 brought her work to wider notice, with paintings such as *Fleurs de Huile* (2001), an arrangement of wilting flowers in a cut-down mineral water bottle, and a series of anatomical studies which explored the representational tensions between narrative and a Modernist insistence on the medium as subject.

Historically, the still life was the lowest of painting's genres. Although these distinctions have ceased to be recognisable, the still life remains associated with allegories of time and transience. Carnegie's *Fleurs de Huile* reprises these connections, prompting the viewer to anthropomorphise the pathos of dying flowers. The flowers are asymmetrically placed on the left of the composition against a tonal background of greys and off-whites which renders the spatial depth unclear. Ridges of impasto paint are used to define the central mass of flowers and foliage, but at the base and tip of the arrangement their depiction is more formally naturalistic through the use of flat washes of paint. This deliberate change in the register and thickness of the pigment is one of the most distinctive features of the composition.

The Modernist critic Greenberg is on record as expressing a personal preference for the work of the French painter and lithographer Henri Fantin-Latour (1836–1904), and in particular his meticulous and noted depictions of flower arrangements.[84] Although Greenberg conceded that the best art had been abstract, he nevertheless perceived in Fantin-Latour's highly figurative aesthetic a keenly Modernist sensibility attuned to the specificities of form, colour and texture. Like Greenberg and the still life example he cited, Carnegie's *Fleurs de Huile* is attentive to the subtleties of form and technique – Édouard Manet is one of the painters Carnegie is on record as admiring. In the case of her still life, we are simultaneously reminded of the depth of the pigment and the materiality of the painting as an object, whilst viewing the naturalistic touches which suggest illusionistic detail.

Carnegie's dual painting style might be read as a reference to some of these historic (and ongoing) tensions. As Polly Staple has suggested of the conceptual (yet visceral and tactile) dimension to Carnegie's paintings:

> They are concerned with the problems intrinsic to painting itself and, as such, they operate as allegories of their own production.[85]

Like Richter, she works from photographs, although these are taken and selected by her, rather than used as found objects. Broad compositions are frequently planned and sketched in advance before the final motifs and details are identified.

In 2002 Carnegie returned to some of these representational tensions through a series of matt black impasto paintings, collectively titled *Black Square*. These were densely worked and highly painterly images which on first glance appear as pastiches of Kasimir Malevich's (1878–1935)

monochrome images of the same name, completed between 1915 and 1929. Instead, Carnegie's series of canvases which theme Malevich's original subject include evocative and highly naturalistic nocturnal woodland scenes. Malevich had famously proclaimed his *Black Square* as the 'zero of consciousness' – the symbol of a new (secular age) and the end of representational painting. Carnegie's deliberate historic referencing draws attention to her appropriation of the idea of a monochrome canvas, but also underlines the contemporary durability of painting – both abstract and representational. As Ben Tufnell observes:

> Monochromes, and specifically black or white monochromes have often been put forward as representing a final advance or an assertion of the death of (representational) painting ... Carnegie's practice ... playfully subverts this heroic tradition of final statements.[86]

Like Maloney, Carnegie's use of allegory within her paintings and titles, references earlier traditions of avant-garde, modernist practice and draws attention to the hybridising effect of combining abstract and representational painting styles.

The Slade School and Morley College trained British painter, Cecily Brown (b. 1969), came to prominence in the United Kingdom with her first solo show at the Museum of Modern Art, Oxford in 2005. Previously an animator for a commercial film business, Brown moved to New York in 1994 and was among those who contributed to the second instalment of Saatchi's three-part *Triumph of Painting* exhibition. Since her *High Society* exhibition in New York (1998), Brown has become more widely known for exploring sensual and evocative subjects, with canvases featuring sexually graphic imagery such as *Performance* (2000) and *Hard, Fast and Beautiful* (2000) (Figure 2.5), or figures sharing companionable intimacies like *Couple* (2003–04) and *These Foolish Things* (2002). In these examples, expressively delineated figures emerge or recede into the facture of the surface, among skeins, washes and runs of paint and bold colours. Brown's images are highly tactile compositions which explore the painterly language of abstraction using the push and pull of fluid figure–ground relationships. Representational subject matter is sometimes easily decipherable, but often motifs dissolve into surfaces heavy with impasto paint.

In the painting *High Society* (1998), Brown adapts the frenetic, all-over compositions associated with Jackson Pollock to choreograph multiple figures and suggestive body parts against an opulent but fractured blue and gold background. There are occasional sequences in which the swirls and skeins of paint delineate discernible subjects, a man attempting orgasm or figure parts suggesting coitus, but overall the figure and ground relationships are both unresolved and undecorative. Discussing the deliberate ambiguities of pictorial space within her work, Brown notes:

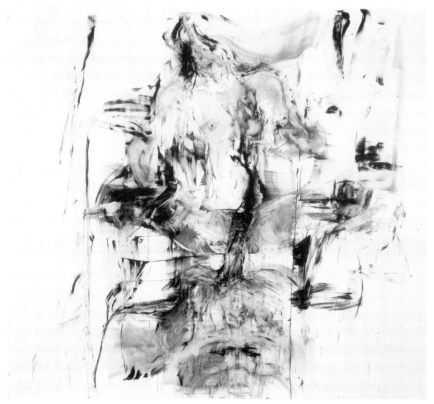

Figure 2.5 Cecily Brown, *Hard, Fast and Beautiful*, 2000. Oil on canvas, 254 × 279 cm. © Cecily Brown, 2010. Photography by Robert McKeever. Courtesy of Gagosian Gallery and Saatchi Gallery.

> it was the attempt to bend and twist pictorial space. I wanted to get the figure off the ground and integrate it more with the flat ground of the picture. That was probably when I first started trying to use ambiguous space, one that defied gravity. I wanted it to be impossible for the viewer to know where they stood in relation to the action.[87]

This deliberate dislocation of the viewing experience characterises many of Brown's paintings, encouraging the spectator both to stand back from, and get closer to, the compositional motifs in an attempt to decipher the forms and images within the work. Brown's use of oils and her acknowledgement of its histories and traditions have been described as 'celebratory' and 'painterly' – characterisations which have prompted comparisons to School of London painters Frank Auerbach, Francis Bacon and Lucian Freud.[88] She has described her canvases as 'slow paintings' which demand 'active' and prolonged looking – qualities associated with a Modernist sensibility. As Brown notes:

Very active looking is what I want people to do. I want to make forms which are either just dissolving or in the process of just becoming something, and to play with the relationship between the eye and the brain.[89]

Like Maloney, Brown is sensitive to the registers of art history and the gender politics of representation. In particular, she is aware of the 'macho' connotations of a particular kind of painting sponsored by Modernist theory and the highly gendered and typically chauvinist cult of celebrity which grew up around it. Discussing her own signature use of Abstract Expressionist imagery in relation to contemporary male painters, Brown has observed:

As white American males they couldn't paint like an Abstract Expressionist because it was too close, too recent, too American and too macho, but as an English girl I could.[90]

The equivalent rendering of male and female subjects within her compositions acknowledges the latter's objectification within visual representation. Discussing Brown's nuanced approach to the figure, and to the process of painting as metaphor, the art historian Linda Nochlin has noted:

Certainly, her paintings make reference to the act of painting, painting as a process. And within this process, the sex act serves as both an analogy and a specific referent. Male artists have often made the explicit comparison between painting and fucking. Brown has made it possible for critics to speak of sex in relation to a woman artist – and it's about time.[91]

Brown's aesthetic retains a strongly Modernist idiom, with a sense of painting as primarily a visual, rather than a conceptual process. It is also a sensibility filtered through the cultural experience of gender and the perspective of a post-conceptual generation for whom Abstract Expressionism offers a historical repertoire of possibilities, rather than a prescriptive stylistic lexicon.

Like Brown, Fiona Rae (b. 1963) is a painter whose practice has been discussed in relation to Modernist concerns, although her approach to themes taken from contemporary culture is highly decorative. *Lovesexy*, 2000 (Plate 11) was one of several canvases which Rae exhibited at the Tate Liverpool's *Hybrids* exhibition in 2001 (discussed on pages 78–79). The painting was a play and compendium of Modernist references, displayed on a pink and blue ground in which colour-field and gestural forms of Abstract Expressionism fused with biomorphic shapes reminiscent of Surrealist automatism. The black asterisk and figure-based shape in the painting's top

right suggest comic-based or graphic imagery, but the connection between Modernist motifs and mass culture remains unresolved and ambiguous. The stylistic stand-off between these idioms is underlined by the painting's media – oil, acrylic and glitter on canvas.

The art commentator Louisa Buck has described Rae as making 'paintings about paintings', and the experience of looking at her canvases as akin to 'being taken on a ram-raid through art history, grabbing handfuls of popular culture on the way'.[92] In crafting images which reference painting's previous status as the high Modernist art form, Rae's all-over compositions refuse any definite hierarchy or ordering of motifs. The viewer is presented with evasive motifs and equivalent interest in medium and technique; collage, assemblage, the re-use of found elements, abstract, biomorphic shapes and motifs, are central to Rae's aesthetic. The densely worked surfaces of her canvases offer discursive spaces for play and juxtaposition. Interviewed on the attractions of painting, Rae stated:

> The appeal of painting is that there is no solution. It always eludes you, you can't solve it or quantify it. It's a process with no possibility of arrival, a long and engaging attempt to conquer something unconquerable.[93]

The observation recognises painting's versatility and its opacity as a medium. But although her characterisation has a Modernist feel to it, the cultural context in which these canvases are made has moved on. Discussing Rae's inclusion in the *Hybrids* exhibition, the art historian Jonathan Harris has drawn attention to painting's 'relational definition'. That is the extent to which it acquires meaning through difference and distinctness from other media such as photography and video, while nevertheless sharing with them a contemporaneous 'time and location'.[94] Rae's work explores this dynamic through seemingly randomised motifs and themes arising from this sharing of cultural time and location. Like Brown's densely packed canvases, her work has a durational quality; the orchestration of motifs and forms is designed to arrest, steer and hold the gaze.

A formalist Modernism based on the gestural and colour-field abstraction of the 1940s and 1950s provides an implicit source or reference for another contemporary painter. Angus Pryor (b. 1966) studied at the Wimbledon School of Art and took his MA at the Kent Institute of Art & Design. Pryor's canvases are large and highly tactile surfaces based around what he terms 'disguised narratives' which foreground the use of pigment as both the medium and the subject of the work. *The Deluge* (2007) is typical of his aesthetic (Plate 9). Based on a visit to Venice, Pryor melds the apocalyptic motif of Noah and the Ark, which is under the water, with that of the Adriatic city, which is depicted floating on top. This chaotic reversal of fortune is themed by the dominant palette of crimsons and reds. The canvas is saturated in multiple layers and skeins of paint (household undercoat

mixed with oil paint), to which is added caustic builders' caulk which raises the surface to ridges and buttons of pigment. Discussing his method of painting, Pryor states:

> There's a dialogue between the surface and the mark ... overpainting of the mark where there's a line which is a definite and then another mark goes on top. It stops it [the painting] becoming an illustration of a mark and starts to be something else.[95]

Pryor's canvases explore permutational excess; motifs are worked and reworked; earlier mark marking is erased, revised or obsessively repeated. Within some paintings there are small, almost incidental islands where the weave of the canvas is just decipherable under a wash of light colour, a foil to the avalanche of pigment. Pryor describes his work as an 'opulent cornucopia, an assault on the visual senses enough to elate or turn your stomach'.[96] Multiple and half-realised narratives collide across the surfaces of these paintings. He notes:

> Everyone grew up being told stories, linear narratives are part of our everyday consciousness. My paintings are real narratives. They exist in settings where a multitude of experiences are happening at once. Like the hieroglyph in archaeology everything has a meaning.[97]

Formative influences for Pryor include the paintings of Philip Guston and Willem de Kooning, in which the application and working of the medium is an intensely physical and gestural process. In his manifesto statement 'Plastic Propaganda', Pryor asserts that painting should reclaim its vanguard status, not only trading on the medium specificity of Modernism – the 'language of the mark, gesture and surface', but should be equally receptive to motifs taken from contemporary culture and older narrative traditions of image-making, including those of the Venetian artists Veronese and Tiepolo. Consistent with this meeting of influences, Pryor is keen for his paintings to be seen in a relational sense. Unlike the 'private symbolic spaces' typically associated with Modernist abstraction, his canvases are fashioned as imaginative and discursive prompts for the spectator:

> The paintings border on abstraction and figuration, letting one's gaze refine memories and letting the viewer bring their own directed memories to the work.[98]

Shortlisted for the Turner Prize in 1996, and Britain's representative at the 1999 Venice Biennale, Gary Hume (b. 1962) was among Hirst's contemporaries who took part in the 1988 *Freeze* exhibition held in London's Docklands. He had previously studied art at Chelsea College of Art and

briefly at Liverpool Polytechnic before transferring to Goldsmiths College in 1986. In the late 1980s, Hume developed a technique which used smooth gloss household enamel paints, experimentally applied to canvas, MDF, Perspex and then polished aluminium panels in a signature series which has since extended to some fifty iconic door paintings.

Hume incorporated the functional designs of double porthole windows and kick plates associated with hospital swing doors into large monochrome paintings. Described by Andrew Nairne as a 'foundational' part of Hume's oeuvre, the series combined the language of Modernist abstraction with a functional and familiar medium, defamiliarising the response to both. In early examples such as *Mushroom Door* (1988), tears and runs of gloss paint combine with a matt depthlessness which just makes the portholes of the swing doors visible in a way which is vaguely anthropomorphic. As the series developed, Hume experimented with different and stark colour juxtapositions, as with *Dream* (1991), *Dolphin Painting IV* (1991) and *Four Coloured Doors II* (1990) (Plate 12). The doors for the series were based on those inside London's St Bartholomew's Hospital, with their functional kick plates and porthole-design windows. Discussing the source for the designs, Hume recalled:

> I didn't want them to have class references ... or design consciousness, so I chose the kind of doors that we all go through at one time or another.[99]

In Roman mythology, Janus, the two-headed god of gates and doors, was associated with change, transition, futures and pasts. Despite the convenience of linking the context in which we experience hospital-related design with existential possibilities of futures and change, Hume was not principally interested in this specific narrative. Instead, the series underlined a fascination with the specificity of the chosen medium, which suggested a highly Modernist inflexion to his practice:

> I found that gloss paint suited me entirely, and its qualities still intrigue me. It's viscous and fluid and feels like a pool. It's highly reflective, which means that there are layers of looking.[100]

As commentators noted early on, the functional door designs recalled the fashion for 'Neo-Geometric paintings' ('Neo-Geo') in the late 1980s and also the commodity sculptures of Jeff Koons and Haim Steinbach. But the preoccupation of these images is the tension between a formalist Modernist interest in flatness and surface with the Duchampian tradition of the found, contingent object or ready-made – the depth of the aluminium when hung suggests a door's actual width. The intention is not to create an illusory sense of space or recession (the ubiquity of the door motif discourages this anyway), but to explore the actuality of the painted surface.

But looking at these examples, our gaze nevertheless oscillates between a recognisable, if uninteresting object, and the pristine, glossy surface which diverts attention away from the painting's ostensible motif or object. Discussing his door paintings in relation to a British Art Show exhibition in 1990, Hume noted:

> I see them as unheroic. There is no essential core of meaning but they are meaningful through cognition and in relation to the synchronic state of art and society, whilst they remain an empty sign, a door motif in a potentially endless series – simultaneously spacious and oppressive.[101]

The ambiguity that situates Hume's paintings and that of the other practitioners briefly mentioned here has arisen precisely because of the cultural space that has opened up since the demise of a mainstream formalist Modernism. A post-conceptual generation of practitioners can variously index or suggest gestural or colour-field painting styles with a potentially open range of formal, contextual or highly idiomatic meanings and associations.

In the mid and later 1980s, oppositional late modern culture was principally associated with what the art historian Hal Foster has called 'anti-aesthetic' practices – photography, film, installation and text-based interventions. Whilst these media have since become mainstream within contemporary art, painting has regained both cultural relevance and legitimacy. Although no longer culturally privileged, neither is painting judged as an intrinsically conservative or reactionary aesthetic form. The rapprochement with the legacy of Modernism discussed here suggests reflexivity and confidence among recent and contemporary practitioners concerning abstract painting's ongoing standing, rather than defensiveness about its endgame status.

The possibility of recovering a marginalised tradition within Modernism for contemporary painting was central to the academic conference *Allegory, Repression and a Future for Modernism,* convened in London by Manchester Metropolitan University's Art and Media Arts Research Centre (2007). In the introductory address which discussed the 'virtual disappearance' of high Modernism in British practice, David Sweet noted:

> in a pluralist, contemporary visual art culture, an adapted type of modernism, one less tempted by hegemonic ambition, may have something important to add to our current range of critical strategies.[102]

The observation supports the tenor and sensibility of much of the practice surveyed here, suggesting that Modernist ideas continue to inform and mediate the direction and priorities of significant strands within recent and contemporary British painting.

One practitioner whose work has been emblematic of this rapprochement is Gerhard Richter, whose synthesis of the photographic and the painterly has been formative for a post-conceptual generation of British artists. Richter has described painting as a 'moral action' through which he has variously explored terrorism, memory and the conditions of cultural reproduction.[103] In his work, the 'aesthetic' dimension of painting has itself become a critical intervention and a point of cultural resistance. Richter's commitment to sustaining a discursive painting practice reflects the concerns of critical theory which, as Hal Foster suggests, has stood in as a tacit continuation of 'modernism by other means' after the defeat of radical politics in 1968 and the decline of abstract formalism. Like Richter, a range of contemporary painters remain receptive to the genre's hybridity; its implication within historical avant-garde gestures and its critical purchase within contemporary cultural theory.

Discussing the changed bases of these interactions, one commentator has suggested that the postmodern artist increasingly becomes 'a manipulator of signs and symbols ... and the viewer an active reader of messages rather than a passive contemplator of the aesthetic'.[104] In this context, Paul Wood and Charles Harrison have asked what an appropriate aesthetic for painting after formalist Modernism might be, and how might it be reconstructed? They conclude:

> The paradoxical precondition of that reconstruction has been a passage through the critique of authorship, through the implications of reproducibility, through, in short, the ruin of Modernism which Conceptual Art brought about.[105]

Regardless of high Modernism's demise, the durability of post-conceptual abstract painting suggests that its practitioners have been refashioning and redefining the medium with some of these earlier histories and aspirations in mind. For a post-1960s generation, such a 'reconstruction' of painting is not just an act of cultural archaeology or ritual nostalgia. Although conscious that painting is no longer a privileged medium, its practitioners continue to explore the genre's relationship to a constellation of interests. The characterisation of so much recent art practice and theory as symptomatic of the 'return of the real' suggests a recognition that genres such as painting are contributing to new cultural possibilities and more pluralist aesthetic directions.

Notes

1 Jon Thompson, 'Life after death: the new face of painting', in Ros Carter and Stephen Foster (eds), *New British Painting* (John Hansard Gallery, Southampton, 2004), p. 1.

2 Quoted by Gordon Burn, *Sex & Violence, Death & Silence: Encounters with Recent Art* (Faber & Faber, 2009), p. 395.

3 Sarah Kent (with Jenny Blyth), *Shark Infested Waters: The Saatchi Collection of British Art in the 1990s* (Zwemmer, 1994), p. 33.

4 Jaime Stapleton, text commentary on Juan Bolivar from *New British Painting* (John Hansard Gallery, 2004), p. 15.

5 Griselda Pollock and Alison Rowley, 'Painting in a "hybrid moment"', in Jonathan Harris (ed.), *Critical Perspectives on Contemporary Painting: Hybridity, Hegemony, Historicism* (Liverpool University Press and Tate Liverpool, 2003), p. 38.

6 Katharine Stout and Lizzie Carey-Thomas, *The Turner Prize and British Art* (Tate Publishing, 2007), pp. 101–7.

7 Adrian Searle, Preface to the exhibition guide, *Unbound: Possibilities in Painting*, designed by Herman Leslie (Hayward Gallery, 1994).

8 The observation was articulated in an interview with T. J. Clark, 'Greenberg on art criticism', recorded by the Open University for the art history course presentation A315, 1981.

9 Jon Thompson, 'Life after death: the new face of painting', in Carter and Foster, *New British Painting* (2004), p. 5.

10 'Clement Greenberg, 'The Decline of Cubism', quoted in Charles Harrison and Paul Wood (eds), *Art in Theory 1900–2000: An Anthology of Changing Ideas* (Blackwell, 2003), pp. 577–80.

11 Yve-Alain Bois, 'Painting: the task of mourning', in *Painting as Model* (MIT Press, 1993), p. 230.

12 Ibid., p. 231.

13 See for example Peter Watson's *Manet to Manhattan: The Rise of the Modern Art Market* (Vintage, 1993).

14 Terry Smith quoted in Frances Colpitt (ed.), *Abstract Art in the Late Twentieth Century* (Cambridge University Press, 2002), p. xviii.

15 Christos Joachimides, 'A New Spirit in Painting', in Christos Joachimides, Norman Rosenthal and Nicholas Serota (eds), *A New Spirit in Painting* (Royal Academy of Arts, 1981), p. 15.

16 Ibid., p. 12.

17 David Hopkins, *After Modern Art 1945–2000* (Oxford History of Art, 2000), p. 72.

18 Hal Foster, 'The expressive fallacy', in *Recodings: Art, Spectacle, Cultural Politics* (Bay Press, 1985), pp. 59–64.

19 Julian Stallabrass, 'Economics alone do not explain painting's revival', *The Art Newspaper*, No. 159 (June 2005), p. 35.

20 See for example Hopkins, *After Modern Art*, pp. 207–8.

21 David Green, 'Painting as Aporia', in Harris, *Critical Perspectives on Contemporary Painting*, p. 81.

22 Ibid., p. 83.

23 Jonathan Harris, 'Hybridity, hegemony, historicism', in *Critical*

Perspectives on Contemporary Painting, p. 33.

24 Adrian Searle, Preface to *Unbound. Possibilities in Painting* (exhibition guide, 1994).

25 Quoted by Brandon Taylor, *Art Today* (Laurence King, 2004), p. 75.

26 Jason Gaiger, *Aesthetics & Painting* (Continuum, 2008), p. 142.

27 Julian Stallabrass, *High Art Lite: British Art in the 1990s* (Verso, 1999) , p. 227.

28 Robert Young, *Postcolonialism: A Very Short Introduction* (Oxford University Press, 2003), p. 2.

29 See: Niru Ratnam, 'This is I', in Gavin Butt (ed.), *After Criticism: New Responses to Art and Performance* (Blackwell, 2005), pp. 66–7.

30 Rasheed Araeen, 'Postscript', in Steve Edwards (ed.), *Art and Its Histories: A Reader* (Yale University Press and Open University, 1999), pp. 264–6.

31 Homi Bhabha and Sutapa Biswas, 'The wrong story', *New Statesman*, 15 December 1989.

32 Chris Ofili quoted in Gary Younge, 'A bright new wave', *Guardian Weekend*, 16 January 2010.

33 Judith Nesbitt, 'Beginnings', in Judith Nesbitt (ed.), *Ofili* (Tate Publishing, 2010), p. 16.

34 Okwui Enwezor, 'The vexations and pleasures of colour: Chris Ofili's "Afromuses" and the dialectic of painting', in Nesbitt, *Ofili* (2010), p. 65.

35 Quoted by Bibi van der Zee, *Guardian*, 1 November 2003.

36 Martin Maloney, 'Everyone a winner! Selected British art from the Saatchi Collection 1987–97', in *Sensation: Young British Artists from the Saatchi Collection* (1997), p. 29.

37 Richard Dorment, review, *Daily Telegraph*, 20 September 2005.

38 Quoted by Judith Nesbitt, *Ofili*, p. 17.

39 Foreword by Joanna Drew and Catherine Lampert for the exhibition catalogue, *Art History: Artists Look at Contemporary Britain* (Hayward Gallery, 1987).

40 *Art History: Artists Look at Contemporary Britain*, p. 11.

41 Richard Cork, *Artists Look at Contemporary Britain*, preface, p. 5.

42 *Art History: Artists Look at Contemporary Britain*, pp. 16–17.

43 Ibid., p. 12.

44 Murdo Macdonald, *Scottish Art* (Thames & Hudson, 2000), pp. 209–10.

45 Email correspondence from Ken Currie to the author, 29 October 2009.

46 See: http://www.geraldlaing.com (accessed September 2008).

47 Arthur Danto, *The Wake of Art: Criticism, Philosophy and the Ends of Taste* (Routledge, 1998), pp. 115–28.

48 Mark Lawson, *Conflicts of Interest: John Keane* (Momentum, 1995), p. 18.

49 Ibid., p. 67.

50 Ibid., p. 69.

51 Ibid., p. 72.

52 Clement Greenberg, 'The Pasted-Paper Revolution' (1958), reprinted in Jason Gaiger and Paul Wood (eds), *Art of the Twentieth Century: A Reader* (Yale University Press and Open University, 2004), pp. 89–94.

53 Ibid., p. 93.

54 See Matthew Biro, 'Allegorical Modernism: Carl Einstein on Otto Dix', *Art Criticism*, vol. 15, no. 1 (2000), pp. 46–70.

55 Alice Coggins, 'Allegory, repression and a future for Modernism', reproduced at: http://www.miriad.mmu.ac.uk/ama/modernism/7-alice-coggins.php (accessed June 2008).

56 John Gray, 'The landscape of the body: Ballard, Bacon, and Saville', in *Saville* (Rizzoli International, 2005), p. 10.

57 Jenny Saville interviewed by David Sylvester, reproduced in *Saville*, p. 14.

58 Saville interviewed by Simon Schama, reproduced in *Saville*, p. 126.

59 I would like to acknowledge several conversations with Peter McMaster (PhD candidate), University of Kent, on the subject of Fuller's thinking, 2008–09.

60 Jean Baudrillard, *Simulacra and Simulation*, trans. S. F. Glaser (University of Michigan, 1994), p. 6.

61 Quoted by Helen Luckett in Alex Farquharson and Andrea Schlieker (eds), *British Art Show 6* (Hayward Gallery Touring Exhibition, 2006), p. 136.

62 Interview by Alice Jones, 'Undercover', *Independent*, 14 June 2007.

63 Nigel Cooke in discussion with Ingvild and Stephan Goetz, April 2005, in Suhail Malik and Darien Leader, *Nigel Cooke: Paintings 01–06* (Buchhandlung, Walter Konig, 2006), pp. 5–6.

64 Darian Leader, 'The Information', in *Nigel Cooke Paintings* (2006), p. 35.

65 Nigel Cooke in discussion with Ingvild and Stephan Goetz, *Nigel Cooke Paintings*, p. 9.

66 Gallery notes to *New Accursed Art Club*, Stuart Shave/Modern Art, April–May 2008.

67 Interview with Chris Arnot, *Guardian*, 13 August 2003.

68 Chris Townsend, *New Art from London* (Thames & Hudson, 2006), p. 104.

69 Interview for Channel 4 *The Art Show*: http://www.channel4.com/culture/microsites/A/art_show/george_shaw (accessed December 2009).

70 Interview with Chris Arnot, *Guardian*, 13 August 2003.

71 Peter Fuller, *Theoria, Art, and the Absence of Grace* (Chatto & Windus, 1988), pp. 3–4.

72 Charles Thomson, 'A Stuckist on Stuckism', in *The Stuckists Punk Victorian* (exhibition catalogue), Frank Milner, National Museums and Galleries on Merseyside, 2004), p. 7.

73 See 'Remodernism: towards a new spirituality in art' in Katherine Evans, *The Stuckists: The First Remodernist Art Group* (Victoria Press, 2001), pp. 6, 10.

74 Billy Childish and Charles Thomson quoted in Evans, *The Stuckists*, p. 13.

75 *A New Spirit in Painting*, p. 11.

76 Childish quoted in Evans, *The Stuckists*, p. 34.

77 Quoted in *The Stuckists Punk Victorian* (2004), p. 50.

78 Evans, *The Stuckists*, p. 39.

79 Paul O'Keeffe, 'Manifestoes from the edge and beyond', in *The Stuckists Punk Victorian* (2004), p. 37.

80 W. Gordon Smith, *Fallen Angels* (Pavilion,1999), p. 6.

81 Duncan Macmillan's review of the exhibition 'A Dance with Fate', *The Scotsman*, 22 August 1995.

82 Interview with the author, 21 September 2007.

83 Interview with the author, 21 September 2007.

84 Greenberg expressed the preference in a video interview recorded with T. J. Clark in 1981 for the Open University. The material was later used for the course presentation Modern Art and Modernism (A315).

85 Polly Staple, 'The finishing touch', *Frieze 64*, January–February 2002. See: http://www.frieze.com/issue/article/the_finishing_touch (accessed November 2009).

86 Ben Tufnell, Entry on Gillian Carnegie, in Judith Nesbitt and Jonathan Watkins (eds), *Days Like These. Tate Triennial Exhibition of Contemporary British Art* (Tate Publishing, 2003), p. 48.

87 Quoted in Suzanne Cotter, 'Seeing double', in Suzanne Cotter and Caoimhín Mac Giolla Léith, *Cecily Brown, Paintings* (Museum of Modern Art, 2005), p. 41.

88 Jeff Fleming, 'Cecily Brown: living pictures', in *Cecily Brown* (Des Moines Art Center, 2006), pp. 48–9.

89 Quoted by Louisa Buck, *The Art Newspaper*, No. 159 (June 2005).

90 Quoted by Suzanne Cotter in 'Seeing double', p. 42.

91 Linda Nochlin, 'Cecily Brown: the erotics of touch', in *Cecily Brown* (2006), p. 55.

92 Louisa Buck, *Moving Targets: A User's Guide to British Art Now* (Tate Publishing, 1997), p. 58.

93 Sarah Kent, *Shark Infested Waters*, p. 79.

94 Jonathan Harris, *Critical Perspectives on Contemporary Painting*, p. 18.

95 Angus Pryor interview with the author, 10 June 2008.

96 Artist's statement to the author, 11 July 2008.

97 Ibid.

98 Ibid.

99 Quoted in *New Art Up-Close 1: Gary Hume*, interviewed by Dave Barrett (Royal Jelly Factory, 2004), p. 41.

100 Quoted by Thomas Lawson, 'Gary Hume: modern painting', in *Gary Hume Door Paintings* (catalogue, Oxford Museum of Modern Art, 2008), p. 6.

101 Gary Hume, quoted in *The British Art Show*, 1990 (South Bank Centre, 1990), p. 66.

102 David Sweet, Introductory address, *Allegory, Repression and a Future for Modernism*, 2007. See: http://www.miriad.mmu.ac.uk/ama/ modernism/3-david-sweet.php (accessed June 2008).

103 Quoted from Van Bruggen in Paul Wood, Francis Frascina, Jonathan Harris and Charles Harrison (eds), *Modernism in Dispute: Art Since the Forties* (Yale University Press, 1993), p. 254.

104 Hal Foster, *Recodings: Art, Spectacle, Cultural Politics* (Bay Press, 1985), pp. 99–100.

105 Paul Wood and Charles Harrison, 'Modernity and Modernism reconsidered', in *Modernism in Dispute: Art Since the Forties*, p. 254.

Installation Art and Sculpture as Institutional Paradigms

Introduction

Art is a state of encounter.

(Nicolas Bourriaud, 2002)[1]

In 2007, Turner Prize-winning British sculptor Anthony Gormley completed a major installation project. *Event Horizon* comprised thirty-one lifesize iron casts of the artist's body, variously sited on rooftops, bridges and pavements across central London. Sometimes seen, but often beyond immediate sightlines, *Event Horizon* melded with the city's urban fabric, incorporating the built environment as a site of navigable aesthetic spectacle. Widely covered in the various art journals and the national press, *Event Horizon* confirmed the high public profile and ubiquity of installation practice within recent British art. It also underlined the increasingly fluid interaction between sculpture and the comparatively recent genre of installation art.

Over the past two decades, the YBAs – the Goldsmiths College-dominated generation of artists who graduated in the late 1980s – have played a major role in the mainstreaming and institutionalisation of British installation art and related assemblage-based practice. A roll call of those who established their professional careers primarily in these areas would include names such as Jake and Dinos Chapman, Tracey Emin, Angus Fairhurst, Anya Gallaccio, Liam Gillick, Damien Hirst, Michael Landy, Sarah Lucas, Cornelia Parker, Marc Quinn, Gavin Turk, Mark Wallinger and Rachel Whiteread. Julian Opie, an earlier Goldsmiths College graduate, had been exploring installation and sculpture since the early 1980s, as had his near contemporary, Richard Wilson.

Work produced by the conceptual artist Helen Chadwick (1953–1996) looked both back to the performance practice of the 1950s and 1960s and forward to the object-based work of the YBAs. In *Piss Flowers* (1991–92), Chadwick cast bronze sculptures made by the cavities left after urinating in snow. The combination of traditional materials with new concepts, ideas and contexts has defined installation and a wide-range of assemblage-based

practice. Throughout the 1990s and the first decade of the new millennium, a younger generation of post-conceptual British artists have also turned to installation (often in conjunction with other practices and genres), to situate changing concerns, directions and priorities.

As mentioned in Chapter 1, the recession of the early 1990s resulted in widespread gallery closures and the retrenchment of much of the UK's visual arts infrastructure. The sometimes improvised materials and flexible methods of working typically associated with installation art, and to a lesser extent film making and performance practice, offered pragmatic options for a new generation of fine art graduates looking to develop and curate their art practice during the economic downturn. Clearly demarcated from the expressive character of figurative and abstract painting, installation had the advantage of a backward glance to a nascent postmodern tradition and the ready-mades of Marcel Duchamp, Meret Oppenheim and Kurt Schwitters: it was also suited to what became an abundance of large post-industrial warehouse and dock spaces which the decline of the UK's manufacturing and heavy industries was making available in some of the country's major conurbations – Birmingham, Glasgow, London, Liverpool and Newcastle.

As the art historian and critic Julian Stallabrass has noted, the cultural fashion for installation art has rested on the perception of two particular advantages relative to more traditional genres. The tendency towards scale and spectacle has enabled installation art to compete with the attractions of contemporary consumer culture; its audience is presented with a more tangible and immediate experience than offered by television or DVD. Second, with larger site-specific, commissioned projects, the audience is compelled to attend the venue or gallery to see in situ installations.[2] These twin pressures have encouraged a fashion for installations and object-based making which combine the blandishments of consumer culture and entertainment with the look and finish of Minimalist high art. In recent decades both genres have developed in highly interactive and discursive directions, foregrounding an open dynamic between object, viewer and space; its practitioners adapting their practice to explore signature styles of presentation, subject matter and to question curatorial convention.

Some examples illustrate the expansiveness and range of approach: Anya Gallaccio and Cornelia Parker have crafted work exploring mutability, transience and decay. Sarah Lucas has adapted the subject matter and idiom of mass culture to make trenchant interventions concerning gender and the cultural politics of identity. Sue Noble and Tim Webster have fashioned a grunge aesthetic using rubbish to create playful and imaginative silhouettes, while David Batchelor, known for his intense exploration of colour, has referenced both sculpture and installation-based formats for his 'glowing electric towers' which explore the garish and 'unnatural' hues of a corporate postmodernity.[3] Mike Nelson has created immersive scenarios

which disorientate and defamiliarise the viewing experience. Liam Gillick has undertaken wide-ranging interventions and investigations, including explorations of the social, bureaucratic and corporate structures of an increasingly administered society. Yinka Shonibare has composed intricate tableaux referencing historical realities of race, class and identity, while Mona Hatoum has tackled contemporary diasporas using constructions and assemblages of wire and light which reference the politics of confinement and containment.

The institutional acceptance of installation practice is most apparent in its explicit incorporation as spectacle in some of the world's high-profile exhibition spaces such as the Tate Modern's Turbine Hall and Bilbao's Guggenheim. Major work by international practitioners such as Louise Bourgeois, Carsten Höller, Anish Kapoor and Olafur Oliasson confirm a tendency towards scale, matched by corporate largesse and investment. Describing these shifts in status and recognition, the art historian Julie Reiss has characterised installation's recent progress as one of travel from the 'margins to the centre'.[4]

Installations and installation art

What do we mean by installation art? The term 'installation' can refer to the hang or arrangement of art within a gallery or exhibition space. Understood like this, it refers to a range of curatorial, aesthetic and practical decisions integral to the presentation and viewing of art. For example, Modernism made fashionable the tendency for 'white cube' displays, especially prevalent since the 1950s and 1960s. Paintings (and identified examples of Modernist sculpture), were conventionally arranged in single-line hangs or placements against well-lit neutral or white backgrounds with plenty of surrounding space, a mode of display which has more or less remained the default option for exhibiting art work in galleries ever since.

But installation also has a more definite meaning as a specific genre of art practice, often with particular assumptions about the viewing audience and the contexts of display. Understood as a specific category of art, installation practice is described by art historian Claire Bishop as that which 'addresses the viewer directly as a literal presence in the space'.[5] It presupposes an 'embodied' and active encounter with the audience rather than the spatially determined and fixed viewing frequently associated with abstract or figurative painting. Since the early 1990s, the term 'installation art' has increasingly been used to describe fluid inter-relationships between objects, viewers, and the spaces or contexts of display.[6] Installation art is not always medium or location specific, attributes which make it seem amorphous. Discussing some of the ambiguities surrounding its definition, the art historian Jonathan Harris defines the genre as:

artefacts commissioned and designed to be located within a particular indoor or exterior place or space ... and intended to generate their meanings and value from their relationship to – as part of – the chosen environment.[7]

Apparent from these characterisations is the extent to which installation as a curatorial and presentational process may blend into installation understood as a categorisation of particular art practices, objects and intentions. Other commentators, noting the genre's origins in the ready-made tradition of Duchamp and others, suggest that attempting a concise definition of the category contradicts what installation is actually all about. For example, despite its having become so mainstream and popular, some artists have used installation practice to articulate ideas and viewpoints that question its incorporation or complicity with art galleries and museums. One example of which was Michael Landy's hybrid performance/installation work *Break Down* (2001) (Figure 3.1), discussed later in this chapter. Paradoxically, the enabling conditions and guarantors of the genre's viability within and beyond the gallery also provide the basis for critique and subversion.

Site-specific and non-site-specific installations

Installations are usually described as site-specific or non-site-specific; either temporary or permanent. If site-specific, the installation will have been planned and executed with particular reference to the architectural or spatial environment in which it has been designed to be exhibited. Consider for example *Marsyas* (2002) by Anish Kapoor (b. 1954), the third in a series of sponsored works for the Tate Modern's Turbine Hall. According to Greek mythology, Marsyas, a very skilful flute player and one of the followers of Bacchus, was flayed alive by Apollo, one of the twelve gods of Olympus, for his presumption in attempting to rival the musical accomplishments of the deity.[8]

Marsyas is 155 metres in length and 35 metres in height, its architecturally sized scale a deliberate match to the cavernous interior of the Tate Modern's Turbine Hall. Constructed using three steel rings joined with a single span of red PVC which the artist has described as akin to a 'flayed skin', the installation enabled the viewer to experience the work in its entirety, either from the gallery's ground floor space or from the balconies on the subsequent gallery levels. The location of *Marsyas* within its designated exhibition space is integral to our response; its placement, scale and colour are metaphors for the hubris and fate of its mythological subject.

But installation art's status as site- or non-site-specific can be qualified. Richard Wilson's (b. 1953) *20:50* (1987) is a mixed-media work comprising 200 gallons of used sump oil and is of variable dimensions. (Figure 3.2). It is probably the most immediately recognisable and iconic example of

Figure 3.1 Michael Landy, *Break Down*, 2001. Commissioned and produced by Artangel. Photo © Hugo Glendinning.

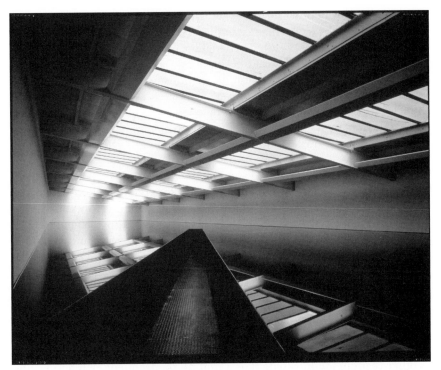

Figure 3.2 Richard Wilson, *20:50*, 1987. Used sump oil, steel dimensions variable. Courtesy of The Saatchi Gallery, London. © Richard Wilson, 2009.

British installation art, the exhibition of which brought Wilson international acclaim. The title of *20:50* refers to engine oil's standard viscosity, the reflective qualities of which prevents light from penetrating its seamless liquid skin surface. In what seems an elaborate ritual, spectators are relieved of any bags before walking out along a diagonal and tapering metal jetty. With sides around a metre high, the spectator is brought close to the surface tension of the surrounding expanse of thick oil which is contained by a metallic tank. Of unspecified depth, the oil is completely reflective of whatever space or interior contains it. The pungent smell of petroleum gives *20:50* its visceral and physically enveloping quality which, like the spectacle of its installation itself, remains with the viewer.

Wilson has suggested that the idea for *20:50*'s format arose from the experience of casting aluminium for a previous gallery-based installation and from noticing the 'horizontal plane' of a swimming pool while holidaying in the Algarve:

> I wanted to define a plane in the gallery just as the water defined a plane in the pool, to use liquid to describe the horizontal within an architectural space.[9]

A drum of oil which Wilson had kept in his studio for annealing steel provided the final part of the design plan. Several of his installations (such as *Slice of Reality* (2000) – a 20 metre high cross-section of a 700 tonne sand dredger placed on six piles and permanently set on the Thames riverbed near the Millennium Dome, London), demonstrate an interest in Britain's industrialised past and the decline of associated skills and trades.[10] With these examples, Wilson has adapted the techniques of welding, excavation, recomposition and the effects of gravity to a highly experimental and innovative range of installation practice. Discussing *20:50* as a 'conceptual installation', he notes:

> *20:50* is essentially an idea. It can be applied to any internal space and in each space it will be radically different in appearance – because it will reflect that specific space and adapt to that space's physical parameters – but fundamentally on the level of function, materials and meaning, it's always exactly the same.[11]

Some critics have read the use of oil in *20:50* as an oblique reference to industrial stasis and the passing or effects of deep geological time – installation as a commentary on entropic breakdown. This association has prompted the critic Andrew Graham-Dixon to describe *20:50* as a 'work of art of and for the late twentieth century. Its beauty is elegaic'.[12] Equally, another reading might situate it as a pun on the frequent characterisation of late modern art as 'depthless' – an aesthetic which is based on surface, exteriority and the idea of the copy.

Originally commissioned and designed for Matt's Gallery in East London, *20:50* was acquired for Charles Saatchi's art collection and then displayed in the *Art of Our Time* exhibition at the Royal Scottish Academy, Edinburgh (1987). It was subsequently installed and exhibited in the Saatchi Gallery at Boundary Road, North London, before being moved to interim premises at London's County Hall in 2003. Although technically another example of a site-specific installation, and originally made as a gallery commission, it is debateable whether this still applies. The dimensions of *20:50* have changed to frame variations in available exhibition and display space within different gallery locations – adaptations which underline its inherent flexibility and more generally, the responsiveness of installation as a genre to location and context.

With this in mind, we might suggest additional terms to describe examples of installation and assemblage. In addition to the idea of site specificity (where work is intended for a given venue which cannot be relocated), the American installation artist Robert Irwin has made distinctions between practice that is site determined – a response to a site; site-dominant, for work fashioned in the studio without a final destination or placement decided; or site adjusted – 'work commissioned for a particular situation

but relocatable'.[13] In the light of these characterisations, we might understand Wilson's *20:50* as an example of practice that is site adjusted – originally intended for Matt's Gallery, but with a subsequent display history determined by the location(s) of the Saatchi art collection. Such flexibility has prompted Simon Morrissey's description of Wilson's aesthetic as one of 'continuous physical reconfiguration'. He continues:

> it is a tangible and intense re-negotiation of the built environment ... an exploration of possibility, but one that Wilson bases on the contingency of the materials that surround us, in a highly concrete form of conjecture.[14]

The extent to which the intended placement or immediate context can determine an installation's aesthetic and physiological effect is evident if you compare two frequently reproduced photographs of *20:50*; one in the 'white cube' space of either the former Saatchi Gallery in Boundary Road or Matt's Gallery (reproduced here), and the other taken in the ornate oak-panelled Edwardian interior of London's former County Hall offices which Saatchi opened as a gallery to the public in 2003. The spare, minimal interior of a 'white cube' gallery space is a dramatic foil to the sump oil's reflective density and the angled metal jetty which gives the installation a sharply delineated appearance. In the various County Hall photographs, the sheen and expanse of *20:50* appears to be displaced by the light wood panelling, interior veneers and the 'fussiness' of office space designed for the Edwardian era. The overall effect is less one of disorientation than of distraction; the sense of stark perspective and depth are reduced, with the reflected interior panelled space tending to integrate *20:50* with its immediate environment.

Installation, objecthood and active spectatorship

From a brief exploration of some of these initial examples, we might understand installation art as a genre that operates around and between various registers of engagement: visual and perceptual, physical and tactile, emotional and affective. In doing so, it solicits a dynamic and active response from the spectator. With Kapoor's *Marsyas*, this is determined by an encounter with the sheer scale and visual ambition of the piece; with Wilson's *20:50*, the viewer may experience a tangible sense of vertigo and dislocation.

Both these examples of installation practice project an entirely different kind of objecthood or physical presence when compared with the relative flatness of a wall-hung painting or print. Installations and assemblages like these literally displace and decentre the viewer spatially and physically; time is needed to interact and to respond to the object. Typically when viewing a

painting, we are prepositioned, either by the hang of the work against the wall (perhaps one of a series in a single line display), or, more subtly, by size and pictorial format (landscape or portrait), or perhaps by the internal composition and handling of the medium which may dictate particular viewing angles or distances.

Although these differences may seem self-evident, their implications have influenced important theoretical debates and exchanges between artists, critics and theorists which have continued to inform more recent practice, principally in relation to sculpture and installation, but also film and performance. In the summer of 1967 'Art and Objecthood', an essay by the Modernist art critic and theorist Michael Fried (b. 1939), was published in a special issue of the art journal *Artforum* concerned with American sculpture. According to Fried, conceptually based work produced by Minimalist (or 'literalist') artists such as Donald Judd and Robert Morris required forms of response and engagement which he judged to be fundamentally different from and inferior to those prompted by abstract Modernist paintings. The various configurations of Minimalist installations and sculpture required that they be viewed in the round, prompting an encounter which, according to Fried, was 'theatrical' and based on duration.[15]

According to this interpretation, the orchestrated physicality of Minimalist sculpture and assemblages encouraged a cumulative response since the spectator was required to move around and to explore the object from multiple viewpoints. Fried believed that work of this kind corrupted aesthetic sensibility since it engendered a staged and inauthentic encounter. By contrast, the relative two-dimensionality and composition of abstract Modernist painting encouraged an immediate response which suspended the sense of both objecthood and duration; the encounter, so it was argued, was intuitive and involuntary – the image (and its aesthetic effect) was immediately registered in a single glance and moment. What should have been an instantaneous and immediate optical 'presentness' which Fried observed in responding to the best Modernist paintings, became in response to Minimalist objects a staged and 'theatrical' search for transient and increasingly self-conscious effect. Fried famously concluded his essay with the assertion:

> In these last sentences, however, I want to call attention to the utter pervasiveness – the virtual universality – of the sensibility or mode of being that I have characterized as corrupted or perverted by theatre. We are all literalists most of our lives. Presentness is grace.[16]

Fried's essay was based on a Modernist conviction that certain forms of art – typically flat, abstract, colour field paintings – engendered a qualitative aesthetic response arising from the fact and effect of their opticality. The three-dimensional 'objecthood' of conceptually based Minimalist sculpture

and installations he regarded as both diminished and, ultimately, diminishing of the spectator. For Fried's critics, these ideas represented an unspecific transcendentalism at odds with the materiality and direction of their own practice, much of which heralded a far more participative and open-ended interaction with the spectator and the various contexts of display.[17]

According to Minimalist practitioners like Carl Andre, Judd and Morris, it was this dynamic which made the category of installation art 'active' and the spectator's response to it embodied, rather than a purely instantaneous optical experience. These distinctions were not just about different forms of art, but more fundamentally concerned the nature of aesthetic experience – how we respond to what we encounter. Also relevant to these debates were ideas and theories associated with continental philosophy which were then being translated and made available in the English-speaking world for the first time.

Phenomenology and installation art

Maurice Merleau-Ponty (1908–1961) was a French philosopher whose work revised theories of perception at a time when neo-Marxist interpretations of knowledge and society remained influential. The English translation of Merleau-Ponty's *The Phenomenology of Perception*, initially published in 1945, appeared in 1962. Its arguments became influential on debates concerning perception and attempts to understand the relationship between the human as subject and phenomena in the world – the things we see and experience. Merleau-Ponty believed that both subject and object were integrally related, or as he put it:

> the thing is inseparable from a person perceiving it, and can never be actually in itself because it stands at the other end of our gaze or at the terminus of a sensory exploration which invests it with humanity.[18]

If perception is accepted as 'embodied' it follows that our response to phenomena and objects has an experiential and cumulative dimension. In other words, the encounter with art objects, and the response to them, is mediated through all of our senses, rather than just through sight or optical sensation.

The repercussions of these ideas and the central principle of embodied perception provided the context to the Fried debate, and were initially embraced by a range of conceptual artists involved in making installation and performance-based art from the mid and later 1960s onwards.[19] As Modernist painting lost its dominant status throughout Europe and North America, these ideas increasingly became part of mainstream critical thinking about conceptual art practice and responses to it. In the decade that followed, perspectives associated with poststructuralism, gender theory,

psychoanalysis and social anthropology questioned conventional assumptions concerning a centred and unitary human identity, developments which refined and revised the phenomenological ideas already being applied to cultural practice.

Although these debates predate the examples of installation practice explored here, they provide a context and hinterland which remain relevant to the genre and to some of the tacit assumptions made by its practitioners. In particular, the discursive interaction between viewer, space and installation or assemblage remains a key concern for artists and curators.

Installation art, praxis and relational aesthetics

More recent studies have explored various forms of installation practice and how these in turn encourage different kinds of spectator response. Claire Bishop's influential account, *Installation Art: A Critical History* (2005), considers the genre's history and diversity by characterising distinct types of aesthetic experience offered to the embodied subject by and through installation practice. Bishop categorises four main kinds of viewer experience which, although not mutually exclusive or exhaustive, provides a useful starting point for identification and comparison:

- a dream-like encounter in which the viewing subject is immersed; the installation providing a total environment in which disbelief is temporarily suspended
- examples that explore the apparent disintegration of the subject, adapting the psychoanalytic idea of 'thanatos' or the death drive
- installations which accent bodily experience and response
- examples that situate and address the viewer as a politicised subject.[20]

Implicit in these debates and in much of the installation art undertaken more recently are two further principles which Bishop refers to as 'decentring' and 'activation'. The latter refers to the expectation of movement in and around the installation, rather than just stationary contemplation: the encounter encourages a state of 'heightened awareness':

> This activation is, moreover, regarded as emancipatory, since it is analogous to the viewer's engagement in the world. A transitive relationship therefore comes to be implied between 'activated spectatorship' and active engagement in the social-political arena.[21]

The idea of the 'decentred subject' builds upon phenomenological, psychoanalytical and poststructuralist perspectives which understand the human subject (and psyche) as complex, evolving and unstable. This is in contradiction to the conventional Enlightenment view of the mind and

body as a fixed duality. As Bishop notes of the human psyche, it might be understood as: 'fragmented, multiple and decentred – by unconscious desires and anxieties, by an interdependent and differential relationship to the world, or by pre-existing social structures'.[22] The embodied and highly individualised character of human identity that these terms suggest underlines the extreme subjectivity – and instability – of response that the various categories of installation, and the location of their presentation, attempt to elicit.

The apparent attributes shared by recent examples of installation (and performance) art have also prompted broader characterisations of the increasingly participative and proximate character of art practice, particularly since the onset of the 1990s. In two books, *Postproduction* (2007) and *Relational Aesthetics* (2002), the curator and art theorist Nicolas Bourriaud has explored the phenomenological character to forms of art within post-industrial society. In *Relational Aesthetics,* he identifies discursiveness as among its distinct attributes:

> The artwork of the 1990s turns the beholder into a neighbour, a direct interlocutor. It is precisely the attitude of this generation toward communications that makes it possible to define it in relation to previous generations.[23]

Bourriaud has described the 'reification' of human relationships as one of the central features of post-industrial society; interactions between people become impersonal, controlled and functional. By contrast, the 'relational' character of installation, assemblage and performance genres is understood to offer the prospect through which meaning might be more collectively and consensually negotiated. For Bourriaud such interactions are an unqualified good.

As mentioned earlier, this discursiveness contradicts earlier forms of Modernist art (typically painting), in which meaning was conventionally situated within an independent and 'private symbolic space', dictated by the nature of the medium and the 'white cube' context in which such art was displayed and encountered. Bourriaud is optimistic that relational forms of recent and contemporary art practice, like installation, might offer an arena for social experiment or 'hands-on utopias', otherwise absent within an increasingly centralised and administered culture. Although he accepts that art has always been relational to varying degrees, it is installation art's 'unfinished discursiveness' which ultimately links it to the broader and ongoing project of cultural politics and human emancipation.[24]

But other commentators remain more sceptical. Some question whether relational art forms like installation or performance can offer anything approaching practical or workable paradigms of enhanced social or political emancipation. Bishop, for example, has suggested that practice that appeals

to group consensus can actually misrepresent what is in reality a fractured and more complex human subjectivity. According to this viewpoint, the most authentic relationship that emerges through relational practice is that of 'antagonism' and disagreement, interactions which take place within discursive cultural spaces which enable them to happen.[25] The relational character of art which Bourriaud identifies is not new. The earlier avant-garde movements such as Dada, Constructivism and Surrealism adopted forms of installation and performance practice which often asserted highly critical and oppositional explorations of social values and ideas, approaches more congruent with Bishop's reading of relational practice.

The legacy of some of these earlier avant-gardes in relation to forms of social and political engagement has been considered by earlier art historians. Although not primarily concerned with installation art, Peter Bürger's essay *Theory of the Avant-Garde* (1974) addressed those movements in which the forms of assemblage, installation and performance were widely employed. According to Bürger, earlier 'historical avant-gardes' such as Dada and Surrealism were distinctive because they attempted to combine art with the 'praxis' of life – art engaging with, or responding to, issues and events outside the studio. With this in mind, he uses the term the 'neo-avant-garde' to identify and differentiate some of the art practices of the 1960s and 1970s from the earlier explorations undertaken by Dada, Surrealism and Constructivism. For Bürger, this latter incarnation of radical politics through art practice was ineffectual, largely serving to repeat the failed strategies of the 1930s which had been either censored or co-opted by totalitarian regimes for their own use.[26]

Since Bürger's essay, contemporary politics and associated institutions (both in the United Kingdom and globally) have faced widespread scepticism, underlined more recently by the economic instability brought about by free market capitalism. Equally, the perceived failure of the mass ideologies of socialism and communism which provided the basis for Jean-François Lyotard's influential book *The Postmodern Condition: A Report on Knowledge* (1979) suggests that such attitudes have a broader and more pervasive historic basis. Bourriaud's formulation that relational art has the potential for positive social and political effects underlines a point of connection with these earlier movements and explorations, although both contexts are clearly very different. Of particular relevance here, however, is the extent to which relational practice privileges genres like installation and performance which accent communication, discursiveness and audience engagement.

The debates and ideas briefly sketched here are just part of a much broader intellectual and theoretical landscape to installation art undertaken by a post-conceptual generation. What then of installation undertaken in recent decades within the United Kingdom? As John Welchman has noted, the genre's apparent re-emergence in the early 1990s actually masked the

absence of more widespread social or politically engaged aesthetic practices, concerns which had been more appreciable with the photographic and video-based work of the previous decade.[27] The profile and commercial success achieved by several of the YBAs was principally in relation to installation, sculpture and assemblage, practices more suited to what had become a robust market in contemporary art throughout the 1990s and the initial years of the new millennium.

Bishop's characterisation of installation art relates principally to the tangible effects of different examples and how these solicit particular responses and forms of engagement. Her study, with some exceptions, applied these categories to examples of installation practice dating from the 1960s and 1970s, although more recent instances also spanned the 1980s and 1990s, with pieces by internationally known European, Russian, North American and Latin American artists. The sections that follow discuss possible examples that might be identified in relation to some of these categories by British or UK-based artists. Of course, forms of response are not fixed or prescriptive, but often porous – an installation might register various effects or it might engage a spectrum of responses which might differ from one activated spectator to another. In some cases, where a particular installation might be placed is a matter of subjective judgement. However, these categories offer a useful and suggestive framework through which comparisons and connections (including to other genres such a film and performance), might be explored and discussed.

Installation practice as a dream-like encounter

The first category suggests a viewing experience analogous to the cumulative sensation and reconstruction of a dream. Our disbelief is suspended through the immediacy of what is perceived, its composite structure encourages the use of free association to relive and make sense of the experience. For Bishop, the paradigms for this kind of practice are the sometimes labyrinthine 'total' installations (and narratives) associated with the Russian artist Ilya Kabakov (b. 1933). Also symptomatic of this kind of experience is the capacity for 'psychological absorption' – we can be submerged and engaged by exposure to the installation as with a film, book or dream.[28]

Other examples include work by Mike Nelson (b. 1967), who with *The Coral Reef* (2000) created a total installation space, comprising a series of corridors, rooms, evocations of shabby minicab office interiors, garages and other functional, pared-down spaces which hinted at the lives and lifestyles of their absent inhabitants. Jodie Carey's (b. 1981) *In the Eyes of Others* (2009) is a labyrinthine installation, illuminated (just) by subdued lighting. Walking between piles of newspapers and cardboard boxes, the spectator negotiates a path through to the installation's centre, in the middle of which are suspended three large, elaborate chandeliers. Each chandelier, comprising brilliant

white concentric, circular tiers and swags, weighs over one tonne and is formed of 9,000 pieces of plaster made from the casts of human bones.

The dream sequence associations of installation (and their Freudian context) form an explicit register in work by the partnership of Tim Noble (b. 1966) and Sue Webster (b. 1967). Since they first came to prominence in the early 1990s, Noble and Webster have used the fact of their artistic partnership and collaboration as a distinctive aspect of their installation practice. In *Dirty White Trash (with Gulls)* (1998), a pile of household rubbish was backlit, cleverly projecting the pair's detailed facial profiles against the wall of the white cube gallery space. In *A Pair of Dirty Fucking Rats* (2005), the idea was adapted, this time projecting a silhouette of copulating rats, an illusion generated by a grungy, backlit assemblage of cigarette packets, wire, tea bags, screws, razors and glue.

In two subsequent installation works, Noble and Webster returned to the Freudian psychoanalytic tradition both literally and symbolically. *Black Narcissus* (2006) and *Scarlet* (2006) were two site-specific installations produced for the Freud Museum, in commemoration of celebrations to mark the 150th anniversary of the psychoanalyst's birth. The exhibition's title, *Polymorphous Perverse,* arose from Freud's characterisation of infant sexuality as amoral and clinically perverse, orientations later suppressed by socialisation and education.

Black Narcissus (2006) is made from rubber, wood and black silicone rubber casts of Webster's fingers and Noble's penis in 'various states of arousal'.[29] (Figure 3.3). Strategically placed and positioned on a plinth in Freud's study, *Black Narcissus* makes a silhouette of the artists' facial profiles adjacent to the psychoanalyst's carved bust. The title of *Black Narcissus* suggests a possible reference to Rumer Godden's book (1939) and the subsequent Powell and Pressburger film (1947) which explored temptation, psychological breakdown and its consequences within a remote Himalayan convent. Although the work's plinth and its figurative dimension give the work a formality and verticality associated with more traditional forms of sculpture, the relational context of Freud's study and the projected silhouette against his portrait bust ensures that it is only fully intelligible as a site-specific installation in its present location.

Black Narcissus registers on various literal and symbolic levels. The projected silhouette and the immediate environment of Freud's library suggests a physical and aesthetic inscription, referencing the legacy of Freudian and post-Freudian paradigms on art theory and practice. More immediately, the scatological subject matter identifies abjection and ambivalence, explored later in this section with sculpture and in relation to performance art in Chapter 4. *Black Narcissus* might also be said to objectify the externalisation or displacement of otherwise sublimated drives and desires, conventionally according to Freud through social and cultural pursuits such as art, music and literature. As the Marxist art theorist Terry Eagleton suggests of the

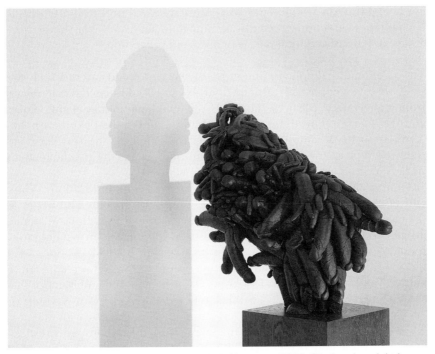

Figure 3.3 Tim Noble & Sue Webster, *Black Narcissus*, 2006. Black poly-sulphide rubber, wood, light projector. Sculpture dimensions: 38 x 72 x 60 cm. Plinth dimensions: 30.5 x 30.5 x 91.5 cm. © Tim Noble and Sue Webster. Image courtesy of the artists.

psychoanalyst's theory of culture as sublimation, 'men and women go from toying with their faeces to tinkering with trombones'.[30]

The installation can also be interpreted more broadly as emblematic of the psychoanalytic 'dissolution' of the human subject as conventionally understood. As such it directly situates the embodied character of human experience noted earlier. A product of the European Enlightenment, humanist philosophy understood human subjecthood principally as a duality of mind and body. Freud's contribution and that of subsequent psychoanalytic enquiry and critical thinking have been to see identity as more complex and frequently less rational or stable, suggesting human psyches that are subject to competing and conflicting 'drives', motivations and impulses.

Noble and Webster's accompanying exhibited piece, *Scarlet* (2006), was a multimedia installation based around the artists' actual studio workbench. Workshop tools – clamps, pliers, mallets and scalpels – compete for space with less typical objects – fornicating dolls, eviscerating motor-operated saws and partial bird carcasses. Referencing a 'cornucopia of Freudian references', the exhibition text describes:

a nightmarish wonderland of repressed sexual and sadomasochistic fantasies and transgressions ... innocent children's playthings have been bastardized into objects of apparent perversion.[31]

The relational or implied context for *Scarlet* was Freud's desk which was similarly covered, but with antique figurines and accumulated fetish objects from non-western cultures. Through this emblematic miscellany, Noble and Webster referenced the conceptual hinterland to their exhibition, but in order to make some of these connections explicit, the spectator was required to navigate the Freud Museum and to see the psychoanalyst's preserved studio and library.

Appropriately, given the theme and location of both installations, *Scarlet* and *Black Narcissus* objectified otherwise sublimated appetite and desire as the unstable outcomes of drives and impulse. *Scarlet's* iconography of animal evisceration implied sadistic and masochistic fantasy. In iconography reminiscent of work by Jake and Dinos Chapman, both installations used metaphor and adapted their surrounding space and context to create fugitive and provocative associations. Discussing the instability and ambivalence that locates much of their practice, Noble has noted of his work with Webster:

> We've always been interested in making work that is constantly restless, never static and [which] could transcend itself to become something else.[32]

This description underlines the deliberate ambiguity and ambivalence of response that these installations can solicit. Both examples suggest Bishop's categorisation of composite installations which invoke dream sequences which suspend disbelief, while provoking narratives or partial stories. Although *Scarlet* and *Black Narcissus* were distinct in form, their placement and subject matter implicated them within the total interior space of the museum, which, like Nelson's corridors or Wilson's gantry for *20:50*, the spectator was required to navigate in order to construct a narrative or context for what was encountered.

In the public mind, Damien Hirst (b. 1965) is irrevocably associated with what became a signature practice – composite installations using bisected or complete examples of animal anatomy, preserved in formaldehyde solution. While still a student at Goldsmiths College, Hirst played a formative organisational and promotional role in the early groups shows by the YBAs, most notably the three-section event *Freeze* (1988), and *Modern Medicine* (1990). Aside from vitrine-based installations, Hirst is widely known for his spin and spot paintings and cabinet sculptures.

At interview, Hirst has frequently acknowledged the influence of Andy Warhol through the stylistic and formal devices of repetition, as he has Francis Bacon with (earlier) documented interest in human and then

animal pathology, mixing the forensic with the existential.[33] With nods to the accomplishment and self-promotion of both Warhol and Jeff Koons, Hirst has diversified into various entrepreneurial and business ventures, including film making, designing art work for albums, theming and co-managing upmarket restaurants, publishing and, more recently, establishing what may become the UK's largest private collection of recent and contemporary art.

Although Hirst has worked across several art genres, installation and assemblages using various materials have remained central to his aesthetic. Since *The Physical Impossibility of Death in the Mind of Someone Living* (1992), a tiger shark presented in a formaldehyde-filled tank, he has explored various elaborations based on the use of vitrines, combined with sometimes spectacular visual representations – and reconceptualisations – of subject matter. Hirst's work offers visceral and sometimes compelling juxtapositions of flesh, steel and glass with the increasingly high production values associated with post-Minimalist installation.

In *Mother and Child, Divided* (1993), bisected cow and calf carcasses are preserved in formaldehyde solution, providing a compelling viewing corridor between parallel vitrines, spaces which, in a literal sense, should not exist. In a subsequent installation, *Some Comfort Gained from the Acceptance of the Inherent Lies in Everything* (1996), Hirst revisited the spatial and visual effects gained through permutation and repetition; two cows were sliced into twelve vertical cross-sections, and presented in separate glass vitrines.

Memento mori themes are a central and recognised leitmotif of Hirst's aesthetic and the subject of other well-known works. *In & Out of Love* (1991), installed at the Tamara Chodzko Gallery, London, aestheticised the lifecycle of exotic butterflies from chrysalis to death as transient spectacle. After hatching in a well-heated gallery space, complete with sugar water and foliage, many of the butterflies became embedded and fixed on the wet and sticky surfaces of large canvasses hung for that purpose.

With the installation *A Thousand Years* (1990), Hirst returned to the idea of an observable, if artificially accelerated lifecycle – that of the blowfly (Figure 3.4). A steel and glass vitrine was divided by a transparent panel in which there were four round holes. On one side a sugar solution fed blowflies emerging from a square MDF hatchery, which were then attracted through the apertures to feed on a rotting cow's head positioned on the floor of the adjoining section of the vitrine. Two grill vents set into either side of the vitrine provided the necessary air flow, while sealing the flies within the installation's constructed micro-environment. Above the cow's head, the addition of a suspended insect-o-cutor and hinged double collecting tray, completed the brief lifecycle of the flies, before or after they had fed.

Despite, or perhaps because of, its conceptual simplicity, *A Thousand Years* offered an absorbing encounter. As a micro-environment, once its

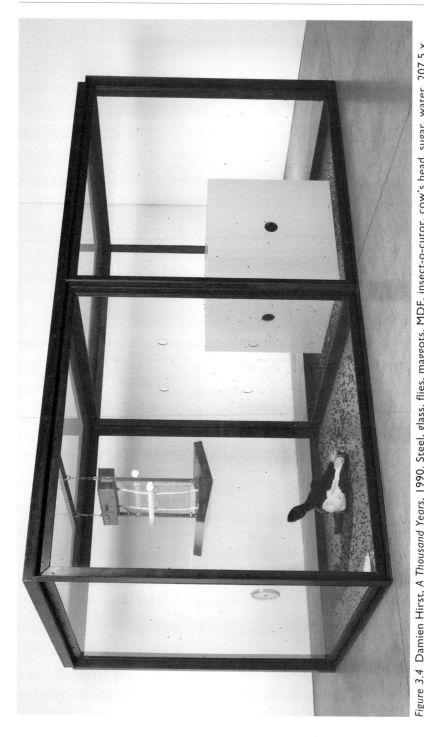

Figure 3.4 Damien Hirst, *A Thousand Years*, 1990. Steel, glass, flies, maggots, MDF, insect-o-cutor, cow's head, sugar, water, 207.5 × 400 × 215 cm. Photo © Roger Wooldridge. © Damien Hirst. All rights reserved, DACS 2010.

structure and working had been recognised, spectators were invariably drawn to watching the blue light and listening to the sound of the insect-o-cutor. The apparent banality of dying flies was refashioned as macabre diversion played out over countless lifecycles and repetitions.

As installations, these examples by Hirst share some of the features of the genre understood as a dream-like encounter. They typically share composite or segmented structures or, like *A Thousand Years*, comprise an enclosed micro-environment within which a narrative is orchestrated or for which one might be imagined or projected by the activated spectator. The orchestrated spectacle of animal viscera, the preservation of entire specimens in stasis or evocative 'total' environments like *In & Out of Love*, combine the sensory with the affective and the visual. Through conceptually mediated techniques of provocation and disassociation, we are asked to suspend disbelief and then to imagine narratives for what is presented.

Among the art works lost in the Momart storage depot fire of 2004 (see pages 9–10) was a large-scale installation titled *Hell* (1999–2000). It comprised a series of nine glass cases each containing intricate fibreglass, plastic and mixed-media landscapes depicting a virtual and terrifying world: thousands of miniature figures dressed in Nazi regalia, variously engaged in Sadean acts of violence – evisceration, torture and dismemberment. The individual vitrines that comprised *Hell* were arranged in the configuration of a swastika through and around which the spectator could navigate, looking at the intricately detailed figures and dioramas which comprised the installation.

Hell had been meticulously crafted by Turner Prize nominees Jake (b. 1962) and Dinos Chapman (b. 1966). Since graduating from the Royal College of Art in the early 1990s, the Chapmans have worked across a range of media, but *Hell* and what became its replacement, *Fucking Hell* (2004–08), have become iconic of their work and reputation. In the booklet that accompanied the Royal Academy's exhibition *Apocalypse Now: Beauty and Horror in Contemporary Art* (2000), Max Wigram described the original *Hell* installation as:

> a bloodbath – a gargantuan, monumental reminder of the horrors of the last century. The figures become metaphors, their repetition and their diminutive scale gradually erasing the shock until the whole sculpture becomes a toy.[34]

The scale and composite configuration of *Hell*, which survives now only in photographic representations, and its successor piece, *Fucking Hell* (for a detail see Plate 14), provide an immersive and psychologically absorbing spectacle. The meticulous realisation of various permutations and rankings of suffering and dismemberment mediate the idea of the Sublime as a terrifying negation of the subject. Describing the scenes of the first installation, *Hell*, James Hall wrote:

In the centre a volcano spews out Nazis. The landscapes are killing fields where tortures and punishments of Bosch-like ingenuity are meted out to Nazis by naked mutant figures. Body parts, skeletons and skulls are strewn everywhere.[35]

The multi-part landscapes of *Fucking Hell* solicit responses across categories of installation practice. The detail reproduced depicts a watercolour-painting Hitler (complete with easel), looking out over a valley of writhing corpses dressed in Nazi regalia. As navigable forms and free-standing tableaux, the vitrines provide an absorbing, subterranean dreamscape, a dystopia which forces the viewer to suspend disbelief as each viewing angle and perspective reveals new permutations of horror. The calm, clinical neutrality of the white cube gallery interior in which both installations have been presented provides a foil to the manic and dense vistas of human sadism and suffering which have been so meticulously constructed.

At the detailed level of iconography, the images of mutilation and torture literalise the disintegration of the subject – Freud's death drive given collective form by the Nazi genocide which the uniforms and regalia of the figures clearly reference. Both installations tangentially explore the fourth classificatory response associated with the genre – addressing the viewer as a politicised subject, through the foregrounding and configuration of a swastika, the symbolic format taken by the layout of both installation pieces. More generally, the choice of subject questions the viability of human rationality and the legacy of the European Enlightenment which culminated in the mass ideologies and genocide of the mid-twentieth century.

In respect of the final category of installation practice which situates the spectator as a politicised subject, *Fucking Hell* and its predecessor, *Hell*, both suggest a transitive and discursive encounter with the activated spectator. In the Chapmans' co-authored book and catalogue that accompanied the initial exhibition of *Fucking Hell* and adapted watercolours at the White Cube Gallery, explicit textual reference is made to the amorality that provoked the avant-garde nihilism of the early twentieth century. Simon Barker recounts a narrative in which the Viennese satirist and critic Karl Krauss responded with shock to battlefield tours of the Verdun trenches glibly advertised in the *Basel News* within just a couple of years of the ending of the First World War.[36] What the advertised copy states as the 'phenomenal panorama of horror and dread' is self-consciously restaged and re-articulated in these descriptive tableaux.

The Chapmans' make explicit reference to this earlier act of obscene commodification through their Baedeker-style introduction, 'An illustrated guide to *Fucking Hell*'. But the polyptych, as Barker concludes, is more broadly emblematic of this impugned moral framework and the successive fictions (including art and the realm of the aesthetic) that have been used to conceal it:

the work restages the precarious fabrications by which exceptional real events are absorbed by greater (contrived) fictions in order that they may somehow 'make sense' as truths on an abstract level. It not only describes relentlessly (and explicitly) but it implicitly (and relentlessly) unveils the synthetic work of art ... for the fictive framing device that it is.[37]

Fucking Hell interrogates humanist assumptions of positive and rational agency, instead objectifying the fashioning of human pathology and appetite towards genocide. The Chapmans' have consistently denied making any 'transcendent propositions' through their work, a stance underlined by the appropriation of work by the Spanish painter and liberal humanist Francisco de Goya. A representative of the aspirations and rationalism of the failed Enlightenment, Goya provides an easy target for satire and parody to the extent to which such ideals are perceived as having been (again) betrayed or left unrealised by the mass ideologies of the twentieth century to which *Fucking Hell* makes explicit reference. The activated spectator is faced with the apparent nihilism of its subject matter which might be read as a refusal and negation of human rationality. Equally, in prompting 'self-suspicion', the Chapmans' encourage reflexivity concerning the legacies and possibilities of the human condition.

Discussing various readings and interpretations of their practice, they have suggested that each piece they make sets up a process of 'physiological oscillation' in which 'the reading [of the work] never really becomes one or the other; either a conscious rationalisation of an idea or merely an expressionist discourse'.[38] The instability and ambivalence suggested here is matched by the total environment and content of *Fucking Hell* which, literally and metaphorically, decentres and provokes the spectator. Like the narrative of the Marquis de Sade's *120 Days of Sodom*, the Chapmans' adopt a proposition, exploring (and ultimately exhausting) its numerous permutations and possibilities towards an 'episteme of death'.

Paradigms of installation art as immersive experience and subjective disintegration

Among installation art's most appreciable tendencies in recent years has been a marked tendency towards scale, size and the consequent envelopment and immersion of the spectator. The compelling experience offered by *20:50* (Figure 3.2) arises not just from Wilson's imaginative use of oil as an aesthetic medium (its lustre, depth and reflective properties providing a powerful juxtaposition with the white cube gallery space), but the tangible sense of disorientation that its size and adaptive placement within the gallery space successfully generates.

More recently, other major institutional commissions have accented the immersive and participative dimension to encountering large-scale,

site-specific installations. Carsten Höller's (b. 1961) *Test Site* displayed at the Tate Modern (2006–7) provided the sensation of speed and apparent loss of control associated with funfair helterskelters. In what was possibly an ironic reference to the apparent British obsession with indifferent weather, Olafur Eliasson's (b. 1967) *The Weather Project* (2003–4) was a site-specific work designed for the Tate Modern's Turbine Hall in which the entire space was bathed with the light from an artificial sun. The installation was part of the Unilever series of commissioned works, and was among the most visually spectacular of the series, since this was also the largest space Eliasson had worked with. Discussing the intention behind his work, he noted:

> Today the communal feeling lies in the concept of singularity; through evaluating and changing our individual position we can have an impact on our surroundings ... even a minimal project ... is about social relations ... I want to show you some things. I want you to look at yourself in regard to those things.[39]

Visitors to the installation were suffused with an intense sensation of heat and light. Seen from a distance, the spectator was aware of the silhouettes of other viewers, defined and singular against the heat and glare. Through its tangible presence, *The Weather Project* seemed to miniaturise the surrounding space, atomising and objectifying its spectators. Noting Eliasson's observation on social relations, the affective and almost tactile encounter with his installation prompted interpretations that read it as a metaphor for global warming and eventual entropic breakdown, but one self-consciously presented for collective engagement and 'consumption' as transient aesthetic spectacle.

Anthony Gormley (b. 1950) established his reputation as a British sculptor and installation artist engaged with the body as the site of transformation, memory and experience. Awarded the Turner Prize in 1994 and the South Bank Prize for Visual Art in 1999, he is probably most well known for the *Angel of the North* at Gateshead (1994–98) (Plate 2) and the installation series *Field*, variously made in collaboration with communities across the globe. *Field for the British Isles*, one of the series, was displayed by the Tate Liverpool in 1993. In 2007 the Hayward Gallery, hosted a retrospective of work by Gormley, his first major exhibition in London. Titled *Blind Light*, it featured installation pieces, drawings, prints, photographs, the exhibition exploring different experiences of space and our response to the built environment. For example, as embodied spectators, how do we navigate space or respond to spatial disorientation? Introducing the exhibition, the organiser and curator Helen Luckett wrote:

> space is defined and articulated by crowds and solitary figures – concrete, steel, cast iron or lead; representational or abstract; real or imagined – and voids where bodies could be. In encountering these

presences and absences, we are asked not to be passive onlookers, but to become part of the work as we walk through or around it, navigating and negotiating space.[40]

The exhibition's title piece, *Blind Light* was a room-sized rectangular glass box in which ultraviolet purifiers and vapour from distilled water were used to reduce visibility to a matter of centimetres. On entering, the spectator was immediately enveloped in dense, chilly vapour in which light only aided a sense of complete disorientation and dislocation. From outside, it was possible to catch partial glimpses of the hands and faces of those inside the box, but only when they actually came up very close or touched the plate glass. Access or exit was only possible by following the glass wall by touch; away from these anchors, orientation was impossible. Describing the experience of *Blind Light*, Gormley observed:

> Architecture is supposed to be the location of security and certainty about where you are. *Blind Light* undermines all of that. You enter this interior space that is the equivalent of being on top of a mountain or at the bottom of the sea ... you become the immersed figure in an endless ground, literally the subject of the work.[41]

In this and other works such as *Allotment II* (1996), a field of 300 life-size concrete pillars, the spectator is subsumed within and by the work. The experience both engages and dislocates all the senses, especially when, as with *Blind Light*, sight is of limited use in navigating and making sense of a constructed void. Other visitor accounts variously recorded feelings of profound claustrophobia, disorientation and near panic.[42]

Blind Light examples a post-Minimalist installation which succeeds in disorientating senses of perception and dissolving orientation. Discussing this category of experience, Bishop has compared it to ideas associated with the French theorist Roger Caillois (1913–78) and Freud's theory of the 'death drive', a defensive, instinctual response to external threat which can also lead to destructive impulses when turned inward. At one level, *Blind Light* simulates this experience which can be both terrifying, but also pleasurable. Describing this as akin to 'mimetic engulfment' – we are literally subsumed by the experience – Bishop notes:

> Rather than heightening awareness of our perceiving body and its physical boundaries, these ... installations suggest our dissolution; they seem to dislodge or annihilate our sense of self – albeit only temporarily – by plunging us into darkness, saturated colour... .[43]

Although Gormley's *Blind Light* can be tangentially categorised in other ways, as can Eliasson's *The Weather Project* and Wilson's *20:50*, all three

decentre and dislocate ideas of temporal or physical location. Each questions the reliability of our senses in establishing self-definition in relation to the effects and the apparent magnitude of the environment encountered.

Installations, bodily response and experience

The third categorisation of installation practice links more directly to the legacy of Minimalism the 1960s and 1970s and to the debates on embodied response and phenomenology mentioned earlier. In particular, these examples heighten or engage spatial, visual or aural perception, often making full use of the gallery or display environment in which the work is presented. In some cases the installation's particular configuration or scale is similar to those examples that create a dream-like encounter through constructing a total environment in which the spectator is placed.

One of the themes explored by the neo-avant-garde in the 1960s and 1970s related to the physical and cultural consequences of entropy – the slow cooling, transformation and eventual dissolution of all natural phenomena. These interests were informed by wider debates on ecology, sustainability and the balance between nature and the built environment, although the political and cultural implications of these ideas were still at an early stage. In particular, the iconic 'earth projects' initiated by the American land artist Robert Smithson (1938–1973) and the large-scale installation work subsequently undertaken by Richard Serra (b. 1939) explored the aesthetic and innate properties of materials and associated ideas of entropy and stasis.

Related concerns have situated work by Cornelia Parker (b. 1956). Shortlisted for the Turner Prize in 1997, Parker has produced disconcerting and often profoundly absorbing installations which have defamiliarised and displaced otherwise banal objects. The installation *Cold Dark Matter: An Exploded View* (1991) was first exhibited and photographed in situ at London's Chisenhale Gallery. It was initially a small timber garden shed, filled with the usual garden-related contents and unwanted household items, to which was added a volume of Proust's *Remembrance of Things Past* and a memoir, *The Artist's Dilemma*. The shed was then taken to an army site where it was exploded by the British Army School of Ammunition. The resulting fragments were then systematically reassembled, suspended from wires and exhibited in orbit around a 200 watt light bulb in the original gallery space.[44] The title of the work references the 'dark matter' or negative energy which comprises much of the universe, but which is otherwise invisible other than by its effects. Discussing the installation's iconography in conversation with art historian and critic Lisa Tickner, Parker noted:

> It was about a lot of things. The work points out into the world, or inwards into your psyche, and I like to do both. The explosion might be

looking at the universe, at the Big Bang, but it also means something psychological, something unsettling … So, cold dark matter is in the universe, but it's also in the mind.[45]

Parker's observation references dual effects and associations. Experiencing these myriad objects discretely lit and suspended in space, the spectator is engaged by what appears an alchemical re-imaging of otherwise functional and mundane objects. As the spectator explores the periphery of the installation these atomised fragments acquire a curious syntax and 'wholeness' through their shared and carefully choreographed suspension, effects enhanced by subdued lighting and a neutral gallery backdrop. Perceptually, the spectator is reminded that they are navigating the exploded residue of objects made tangible by the space between them; cause, effect and time are miniaturised and frozen as spectacle. Discussing the installation's configuration, Parker notes:

> this fluid, atmospheric sense … is a model of the way I think … it's quite a feminine way of thinking. It's always this anti-centre thing … in *Cold Dark Matter* you have a light bulb in the centre … but it's the thing that's blown it apart. The shed is porous; you can see through it; there's light radiating through the walls; it's not this dark bunker. The desire to make things imperfect or porous or break the mould of the cliché … – that's something which recurs.[46]

In discussing her practice, Parker has acknowledged the formative influence of the 'unmade', the fragment and the Italian neo-avant-garde movement, Arte Povera, the members of which used discarded, marginal or overlooked materials to make and fashion art. Also influential on her work has been the ethos and legacy of practitioners like Tony Cragg and Richard Wentworth who, with Bill Woodrow, re-situated British sculpture in response to broader conceptual shifts which had already overtaken British painting in the later 1960s and early 1970s.

In 1995 Parker presented *The Maybe*, a hybrid installation-performance work made in collaboration with the actress Tilda Swinton at the Serpentine Gallery. For seven days, the actress slept in a glass cabinet within the gallery, surrounded by smaller glass vitrines with fragments of historical miscellany, ranging from scientific apparatus belonging to Michael Faraday to personal items variously associated with Edith Cavell, Charles Dickens, Sigmund Freud, Wilfred Owen, Wallis Simpson and Queen Victoria. The signage of the installation – 'Matilda Swinton' (b. 1960) – mobilised conventional expectations surrounding the historical presentation and display of static and inanimate objects as proper subjects of art historical display. But as its speculative title implied, *The Maybe* was suggestive of a more discursive exploration of time, the human associations inscribed around objects and the contingency of human life.

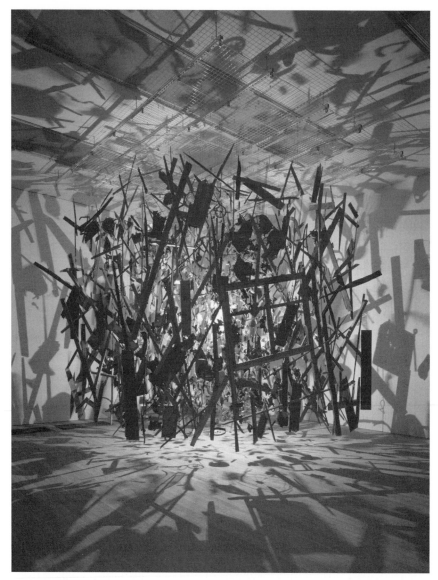

Figure 3.5 Cornelia Parker, *Cold Dark Matter: An Exploded View*, 1991. © Tate, London 2010.

Parker has described the intention for the installation as being to make a 'reliquary' and 'trying to make ... a representation of how you feel about the ephemerality of life'.[47] Describing the encounter with *The Maybe*, Tickner writes:

> Here was a heterogeneous collection of apparently nondescript objects given resonance and meaning by labels deliberately placed a little distance away. And here was a series of chance encounters, imaginary encounters between the ghosts of the past and encounters with the dead in the minds of the living.[48]

As an installation with a performative dimension, it attempted a space for contemplation and reflection akin to the example of a reliquary which Parker mentions. In setting up spectres arising from seemingly improbable connections, it nevertheless prompted ideas of reverie and the imaginative reconstruction of narratives arising from the experience of the work. Rather than strident effect or immediate sensation, *The Maybe* attempted a more cumulative and subtle altering of one's awareness of just being – and the remembrance of the shades of others.

Turner Prize nominee Tracey Emin (b. 1963) has worked across a wide range of art practice, but installation has remained a consistent interest. In 1993 Emin and her YBA contemporary Sarah Lucas opened a makeshift space using the premises of a former minicab office in London's East End. The impromptu *Shop* was used to display and sell some of their early work, in addition to a range of self-made and art-related merchandise. Emin later self-curated her own space, establishing the Emin Museum in Waterloo Road, London.

The media coverage of her installation *My Bed* (1998), following its shortlisting for the Turner Prize in 1999, defined the tempo of that year's award, although the final nomination went to Steve McQueen. Mandy Muerk has described the contribution of *My Bed* to that year's Turner Prize exhibition as being the 'literal foregrounding of sex' – its iconography that of 'soiled sheets, bloodied underwear, empty vodka bottles, discarded tissues, fag ends, used condoms and other post-coital detritus'.[49] An earlier exploration of appliqué technique, *Hotel International* (1993), had adapted a large quilt as the base for a biographical montage of names, associations, family and personal history from her early years and adolescence in the South Coast seaside resort of Margate.

Emin returned to the technique of embroidery for a subsequent installation which has become one of her most iconic and well known works. *Everyone I Have Ever Slept With 1963–1995* (1995) (Plate 13), was a blue dome-shaped tent and camping mattress appliquéd with the names and short texts associated with former lovers and partners, platonic friends and family, including her fraternal twin, grandmother and the name of an aborted foetus.

As with other examples of installation work, Emin has adapted a functional object to serve as what the art critic David Bussell has described as a 'kind of archaeology of variously intimate relations within the confines of a confessional shelter'.[50] To see the illuminated lettering and texts inside the tent, the spectator has to crouch down and crawl into the tent space, a gesture suggestive of intimacy and contact. In doing so, the viewer must lie on top of the mattress which forms the base to the tent's interior. On the mattress blanket are appliquéd the words of Emin's personal statement, white lettering on a blue background, which read 'With myself, always myself, never forgetting'. Discussing the intention behind her work with Andrew Nairne, at the time of her exhibition at Modern Art Oxford, *This is Another Place*, (2002–3), she noted:

> I'm making work for all kinds of people – the whole spectrum of society. But I'm not making work to convert people – I'm making work to actually have a conversation with people.[51]

Emin's intensely biographical aesthetic accents personal experience and confession. Place and locality are recurrent anchors throughout her installations such as *The Last Thing I Said to You is Don't Leave Me Here* (1999) – a Whitstable beach hut salvaged from demolition because it recalled the weekend breaks of Emin's youth. The intense association of place is also explored through her autobiography, *Strangeland* (2005), which, unsurprisingly recalls Margate, the place of her adolescence and youth. Calculated or otherwise, the candour and accessibility of these works encourage and accent an emotionally heightened response – of either empathy and responsive engagement or wary scepticism.

Colin Booth's (b. 1951) *Metropolis* (2008), a found beechwood installation, is an architectonic-looking landscape comprising hundreds of beech block offcuts, each with one edge painted blue (Plate 16). The blocks, lightly sanded prior to installation, but otherwise as found, were reclaimed and recycled from a furniture workshop local to Booth's studio in St Leonards-on-Sea, East Sussex. Before temporary installation at Canterbury's Herbert Read Gallery in 2009, *Metropolis* had occupied, rhizome-like, the entire rectangular floor space of Booth's sea-facing studio. Walking around the installation as the raking light changed and shifted gave an acute and palpably physical sense of miniaturised immersion in a futuristic modernist cityscape, which the work's choice of title partly references. The brittle morning daylight animated the vertical and horizontal bricolage of shapes and forms, casting shadows and illuminating the wood-grain patinas and varied shades of the wood block surfaces.

As this brief description and image suggest, light and an immediate white cube environment accent and heighten the viewing experience. As the spectator navigates the periphery of the installation, the individually

arranged, but essentially generic forms, emerge and dissolve into one expansive vista. Light has long been a central compositional principle for Booth. A 2004 solo exhibition, *Revealing Light*, at Folkestone's Sassoon Gallery explored what commentator Simon Barker described as the 'light industrial or craft processes' of pooling paint onto meticulously prepared grounds.[52] The elaborate configurations of these 'fugitive' canvases were animated by the reflected light from their glazes and varnishes.

The genesis of *Metropolis* and a related installation work, *Streamline* (2008), arose through the interest in light and placement of these earlier, post-Minimalist paintings. Discussing the aesthetic origins and context to the work that culminated in *Metropolis*, his largest and most ambitious installation to date, Booth recalls:

> I wanted to develop painting in the round and made a whole series of grid paintings in which the edge was an integral part of the painted surface. The paintings could be seen quite clearly as three-dimensional objects which had a direct relationship to the surrounding space. I then started to work with small blocks which I also painted in a grid-pattern and these became small sculptures and installation pieces.[53]

As Booth suggests, this installation arose from highly tactile Modernist-looking canvases composed of gloss and matt grids with the patterns arranged and intuitively broken up for visual effect. The aspiration behind *Metropolis* was to fashion a tactile installation, the patinas and syntax of its otherwise generic beech-ply blocks responsive to the changing light and atmosphere. The direct placement of *Metropolis* on the gallery floor and its room-sized length encouraged a physical and perceptual navigation of the work. Standing over and looking across the panoramic vista of blocks, the spectator was struck by the deliberate referencing of Fritz Lang's futuristic film of 1927. Despite the installation's obvious proximity, kneeling and looking across the configuration of seemingly miniaturised blocks gave a keen sense of aerial perspective and a suggestion of distance that displaced the object in time and space.

Installation, politics and activated spectatorship

The fourth installation category listed explores the idea of 'activated spectatorship' as a politicised aesthetic practice. In this sense, the political is understood less in a specific or programmatic sense, but more as a general expectation of action or engagement. The installation establishes a scenario or environment which communicates with the spectator, who by implication is addressed as part of a larger collective or community that may have the capacity for more directly influential forms of political or social intervention. Discussing recent trends in critical practice, Bishop notes:

the viewer's active presence within the work is more political and ethical in implication than when viewing more traditional types of art. A transitive relationship is implied between activated spectatorship and active engagement in the wider social and political arena.[54]

The transitive relationship suggested here is more apparent with some installations than others, but its ethos echoes Bourriaud's idea of the 'relational', a tendency noted earlier in respect of some contemporary art practice. In discussing the emphasis on the political that is appreciable with some forms of installation, Bishop has referenced the 'antagonistic' theory of democracy advanced by Ernesto Laclau and Chantal Mouffe's *Hegemony and Socialist Strategy* (1985). This reading questions the assumption that inclusivity is itself sufficient for democratic discourse, but rather:

> the public sphere remains democratic only insofar as its naturalised exclusions are taken into account and made open to contestation ... democracy occurs when the frontiers between different positions continue to be drawn up and brought into debate.[55]

Incorporating and questioning some of the assumptions made by Bourriaud concerning collective and inclusive forms of address mediated principally through examples of installation and performance art, Bishop has coined the term 'relational antagonism'. This is used to characterise the effect and ethos of work that is itself both reflexive and constitutive of these unresolved tensions and conflicts, and also of the limits of its own social effectiveness. As Bishop notes in her essay 'Antagonism and relational aesthetics', modes of installation practice that are judged to be more 'disruptive' and authentic address subjects or engage responses that attempt to recognise 'the divided and incomplete subject of today', which is in 'constant flux'. Having discussed examples of practice by Thomas Hirschhorn (b. 1957) and Santiago Sierra (b. 1966), she concludes with the observation:

> This relational antagonism would be predicated not on social harmony, but on exposing that which is repressed in sustaining the semblance of this harmony. It would thereby provide a more concrete and polemical grounds for rethinking our relationship to the world and to one another.[56]

The examples chosen to support this argument suggest forms of art practice that are sufficiently reflexive and sensitive to their own incompleteness or contingency, but that attempt to provoke a consciousness among their activated spectators, although without assuming (or even desiring) a commonality of response. This reading of the relational model suggests some similarity with the more directly politicised techniques pursued by the

German playwright and theatre director Bertolt Brecht. His use of the 'alienation' or estrangement effect was designed to provoke critical consciousness among audiences, rather than passive identification with the narratives and actors in their stage personae. Although Bishop's idea of relational antagonism is potentially more open-ended in its aims and effects, both paradigms stress the intersubjective and concede the prospect of an activated but ultimately 'incomplete' subject. Several of the installations briefly surveyed here and earlier in the book might be characterised in these general terms, although their use of medium, content and composition varies widely.

One further point might also be made here since it relates to all forms of recent and contemporary art and the various registers of installation practice in particular. Globalisation – understood as increasing interaction, communication and trade between the developed and the developing world – has become prominent since the decolonisation of Western European imperial territories from the late 1940s and since the end of the Cold War in the 1980s. Politically, it has tended to be equated with westernisation, capitalisation or Americanisation, but culturally, globalisation has also resulted in fusion and hybridisation, generating fresh perspectives on artistic production, meaning and display.[57] These shifts have provided the context in which installation art as a new critical paradigm has evolved and developed, regardless of the actual place of making or display. It follows that ideas of the political and the 'activated spectator' mediate other (and more profound) displacements and dislocations associated with transnational capital, labour markets and an accelerating awareness of global proximities, conflicts and interdependence.

Michael Landy (b. 1963) has established a reputation for making work which combines trenchant social commentary with formal and imaginative innovation. During a two-week period in February 2001, Landy systematically and publically destroyed all his possessions in the powerful installation/performance work *Break Down* (Figure 3.1). Assisted by a team of ten 'operatives' and managing the process of deconstruction from an elevated viewing platform, Landy oversaw the meticulous cataloguing and granulation of all his possessions.

The 'production line of destruction' comprised a colour-coded blue and yellow industrial reclamation facility in which mechanised deconstruction was forensically undertaken by blue boiler-clad assistants wearing ear defenders. Landy's 'existential audit' – everything from his Saab car and his dad's old sheepskin coat (inventory number C714), to private letters, art work, photographs, LP records and personal memorabilia – was placed on a conveyor belt for display before granulation or shredding. Larger items were dismantled using drills and jigsaws before processing. An estimated 45,000 people visited or watched *Break Down* at some point during the two weeks, with over 8,000 attending on the final day.[58]

Installed and performed behind plate-glass windows in the vacant premises of C&A in London's Oxford Street, *Break Down* dramatised the fetish for commodities; the ownership of 'stuff' as a signifier of status, value and meaning. Landy noted at interview:

> Consumerism divides people … it promises fulfilment but never delivers it. Part of what this work is about is sustainability. As consumerism grows and accelerates, it does come up against the material limits of what this planet can sustain.[59]

Commissioned by the visual arts charity Artangel, *Break Down* followed a series of installations in which Landy had broached overtly political and social themes concerning the ideology of consumption and the ethos promoted by free market capitalism. In *Closing Down Sale* (1992) he had displayed shopping trolleys loaded with the laminated signs associated with the disposal of cheap shop merchandise. As Stallabrass has noted, this particular installation was explicit in its reference to the UK recession and the realities of a contracting private gallery and dealer system.[60]

In *Scrapheap Services* (1995–96), Landy created a waste disposal system of machines peopled by uniformed shop dummies, sweeping up thousands of cut-out human figures, made from branded packaging. Spectators were able to walk around and between the dummies and disposal machines, reflecting perhaps on a system that treats individuals like 'human capital' – as contingent and expendable as the heaps of shredded paper on the gallery floor. This was the installation's political subtext; the social and economic dispensability of people, a legacy of the Thatcherite nostrum that there was no such thing as 'society', but only individuals.

As Landy and his critics recognised at the time, *Break Down* was a symbolic and ultimately profitable exchange of possessions for the more intangible reward of 'cultural capital' and artistic reputation. The part manual and computerised inventory of the 7,227 possessions destroyed, illustrated with photographs of *Break Down*, was published by the commissioning organisation and visual art's charity Artangel in 2002. The original intention had been to compensate the installation's backers and sponsors by producing sacks of the granulated objects which could be sold for £4,000 each, but in keeping with the serious intent behind *Break Down*, Landy ultimately put these into landfill, observing:

> it was important to me that the only thing you take away from this is your experience of it. It doesn't get commodified. It is not for sale. Often with contemporary art people get sidetracked instead of talking about their experience of it they just talk about how much it is.[61]

A documentary filmed for the BBC4 arts channel, *The Man Who Destroyed*

Everything, recorded Landy's challenging and sometimes painful re-immersion into consumer society. Discussing the experience, he underlined how personally affirmative its preparation and execution had been:

> This is a celebration of a life, but I'm still alive. People come in who I haven't seen for years. It's really nice. I'm happy every day. It's like my own funeral, but I'm alive to watch it.[62]

Although not a politically programmatic installation, *Break Down* was a powerful critique of the cult of consumption and how social identity is conveyed through the ownership and possession of objects. While it objectified dissolution and stasis, Landy's sense of liberation and elation can be understood as a recovery of personal agency and a revised sense of self. The refusal to leave behind anything other than the inventory of granulated and destroyed objects underlined his refusal to make the work complicit with the mechanisms of the art market. For the London shoppers passing the windows or looking inside, *Break Down* suggested a radically alternative paradigm of self-realisation and authentication through being, rather than just buying. As Judith Nesbitt observed:

> A performative art work, this controlled act of dematerialisation directly addressed its audience … in a systematic, uncompromising way … *Break Down* – however temporarily – detached 'I am' from 'I have'.[63]

Radically innovative and existential in conception, *Break Down* reconnected the genres of installation and performance with an earlier heritage of refusal and social engagement. In doing so, it drew attention to contemporary art's enmeshed role within the institutional structures of cultural display, purchase and consumption.

While *Break Down* referenced the political tangentially through the example of public de-consumption, other instances of recent installation practice have been more direct in their identification with a specific issue. Mark Wallinger's *State Britain* (2007) was exhibited in the central sculpture court of the Duveen Galleries, Tate Britain. Wallinger's 40 metre long installation was a near-perfect reconstruction of Brian Haw's multi-part anti-war demonstration, a one-man camp complete with banners, placards, paintings, texts, teddy bears and messages from supporters. Haw began his symbolic demonstration in Westminster's Parliament Square in June 2001, in protest against western sanctions and the no-fly zone that had been imposed on northern and southern Iraq.

In 2005, Parliament passed the Serious Organised Crime and Police Act as part of the response to the 'War on Terror'. Under section 132 of this legislation, protesters are legally required to gain police permission before

demonstrating within a 1 kilometre radius of Parliament Square. The legislation quickly found its precedent with the arrest and conviction of one anti-war protestor for reading out the names of the [then] ninety-seven British soldiers who had been killed in Iraq. In May 2006 the legislation was used to curtail Haw's demonstration, which at the time of writing has been reduced to a small pitch of 3 metres by 2.[64]

Both the original protest and its virtual ready-made, meticulously recreated from Wallinger's photographs in the Duveen Galleries, confront the limits of personal liberty and its interface with State power and sanction. A line on the gallery floor halfway through the installation indicates the extent of the kilometre cordon covered by the provisions of the Act. Wallinger's exact copy of Haw's original demonstration, presented within the confines of a national art gallery, made explicit the efforts of the State to constrain and institutionalise 'protest' to within manageable (and marginalised) norms. As the curator of the exhibition, Clarrie Wallis, writes:

> *State Britain's* unique physical position is thus politically charged, and suggests that the physical, social and intellectual space of the museum is both contested and free. *State Britain* does not just represent a historical event; nor is it simply a protest in itself. Rather it raises questions about the right to protest and the limits and nature of art and its institutional context.[65]

Wallis's observation identifies the radical ambiguity of Wallinger's installation. In restaging an authentic and principled protest as aesthetic spectacle, *State Britain* in one sense co-opts and negates Haw's authentic and original protest. But considered from another perspective, Wallinger's installation achieved considerable press coverage, emblematic as it was of a protest against increasingly punitive State powers over civil liberties which were judged to be expendable in the interests of political and social control. Discussing Haw's original protest and Wallinger's site-specific installation, the art critic Adrian Searle wrote:

> What *State Britain* offers is a sort of portrait of British institutions at a time of war, of the lip service government pays to dissent, on the attacks being made on our freedoms in the name of security, on the impotence of protest and of art itself as a form of protest. How rich this work is, and how saddening our state.[66]

Wallinger's installation is emblematic of these productive and antagonistic tensions since both its form (which demarcates the radius of a mile available to proscribe protest) and content (the material of Haw's original protest), publicise and question the actual legal constraints applied to the policing of

legitimate public dissent. Signifying the boundaries and thresholds of State, judicial and territorial power has been a recurrent theme in other works by Wallinger such as the video-film *Threshold to the Kingdom* (see pages 225 to 226). Similarly, his sculptural representation of Christ, *Ecce Homo* ('Behold the Man') designed for the fourth plinth in Trafalgar Square – a historic location for political rallies and protests – referred to the alleged words uttered by Pontius Pilate before he turned Jesus over to the crowd for judgement and punishment. The Biblical narrative to which *Ecce Homo* refers is understood as a parable of the conflict between religious and secular (or imperial) authority (see pages 37 to 39).

Conflicts and confinements arising from different geo-politics have been among the issues addressed in wide-ranging work by the Lebanese born exile Mona Hatoum (b. 1952). Installation has remained a major register in Hatoum's work, one example of which is *Light Sentence* (1992). It comprises a rectangular arrangement of stacked wire mesh lockers, lit by a single mobile light bulb. The moving light determines the throw of shadows across and around the installation and gallery space. This installation piece has generated various readings: the mesh lockers suggest containment and incarceration, associations further evoked by the word play of the installation's title. Equally, the limited light source choreographs the flickering shadows which create a fugitive sense of space, movement and possibility. These in turn disorientate the spectator, dissolving the installation's contours and making its extent ambiguous and unclear. As the art historian Gill Perry has noted of the work:

> Whatever political or domestic meanings we seek to identify, they are enmeshed with our perceptions of the work's aesthetic legacy – the abstract patterns, the shadowy grids and strange luminous sense of flux produced by each.[67]

The contexts of Hatoum's life – exile, diaspora and displacement – are formative of her installation practice, as are some of the broader geo-political conflicts involving parts of the Middle East and the Palestinian people. The modalities of experience suggested by installations such as *Light Sentence* are often prompted by metaphorical association, which while indirect, nevertheless situates installation practice as a paradigm of the political, and the activated viewer (and the context of display) as prospective or possible agents for engagement or change.

Yinka Shonibare MBE (b. 1962), a 2004 Turner Prize nominee, has used mixed-media tableaux to explore themes of cultural and colonial appropriation by referencing and hybridising Westernised canons of art and value systems which make explicit social and cultural difference. Using humour and irony, Shonibare has adapted conventions taken from eighteenth and nineteenth-century British portraiture to tackle

contemporary issues within post-colonial debate. These have ranged from a personal take on mutually assured class destruction through a duelling stand-off – '*How to Blow up Two Heads at Once (Gentlemen)*' (2006) to satires on the sexual adventures of aristocrats undertaken during the European Grand Tour, *Gallantry and Criminal Conversation* (2002).

With the work *Mr and Mrs Andrews* (1998) he cast in bronze and fibreglass the couple depicted in Gainsborough's painting of that title, but without their heads and devoid of the surrounding landscape which frames the country estate and identifies ownership and social status in the original painting. The reference to Britain's involvement in colonial exploitation and slavery (the origin of much of the wealth of the British aristocracy) is underlined by the dressing of both figures in African batik textiles, with the material actually originating from Indonesia – another legacy of divisive colonial histories. Shonibare's tableau *Diary of a Victorian Dandy* (1998) (Plate 15) (discussed in Chapter 4), in which he was photographed in the title role as the immaculately attired and wealthy object of his peers' and servants' admiration, also references stereotypical preconceptions of race, class and social identity.

More recently a major exhibition at the Stephen Friedman Gallery (*Flower Time*, December 2006–January 2007), has made even more explicit Shonibare's engagement with the contradictions and challenges of globalisation. The exhibition's theme was taken from the title work which depicted a handmade, mixed-flower bouquet fashioned from Dutch wax printed fabric. Described in the accompanying exhibition notes as a melancholy memento mori, *Flower Time* was intended by the artist as a response to the global political climate and to conflict in the Middle East.

The exhibition's centrepiece, *Black Gold* (2007), was a series of round black and gold painted wall installations set against a viscous background suggestive of oil. The timing of the exhibition – against a backdrop of recriminations over the Iraq invasion, and the acquisition of oil and its regional control as a US policy objective – made Shonibare's target seem explicit. But other readings suggested more historically distant subjects such as the legacy of resource exploitation and export by imperial western powers throughout the African subcontinent.

Shonibare's self-identification as a 'post-cultural hybrid' and his use of iconography also demonstrate the tangible effects of global shifts and cultural histories. Born in London to Nigerian parents, and schooled in Lagos, he is a graduate of Goldsmiths College. These cultural influences have informed the use of coloured, patterned fabric – Dutch Wax – throughout Shonibare's tableaux. Widely worn in contemporary Africa, Dutch wax fabric came from Indonesia from where it was exported across the colonial trade routes to Holland and then manufactured in Manchester's cotton mills. The completed fabric was then re-exported to markets in West Africa, where it was widely copied by indigenous peoples.

In re-appropriating these fabrics for his installations, Shonibare draws attention to cultural synthesis, difference and hybridity, and how these in turn mediate the legacy of colonial history, hegemony and asymmetries of power. The idea of relational antagonism noted earlier seems especially relevant to much of his aesthetic. The legacies of cultural difference, exploitation and racial conflict which are frequently referenced, both directly and elliptically, are not tractable issues easily resolvable in the post-colonial present by bland gestures of inclusion or cultural apology. Instead, through irony and humour, Shonibare's discursive tableaux and installations draw attention to these incomplete cultural histories, prompting the politicised and transitive spectator to play a more reflexive role in humanising contemporary and future narratives.

Liam Gillick (b. 1964) is a London and New York based artist and writer whose work came to critical notice in the early 1990s. He is among a group of contemporary artists whose work was foregrounded in relational aesthetics and postproduction, although Gillick has qualified and refuted some of the attributes and characterisations of his practice made by Bourriaud and Bishop.[68] Working in a wide range of media and formats, including installation, photography, performance, music composition, design and self-authored texts encompassing criticism, semi-fiction and speculative exploration, Gillick's work evades easy categorisation, but 'discursiveness' is one frequent adjective used by critics and peers who describe his practice. One contemporary curator and art critic, Peio Aguirre, has used the terms 'holistic, totalizing' and 'complex, meandering and nonlinear' to account for Gillick's diverse and expansive aesthetic.[69]

In very general terms, much of Gillick's work has been concerned to explore how bureaucratic structures, corporate organisations and other collective forums for social and political regulation and decision making (and the spaces they colonise) determine who we are and what we do – in the broadest sense. He has frequently adapted the opaque language and design rubrics associated with corporate and governmental language while seeking to question their original purpose, what one critic describes as resisting an administered present by quoting 'post-industrial society back at itself'.[70] For example, in tackling the administrative and functional arrangement of space in an office or factory, Gillick explores how the design of an environment can have both utopian potential whilst retaining a more limiting and restrictive sense of the present.

As some of these interests suggest, his aesthetic comprises wide-ranging interventions, actions and enquiries. In a collaborative series of interventions dating from the early 1990s and collectively titled *Documents*, Gillick and Henry Bond (b. 1966) gatecrashed a range of corporate events in the guise of business journalists and photographers. *Documents* comprises a series of variable quality photographs of auditoriums and conference rooms filled with suited middle and senior managers. For Monika Szewczyk, these

images explore the 'blurred subjectivity' arising from group-based decision making:

> We might see them as decoys … as devices – the real point of the exercise being to infiltrate these contemporary sites of decision making and gain greater proximity to closed-door discussions and information transfer.[71]

The Wood Way (Figure 3.6) was the title of an exhibition by Gillick held at the Whitechapel Gallery in 2002. It featured some of Gillick's signature brightly coloured aluminium and Perspex screens overlaid with text. As Marcus Verhagen notes of similar pieces:

> their clean lines and bright colors recalling high Modernist architecture and Minimalist sculpture while also pointing to contemporary corporate design and flat-pack furniture.[72]

The Wood Way was also associated with one of Gillick's texts, *Literally No Place*, a speculative and personal piece exploring ideas of utopia. At face value, the exhibition's title, *The Wood Way*, suggests something pastoral or picturesque – possibly a scenic (if longer) winding path through the trees to home or safety. It has connotations of the pre-industrial and the fabular; a known locality – a sense of destination.

Counterposed to this, the exhibition displayed brightly coloured but functional-looking screens, familiar as impromptu work space and desk dividers in open-plan offices or corporate suites. Across these, Gillick had inscribed strands of text as a stream-of-consciousness discourse which spectators encountered as they wandered through the configuration of screens. *The Wood Way* appeared to explore disjuncture and displacement; between the connotations of title and Gillick's text; between the bland placelessness of socially regulated, corporate space and the possibility of other forms of lived experience; and perhaps more meaningful vistas than those sanctioned by corporate modernity.

The examples of installation art considered so far have been made and conceived for interior gallery spaces of various sizes. But forms of environmental art such as graffiti and landscape-based practice can also make claim to installation status, since they share the expectation of an activated response and are conceived in a dynamic relation to the space and surrounding (frequently urban) environment. The anonymous graffiti artist popularly known as Banksy (b. 1974) has, in recent years, achieved an internationally recognised profile with his trademark signature of spray and template-based street art. In *Another Crap Advert* (c. 2002–05) photographed at Shoreditch Bridge, the subject of Banksy's image is the unsolicited corporate branding and advertising of goods and services within the urban environment – 'Brandalism'. (Figure 3.7). In *Wall and Piece* he notes:

Plate 1 Daria Martin, *Closeup Gallery*, 2003. 16 mm film, 10 minutes. Courtesy of Maureen Paley, London.

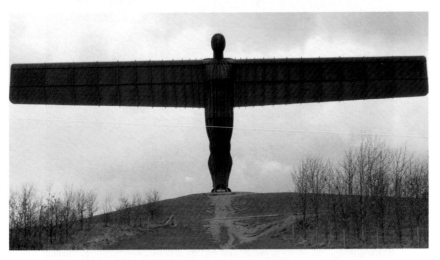

Plate 2 Anthony Gormley, *Angel of the North*, 1998. Corten steel, 20 × 54 m. Gateshead, UK. Courtesy of Dr Graham Whitham, 2010.

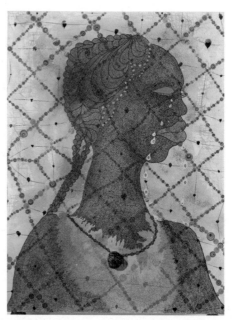

Plate 3 Chris Ofili, *No Woman, No Cry*, 1998. Acrylic, oil, polyester resin, pencil, paper collage, glitter, map pins and elephant dung on linen, 96 × 72 inches. © Chris Ofili. Courtesy of Victoria Miro Gallery, London. © Tate, London, 2010.

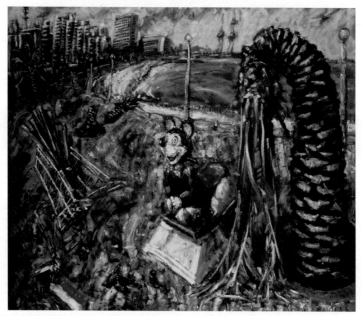

Plate 4 John Keane, *Mickey Mouse at the Front 1991*, 1991. Oil on canvas, 173 × 198.5 cm. © Imperial War Museum.

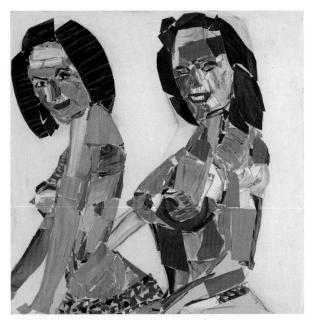

Plate 5 Martin Maloney, *Actress / Model #9 "Paris & Roma"*, 2007. Oil on canvas collage with wax encaustic and paper, 43 ½ × 43 ¼ inches. © the artist. Courtesy of Timothy Taylor Gallery, London.

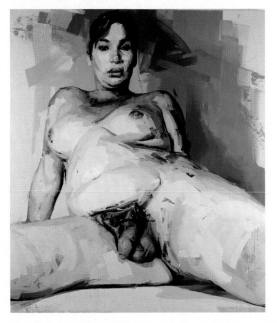

Plate 6 Jenny Saville, *Passage*, 2004-2005. Oil on canvas, 132^{1}/$_{8}$ × 114^{1}/$_{3}$ inches. © Jenny Saville. Courtesy of Gagosian Gallery, London.

Plate 7 Nigel Cooke, *New Accursed Art Club*, 2007. Oil on canvas, 220.2 × 370.2 × 7.1 cm. Courtesy of Stuart Shave/Modern Art, London, and Andrea Rosen Gallery, New York.

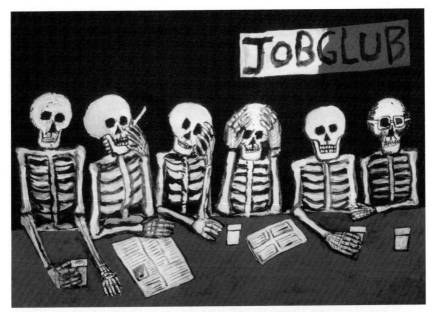

Plate 8 Philip Absolon, *Job Club*, 1997. Acrylic on board, 20 × 24 inches. © the artist. Courtesy of Philip Absolon, 2010.

Plate 9 Angus Pryor, *The Deluge*, 2007. Oil-based paint and builders' caulk on canvas, 2.4 × 2.4 m. © the artist. Courtesy of Angus Pryor, 2009.

Plate 10 Jack Vettriano, *Yesterday's Dreams*, 1994. Oil on canvas, 24 × 20 inches. ©
Jack Vettriano. www.jackvettriano.com.

Plate 11 Fiona Rae, *Lovesexy*, 2000. Oil, acrylic and glitter on canvas, 97 × 80 inches. © the artist. Courtesy of Timothy Taylor Gallery, London.

Plate 12 Gary Hume, *Four Coloured Doors II*, 1990. Gloss household paint on four canvases, 83¹¹/₁₆ × 231²/₁₆ inches. © the artist. Photo: Stephen White. Courtesy of White Cube.

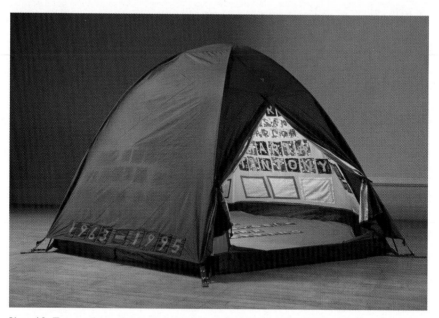

Plate 13 Tracey Emin, *Everyone I Have Ever Slept With 1963-1995*, 1995. Appliquéd tent, mattress and light, 48 × 96½ × 84½ inches. © the artist. Photo: Stephen White. Courtesy of White Cube.

Plate 14 Jake and Dinos Chapman, *Fucking Hell* (Detail), 2008. Glass-fibre, plastic and mixed media, (nine parts). 8 parts: 84⅝ × 50¹¹/₁₆ × 98⅞ in. 1 part: 84¹³/₁₆ × 50⅜ × 50⅜ inches. © the artists. Photo: Hugo Glendinning. Courtesy of White Cube.

Plate 15 Yinka Shonibare, MBE, *Diary of a Victorian Dandy: 14:00 hours*, 1998. Type C photograph. Each image size 183 × 228.6 cm; frame size 130 × 191 × 4 cm, Edition of 3 (1 AP). Courtesy of James Cohan Gallery.

Plate 16 Colin Booth, *Metropolis*, 2008. Found beech wood installation, dimensions variable. © the artist. Courtesy of Colin Booth, 2009.

Plate 17 David Batchelor, *Parapillar 7* (multicolour), 2006-7. Steel support with plastic, metal, rubber, painted wood and feather objects, 267 × 78 × 78 cm. Image courtesy of the Saatchi Gallery, London. © David Batchelor, 2009.

Plate 18 Pil and Galia Kollectiv, *Asparagus: A Horticultural Ballet*, Conway Hall, London, March 6 2007. 35 minutes. © the artists. Photographer: Chris Davis. Courtesy of Pil and Galia Kollectiv.

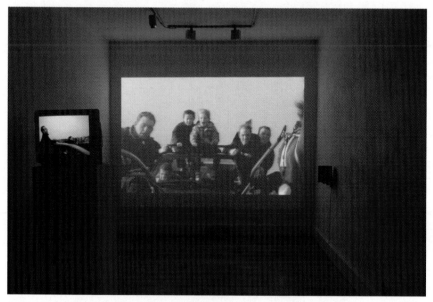

Plate 19 Clio Barnard, *Road Race* (installation view). Platform Gallery, January 2005. © the artist. Courtesy of Clio Barnard, 2009.

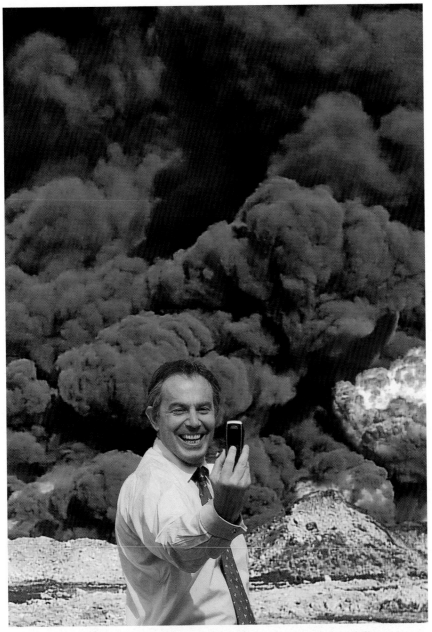

Plate 20 kennardphillipps, *Photo-Op*, 2005. Pigment print. © kennardphillipps. Courtesy of the artists. www.kennardphillipps.com. Originally printed on newsprint as a protest poster for the G8 protests in 2005. Subsequently printed as a pigment print for *Santa's Ghetto* in 2006; produced as a lightbox for exhibition.

Plate 21 Sam Taylor-Wood, *Still Life*, 2001. 35mm film/DVD, Duration: 3 minutes 44 seconds. © the artist. Courtesy of White Cube.

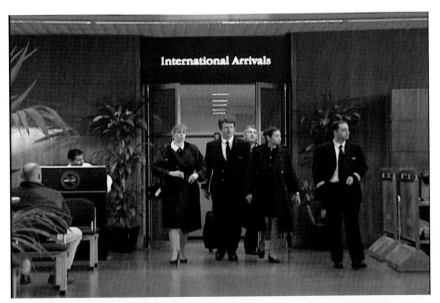

Plate 22 Mark Wallinger, *Threshold to the Kingdom*, 2000, (video still). © the artist. Courtesy of Anthony Reynolds Gallery, London.

Plate 23 Richard Billingham, *Untitled*, 1994. © the artist. Courtesy of Anthony Reynolds Gallery, London.

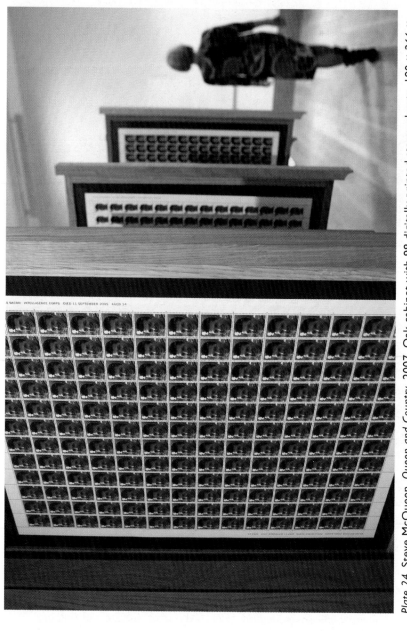

Plate 24 Steve McQueen, *Queen and Country*, 2007. Oak cabinet with 98 digitally printed stamp sheets, 190 × 266 × 140 cm. © Steve McQueen. Courtesy of Thomas Dane Gallery. Image © Getty Images / Cate Gillon.

Figure 3.6 Liam Gillick, *The Wood Way*, 2002. Courtesy of Whitechapel Gallery, Whitechapel Gallery Archive.

> Any advertisement in public space that gives you no choice as to whether you see it or not is yours. It belongs to you. It's yours to take, re-arrange and re-use. Asking for permission is like asking to keep a rock someone just threw at your head.[73]

Banksy's opposition to corporate advertising and his techniques of appropriation recall some of the principled stands made by members of the Situationist International (SI), a neo-avant-garde group which came to prominence in the 1960 and 1970s. Central to the SI was the strategy of '*détournement*' – the negation of existing elements and the 'organisation of another meaningful ensemble that confers on each element its new scope and effect'.[74]

The other strategy – the '*dérive*' is described by the art historian Robert Graham as a 'loosely programmed drift through urban spaces' which in

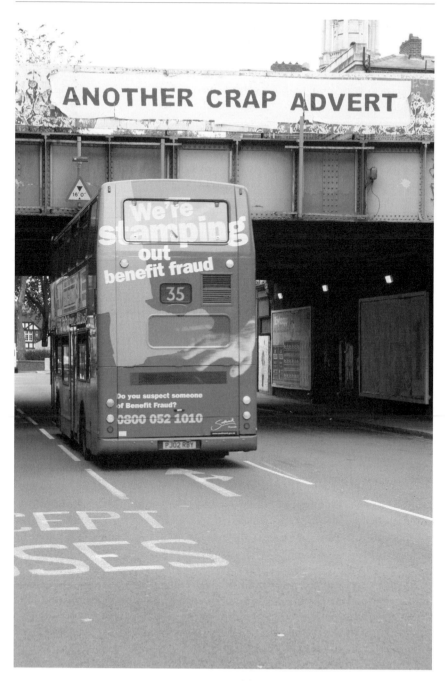

Figure 3.7 Banksy, *Another Crap Advert*, 2002–2005, Shoreditch Bridge, London.
Image courtesy of Steve Cotton/artofthestate.co.uk.

practice meant a general critique of the urban landscape.[75] The techniques of photomontage, graffiti and the modification of paintings can be seen as forms of contemporary *détournement* – and a re-engagement with the spirit of oppositional politics of the 1960s and 1970s. Banksy's title of *Another Crap Advert* is also consistent with aspects of the *dérive* understood as a critique of the commodification and colonisation of shared social spaces. Again, the idea of the activated spectator is not understood in any programmatic or political sense, but in opposing what is perceived as the imposition of corporate advertising and the cult of 'Brandalism', Banksy is suggesting the desirability of a different kind of contemporary attitude from just one of mute or indifferent compliance. The subsequent branding (and marketability) of Banksy's own practice is eloquent of the process and reach of contemporary cultural commodification.

Some examples of installation practice can be understood as influencing the activated spectator in more oblique ways. For example, while Gormley's *Blind Light* was mentioned earlier principally as an immersive and engulfing experience, it also had a tangible effect on individual and shared subjectivity – albeit temporary. One journalist anecdotally noted how a group of schoolchildren, making use of the concealment offered by the installation, initially refused to leave the refuge offered by its light and vapour. Apocryphal or otherwise, the story dramatises how an immersive installation can change the shared subjectivity or behaviour of those experiencing it.

To take another example, Hirst's installations were discussed earlier in relation to their effect on heightening experience and response – depicting spaces and anatomical interiors made possible through dissection and representation. But at a tangential level, the forms of production that his aesthetic relies upon might suggest a more 'social' and collaborative model for making contemporary art, which might alter a spectator's subjective response to cultural enterprise more generally. Hirst's reliance on teams of assistants to assist in the manufacture of his many spin paintings and installations is well documented. The art critic and writer John Roberts has noted Warhol's 'factory' approach to art as akin to a production line operation which, he suggests, can be seen as an attempt to engage with the democratic impulses of mass culture. Roberts notes:

> Warhol was interested in establishing a new democratic space for the production and reception of art, in which a deflated, de-heroicised and collectivised version of 'high culture' might participate in, and revivify, the banal and kitsch-exotic forms of mass culture.[76]

Hirst is known to have high regard for Warhol, in particular the latter's entrepreneurial approach to marketing, branding and self-celebrity which Hirst's own activities have largely emulated. Like Warhol's 'factory', his use of assistants in relation to the spin paintings came close to a franchising

operation, with multiple sets, series and editions. Throughout the 1990s, the composite installations that remain one of the hallmarks of Hirst's practice required increasingly high levels of production and finish, necessitating project planning, delegation and team-based, technical collaboration. This ethos of making art has much in common with the Minimalist practice associated with Donald Judd, whose carefully calibrated aluminium installations were manufactured to high specifications for him by small teams of engineers and product designers in Germany.

But unlike his Minimalist predecessor, Hirst's approach to making art, like Roberts's observation on Warhol, suggests a sensibility angled towards forms of mass culture which is, if anything, fairly conservative. As various commentators have noted, even in formal and iconographic terms, many of his installations adapt familiar memento mori themes and the established mimetic conventions of still life painting. Hirst's aesthetic looks to popular or mass culture, rather than high Modernist culture, for its material. In this sense, an activated spectator of Hirst's installation work might experience a confirmation of wider lived and social experience through the selection of subject matter taken from mass culture – the interior of a pharmacy or a hospital consulting room for example, and the corresponding implication that such subjects, and the forms of subjectivity they mediate, are as valid a basis for art and representation as anything else.

Writing in the 2005 *Beck's Futures* catalogue, the curator Jens Hoffmann noted the show's artists as being linked by their 'refusal of the market-affirming object-based practice of the ybas'.[77] The comment suggests that, for new generation of artists, such idioms – either installations or assemblages – had become closely linked with the YBA-dominated tranche of artists whose work had driven the contemporary art market throughout much of the 1990s. While the latter have provided some iconic examples of the genre (Gillick was also a Goldsmiths student, although not connected to this grouping), installation, assemblage and various forms of object-based practice, have been adopted by a generation of post-conceptual British artists in order to explore an expansive range of subjects and themes.

Although installation art has a relatively recent history, it arose from earlier, modernist avant-gardes and experimentation undertaken in opposition to the hegemony of painting and expectations of the medium-specific art-making associated with the aesthetic theories of Greenberg and Fried. As a genre, it has been informed by subsequent critical debates which have taken account of the changing material conditions of display, whether within a gallery space or as part of an outside urban location or landscape. In particular, installation art (and the ready-mades associated with Duchamp) have typically been cited in relation to George Dickie's institutional theory of art. An American philosopher and art theorist, Dickie has argued that for an object to be judged art, it must meet two criteria. First, it must have been changed in some way by human agency or

intervention. Second, the resulting object(s) must have been displayed or exhibited – in other words, given recognition by the art world. [78]

The institutional theory of art is classificatory – it simply identifies whether an object or practice might be designated as having the status of art. It does not provide guidance on whether (or how) one example might be judged qualitatively superior to another. The second validating criteria – the 'art world' – also implies a necessary consensus or agreement about artistic status among a multitude of dealers, curators, critics, gallerists, theorists – and artists. It is doubtful whether there are unified and agreed procedures for conferring the status of an art work in the first place. As various critics like Gordon Graham, have pointed out, the art world is heterogeneous and hardly a corporate entity where agreement can be assumed.[79] For example, the routine scepticism in some quarters that greets the announcement of the annual Turner Prize is not just about the works of art, but is a comment on the perceived credibility and institutional politics of the 'art world' itself.

But the importance of Dickie's theory for installation and related art practices is that it recognises the making and validation of art as a culturally relative phenomenon, rather than a timeless canon of art-making which can (or should) be restricted to particular genres such as painting or sculpture. It also moves the debate on from whether something is art or not (good or bad depending on the criteria applied), to questions concerning interpretation and communication – according to Bourriaud the relational component of much contemporary practice.

The proliferation of installation practice, particularly composite and often complex arrangements which feature differing materials, effects and registers of response, has foregrounded the extent to which contemporary art takes place within a highly pluralistic and inclusive spectrum. What has become in recent years the cultural mainstreaming of installation practice – in the United Kingdom as elsewhere – has given the genre a legitimacy and currency once reserved for Modernist painting and sculpture alone.

Although Bishop's categorisation of installation art does not claim to be a comprehensive or prescriptive basis for understanding the genre, it provides a framework for approaching and comparing the differing registers that practitioners use in order to solicit and engage responses from activated spectators. These ideas can be used to explore immersive, gallery-based film or video installations (discussed in Chapter 4) or, if installation is understood in a generic sense, the arrangement, layout and presentation of art works within an exhibition or display. Installation art takes as read the decentred and activated condition of contemporary spectatorship as it does the nuances of individual identity.

Some of the above examples suggest the emergence of a more critically engaged installation practice that is more sensitive to recent and contemporary political and social issues. In 2006, the Tate Modern curated *Media Burn*, an exhibition of political and protest art, including work from

the 1970s and 1980s onwards which underlined the continuity of dissent within British visual culture. A year later, two UK exhibitions, both including installation art, registered direct protest over the 2003 intervention in Iraq by the US and UK-led coalition and its political consequences: *Blairaq* by Peter Kennard and Cat Picton Phillipps (Leonard Street Gallery, EC2) and Mark Wallinger's *State Britain* (Tate Britain). Steve McQueen's photographic installation *Queen and Country* (2008), concerned with similar subject matter, has since toured extensively in the United Kingdom, supported by a growing campaign for Royal Mail to issue commemorative stamps in remembrance of soldiers who have lost their lives in Iraq (Plate 24).

Clearly, these are highly selective examples which share a particular focus or subject, but dissent and refusal has characterised other examples of installation practice. Landy's *Break Down*, for example, offered a more generalised critique of consumerism, as does Banksy's graffiti work, *Another Crap Advert*. Practices by Hatoum and Shonibare have given sustained critical attention to issues of social identity, displacement and cultural hybridity. The nuanced deliberations appreciable in installation practice by Gillick identify a lack and absence communicated through the architecture of public and private spaces; a language of euphemisms and mission statements which actually conveys social constraint and ideological concealment. Work such as *Fucking Hell* by the Chapmans raises the most fundamental questions about the inheritance of the European Enlightenment and how shared human agency can be rationalised through ideology to produce pathological and extreme outcomes.

The politicised register of these concerns is as evident across other genres and media within British art practice, from film and performance, as it is in examples of painting. Collectively, these instances serve to accent accelerating (and more long-standing concerns) over a range of issues, from climate change and the negative effects of globalisation, to the apparent erosion of civil liberties and political disenfranchisement. These issues, and the more recent global economic depression, have revitalised existing coalitions of dissident anti-war, environmental and protest groups, no longer persuaded that free market economics and a centralised political culture offer sustainable solutions.

'Sculpture in the expanded field' – traditions and revisions

While forms of installation and assemblage appear ubiquitous within recent and contemporary British art, what of sculpture and other, perhaps more discrete and previously distinct forms of object-based practice? Before the arrival of successive avant-garde movements in the early years and decades of the twentieth century, British sculpture as a genre had clearly defined social functions and aesthetic forms. As Andrew Causey notes, sculpture was a 'stable concept with fixed boundaries' which were defined by the 'votive,

commemorative, didactic and decorative' purposes for which it was produced.[80] It was typically understood as a distinct art form which depicted its subject matter figuratively, either in the round or in relief.

Throughout Europe much of the formal commemorative sculpture of the eighteenth and nineteenth centuries followed academic protocols and inherited ideas concerning idealised presentation taken from Hellenistic Greece, imperial Rome and the Renaissance.

In what was to become a highly influential essay, the art historian and critic Rosalind Krauss identified the 'expanded field of sculpture' which had characterised the practice of the 1960s and 1970s. Where once the 'logic of sculpture' had been 'inseparable from that of the 'monument', the genre had proliferated to include assemblages of objects, installations, gallery-based documentary practice. As Krauss continued:

> Nothing it would seem, could possibly give … such a motley of effort the right to lay claim to whatever one might mean by the category of sculpture. Unless, that is, the category can be made to become almost infinitely malleable.[81]

In the western tradition (Europe, North America, Australia and those parts of the world significantly influenced by these land masses), sculpture had been figurative and principally vertical, typically with a base or plinth. It had been carved, cast or modelled, with widespread use made of bronze, lead, plaster, marble, stone or wood. In the initial years of the twentieth century, many of these conventions and traditions were revised by modernism which undermined the hegemony previously exercised by the European Academies which had 'normalised' the use of sculpture (and painting) for largely institutional and official purposes.

Early in the twentieth century, the fashion for direct carving in the chosen medium, rather than casting from preliminary materials like wax or clay, became a defining feature of European modernist sculpture, popularised by practitioners such as Constantin Brancusi, Henri Gaudier-Brzeska and Jacob Epstein. A subsequent generation of British sculptors including Barbara Hepworth, and Henry Moore continued the tradition, creating radically abstract sculptural forms.

By the mid-twentieth century, the legacy of totalitarianism and two world wars had not only lessened the appetite for memorial and commemorative sculpture as such, but broader shifts in social relations had transformed its relationship to 'audience', refashioning sculpture as an increasingly expansive and interactive medium. By the 1960s, Minimalist and performance-based artists, opposed to painting and an institutionally prevalent Modernism, further expanded the categories and forms of sculpture. Minimalist and conceptual work by Eva Hesse, Robert Morris, Donald Judd, Robert Smithson and Sol Le Witt explored the 'newer'

mediums of aluminium, latex, plastic and zinc. Judd's trademark 'stacks' – evenly spaced rectangular metal boxes cantilevered off gallery walls – used prefabricated and pre-welded steel, a technology then being developed for the construction and engineering industries. The development of Minimalist sculpture as an increasingly mixed-media and interactive undertaking ensured that it became the focus of Modernist and anti-Modernist claims to value and meaning, aspects of which were discussed earlier in relation to Fried's article 'Art & Objecthood'.

Parallel to these debates, the British artist Eduardo Paolozzi (1924–2005) produced large metal sculptures while his contemporary Robert Morris investigated ideas of 'anti-form' – using non-traditional materials, processes and conjunctions, thereby shifting attention away from the specificity of traditional aesthetic forms and contexts. London's St Martins College of Art became associated with the so-called 'New Generation' sculptors. Philip King (b. 1934), William Tucker (b. 1935) and David Annesley (b. 1936) explored abstract forms and combinations in their own work, although the shared influence had been the exploration of syntax, rhythm and interlinking abstract forms by the Modernist sculptor Anthony Caro (b. 1925). Rejecting traditional ideas of carving and modelling, New Generation sculptors, like their Minimalist contemporaries, adapted construction and moulding techniques from product design and manufacture. The use of strong and frequently primary colours underlined the abstract 'modernity' of this new aesthetic, which paralleled Minimalist innovation in America.

In opposition to the formalist concerns of New Generation British sculptors, Gilbert Proesch (b. 1943) & George Passmore (b. 1942), having recently graduated from St Martins College of Art, designated themselves as Gilbert & George – 'Living Sculptures'. Costumed and choreographed as metallic-looking mannequins, they re-enacted the Hardy and Hudson version of the depression-era music hall song *Underneath the Arches* by Flanagan and Allen. This signature performance, perennially reprised and represented in varying durations and contexts, became central to Gilbert & George's artistic personae and their subsequent aesthetic.

Although the robotic continuity of the piece recognised the legacy of Minimalism, it also underlined the extent to which British sculpture in the later 1960s and 1970s became increasingly hybrid and porous, melding with assemblage and installation, rather than being a primarily medium-specific practice. Instead, to label an art work as 'sculpture' suggested a wide range of assemblage and mixed-media practice which implicated both audience and context in the communication (and deferral) of meaning. Noting these shifts, Causey describes Minimalist sculpture as 'situational and conditional' and as having a 'positive relation to the physical presence of the viewer'.[82] Similarly, by the 1980s there ceased to be argument over the 'temporality' of sculpture – the fault line which had characterised Modernist and Minimalist disputes in the 1960s.

These earlier shifts towards a more expansive idea of sculpture provided a post-conceptual generation of British artists from the mid-1980s onwards with an open-ended spectrum of practice which could be customised to explore different forms, subject matter and effects. For example, an interest in mass culture, identity and urban iconography as such was not just a feature of the YBAs, but was anticipated in work by Helen Chadwick (1953–1996), Tony Cragg (b. 1949), Richard Deacon (b. 1949), Anish Kapoor (b. 1954) and Richard Wentworth (b. 1947). Surveying these and earlier shifts, the art historian and art critic Rosalind Krauss identified a new condition or 'expanded field' of sculpture in which the fixity of commemorative or memorial sculpture, historically plinth-mounted and frontal, had been superseded by discursive and typically mixed-media practices and interventions. For Krauss, the absence of assumptions about place, location and increasing self-referentiality encoded sculpture's 'negative condition'.[83]

Unmonumental: The Object in the 21st Century (2007) was the inaugural exhibition that marked the opening of the New Museum of Contemporary Art on the Bowery, New York. The ambitious survey exhibition was an attempt to survey the character and diversity of contemporary sculpture in the half-dozen years since the start of the new millennium. International in scope, it featured work by a range of British practitioners which, for the curators, shared this new zeitgeist – a composite aesthetic of fragmentation and resistance. But in stressing its anti-monumentality, the curators also recognised a pervasive refusal of hierarchies of material or format. Contemporary sculpture was seen as having accelerated trends towards assemblage, bricolage and diverse object-based making identified by Allan Kaprow and Krauss, although some practitioners retained an interest in the medium-specificity and syntax associated with Modernist theory.

Sculpture as commodity and appropriation

The emergence in the mid-1980s of work by Haim Steinbach (b. 1944) and Jeff Koons (b. 1955) provided a new inflexion to the Duchampian tradition of the found object and the ready-made. Steinbach's 'shopping sculptures' used everyday consumer objects and brands, arranging them in multiples in signature triangular formats that suggested the gaze of the detached ethnographer. The display of Steinbach's commodity objects matched the use of Plexiglass vitrines by Koons, whose cool surfaces and pristine objects combined a fetishistic sensibility with what could be interpreted as an existential vacuity. For example in *Three Ball Total Equilibrium Tank (Two Dr J Silver Series, Spalding NBA Tip-Off)*, the suspension of the three basketballs in liquid stasis was identified by one writer as an allegory of 'being and nothingness'.[84]

The hyper-realism of New York commodity sculpture (combined with references to British mass culture) was a formula adopted by several of the

YBAs. Damien Hirst and Marc Quinn used glass vitrines to house their composite sculptures and assemblages. Highly figurative installations by Abigail Lane, Sarah Lucas and Gavin Turk referenced both a grunge aesthetic and a burgeoning consumer and celebrity culture. Turk's (b. 1967) life-size wax self-portrait as the Sex Pistols bassist Sid Vicious in *Pop* (1993) selected a commodified and safely neutralised icon, presented in the stance of Warhol's painting of Elvis Presley dressed and armed as a cowboy.

Pop captured a pervasive cultural condition of quotation and re-appropriation. In Turk's slick portrayal of the hyper-real, Punk's anarchic and vibrant counterculture was subsumed and anaesthetised as a remote, ethnographic sign. *Pop* offered a take on the postmodern culture of the simulacra – a copy of an original that no longer existed. As a metaphor, it also characterised the schizophrenic and randomly cannibalistic character of late modern culture. Turk's sculpture *Cave* (1991) offered further reflection on the constructed nature of celebrity and the vacuous self-referentiality of the contemporary cult of personality. A pastiche of the blue ceramic plaques used by English Heritage to record the residences of famous people on historic buildings, it was instead inscribed with the words 'Borough of Kensington Gavin Turk Sculptor Worked Here 1989–1991' and was submitted in lieu of work for his MA degree at the Royal College of Art.[85]

A graduate of Goldsmiths College and a participant in the *Freeze* exhibition in 1988, Sarah Lucas (b. 1962) was among the artists included in the *Young British Artists II* show at the Saatchi Gallery (1993). Lucas has made sculptures and installations which explore and satirise the objectification and treatment of the female body within contemporary media culture. For several months after the Saatchi show, Lucas worked with her friend and contemporary Tracey Emin in running and curating *The Shop*, the premises of a former taxi company which were used to sell jointly fashioned art merchandise.

Sculpture and installations by David Batchelor (b. 1955) explore a very different register of interests. An artist, writer and lecturer at the Royal College of Art, Batchelor has undertaken an intensive investigation into the cultural aesthetics of colour and its synthetic transformation through petrochemicals and electrification. His first major text on the subject, *Chromophobia* (2000), asserted the premise that western culture has long perceived colour as an 'object of extreme prejudice'. The apparent fear of 'contamination and corruption through colour' has, according to Batchelor, been signified by its relegation as the 'other' – a realm of the exotic, the feminine, the aberrant or the pathological.[86] A related anthology, *Colour (Documents of Contemporary Art)*, was published in 2008.

Batchelor's aesthetic parallels, and is informed by, the crusading zeal of his writing, which is committed to reclaiming colour's central place within contemporary art and urban culture. *Brick Lane Remix I* (2003) was part of a series of installations which comprised shelving units and found light boxes,

the projected neon recreating the locale and aura of London's multi-ethnic heartland. Since 2006, Batchelor has developed a new group of sculptures which he has termed '*Parapillars*' (Plate 17). Each assemblage comprises hundreds of small, brightly coloured plastic objects – the usual ephemera of cheap combs, hair grips, mirrors, pegs, clips, brushes, toys and utensils. These were usually foraged and bought in bulk from high-street pound shops and discount outlets where Batchelor happened to be living or working; Edinburgh, Glasgow and London offering some of the favoured buying areas. The totemic character of the *Parapillars* was provided by the lightweight Dexion shelving units typically used in shops and industrial storage facilities which enabled Batchelor to hang and attach his finds to a flexible and adjustable base.

Initially showcased in Edinburgh's Talbot Rice Gallery, Batchelor's *Parapillars* were exhibited as *Unplugged (remix)* at the Wilkinson Gallery, East London in 2007. When experienced and seen collectively, these festooned totems are visually compelling; the meticulous placing of up to 500 artificially coloured plastic objects on each *Parapillar* gives an immediate experience of sensory overload. The gallery catalogue described these as 'flimsy and mass produced' objects which carried 'no cultural weight' or connotations of 'status for their owners'. It continued:

> Their colour is a vivid marker of this lack of value, but at the same time it also offers a temporary release from these same conditions.[87]

But the objects that populate these assemblages suggest what curator, Martin Holman has described as signifiers of 'global economic exchange'.[88] Typically produced in China and imported, the use of the highly coloured ephemera identifies broader themes of 'connectivity' and interconnection. As Holman continued:

> linkages branch into networks like pegs on a steel armature. Batchelor unfolds possibilities around his core concern with colour: from shape to colour to line … frame and border, society and artistic practice, and between art and life.[89]

Batchelor's *Parapillars* confront the spectator with the logic and excess of commodity capitalism and with the allure of under-noticed ephemera, shipped around the world to bedeck pound shops and discount stores.

A graduate of the University of Ulster, Belfast (1993) and Goldsmiths College (1999), Eva Rothschild's (b. 1972) typically elegant abstract sculpture combines the formal geometry of Minimalism with patterns and designs associated with new age spirituality – variations of pyramids and spheres are recurrent archetypal forms. Her sculpture juxtaposes 'soft' materials such as incense candles, leather fringes (*High Times*, 2004),

transparent acrylic, resin and wood (*Stairway*, 2005), with steel – the organic and the inorganic. As Helen Luckett notes, industrial processes of manufacture combine with craft: 'Her work embraces abstract geometrical forms and representational objects, and for both types of sculpture the precedents lie in the art and culture of the late 1960s'.[90]

Rothschild's giant sculpture *Cold Corners* (2009) was installed at Tate Britain's Duveen Galleries, the first UK space dedicated entirely to the exhibition of sculpture (Figure 3.8). Comprising twenty-six interlinking giant metal triangles made from aluminium box tubing, *Cold Corners* spanned the gallery's entire interior space, reaching as high as the architraves. Described by curator Katharine Stout as 'like a scribble in space', Rothschild's composite sculpture had an open form, its interlinking shapes asserting a dynamic presence within the Duveen Galleries.

The presence of *Cold Corners* was defined by open rhythms and syntax as well as by scale and size. Rothschild's sculpture is as much composed as constructed. Earlier sculptors like Anthony Caro in pieces such as *Early One Morning* (1962) also experimented with open and irregular forms which critics such as Greenberg saw as analogous to the abstract, all-over compositional forms of Modernist painting. Rothschild's open, light and airy sculptures reprise the language of Modernism, but they do as magnified quotation – refashioning the neoclassical interior of the Duveen Galleries as a space for exploration and visual experimentation.

Sculpture, ambivalence and the abject

As an increasingly porous category of practice, British sculpture has in recent decades demonstrated a renewed interest in depictions of the human form, a trope it has shared with aspects of performance practice discussed in the next chapter. Hal Foster's *Return of the Real* (1996) offers an account of the apparent return to illusionistic practice and the actuality of the body within recent art practice, described at one point, in relation to work by Warhol, as instances of 'traumatic realism'.[91]

As discussed in Chapter 4 in relation to performance, the abject is understood as a pervasive psychological condition and sensibility which contemporary society seeks to deny or conceal. Popularised by Julia Kristeva's text 'Powers of Horror: An Essay on Abjection' (1980), the abject, among other things, suggests ambiguity, fragility, the collapsing of boundaries and the trauma of the subject. According to Kristeva, the exploration of provocative or extreme subject matter can have a cathartic effect on human subjectivity by drawing attention to the artificial mores of social rationality and preconceived ideas of order and control. These are among the reasons for interest in the abject among recent and contemporary artists spanning the genres of installation, performance, film and video.

Other theorists have also drawn upon a post-Freudian psychoanalytic

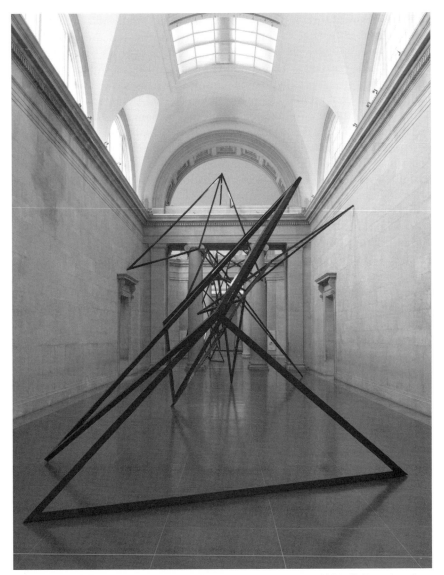

Figure 3.8 Eva Rothschild, *Cold Corners* (Duveen Installation), 2009. © Tate, London 2010.

tradition referenced by Foster and Kristeva in order to identify broader directions and pathologies within recent and contemporary cultural practice. Janine Chasseguet-Smirgel's *Creativity and Perversion* (1992), although centrally concerned with group psychology and political discourse, offered important insights on art, abjection and human subjectivity. Its author established linkages between Freud's 'anal structure of perversion'

and 'regressive and sadistic' impulses which abolished sexual and generational difference.[92] The book's main interest was the relationship between pre-genitality (the stage before the recognition of sexual difference occurs) and creativity. Understood in its more pathological forms, externalised pre-genitality could result in obsessive and aberrant compulsions, extreme narcissism and fetishism.

Developing the phenomenological perspectives on human response and engagement discussed earlier in relation to installation practice, these perspectives understand human subjectivity and selfhood as fragile and constructed. Rather than a humanistic tradition represented by earlier sculptural traditions, examples of installation, sculpture and performance practice have broached subjects which might be perceived as challenging, transgressive, or which tackle conventional interpretations and representations of the human. For example, the iconography explored earlier by Sue Noble and Tim Webster's *Black Narcissus* (see pages 138–140) or by the Chapmans in relation to *Fucking Hell* (pages 143–145) might be understood in relation to some of the more extreme character pathologies suggested by Kristeva and Chasseguet-Smirgel. The candid and highly confessional register to work by Tracey Emin (pages 151–152) might be seen as abject insofar as it suggests personal catharsis, challenging some of the conventional assumptions regarding biographical disclosure in art.

The abject can also be applied as an adjective to subject matter or techniques within art practice which may appear unusual, challenging or uncanny. Consider for example David Falconer's (b. 1967) *Vermin Death Stack* (1998) (Figure 3.9). The totem-shaped sculpture comprises hundreds of freeze-dried rat carcasses encased in fiberglass and resin. Exhibited in the *New Blood* show which marked the first anniversary of the Saatchi Gallery at its temporary venue, London's County Hall, *Vermin Death Stack* explores a 'logic of excess'. Falconer adapts organic material with gothic connotations of plague and infestation, by using the preserving agents of extreme temperature and fibreglass to replicate the durability of more traditional sculptural materials. Like examples of practice by Jake and Dinos Chapman, with whom Falconer has been compared, the sculpture objectifies and perhaps caricatures ideas of permutation and replication until both concepts are nullified through sheer excess.

Other sculptors have explored themes of corporeality and the abject by combining unusual media with traditional forms of self-portraiture. Since 1991, Marc Quinn (b. 1964) has made a series of sculptural casts of his face using eight pints of his own blood. The sequential casts which capture Quinn's transformation and ageing were inspired by a cast of William Blake's face. *Self* (1991) conflates the cultural practice of the death mask and the memorial conventions of self-portraiture with contemporary refrigeration technology (Figure 3.10). The blood required to make the sculpture was taken from the artist over five months and then poured into

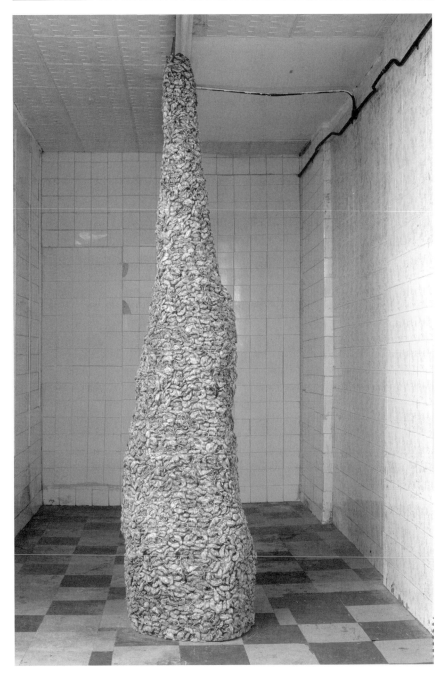

Figure 3.9 David Falconer, *Vermin Death Stack*, 1998. Cast resin, enamel paint, 301 × 91.5 × 91.5 cm. Image courtesy of the Saatchi Gallery, London. © David Falconer, 2009.

a dental plaster cast of Quinn's head which was frozen and placed in a Perspex cube connected to a customised refrigeration unit. Quinn experimented with silicone and other materials to create an inert barrier to stop the head from desiccating and crumbling whilst frozen. The pristine, rectangular stainless steel refrigeration cabinet anachronistically suggests the plinth and verticality of traditional, memorial sculpture, but unlike its marble and stone antecedents, Quinn's self-portrait is fragile and unstable. Dependent upon electricity and refrigeration to prevent thawing and melting, *Self* is a metaphor of transience and fragility.

With *Lucas* (2001), Quinn modelled a cast of his son's head, three days after his birth, using the child's liquidised placenta. Quinn has acknowledged how themes of dependency, separation and emergence underpin the work. At interview he noted:

> A baby's head is physically sculpting itself. The plates are all soft and every day the head is changing shape. In a sense, he's making a sculpture of himself. The fact that it's cast in placenta comes from the idea of separation from his mother's body and becoming himself ... The placenta is a material meeting point between the two ... [93]

The visceral qualities of these and other works by Quinn accent the boundaries and porosity of the human body. With *Lucas*, the use of the placenta literalises the child's relationship with the mother and its separate, but dependent entry into the world. Curator and gallery director Victoria Pomery has discussed the dynamic of these sculptures in terms of attraction towards the form and repulsion at the use of medium. In the catalogue which accompanied Quinn's retrospective at Tate Liverpool, she described the beauty of the form and the surface of the blood which had crystallised during freezing, whilst acknowledging repulsion at the use of material. She continued:

> Blood, like faeces and marble, has both symbolic and literal associations and Quinn uses these associations to explore the polarities of inside/ outside, natural/artificial, seduction/repulsion and also the points at which such polarities collide.[94]

These sculptures index and hold in stasis the fragile border and boundary between interior and exterior which, for Kristeva, comprises one aspect of the abject. In these examples, form and content are inseparable dimensions of shared self-portraiture. Whilst Quinn has worked with the genre's traditional votive and commemorative uses, his work has nevertheless revised and expanded material concepts of what sculpture might be – or become.

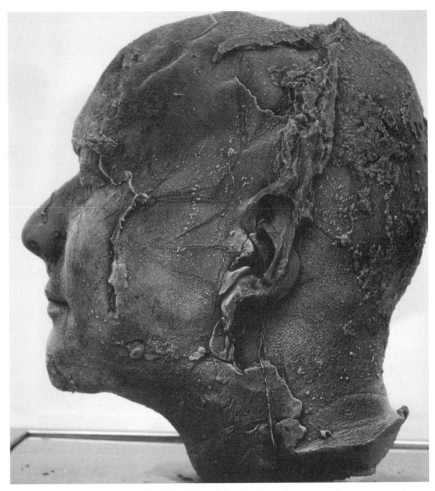

Figure 3.10 Marc Quinn, *Self*, 1991. Blood (artist's), stainless steel, perspex and refrigeration equipment, 81⅞ x 24¹³⁄₁₆ in. (208 x 63 x 63 cm). © the artist. Photo: Stephen White. Courtesy of White Cube.

Notes

1 Nicolas Bourriaud, *Relational Aesthetics*, Translated by Simon Pleasance and Fronza Woods (les presses du réel, 2002), p. 18.

2 Julian Stallabrass, *Contemporary Art: A Very Short Introduction* (Oxford University Press, 2006), p. 17.

3 Clarrie Wallis, entry on David Batchelor in *Days Like These: Tate Triennial Exhibition of Contemporary British Art* (Tate Publishing, 2003), p. 42.

4 See Julie H. Reiss, *From Margin to Center: The Spaces of Installation Art* (MIT Press, 2000).

5 Claire Bishop, *Installation Art: A Critical History* (Tate Publishing, 2005), p. 6.

6 Nicholas de Oliveira, Nicola Oxley and Michael Petry, *Installation Art* (Thames & Hudson, 1998), p. 8.

7 Jonathan Harris, *Art History: The Key Concepts* (Routledge, 2006), p. 163.

8 James Hall, *Hall's Dictionary of Subjects & Symbols in Art* (John Murray, 1996), p. 27.

9 Simon Morrissey, *Richard Wilson* (Tate Publishing, 2005), p. 14.

10 Richard Wilson interview, *the EYE, Illuminations Video* (2001).

11 Morrissey, *Richard Wilson*, p. 19.

12 Andrew Graham-Dixon, *A History of British Art*, BBC, 1999, p. 237.

13 Robert Irwin quoted by Bishop, *Installation Art*, p. 57.

14 Morrissey, *Richard Wilson*, p. 7.

15 See Michael Fried's essay 'Art and objecthood', extracts reprinted in Charles Harrison and Paul Wood (eds), *Art in Theory 1900–2000: An Anthology of Changing Ideas* (Blackwell, 2003), pp. 835–46.

16 Ibid., p. 845.

17 For a more detailed discussion of some of these issues see Frances Colpitt, 'The Formalist connection and originary myths of conceptual art', in Michael Corris (ed.), *Conceptual Art: Theory, Myth, and Practice* (Cambridge University Press, 2004), pp. 28–49.

18 Maurice Merleau-Ponty, *The Phenomenology of Perception* (1998 trans., p. 320), quoted by Bishop, *Installation Art*, p. 50.

19 As installation art took on a more conceptual direction in the later 1960s, the emphasis on perceptual and bodily response shifted to the idea of a more intellectual and critical engagement. See Alex Potts, entry on Maurice Merleau-Ponty in Diarmuid Costello and Jonathan Vickery (eds), *Art: Key Contemporary Thinkers* (Berg, 2007), p. 135.

20 Bishop, *Installation Art*, p. 10.

21 Ibid., p. 11.

22 Ibid., p. 13.

23 Bourriaud, *Relational Aesthetics*, p. 43.

24 Ibid., pp. 14–16, 27.

25 See Bishop's article 'Antagonism and relational aesthetics' in *October*, issue 110 (Fall 2004), pp. 31–79.

26 Peter Bürger, *Theory of the Avant-Garde* (University of Minnesota Press, 1984).

27 John C. Welchman, *Art After Appropriation: Essays on Art in the 1990s*, (Gordon and Breach, 2003), pp. 19–20.

28 Bishop, *Installation Art*, pp. 14–16.

29 James Putnam, *Polymorphous Perverse*, explanatory text for the Freud Museum exhibition, 8 November 2006–7 January 2007.

30 Terry Eagleton, *The Ideology of the Aesthetic* (Blackwell, 1990), p. 264.

31 Putnam, *Polymorphous Perverse*.

32 Quoted by Louisa Buck in *Moving Targets 2: A User's Guide to British Art Now* (Tate Publishing, 2000), p. 130.

33 For an exploration and discussion of themes and interests, see for example Gordon Burn's reviews in *Sex & Violence, Death & Silence: Encounters with Recent Art* (Faber & Faber, 2009), pp. 309–55.

34 Quoted in Norman Rosenthal, Michael Archer, Michael Bracewell, James Hall and Nathan Kernan, *Apocalypse: Beauty and Horror in Contemporary Art* (Royal Academy of Arts, 2000) (exhibition booklet accompanying the Royal Academy of Arts exhibition).

35 James Hall, 'Jake and Dinos Chapman: collaborating with catastrophe', in Rosenthal et al., *Apocalypse*, p. 215.

36 See Simon Barker 'Promotional trip to Hell', in *Fucking Hell*, Jake and Dinos Chapman (Jay Jopling/White Cube, London, 2008, pp. 6–17). Text and paper listing of watercolour works accompanied the exhibition *If Hitler Had Been a Hippy How Happy Would We Be* (May–July 2008).

37 Simon Barker, 'Promotional trip to Hell', p. 14.

38 Jake Chapman and Dinos Chapman, interview with William Furlong, *Audio Arts Magazine*, vol.15, no. 3 (1996).

39 Olafur Eliasson in interview with Dana Lixenberg, *Tate Magazine* (September/October 2003), p. 64.

40 Helen Luckett, *Blind Light* (exhibition guide, Southbank Centre, 2007), p. 1.

41 Anthony Gormley quoted in *Blind Light* exhibition guide, p. 10.

42 Dalya Alberge, 'My art scares you', *The Times*, 15 May 2007.

43 Bishop, *Installation Art*, p. 8 .

44 Michael Archer, *Installation Art* (Thames & Hudson, 1998), pp. 120–1.

45 See the interview with Lisa Tickner, 'A strange alchemy,' in Gill Perry (ed.), *Difference and Excess in Contemporary Art: The Visibility of Women's Practice* (Blackwell, 2004), pp. 46–73.

46 Ibid., p. 51.

47 Ibid., p. 66.

48 Interview commentary, Lisa Tickner, p. 65.

49 Mandy Merck, 'Bedtime,' in Mandy Merck and Chris Townsend (eds), *The Art of Tracey Emin* (Thames & Hudson, 2002), p. 119.

50 David Bussel, catalogue entry for Tracey Emin, *Sensation, Young British Artists From the Saatchi Collection* (Thames and Hudson/Royal Academy of Arts, 1997), p. 197.

51 Tracey Emin in conversation with David Nairne, *This is Another Place* (exhibition booklet, Modern Art Oxford, 2002).

52 Simon Barker, Preface to the exhibition catalogue for *Revealing Light* (Sassoon Gallery, Folkestone, 2004).

53 Colin Booth in Grant Pooke, *Metropolis and Streamline: Iconographies of Time & Light* (exhibition catalogue, Herbert Read Gallery, Canterbury, 2009).

54 Bishop, *Installation Art*, p. 102.

55 Ibid., p. 119.

56 Bishop, 'Antagonism and relational aesthetics', *October*, issue 110 (Fall 2004), p. 79.

57 Sarat Maharaj, 'Perfidious fidelity: the untranslatability of the other', (1994) in Jason Gaiger and Paul Wood (eds), *Art of the Twentieth Century: A Reader* (Yale University Press, 2003), pp. 298–304.

58 Tim Cumming, 'Stuff and nonsense,' *Guardian Arts Education*, 13 February 2002.

59 Michael Landy interviewed by Julian Stallabrass, *Break Down* (Artangel, 2001), pp. 114–15.

60 Julian Stallabrass, *High Art Lite: British Art in the 1990s* (Verso, 2001), p. 6.

61 Michael Landy quoted by Gaby Wood in 'Going for broke', *Observer Review*, 3 February 2001.

62 Ibid.

63 Judith Nesbitt, 'Everything must go', in Judith Nesbitt and John Slyce, *Michael Landy. Semi-detached* (Tate Publishing, 2004), pp. 12–13.

64 *State Britain* exhibition text, project ed. Lillian Davies (2007).

65 Clarrie Wallis, quoted from *State Britain* (2007).

66 Adrian Searle, 'Bears against bombs', *Arts Guardian*, 16 January 2007.

67 Gill Perry, 'Dream houses: installations and the home', in Gillian Perry and Paul Wood (eds), *Themes in Contemporary Art* (Yale and Open University, 2004), p. 248.

68 See for example Liam Gillick's 'Contingent factors: a response to Claire Bishop's '"Antagonism and relational aesthetics"', *October*, issue 115 (Winter 2006), pp. 95–106.

69 Peio Aguirre, 'Elusive social forms', in Monika Szewczyk (ed.), *Meaning Liam Gillick* (MIT Press, 2009), p. 1.

70 Gair Boase, in Szewczyk, *Meaning Liam Gillick*, p. 70.

71 Monika Szewczyk, 'Introduction', in *Meaning Liam Gillick*, p. xvi.

72 Marcus Verhagen, 'Conceptual Perspex', in Szewczyk, *Meaning Liam Gillick*, p. 47.

73 Banksy, 'Brandalism', *Wall and Piece* (Century, 2005), p. 196.

74 'Détournement as negation and prelude' (unattributed), reprinted in K. Knabb (ed. and trans.), *Situationist International Anthology* (Bureau of Public Secrets, 1981), p. 55.

75 Robert Graham, 'In search of a revolutionary consciousness: further adventures of the European avant-garde', in Paul Wood (ed.), *Varieties of Modernism* (Yale University Press/Open University, 2004), p. 385.

76 John Roberts, 'Warhol's "Factory:" painting and the mass-cultural spectator,' in Wood, *Varieties of Modernism*, p. 339.

77 Quoted by Adrian Searle, 'Say it with flowers', *Arts Guardian*, 22 March 2005.

78 See George Dickie, *Art and the Aesthetic* (Cornell University Press, 1974).

79 Gordon Graham, *Philosophy of the Arts: An Introduction to Aesthetics* (Routledge, 1997), p. 157.

80 Andrew Causey, *Sculpture Since 1945* (Oxford History of Art, 1998), p. 1.

81 Rosalind Krauss, 'Sculpture in the expanded field', in *The Originality of the Avant-Garde and Other Modernist Myths* (MIT Press, 1986), p. 277.

82 Causey, Sculpture Since 1945, p. 9.

83 Ibid.

84 Thomas Kellein, *Pictures: Jeff Koons 1980–2002* (Distributed Art Publishers, 1998), p. 19.

85 See Gavin Turk's biographical entry in *Sensation*, p. 208.

86 David Batchelor, *Chromophobia* (Reaktion, 2000), pp. 22–3.

87 David Batchelor, *Unplugged (remix)* (exhibition catalogue, Wilkinson Gallery, 2007).

88 Martin Holman, 'David Batchelor Unplugged,' *Art World*, Issue 1, October/November, p. 44.

89 Ibid., pp. 44–5.

90 Helen Luckett, entry for Eva Rothschild, in Alex Farquharson and Andrea Schlieker (eds), *British Art Show 6* (catalogue for Hayward Gallery touring exhibition, 2005), p. 80.

91 Hal Foster, *The Return of the Real: The Avant-Garde at the End of the Century* (MIT Press, 1996), p. 130.

92 Otto Kernberg, 'Foreword' to Janine Chasseguet-Smirgel, *Creativity and Perversion* (Reaktion, 1992), p. ix.

93 Marc Quinn interviewed by Sarah Whitfield, in Christoph Grunenberg and Victoria Pomery (eds and curators), *Marc Quinn* (catalogue, Tate Liverpool, 2002).

94 Victoria Pomery, 'Art about life,' in Grunenberg and Pomery, *Marc Quinn*.

New Media in Transition: Photography, Video and the Performative

Introduction

> Documentary modes still appeal to institutional modes of power/ knowledge and cite their authority, but the effect is rather a personal doubt; a blurred and agitated documentary uncertainty ... pertinent as an image of our times.
>
> (Maria Lind and Hito Steyerl, 2008)[1]

The increasingly digitised technologies of photography, film and video pervade contemporary life as the central media of communication, experience and surveillance. Modernity has been mediated through the photographic – the mechanical means of reproducing a fixed image of the external world. The medium also registers the ubiquity and spectacle of contemporary advertising and consumer culture, among the most visible characteristics of the developed world. Refinements in digitised image making, and the use of computers and the internet as aesthetic media in their own right, have established new paradigms and platforms for experiencing, curating and making art.

The referentiality of the photograph – the representation of people and objects – has typically taken precedence over the medium's formal qualities. Unlike the genres of abstract painting and sculpture, we typically see 'through' a photograph rather than look 'into' the process of its making. In the United Kingdom as elsewhere, the various categories of the photographic, have used and adapted some of the identifiable conventions associated with painting and sculpture, as well as those of newer genres like performance with which they share cultural histories. Writing in the early 1990s the late photographic historian Graham Clarke noted the paradox that:

> Despite its populist base, the photograph, for all its capacity to reproduce the literal, retains the values and hierarchies so much associated with what might be viewed as its opposite: academic painting.[2]

These connections identify photography's earliest role: its supplementary and illustrative use for the preparation of sketches for drawing, printing or painting. The device of the 'camera obscura' (literally a 'dark room') was the result of light entering through a small hole in the wall of a darkened room which cast an inverted full-colour image on the surface of the opposite wall. These associations prompted Roland Barthes's description of photography as being 'tormented by the ghost of painting'.[3]

Since Clarke's observation, the various forms and formats of the photographic have dissolved many of these dependencies, becoming increasingly hybrid in technique and expansive in subject matter. Although portraiture, landscape and the abstract effects of deadpan and tableaux photography remain widespread, other genres have become prominent such as video art, social documentaries and reportage, docu-fiction and internet-based practice. While digitised film and photography are art and aesthetic media in their own right, they also remain the default options for recording and documenting otherwise transient performances and installations.

In recent years a significant change has been the migration of film and video from the unified viewing conditions of the art cinema to the environment of the white cube gallery, and the more interactive audience opportunities that these spaces offer. In retrospect, this can be seen as a culmination of successive technological shifts: the replacement of much experimental film and photography by video in the 1980s and the progressive replacement of video by DVD and digitised projection technology from the mid-1990s onwards. In parallel with these shifts, the moving image, and the equipment needed to show it, have become increasingly portable and miniaturised. For example, advanced post-production and editing software is widely used within art photography, extending trends apparent within commercial photography and advertising.[4]

It has also been suggested that in the first decade of the twenty-first century the ownership of mainstream communication media has become increasingly centralised and subject to corporate agendas. The Swedish critic and academic Stefan Jonsson has recently described the 'increasing conformism of global mass media' which has lessened the criticality of news and features coverage.[5] One consequence of this has been the default and pervasive politicisation of previously marginal forms of photographic and documentary-based practice. The 'political' here is not just understood in a narrow or partisan way (although the definition includes this), but as a more general exploration and engagement with social issues, ethnicities and experience, what Jonsson describes as 'people's ability to represent themselves and their interests in the public sphere'.[6]

These two processes – the apparent evacuation of criticality from the global news media and its migration and exposition to forms of social engagement within aesthetic practice – are opposing sides of the same coin. Nowhere has this process been more apparent than with the various forms

of the photographic, the filmic and the performative. The mediation of these issues within British art is itself part of a globalised re-emphasis of the political appreciable across recent and contemporary art practice.

Photography: contexts and histories

Photography was recognised by the avant-gardes of the 1920s and 1930s as one of the 'dynamic forms of modernity', its subversive forms and images becoming a 'troubling' presence for subsequent avant-garde art and theory.[7] Although sidelined by Modernist theory for its narrative content and level of mechanisation, photography's attractiveness for these historic avant-gardes was its implicit resistance to painting and sculpture and the cultural politics of the academy which both represented.

As photography's formal and social potential became recognised, it began to attract its own critical discourse. Walter Benjamin's essay 'The work of art in the age of mechanical reproduction' (1936) asserted that photography offered the prospect of vanquishing painting's 'aura' – the authenticity and effect registered through direct encounter with a unique and original painting. The mass circulation of art through the technological reproduction promised by photography also extended the prospect of its cultural ownership beyond the traditional social and political elites which had historically commissioned and owned it. As Benjamin noted:

> But the instant the criterion of authenticity ceases to be applicable to artistic production, the total function of art is reversed. Instead of being based on ritual, it begins to be based on another practice – politics.[8]

Photography did not just delineate new forms of cultural politics and relationships of production, but also offered the prospect of disseminating radical forms of consciousness through the techniques of montage and photomontage. Benjamin's prescient essay heralded photography's growing importance and its eventual challenge to painting and sculpture as dominant modes of avant-garde practice. Recognition of the medium's increasingly mainstream cultural status has generated a distinct literature which drew upon and developed some of Benjamin's ideas as well as the subsequent insights of critical and literary theory. These perspectives have prompted an awareness of the photograph as text, the meanings of which could be indeterminate and ambiguous within cultural representation. The following is a highly selective and very brief listing of some publications that have provided important insights into the medium.

Photography's subversive cultural and aesthetic contribution was among the themes tackled in the collaborative anthology of essays *Ways of Seeing* (1972), edited by the art critic and cultural theorist John Berger. Among Berger's central points is the radical change brought about by photographic

technology. Like the perceptual shifts signified by Impressionism and Cubism, the medium of photography questioned the dominance of single-point perspective which had informed European picture making since the Renaissance. Photographic technology made explicit the extreme variability of that encounter: that we see and experience the dimensionality and 'objectness' of things in time and space.

Referencing Benjamin's earlier work and ideas, Berger argued that photographic technology made a virtue of the medium's reproducibility; multiple images could be made effectively and quickly in ways that rendered them entirely independent of context or location, a flexibility which had characterised the popularity of easel painting in the fourteenth and fifteenth centuries. Berger also noted photography's more ambivalent role, acknowledging the medium's continued use to commodify objects for sale and exchange.[9]

Roland Barthes's posthumously published *Camera Lucida: Reflections on Photography* (1980) is a highly personal exploration of the photographic and its resonance for the author. Among the influential distinctions that Barthes makes is one that concerns the 'studium' and the 'punctum'. The studium, from the Latin to 'study', refers to the photograph's broader cultural context and meaning. The 'punctum', taken from the Latin word to puncture, refers to the instantaneous reaction that photographic subject matter or a particular detail can arouse. In a much-quoted passage, Barthes describes the punctum as 'that accident which pricks me (but also bruises me, is poignant to me)'.[10] Elsewhere, in an expansive series of personal asides and discussions, Barthes explores the connections between photography and theatre, photography and the elegiac, and photography as an apprehension of death. These reflections also underlined the emblematic and symbolic resonance of the photographic as a cultural medium and as an object of avant-garde practice (and academic study) in its own right.

Other formative texts include Victor Burgin's collection of essays *Thinking Photography* (1982) and John Tagg's *The Burden of Representation: Essays on Photographies and Histories* (1988). Burgin argued that photographic theory should be concerned not just with technique and process, but with broader interdisciplinary issues concerning cultural meaning and signification. Although it recognised that such theory was at an early stage, *Thinking Photography* foregrounded the medium's inherent ideological status, the centrality of critical theory, and the importance of freeing it from reliance on the same aesthetic theories as had characterised approaches to other cultural and aesthetic forms. Tagg explored the photographic in relation to theories of hegemony, social surveillance and the development of the modern State, questioning its claim to being a 'record of reality'.[11]

In a frequently quoted observation from Susan Sontag's *On Photography* (1979), the author considers photography's purchase on reality, suggesting that whereas painting and writing share what is described as a 'narrowly

selective interpretation', photography mediates a 'narrowly selective transparency'.[12] Similarly, for Sontag, the photograph's actual subject matter, what it is a photograph 'of', invariably takes precedence over formal qualities – we see through the medium to the representation of content. More recently in *Regarding the Pain of Others* (2003), Sontag has explored the contradictions that attend the use and role of the photographic and photojournalism in recording conflict and trauma. While acknowledging accusations of spectacle, she nevertheless calls for an 'ethics of looking' in confronting the reality of others' suffering.

Graham Clarke's *The Photograph: A Visual and Cultural History* (1997) offered a series of essays, with specific chapters exploring the medium through the themes of landscape, the city, portraiture, the body and social reportage.[13] The social role and presence of portrait photography and the dynamics of that encounter were the subjects of the short but acutely observed anthology of essays, *Face On: Photography As Social Exchange* (2000), edited by Mark Durden and Craig Richardson. Among its particular concerns was 'the common and more everyday sense of a social real' and how this determined the shifting 'relationship artists have with the subjects they represent'.[14]

Further recognition of photography's increasingly mainstream status and its maturation as a cultural practice is evident from the growth of short accounts of the discipline's history and development such as *Photography: A Very Short Introduction* (2006) by Steve Edwards, and anthologies such as *The Photography Reader* by Liz Wells (2002). The recognition of film cultures in transition, both in the United Kingdom and internationally, informs Tanya Leighton's and Charles Esche's *Art and the Moving Image* (2008). The reinvention of documentary practice in recent years and its apparent merging with conceptual, performance and video practices are the subjects of the anthology, *The Greenroom: Reconsidering the Documentary and Contemporary Art #1*, edited by Maria Lind and Hito Steyerl (2008).

The first stage of a major international three-part research project, *The Greenroom* (its title taken from the discursive space used in television stations just before and after filming), is designed to 'overcome the dispersion of texts on documentary practices' and to offer critical perspectives on new directions and forms of practice. Individually and collectively, these publications acknowledge film, video and photography's increasingly central cultural status, becoming, as Esche has noted, 'privileged form[s] for artistic experimentation and communication'.[15]

The UK's own major galleries and museums were slow in giving to photography the kind of recognition accorded to other mediums. Tate Britain's first exhibition dedicated to photography, *How We Are*, effectively a three-part photographic history starting in 1840 and co-curated by Susan Bright and Val Williams, was only held in 2007. It was not until the 1990s that the Tate started to develop a dedicated photographic collection.

Among the consequences of this institutional 'catch-up' was the emergence of a national network of smaller-scale private and public exhibition spaces which sustained and supported the development and display of British photography in the 1980s and 1990s, including the Photographers' Gallery, London (1971), Open Eye, Liverpool (1977), Ikon (Birmingham), the Arnolfini Gallery (Bristol), and the ICA, Serpentine and Hayward spaces.[16]

The use and recognition of film and photography as specifically fine art 'ends' in themselves, rather than technical 'means' of providing news, documentary, entertainment and advertising, is a relatively new development. The historic avant-gardes of the 1920s and 1930s – Constructivism, Dada and Surrealism – recognised in the techniques of montage, juxtaposition and adjacency a profoundly 'social' category of cultural production. But as Steve Edwards has noted, by the time of the Paris World's Fair of 1937, 'photomontage had been domesticated'.[17] Although the mass propaganda campaigns undertaken in Soviet Russia and by the Axis countries had used the 'factuality' of photography for documentary and film purposes, such regimes ultimately favoured representational and monumental forms of painting and sculpture.

Photography and film were widely used as documentary media by conceptual artists and by practitioners of performance art in the 1960s and 1970s as a means of recording otherwise ephemeral installations and events, enabling their reproduction and dissemination through magazines and art journals. These media were widely employed to record 'actions explicitly staged or performed for the camera', and also used in combination with text passages to produce 'complex narratives (or anti-narratives) whose status as artworks was uncertain'.[18] From this period, photography began to establish independence and institutional recognition as an art form in its own right. Practically, the increasing portability of hand-held cine cameras, and the use of direct sound and recording equipment, gave film a perceived authenticity and immediacy. These developments, and the continuing use of film to record and document the conflicts and the civil unrest of the 1960s and 1970s, also linked it more directly to contemporary countercultures.

Narratives and countercultures: video and performance art

Sony's invention of the Portapak video camera in the mid-1960s was a major technological development, enabling cheap, direct and individualised recording. Previously the most portable format had been the hand-held cine cameras that used 35 mm film reels, although some film makers continued using both 16 mm and 8 mm formats for their work.[19] Until the mainstream adoption of video by the music and entertainment industries in the 1980s, many artists who worked with the medium had highly critical views of television as a mass technology. But the extension and popularisation of

television across the developed, and increasingly the developing world, gave the moving image a cultural pervasiveness and ubiquity achieved by few other communication media. Artists associated with the neo-avant-gardes of the 1950s and 1960s such as Nam June Paik (1932–2006) and Wolf Vostell (1932–1998) had variously responded to television's cultural ambiguity by wrapping one in barbed wire, distorting broadcast images using magnets and cannabalising parts from televisions to make small robots.

One of the reasons for such a negative response to television arose from the apparent passivity of the viewer and (implied) consumer in relation to the broadcast content of the various terrestrial television channels. Although deregulation and satellite technology have provided greater flexibility and increased viewer choice, content is still determined by corporate broadcasting and scheduling agendas; even the advent of digitisation and multiple pay-per-view channels has done little to change this underlying power relationship. The invention of the portable video camera promised real-time recording, immediacy and greater personal 'agency' or control, if not in viewing film footage, then at least in making and editing it.

In the 1980s the first colour video cassette recorders appeared. Video (from the Latin 'videre', to see), is a time-based electronic imaging medium which enabled effects unavailable to static format photography, painting and sculpture. The subsequent invention and commercial marketing of the camcorder was accompanied by further refinements in digital technology. In turn this enabled the origination and manipulation of high-definition images (including computer-assisted imaging) which have largely superseded the use of video tape and cassettes for recording. The development and phasing out of Kodak's Polaroid camera in 2009 and the decision to end the retailing of video cassette players were consequences of technological obsolescence and the increased portability and flexibility offered by digitised recording technologies.

Although digitised mediums have largely replaced video, the latter is still used to indicate works that project images onto a screen, although other terms are used such as digital art, multimedia art and new media art. Digitisation has made photographic and film media infinitely malleable, enabling new forms of cultural production. Images can be manipulated, filtered, scaled and enhanced; as software and editing technology becomes faster, smaller and more memory efficient, artists have greater flexibility, enabling post-production work to be undertaken on location, in the studio or on the move.

In 2007, the same year as the Tate's inaugural photography exhibition, the ICA and Beck's commissioned a series of video and music events – *Beck's Fusions*, centred around London's Trafalgar Square. Viewers entered a 12 metre high viewing pod which had been installed on the Square's north terrace steps, complete with multiple screens. Inside, the work of ten video artists had been commissioned with the proviso that the outcome be set

against unfamiliar cover versions of well-known music. The curator, David Metcalfe, used the central London site and the prospect of passing commuters being attracted by the music, to encourage a re-reading of video's cultural status. As he noted:

> People who are used to seeing video in relation to music, on TV and on pop videos, will find this gives them a different sense of what's possible. The video can be its own thing, rather than being subservient to the music.[20]

The work included film by Turner prize nominees Jane and Louise Wilson, of Swan Hunter shipyards and Kazakhstan landscapes set to Cat Power's cover of *Who Knows Where the Times Goes?* Another piece by the US-based conceptual artist Douglas Fishbone combined a remixed version of the Strauss piece, *Also Sprach Zarathustra* (popularised by Stanley Kubrick's sci-fi film, *2001: A Space Odyssey*), with video footage of surfers. In an effort to broaden and extend the exhibition's audience, the film footage was presented at a ticketed, open-air performance event and subsequently toured in Dublin, Manchester and Glasgow.

The techniques of refamiliarisation used by the artists and curator recognised that art films and art videos are still seen as relatively 'esoteric' forms of contemporary art practice, despite the technology's wider use within commercial advertising and mass culture. Obliquely and perhaps unintentionally, *Beck's Fusions* also traced back the social and cultural origins of video to the alternative music and dance scenes of the 1980s and the genre's ambivalent relationship, both to the institutions of the art world and to what became an increasingly packaged entertainment industry in the decades that followed. Like earlier avant-garde art, video practice was domesticated through its increasing placement within art galleries and the associated replacement of TV monitors with cinema-type projection screens, fixtures more suited to the scale and spectacle required by art institutions and exhibition spaces.

Video art and music videos were in many respects the defining art genres of the 1980s, as performance and land art had been the signature art forms of the 1960s and 1970s. But they were also part of a surviving, if residual, counterculture of performance, film, fashion and dance, celebrated by the Institute of Contemporary Art's (ICA's) 2007 retrospective, part of the title of which was taken from the Jon Savage and Linder fanzine *The Secret Public*, created in 1978. If the emergence of the YBAs in the early 1990s was emblematic of a new cultural moment, it was preceded by various subcultures which grew out of punk, 'confrontational sexualities', civil unrest, the rise of Thatcherism and the cultural politics of the perceived AIDS crisis. Describing the ICA retrospective, *The Secret Public. The Last Days of the British Underground 1978–1988*, its curators outlined the exhibition's aim to examine:

a practice which was deeply concerned with gender, sexuality and the performative self In this it also engaged with fashion, dance, performance, film and music. As such it surveys perhaps the last period in British culture before the rise of the consumer environment and the flattening of subcultural manifestations and creative industries into a single, pasteurized range of commodified styles.[21]

Although some commentators suggested that such a reading was overblown, the exhibition was important and iconic in various ways. As the curators noted, much of the art film and experimental video of the period combined Dada's subversive legacy and the political commentary of Hannah Höch with celebrity culture and the ideas of William S. Burroughs. With 'fluency in the reading of style cultures', a range of film and video artists used critical theory and literature in a response to 'a semi-futuristic, post-industrial world'.[22] The ICA exhibition was important because it dramatised how video technology had enabled the performance, recording and display of subcultures in ways similar to the earlier avant-garde use of photomontage – the combination of photographic images and texts, as political, if stylised, acts of refusal.

The film maker, painter, gay activist and writer Derek Jarman (1942–1994) was among those whose work was profiled. In films such as *Jubilee* (1977), *The Tempest* (1979) and *The Last of England* (1987), he developed a highly experimental and lyrical style, combining provocative and sensual cinematic montage with Baroque spectacle. Although Jarman used a small Super 8 camera for shooting films such as *The Last of England*, the footage was transferred to video for editing, before being released on 35 mm for showing. Jarman celebrated video as an alchemical medium, recalling:

> You could achieve effects on video which would have cost a fortune on film ... blown up to 35mm, the quality is something quite new, like stained glass The video gives you a palette like a painter, and I found the result beautiful.[23]

Other contemporaries who realised the social potential of film and video production, and whose work was profiled, included Victor Burgin, Marc Chaimowicz, Cerith Wyn Evans, Isaac Julien, Tina Keane, Rik Lander and Peter Boyd Maclean (aka the 'Duvet Brothers').

A graduate of St Martins College of Art, Julien (b. 1960) was one of the five young film makers who, with Martina Attille, Maureen Blackwood, Nadine Marsh-Edwards and Robert Crusz, established the Sankofa Film and Video Collective (1983–92). Like other independent film-based initiatives such as Ceddo and Retake Film & Video, the venture mediated intergenerational Black and Asian experiences of contemporary culture and politics to new and broader audiences. Julien had come to prominence

with *Looking for Langston* (1989), a meditation on the work and legacy of the
Harlem Renaissance poet and writer Langston Hughes (1902–1967). The
16 mm film short, shot in black and white, combined archive newsreel
footage of Harlem in the 1920s with an impressionistic, evocative exploration
of black and gay desire and identities. Subsequent work such as Julien's
critically acclaimed film *Frantz Fanon: Black Skin, White Mask* (1996) resulted
in his Turner Prize nomination in 2001.

Like some of the narrative painting discussed in Chapter 2, much of the
experimental film and video of this period was a politicised response to the
socially polarised experience of growing up and living in the United
Kingdom in the 1980s. The repressive deployment of State power by the
police, and widespread perceptions that it was unchecked and unduly
coercive, were among the causes of the inner-city riots and demonstrations
that took place at Toxteth in Liverpool, Brixton in London (1981) and
Birmingham, in the UK Midlands (1984). Longer-term grievances included
a volatile combination of high youth unemployment and social alienation,
high crime rates, poor infrastructure and housing, and a history of alleged
police harassment.

The subject and context of some of Julien's work, and that of other British
film makers and video artists at the time, included the repressive anti-gay
legislation symbolised by the introduction of Clause 28 of the Local
Government Act (1988). A controversial amendment to existing legislation,
it explicitly prohibited the 'promotion of homosexuality' and gay
relationships in schools, but the framing of the clause was so broad that it
was applicable to a range of activities, including plays and public
performances, if they were in receipt of government funding. Clause 28
resulted in widespread and divisive self-censorship as individuals and groups
acted to avoid the risk of any possible prosecution. Although it was eventually
repealed after sustained campaigning, the restrictive ethos of Clause 28 was
symptomatic of highly regressive ideas on social identity and lifestyles.

Clause 28 and the institutionalised homophobia it underlined were the
subjects of the short film *Pedagogue* (1988) by video artist Stuart Marshall
(1949–1993) and the theatre producer and performance artist Neil Bartlett
(b. 1958). The ten-minute clip, an acutely observed and amusing monologue
delivered by Bartlett about his personal effects and clothing, was pointedly
interspersed and filmed with footage of his school pupils discussing his
teaching. Another health and social issue that became politicised was the
AIDS virus (Acquired Immune Deficiency Syndrome). The various
campaigns of the time were the subject of Julien's *This is Not An AIDS Ad*
(1987), an eleven-minute video clip, among the earliest independent film
interventions on the subject, following a major government campaign
earlier that year.

Video and performance-based practice was also adopted by artists to
assert and choreograph more flamboyant refusals and to affirm other social

and sexual identities than those 'officially' sanctioned. The Australian-born artist, model, and fashion designer Leigh Bowery (1961–1994) deployed film and performance to record and document a self-created persona, that of a transgender dandy, extrovert and exhibitionist. In 1988 he delivered and choreographed a week-long in situ performance at Anthony d'Offay's West End Dering Street Gallery. Using a chaise longue, a two-way mirror, and aided by various fashion props, Bowery shared personal and intimate moments with a street audience of passers-by, shoppers and commuters.

Performance art, like Bowery's, and the wider idea of the performative – human actions and interventions made within or beyond the recognisable contexts of gallery or exhibition spaces – shared with photography and film a subversive cultural history. Bowery's transgressive performances acknowledged older traditions of dissent and cabaret, traceable to the international Dada and Surrealist avant-gardes of the 1920s and 1930s. These influences had in turn been invoked by the Fluxus 'happenings' of the 1950s and the neo-Marxist ideas of the Situationist International (SI) in the decade that followed.

The use of artistic or stage personae is a strategy that has been adopted by other British artists. In the case of George Passmore (b. 1942) and Gilbert Proesch (b. 1943), it had been used to fashion an entire artistic and life partnership. Since the late 1960s, they have become known simply through the shared personae of 'Gilbert & George'. Their carefully orchestrated aesthetic combines photographic self-portraiture with immaculate and sustained performances as metropolitan flâneurs and dandies which have become iconic. Their signature suits, demure appearance but highly driven work ethic provide a particularly British inflexion to an aesthetic which is otherwise based on permutation, repetition and a much earlier tradition of libertine and Sadean excess.[24]

More recent film-based and performance interventions have adapted the subversive aesthetic of Savage and Linder with the legacy of modernist cabaret, Dada and politics. Pil (b. 1975) and Galia (b. 1976) Kollectiv are artists, writers and curators who work collaboratively. Based in London, their work encompasses film, video, sculpture, curation and installations related to their film practice. Graduates of Goldsmiths College (2000–01) and Central St Martins College (2002–03), their curatorial work has included *DaDaDa: Strategies Against Marketecture* (2004), *Turn to the Left* (2005) and *Modern Lovers* (2006).

More recently, the Kollectiv have increasingly situated their practice as a response to what they have described as the 'diluted form of modernism that continues to seep into contemporary culture'.[25] These interventions have taken diverse forms and have spanned very different registers – from politics and aesthetics to cuisine and cultural-lifestyle commentaries. As the Kollectiv state of their aesthetic:

We often use choreographed movement and ritual as both an aesthetic and a thematic dimension. Reading Dada, Constructivism and the Bauhaus backwards through punk and new wave, we find new uses for the failed utopias of the past.[26]

Asparagus: A Horticultural Ballet (2007) was a live performance piece delivered at Conway Hall, Holborn, London (Plate 18). Like the Dada legacy which it partly emulates, *Asparagus: A Horticultural Ballet* has composite and diverse cultural influences. It was partly influenced by Oskar Schlemmer's undocumented *Triadic Ballet* (c. 1922) and the defunct, but musically pioneering New Jersey synth and electronic pop band *xex* and its founding member Waw Pierogi. The Kollectiv came across music from the band's only released LP, *group xex* (1980), and a story of an experimental audio-visual work which was never realised. The 'lost work' was themed from clues relating to 'rotating hanging baskets of asparagus ferns' and 'attendants serving platters of freshly cooked asparagus'.[27] In the absence of any score or choreography for the idea, the Kollectiv chose extracts from Karl Marx's social and economic critique, *Das Kapital*, as a means of asserting the cabaret's modernist and subversive criticality:

> *Das Kapital* seemed both obvious and ideal, being itself the story of abstraction, with human relationships transposed … in the joyless grind of endless accumulation while producing the transcendent mythical figure of capital. Consequently, our ballet narrates the rise of capital in the medium of asparagus.[28]

In keeping with the textual appropriation, the performance was divided into three acts, each equating to the component parts of Marxist infrastructure: commodities, labour and capital. Members of the Canadian 'petrochemical rock trio' Les Georges Leningrad provided the electronic score to the stylised dance of asparagus spears which ensued. As Jonathan Griffin acutely noted of the cabaret's aspiration:

> By reframing the most significant political theory of the last two centuries … they were perhaps simply seeking to colour Pierogi's work with some of the brave ambition of Marx and the Bauhaus … abstracting a set of histories to the point at which they broke from their original meanings and became alive once more in new hands.[29]

As the Kollectiv have stated, their act of 'retro-gardism … ransacks the past for future activation'. Like the frail utopias that underpinned the modernist dreams of the 1920s and 1930s, a work fashioned from an idea looks to the future with humour – and a reflexive sense of possibility. In their use of (re-)modernist iconography and critical enquiry into its legacy, the Kollectiv

explore themes that inform the work of other contemporary artists such as Martin Boyce (b. 1967), Paulina Olowska (b. 1976) and Mark Titchner (b. 1973).

Performance, abjection and other narratives

As some of these examples suggest, performance remains closely associated with the genres of still photography, film and video. As a practice and genre, performance exists in time and space, and has been historically reliant upon the mediums of video and photography to preserve a tangible record or trace of the event or intervention having 'happened'. The transience of performance, landscape or environment-based interventions was, for many practitioners in the 1960s and 1970s, a way of circumventing dependency on the gallery system. The stance was part of a broader critique of Modernism and the perceived co-option of contemporary art practice. However, digitally based recording and DVD back-ups are now the norm for contemporary performance events, providing a durable and often institutionally based archive, from which copies of particular events may be purchasable.

Performance strategies and associated 'happenings' by feminist artists and social activists concerned with subverting the objectification of the female body and in making explicit the role of the male gaze and its normalisation through historic and contemporary power structures, have an established history. More recent feminist and critical theory has considered the extent to which all forms of identity, whether social or gender-based, are 'performative' – enacted by repetition and negotiated through the embodied character of our experience.

These perspectives have tended to question previous 'essentialist' arguments which understood sexuality and social identity as generally more fixed and given attributes. Judith Butler's book *Gender Trouble* (1990) explored some of the complex interdependencies of sex, gender and identity, and the last section, 'Subversive bodily acts', considered the idea of performativity itself. A recurrent theme was the experience of those whose sexual identity had been marginalised by a received framework which assumed heterosexuality as a given, rather than just one orientation on a fluid spectrum of gay, transgender, asexual and hermaphrodite orientations and possibilities. As the cultural theorist Vicki Kirby has noted, the creation of social and sexual identity results from the repetition of actions that cement the signification of its components – sex, gender and the body.[30]

Given the social importance of these debates and the literal centrality of the body and personal identity to performance art, it is hardly surprising that various British artists have developed practices that have tackled issues of sexual identity and 'normative' expectations of what that identity might or can be. Performance art has frequently broached these issues, questioning

broader social and cultural assumptions which are ultimately framed and imposed through the hegemony of powerful institutions – whether those of church and State, or the typically more tacit and implicit value structures of corporate organisations and the culture industry.

A significant category through which some of these perspectives have been explored is that of abjection. Although it forms a distinct strand within British performance art and object-based exploration (see pages 174–179), it has also characterised aspects of European and American practice. Issues relating to abjection have been popularised by the linguist and theorist Julia Kristeva in her short but highly influential essay, 'Powers of horror: an essay on abjection' (1980). For Kristeva, the abject is 'a point of ambiguity beyond what can be rationally coped with by either the individual or society'.[31] She writes:

> All literature is probably a version of the apocalyptic that seems to me rooted … on the fragile border … where identities (subject/object, etc.) do not exist or only barely so – double, fuzzy, heterogeneous, animal, metamorphosed, altered, abject. … / … in these times of dreary crisis, what is the point of emphasizing the horror of being?[32]

For Kristeva, the abject amounts to a pervasive psychological, material and cultural condition which conventional society, dedicated to instrumentality and logic, attempts to conceal or mask. As a transformative and fluid state, the abject has been invoked to account for a range of scatological material and challenging subject matter tackled by British artists such as Franko B., Chris Burden, Stuart Brisley, Jake and Dinos Chapman, Martin Creed, David Falconer, Gilbert & George, Rebecca Horn, Sarah Lucas, Kira O'Reilly, Tim Noble and Sue Webster. An international selection would additionally include names such as Vito Acconci, Ron Athey, Eva Hesse, Nan Goldin, Robert Mapplethorpe, Orlan, Gina Pane, Joel-Peter Witkin, Andres Serrano and Cindy Sherman.

As these examples suggest, the exploration of the abject extends across a diverse and international range of art practice, but the centrality of the body and its associated iconography has given it particular resonance and topicality within the genre of performance. But the privileging of the body within performance practice is also closely linked to the associated idea that our response to art and the realm of the aesthetic is itself 'embodied' – rooted within wider sense perception. In part this might be understood as a reaction to the ideas of Modernist theory, which emphasised that aesthetic practice (and our responses to it) was, and should be, principally visual in character. Some of these issues were discussed earlier in relation to phenomenology and installation practice.

Kira O'Reilly (b. 1967) is a graduate of Cardiff School of Art and makes video, performance and installation works. In the performance work *Succour*

(2002 and 2003), she applied a tight grid of masking tape to her upper torso and legs. Using a scalpel as part of a meticulously undertaken process, the artist subsequently made and repeated a shallow diagonal cut to the small area of her skin within each of the resulting multiple squares. The tape was then removed, revealing the carefully orchestrated lattice of small cuts (Figure 4.1). As O'Reilly notes of her aesthetic practice, 'Although all my methods are self-taught, they are made with extreme care and deliberation. Techné is fundamental'.[33]

The word 'techné' references the Greek idea and commitment to craft or skill. In the classical world such craft was conveyed through the relative formality of statues and mosaics which had various ceremonial and civic roles. Within Greek culture, sculpture (frequently of the human figure or of named deities) was judged by the extent to which the use of craft or skill represented the most lifelike duality of body and soul (as these ideas where then understood).[34] It might be suggested that both the formality and implied vulnerability of *Succour* mediates a similar melding of the viscerally present body and an evocation of the transcendent other. Alternative readings of the piece have suggested different dualities of exposure and concealment. As one commentator wrote of *Succour*, 'The literal wounding can read as a metaphor for tenderness and disclosure, and the skin as analogous to social guardedness'.[35]

Within the Judaeo-Christian tradition of western painting, the lacerated male body is closely associated with religious imagery depicting the scourging, crucifixion and deposition of Christ, as well as with the iconography of particular saints such as Saint Sebastian. O'Reilly's carefully orchestrated performance might be read as a considered reversal of this masochistic and patrilineal ordering, reclaiming and literally reinscribing female agency. In relation to ideas of the abject, the traditionally bounded and enclosed body is shown to be fissured, porous and fluid. The choreographed aesthetic performance of *Succour* encourages an audience receptive to some of these cultural registers to rethink and reconceive previously unquestioned and ostensibly given relationships.

O'Reilly's *inthewrongplaceness* (2006) has been made and re-enacted six times, each in a specific and already existing space. The four-hour version made and performed at Newlyn, Cornwall, took place in a disused working men's club that had been closed from public view for some time. As the artist has described the performance:

> Over the course of the work … I attempt to move the 48 kg female pig body. I attempt, fail, succeed, there are embracings and moments of stillness but for the most part there is a constant moving, almost to re-animate her.[36]

In discussing the use of non-human animal resources in biotechnology and

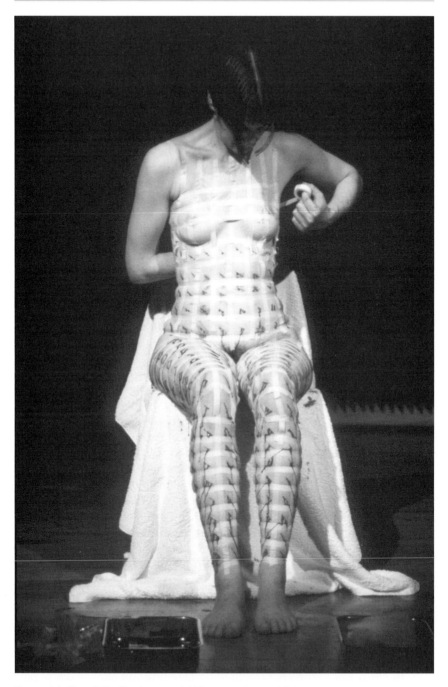

Figure 4.1 Kira O'Reilly, *Succour*, 2002. Break 2.1, 2002. Kapelica Gallery, Ljubljana. Photo by Leonora Jakovljevic. Courtesy of the artist.

her own aesthetic practice, O'Reilly refers to the tenderness of *inthewrongplaceness* as instancing a 'slow crushing dance'. The performances are not videoed, but photographic stills are taken to record what would otherwise remain a wholly discrete and ephemeral art work. Members of the audience were conducted into the performance space and were able to experience the work individually, touching, if they so wished, either the pig or the artist. As one observer noted of the experience:

> There was a faint smell of blood, and no sound except that of traffic, and of Friday night-pub goers who would not have been aware of her presence in the room only a few yards away from them.[37]

As the artist has explained, the work arose from the experience of taking pig biopsies as part of a bio-art residency and research project based in the anatomy department of the University of Western Australia (2003–4). Recalling the experience of taking a biopsy and seeing the sample proliferate like a plant, O'Reilly noted:

> The work left me with an undercurrent of pigginess, unexpected fantasies of mergence and interspecies metamorphoses began to flicker into my consciousness. Strange dreams of porcine/human flesh manifestations that … I wanted to realise.[38]

As a performance work, *inthewrongplaceness* evoked the idea of the abject as an iconographically compelling, but potentially intimate, experience. At a time of increasing biogenetic experimentation and the widespread use of animal DNA in developing vaccines and replacement human organs, O'Reilly explored the post-human condition as one of animal–human hybridisation, externalising a social issue as a personal, but shared experience.

The presentation of the abject and lacerated male body has informed the aesthetic of Franko B. (b. 1960), who has worked across a range of genres, including performance, video, photography, installation, sculpture and mixed-media practice. Born in Milan and based in the United Kingdom since 1979, he attended Camberwell College of Arts (1986–87) and Chelsea College of Art (1987–90), and has performed and exhibited widely, both nationally and internationally.

Franko B. describes himself as a painter who 'works in performance', situating his practice in relation to a visual art background, rather than a 'live art' or theatrical context.[39] In a visceral series of filmed and photographed performances such as *Oh Lover Boy!* (2001), he has used his own body to explore issues of abjection and to objectify the human condition (Figure 4.2). In *I Miss You*, Franko B. presented his bleeding and naked body as part of a live catwalk show in the Tate Modern's Turbine Hall. In the closing event of the gallery's four-day *Live Culture* season in March 2003, the artist

Figure 4.2 Franko B., *Oh Lover Boy!* 2001. Photo courtesy of Manuel Vason.

walked along the 40 metre catwalk, presenting *I Miss You* to a largely silent audience. Describing the orientation of his practice, he has stated:

> My work focuses on the visceral, where the body is a canvas and an unmediated site for representation of the sacred, the beautiful, the untouchable, the unspeakable and for the pain, the love, the hate, the loss, the power and fears of the human condition.[40]

For Franko B., and for some of his contemporaries, the abject is the source of the transcendent, but also part of the sensorium which authenticates our embodied response to objects and experiences in the world. Discussing the symbolic contradictions of the body in performance, and the genre's recent cultural resurgence, the cultural commentator Lea Vergine writes:

> The use of the body as a language has returned ... in new and different forms. The body as triumphant, immolated, diffused, propagated, dramatic and tragic The body as a vehicle ... for declaring opposition to the dominant culture, but also of desperate conformism.[41]

The subject of human 'embodiment' and the experience of being and becoming remain central to performance practice; artists from a post-conceptual generation continue to use the genre biographically and experientially. Tracey Emin (b. 1963) is probably the most well-known British artist who has explored self-disclosure and abjection through a range of performance and film practice. Although well known for installations, textiles, drawing and printmaking, since 1995 Emin has made a range of films, shot on Super 8 film and then transferred to video. The single projection film shorts like *Why I Never Became a Dancer* (1995), *Riding For a Fall* (1999) and *Love is a Strange Thing* (2000) are frank and often confrontational explorations of personal history, trauma and experience.

Typically 'performed' for film and video, they are moving and compelling narratives which in length and format recall music videos – most have personal and period-specific soundtracks. Like crafted home movies, Emin is frequently in close shot, but in narrative technique and lack of artifice, they suggest the idiom of the bio-documentary. As Lorna Healey acutely noted of Emin's aesthetic, it has been made possible by the cultural space left by Neo-Expressionist painting, the scope for personal narrative established by feminist discourse and the manufacture through popular culture and the music industry of the celebrity as 'star'.[42] Whether recounting humiliation and rejection at a local dance competition or staging a triumphant return to her home town of Margate, Emin has used filmed performance and re-enactment as testimonials to success, loss, life and desire.

The expectation of trauma and a dynamic outcome of a different kind situates work by Matt Calderwood (b. 1975). Calderwood, who studied fine art at Newcastle and Sunderland, has developed a signature practice in which seemingly slapstick actions with predictable outcomes (such as sawing the stairs on which he is standing), are executed and performed without prior rehearsal and with clarity and economy of action. Calderwood's filmed performances objectify the dynamic of cause and effect and the expectation of what happens when the frozen spectacle is broken by weight or gravity. In *Battery* (2003), Calderwood is filmed burning through a rope that suspends a battery over him, until it breaks and the battery falls (Figure 4.3). The viewing interest arises, in part, through silent complicity and the expectation of seeing the effect and consequences of self-inflicted pain and trauma.

Documentary genres: docu-fiction and social reportage

The most prominent development in relation to the still and moving image has been the proliferation of documentary, reportage and docu-fiction as central modes of contemporary practice. As noted earlier with performance art, various forms of documentary and reportage have explored political and social themes with a criticality previously associated with more journalistic aspects of media coverage. Although the 'political turn' in recent art has

Figure 4.3 Matt Calderwood, *Battery*, 2003. Video still © Matt Calderwood, 2003. Courtesy of the artist.

been much discussed, many of its British practitioners have re-engaged with established, if marginalised, traditions of image-making and social commentary which have continued across genres since the 1960s and 1970s.

The conventions of photographic documentary have been prevalent within British visual culture since the 1930s. The Mass Observation projects associated with Tom Harrison and the British Documentary Film Movement asserted the medium's essential objectivity and reliability in collating and recording information about the lives and mores of others. The advent of critical theory and the relativistic ethos of late modern discourse have problematised claims to photographic objectivity. Discussing the hypothetical (and actual) example of surveillance photographs used in banks and other high-security buildings, contemporary theorist and photographer Allan Sekula has highlighted the 'fictions' that arise from the human interpretation of even the most seemingly 'extreme form of documentary'. He continues:

> The only 'objective' truth that photographs offer is the assertion that somebody or something – in this case, an automated camera, was somewhere and took a picture. Everything else, everything beyond the imprinting of a trace, is up for grabs.[43]

Sekula's contention that photographic meaning is 'relatively indeterminate' offers a particular caveat for the genre of 'docu-fiction', or what some commentators have described as the 'cine-essay'. In his evocation of the altermodern (see page 11), docu-fiction is described by Bourriaud as one of its eight categories:

> Taking a trend that is prevalent in contemporary film and TV culture, artists are creating works which mix historical, journalistic or personal enquiry with fictionalised accounts. They layer archive and historical material with personal information. Truth and fiction are presented side by side, in modes traditionally associated with the authentic.[44]

The manipulation of 'fact and fiction' ('faction') is inherent within all forms of documentary construction, film or camera use, suggesting that in this respect at least, the impetus for the altermodern has been around for some time. For example, the Soviet cinema of the 1920s and 1930s was an ideologically inflected form of 'docu-fiction'. The values and assumptions of the Mass Observation project and the British Documentary Film movement – social deference, given hierarchies, the construction of national identity and a belief in objectivity and the empirical – were among the myths exploded by critical theory in the 1960s and 1970s. As film academic Will Bradley has noted, these ideas made it clear that 'from the point of view of cinema, truth was an argument to be constructed, rather than a simple collection of facts to be transmitted'.[45]

But regardless of film documentary's limitations as a genre, it attempted to give voice to previously marginalised social groups and communities. At a time of rigid economic and social demarcation and pervasive inequalities, documentary practice articulated tangible social differences and exclusions. In more recent decades there is some agreement that social advantage and the centralisation of State and corporate power have again become more entrenched within and across British society. This may in part explain the visibility and criticality of documentary forms within recent and contemporary practice, and the impetus to assert a plurality of 'voice', social experience and perspective.

The idea of the altermodern, and Bourriaud's inclusion of docu-fiction as one of its categories, underline the widespread use of documentary techniques and conventions within art films and videos – including the construction of narratives, voiceovers, the use of interviews, actual locations and identifiable places. This renewed emphasis on narrative and reportage might be contrasted with the foregrounding of the technical and formal effects associated with video art in the 1970s and 1980s. In some cases, the content of the docu-fiction is delivered without an authorial voiceover, leaving the unfolding narrative to off-screen interviews with participants and co-observers.

Various reasons have been suggested for the fashion for docu-fiction and film making more generally, and their prevalence within contemporary British art galleries. Culturally, it might be seen as a response to the distrust of so-called 'metanarratives' – previously dominant accounts of the world – and an increasingly sceptical attitude towards official forms of knowledge and power. Technologically, the easy availability of editing software and the sheer ubiquity of digitised media on the internet have informed the expectations of a new generation of viewers and potential film makers as to what can be achieved even with modest means. The versatility of smart phones with image capability has, in one sense, empowered users to document and image the world and the people around them.

For example the use of phone and camcorder footage by climate change protestors in recording the techniques used to police the demonstrations in the City of London in 2009 raised the issue of such footage having legal admissibility. It also underlined a new and more immediate viewing paradigm with profound implications for the decentering and apparent de-institutionalisation of social surveillance – and self-surveillance.

Beyond technological and social shifts, the United Kingdom has in recent decades witnessed the decline of small, independent British cinemas, which has reduced one of the venue choices for showing independent art films and videos. Increasingly, they have been replaced by national chains geared towards big-budget movies and a far more commercially oriented 'cinematic experience'. Similar cost pressures have also homogenised the range of coverage and commissioning previously undertaken by terrestrial television, despite the apparent offer of choice suggested by the proliferation of digital and satellite channels.

By contrast, the flexible, typically white cube interiors of contemporary galleries can provide ideal viewing spaces for art films and videos, without some of the stringent legal and vetting restrictions associated with television. Equally, the use of continuous loop set-ups for relatively short films or video clips suits the free flow and movement of visitors through gallery spaces. Typically, art films and videos are projected using TV monitors or computer screens, with sounds relayed through headphones rather than the surround sound associated with in-cinema screenings.[46] With the prospect of new viewing conditions and audiences, recent British film makers have taken a varied and experimental approach to the genre, emphasising its hybrid flexibility.

The prevalence of documentary also mediates the 'de-territorialised' character of global modernity; national boundaries have become increasingly flattened by the homogeneity of media coverage and the dynamic of international markets. As Hito Steyerl puts it, documentary forms have become the 'transnational language of practice', the genre's very closeness to 'material reality' giving it a purchase wherever that 'reality is relevant'.[47] Equally, the technological shifts discussed above and the

development of new public and private spaces have enabled documentary makers to redefine the range and scope of their practice.

Adam Chodzko (b. 1965) came to prominence in the early 1990s. A graduate of Goldsmiths College (Fine Art MA 1992–94) and the University of Manchester (BA Art History 1985–88), he was selected for the British Council-supported group show, *General Release: Young British Artists* (1995), which displayed work by a representative range of emerging British talent at the Scuola San Pasquale as part of that year's Venice Biennale. Film media was particularly well represented, with Chodzko showing work alongside peers including Fiona Banner, Tacita Dean, Cerith Wyn Evans, Douglas Gordon, Jane and Louise Wilson, and Sam Taylor-Wood.

He has since developed a wide-ranging aesthetic, including video, film, installation, performance and mixed-media work. Chodzko's practice frequently explores 'peripheral communities' – the overlooked, contingent and the liminal – what he describes as the 'cultural edges, endings, displacements and disappearances' which arise from looking in the 'wrong place'. The anthropological and investigative slant to Chodzko's work has also provided the basis for lateral and imaginative interventions which combine fiction, fact and mythology.

In 2008, he contributed a commissioned work to the Folkestone Triennial, *Tales of Time and Space*. *Pyramid* (2008) was a site-specific, mixed-media work installed just under Folkestone's Leas Cliff Hall, which consisted of a fake visitor information panel and a film which was screened at a nearby location in the town. The production sketch which is reproduced here provides a montage of the narratives, events and processes which underpinned the work (Figure 4.4). The genesis for the piece was the void underneath the projecting balcony of the Leas Cliff Hall, which was supported by four inverted steel pyramids. The fake information panel narrated a fable that the town's misfortunes (which had included an actual earthquake in April 2007), were caused by bad luck arising from the inverted pyramids. The rest of the 'information' panel narrated a sequence of similarly fictitious events involving the local community, members of which had staged an 'event' to lift the curse:

> The pyramids were ... clad in a brilliant material and an illusion devised so that they now pointed towards the sky. In order to complete the lifting of the curse these 'corrected' pyramids were then ritually destroyed and dragged out to sea.[48]

The film screening which was part of the work recreated and recorded the 'hallucinatory ritual' of this ceremonial removal and the apparent traces and scars of its aftermath on the landscape. Chodzko employs the registers of authenticity; third-party testimony to the town's apparent misfortunes, extended film sequences of specific locations and structures, official and

Figure 4.4 Adam Chodzko, *Production sketch for Pyramid*, 2008. Video with sound, 12 minutes, and mixed-media installation. © Adam Chodzko. Courtesy of the artist, 2009.

authoritative-sounding information panels that we associate with historic sites and National Trust monuments. Appropriating ideas of narrative fact and fiction, *Pyramid* collapses under a panoply of misinformation and its own impossibility, leaving only a video installation as a trace of its 'absence'. As Chodzko concludes:

> So there's nothing really there afterwards … apart from a misinterpretation panel. And perhaps a rumour growing, gossip that gets passed on about what happened in this place. Everything else is just a support structure for this myth.[49]

As an example of docu-fiction, *Pyramid* fabricates ideas, events and associations into a playful bricolage which subverts and suspends expectations of narrative and causality. Elsewhere, Chodzko has explored memory and retrieval as more reliable anchors of personal history. In the 1996 video *From Beyond*, he orchestrated a reunion of uncredited extras from the Ken Russell film *The Devils*. Facing the camera, they recount personal anecdotes and stories against a backdrop of their younger selves as they appeared in the film. As Craig Richardson noted in dialogue with Chodzko:

> Through physical separation, and time, visibly enhanced by the extras' contemporary middle-age appearance contrasted with their younger

selves emerging from beyond the temporal space of *The Devils*, there is
a kind of classic haunting; a reality which was ignored at the time,
declaring itself in the present.[50]

From Beyond choreographs a collision of filmic pasts and contemporary
actuality, a layering of histories made explicit through research,
documentary-type interviews and direct speech to the camera.

Other artists have explored the documentary's archival and dramatic
potential through the staged re-enactment and recording of actual and
socially historic events. A graduate of the Courtauld Institute of Art, Jeremy
Deller (b. 1966), is known for collaborative, mixed-media works which
explore social and historical themes, but typically with a contemporary
resonance. He came to wider notice with *Acid Brass* (1997), a project
involving a Stockport brass band, and an arranged repertoire of Acid House
tracks. The resulting medley of music was produced commercially on CD
and was played widely throughout Europe and the United Kingdom. Behind
the collaboration's 'crossover success' was a serious juxtaposition and
conflation of what Deller has argued are central events in recent British
cultural history: the 1984–85 miners' strike and the fashion for Acid House
music. Discussing what he sees as their points of connection, Deller has
noted, 'At its most extreme, Acid Brass is as much about the kick of a
policeman's boot as the kick of an 808 bass drum'.[51]

Among the work exhibited for Deller's Turner Prize-winning submission
was *Memory Bucket* (2004), a multimedia installation which recorded
interviews and encounters in Texas. The film footage included testimony
from strangers and chance encounters in President Bush's home town of
Crawford, and from Waco, another symbolically charged location because
of its association with the police siege of the Branch Davidian cult compound
which made international news in 1993.

Deller's interest in social memory and cultural reclamation was behind
the national folk archive of photos, videos and collected ephemera which
he worked on with Alan Kane (b. 1961) between 1998 and 2005. The
project's motivation was an aspiration to locate the 'popular' and 'authentic'
within recent and contemporary folk culture, rather than to propagate the
regressive and sanitised versions imposed from above by the culture
industry. The project's strongly social aspect, the testimony of strangers and
the experience of chance encounters, stressed the local and the personal
dimension to the social landscape, otherwise defined by the global and the
corporate. The archive was subsequently exhibited at the Barbican gallery
before being toured in the United Kingdom.

These examples situate an interest in the process of documentary
reportage, suggesting how both can be employed to record social histories
and the archiving of cultural memory. Deller's most dramatic use of the
documentary process was in the site-specific film and performance work,

The Battle of Orgreave (An Injury to One is an Injury to All) (2001), a large-scale
re-enactment of some of the violent clashes that took place between striking
miners and the police outside the South Yorkshire coking plant during the
1984–85 miners' strike. The original event involved several thousand miners
and police on either side, with additional flying pickets and police forces
drafted in from across the country.

In what became a defining image from one of the most bitter industrial
conflicts in recent British history, baton-wielding police cavalry pursued
fleeing miners through the village of Orgreave, following a morning of
increasing tension outside the British Steel coking plant. Bloody clashes
which lasted much of the day (and which set the pattern for the entire
dispute), saw scores of miners and police officers injured, with repercussions
which were to divide hitherto close-knit communities. The re-enactment,
recorded on 17 June 2001, involved 800 people, of whom 280 had been
original participants from the local villages (Figure 4.5).

The work was co-commissioned and produced by Artangel in association
with Channel Four Television, and was filmed by Mike Figgis and
orchestrated by Howard Giles. Photographic film stills together with
original footage including commentaries from some of the veteran miners
and trades unionists involved, including Tony Benn MP, together with a
statement by Jeremy Deller, were broadcast in October 2002, eighteen years
after the original events took place.

The miners' strike came in the aftermath of the Toxteth and Brixton
riots, and worsening relations between the Conservative prime minister,
Margaret Thatcher, and the broader trades union and labour movement. It
came to characterise some of the real and accelerating social divisions and
grievances in Britain during the 1980s. In this sense, Deller's *The Battle of
Orgreave* was a work of social reclamation, restaging an eclipsed social
narrative. In re-orchestrating a major episode from a bitter industrial and
ultimately social dispute, it combined documentary reconstruction and
dramatic re-enactment, demonstrating documentary's versatility through
its reconnection with recent British social history.

Image and text combinations and forms of photomontage have been
used to situate other approaches to trenchant social commentary and
reportage by practitioners such as Willie Doherty, David Farrell, Sunil
Gupta, Paul Graham, Anthony Haughey, Karen Knorr, Sandra Lahire, Paul
Seawright and Jo Spence. Their interventions have spanned the urban
landscapes associated with sectarian politics, issues of gender and ethnicity,
and the mediations of personal experience and cultural identity.

Between 1981 and 2000, the anti-nuclear campaign and vigil sustained by
members of the Women's Peace Camp at the Greenham Common airbase
in Berkshire, UK, provided the background to media coverage and political
debate on nuclear disarmament. The eventual removal of cruise missiles
was seen as a vindication of the campaign, and played an important part in

Figure 4.5 Jeremy Deller, *The Battle of Orgreave Archive (An Injury to One is an Injury to All)*, 2001. © Tate, London 2010. Commissioned and produced by Artangel. Photo: Martin Jenkinson.

contributing to a changing political consensus around the deployment and use of nuclear military technology. Inevitably these issues were reflected in the work of contemporary British film makers and artists, both directly and as an impetus for an exploration of nuclear-related activities in other countries.

Uranium Hex (1988) was the third film in the trilogy concerned with the deleterious effects and consequences of nuclear power by the experimental feminist film maker, critic and teacher Sandra Lahire (1950–2001). The earlier films were *Plutonium Blonde* (1986) and *Terminals* (1986). In *Uranium Hex*, a twelve-minute 16 mm film shot in colour, Lahire used montage, portraiture and metaphor of the cancerous body to convey the effects of uranium mining in Canada on the lives of the women involved. This was among the subjects returned to in *Serpent River* (1989), which explored the effects of uranium mining by the Rio Tinto Zinc corporation on the inhabitants and workers of Elliott Lake and Serpent River in northern Ontario. Lahire used montage techniques and the synthesis of sound and light to create visually acute and evocative spectacles which conveyed a deeply felt belief in social injustice and collective responsibility.

Jane and Louise Wilson (b. 1967) have developed an extensive collaborative practice, spanning photography, video and multi-screen installations. Jane attended Newcastle Polytechnic (1986–89) and Goldsmiths College (1990–02), and her twin sister Louise graduated from Jordanstone College of Art, Dundee, in 1989, before also attending Goldsmiths College (1990–02). A recurrent theme within their work has been the inter-relationship between architectural spaces (and the power such environments represent) and the people who use, occupy or pass through them.

Silo: Gamma (1999) is a cinema-scale, split-screen video installation with sound, which features film footage from the Greenham Common airbase in Berkshire (Figure 4.6). Although now decommissioned, in the 1980s the site was the scene of extensive, frequently televised confrontations between anti-nuclear protestors (the base was then the site of American cruise missiles) and the police. Using a mixture of documentary styles (TV melodrama, news video and surveillance-type camera angles), *Silo: Gamma* has been described as a meditation on paranoia, surveillance and power. It conveys in documentary fragments the ethos of the Cold War and a site that was one of civil resistance to the location of the UK 'nuclear deterrent'.

Silo: Gamma recalls other film and installation-based work such as *Stasi City* (1997) and *Parliament* (1999). In the former, film footage depicts abandoned corridors and interrogation areas used by the former East German Berlin intelligence service. In *Parliament*, the Wilsons explore the Palace of Westminster and its associated rituals, practices and spectacle. All three of these film-based installations examine a location or site of State power, either defunct or extant. But despite the apparent remoteness of the

Figure 4.6 Jane and Louise Wilson, *Silo: Gamma*, 1999. C-print on Diasec, 63 x 106 inches. Courtesy of 303 Gallery, New York.

subject matter, the overall concern is with how power (abstract and frequently invisible) is made tangible through institutions and the mechanisms of the State.

Social and sectarian conflicts have informed photographic, video and installation work by Willie Doherty (b. 1959). A graduate of Ulster Polytechnic (1978–81) and twice nominated for the Turner Prize, Doherty represented Northern Ireland at the 2007 Venice Biennale. A child witness to the events of Derry's Bloody Sunday – the shooting of twenty-six Catholic civil rights protesters by soldiers from a British Parachute regiment in 1972 – the sustained focus of Doherty's photographic and video-based work is Northern Ireland's history of sectarian politics and social division. In earlier black and white photographs, in which he combined text straplines with images taken from the environs of the Troubles, commentators identified the influence of Hamish Fulton, Jenny Holzer and Barbara Kruger and their appropriation of mass media techniques to explore broader social commentary.

Speaking after the lifting of the media ban on Sinn Fein in 1994 and what became the start of protracted negotiations aimed at eventual power sharing, he noted:

> I've tried to give a voice to what has been unspeakable. My work is trying to undermine various notions about what opposites might be, and to show how the media's perceptions of Ireland are completely unreliable.[52]

Doherty uses the techniques of direct reportage as well as metaphor and allegory to explore the voices and contexts of Northern Ireland's sectarian conflict. As the photographic historian Charlotte Cotton notes of images like *Dark Stains* (1997), a photograph of a rubbish-strewn alleyway, Doherty records the 'corroded detritus of marginal and abandoned spaces' and as such, allegorises the Christian rhetoric about 'original sin' and its deployment within Northern Irish politics.[53]

Doherty's digital video installation *Somewhere Else* (1998) comprises four synchronised video sequences which are simultaneously projected onto an x-shaped configuration of four rear projector screens (Figure 4.7). Each video sequence, which features urban and rural scenes from Derry and Donegal, including the 'dead spaces of the city', has a separate soundtrack, the speakers for which are fixed to the wall opposite the screen. The voice-over to the images is interspersed with references and directions to the actual production of the video. The combination of the multiple screens, monologues and the constant fracturing of the narrative is profoundly disorientating, jarring attention between the images and the techniques of their reproduction.

The deferral of meaning and readings that these effects generate can be read as a metaphor for the broader political and religious stand-offs which

Figure 4.7 Willie Doherty, *Somewhere Else*, (still from the video installation), 1998. Four-part video installation, with sound. Photograph © 2009 Carnegie Museum of Art, Pittsburgh; A.W. Mellon Acquisition Endowment Fund.

have determined Northern Ireland's recent history. The competing and parallel monologues which vie for the viewer's attention might suggest the simultaneous and polarised narratives that have defined Irish Republican and Protestant interests. As Doherty notes of the effect:

> The multiple viewpoints and shifts between locations and an inability to fix the role of the narrator reinforces the impossibility of resolution or closure.[54]

Anthony Haughey (b. 1963) has also used metaphor and the symbolism of contested national borders to demarcate civil conflict and war. Like Doherty, Haughey's understated images work elliptically, capturing the silent aftermath, rather than the dramatic acts of conflict and war which preceded it. His prosaically titled photograph *Shotgun Cartridges* (1999) depicts a large cache of spent ammunition shells in a shallow ditch on the Armagh/Louth border, an area notorious for ambushes and exchanges of sniper fire between the Irish Republican Army and British Army forces during the Troubles.

At first glance, the striking whites, blues and reds of the cartridge casings appear as some kind of exotic infestation within the landscape, surrounded by spoil heaps and bramble. But, as the image's title makes clear, the dump indexes a violent paramilitary insurgency which, unlike its counterpart in the urban areas of Northern Ireland, occurred largely out of sight of media cameras in the 'bandit country' of Northern Ireland's border with the south.

Disputed Territory (1998–2005) was a large-scale multimedia piece in which the artist used found images, photographs, video and sound-based work to record the divisive social and geo-political legacies of the boundary in places such as Bosnia, Ireland and Kosovo. *Resolution*, an installation of twenty-four light boxes exhibited at Dublin's Gallery of Photography in 2006, took as its subject the 'disappearance' of around 8,000 mostly Muslim men at Srebrenica, whilst ostensibly under the protection of UN forces. The installation's images included personal effects – keys, watches, combs variously labelled and bagged as forensic effects as if from a postmortem. Working with eyewitness testimony and the International Centre for Missing Persons, Haughey created a sound and image memorial to genocide and 'ethnic cleansing'.

Other practitioners have imaginatively adapted social documentary techniques to explore oblique and seemingly marginal subjects, peripheral communities and the covert practices or subcultures which may be associated with them. Clio Barnard (b. 1965) is a film maker whose work has been shown internationally at film festivals and galleries, including Tate Modern and Tate Britain. In 2005 Barnard received a Paul Hamlyn Award for Artists, and in 2007 she was awarded a major commission by the Jerwood/

Artangel Open in association with Channel 4 and Arts Council England for a feature-length film and performance project which will involve working with diverse communities within the United Kingdom.

Barnard's aesthetic combines documentary reportage and docu-fiction, exploring what has been described as the 'subjectivity of recollection'. She has produced several single-screen short films including *Random Acts of Intimacy* (1998), *Lambeth Marsh* (2000) and *Flood* (2002). Barnard's films have frequently researched and explored tangential social experiences and seemingly marginal communities. The two-screen film and video installation *Road Race* (2004), recorded the illicit practice of travellers racing their horses on the M2 in Kent (Plate 19).

This covert and illegal practice is alleged to take place on early Sunday mornings on motorways across the United Kingdom, with spectators and supporters forming rolling roadblocks as light two-wheeled carts and their drivers compete in fast races on the public highway. The events draw participants from across the traveller community, with bets placed on the competitors. It is alleged that the police forces concerned are aware of the practice, but ignore it.[55]

As the press release makes explicit, *Road Race* presents and parallels two modes of presentation simultaneously. One is hand-held digital video (DV) footage taken of an actual event with synchronous sound and few edits, and the other is a film-shot, location-based 'constructed sequence' with post-production sound – a 'fictional construction based on fact' in the tradition of 'classical cinema'. The juxtaposition explores the instability, not just of representational documentary making, but the elisions of edited cinematic practice.

Anticipating the vogue for film coverage taken and streamed from mobile phones mentioned earlier, Barnard's *Dark Glass* (2006), a work shot entirely on mobile phone and screened at Tate Britain and New York's Museum of Modern Art, included recorded descriptions of family photographs recalled under hypnosis. More recently, Barnard has returned to local subcultures; the subject of *Plotlands,* shown at the 2008 Whitstable Biennale, was the transient marshland community of East Kent's Seasalter Levels.

Similarly tangential subject matter has been given a more biographical focus by Oliver Payne (b. 1977) and Nick Relph (b. 1979). Nominated for the Beck's Futures Award in 2002, and collaborating film makers since the early 1990s, they established their reputation with a series of films using hand-held digital video cameras. *Driftwood* (1999) and *House and Garage* (2000) offer a personal collage of London and suburban locations. *House and Garage* has been described as a 'road movie around London's zones 3–6 by two artists on travelcards'.[56] Payne and Relph film the 'non-spaces' of shopping arcades, bus stops and park benches as kaleidoscopic fragments of personal recollections and shared histories, combining 'psycho-geography' with video-documentary and a music diary.

In their subsequent film *Jungle* (2001), these associations are more explicit. As the title suggests, it is a dispassionate navigation of the British countryside, less as pastoral other, but more as a rural hell; its immediate context the spectacle of banked-up and smoking pyres of industrially slaughtered livestock, the government response to the last major outbreak of foot and mouth. As Michael Wilson generously noted, *Jungle* evoked the 'debased hinterland of mock Medievalism, battery farms and entrenched misapprehension, attractive only through its association with UFO's and crop circles'.[57]

The use of documentary to estrange and dissociate the seemingly familiar has been applied to a specifically urban locations by Paul Rooney (b. 1967), a Liverpool and Wolverhampton-based musician and video artist whose work was showcased in *British Art 6* (2005–6). He graduated with an MA in Fine Art from the Edinburgh College of Art in 1991, and since 1997 has incorporated music into his work. Rooney typically develops music and video-based collaborations with what Emma Mahoney describes as 'disenfranchised members of the community' and 'individuals who play a marginal (yet vital) role in cultural organisations'.[58] In *Lights Go On: The Song of the Nightclub* (2001), his video set to music and recorded the job and routine of the nightclub cloakroom attendant.

In 2004, Rooney worked with several shopworkers to make *In the Distance the Dawn is Breaking*, a looped three-minute video and sound-based work, displayed via five ceiling-hung monitors (Figure 4.8). It records five shopworkers discussing their night-time dreams, their dialogue set to music and voice harmonies which overlap to form a chorus of shared dreams and hopes. The soundtrack plays to static video shots of five different night-time shop interiors, reminiscent of CCTV surveillance cameras. Devoid of people and without the associations of light and movement, the images look funereal, making the seemingly bland, everyday interiors of convenience stores appear estranging and surreal.

Some of the localised and informal techniques (and orientation) of the social reportage used by the artists surveyed here recall the strategy of the 'dérive' associated with the Situationist International (SI) in the 1960s and 1970s. For members of the SI, the 'dérive' was understood as a 'loosely programmed drift through urban spaces'.[59] Its experience was understood as the basis for the study of the impact of environment on the consciousness and behaviour of individuals. As a neo-Marxist and libertarian alliance of artists, intellectuals and 'fellow travellers', the SI had a utopian social agenda which reflected the counterculture of the period.

The selection of social reportage and art documentary practice discussed here is not politically programmatic. Although some, like the SI, address the political more directly than others, in exploring dimensions of the social through otherwise peripheral subjects, spaces, objects and communities, they collectively explore a plurality of 'voice' and 'experience' which recall earlier British documentary practices of the 1930s.

Figure 4.8 Paul Rooney, *In the Distance the Dawn is Breaking* (video still), 2004. Five screen video installation. Courtesy of the artist.

British photographers and documentary makers such as Lindsay Anderson (1923–1994), Ken Loach (b. 1936) and Karel Reisz (1926–2002) have also been explicit in referencing earlier traditions of film making and social reportage. The techniques of collage and photomontage had been widely used by the Surrealist and Constructivist avant-gardes of the 1920s and 1930s. In the case of Berlin Dada, photomontage formed part of a protest at the futility and loss of the Great War of 1914–18 and a refusal of bourgeois culture and values more generally. But in addition to its direct social and political use, photomontage enabled formal and technical innovation. As Edwards notes of the genre's use of the photograph:

> it allowed modern artists to reintroduce dense pictorial references into their work without abandoning the complex picture space and formal arrangements developed in Cubism and abstraction. Photomontage meant that artists could combine the readymade with modernist form.[60]

For the Surrealists, the apparently random juxtaposition of text and image made explicit the contingency of meaning and the inauthenticity of the dominant social order, prompting Sontag's description of photography as the art form that enabled the 'Surrealist takeover of modern sensibility'.[61] Soviet Constructivists Alexsandr Rodchenko and Gustav Klutsis employed photomontage as a metaphor for Soviet modernity and a jettisoned high culture based on the painting academy and the old imperial order.

This modernist legacy to photomontage is implicit in the work of Peter Kennard (b. 1949), who has remained one of the most consistent practitioners of the genre. His signature clean-lined monochromatic style became synonymous with the dissident political culture and causes of the 1970s and 1980s. Kennard undertook commissioned work for a range of organisations including anti-nuclear campaign groups, the animal rights movement and the peace lobby, as well as defining the visual identity of underground media like *International Times* and *Class War*.[62] In more recent years, he has showcased work in the annual group show ironically titled *Santa's Ghetto* at various venues throughout London's West End.

Kennard collaborated with Cat Picton Phillipps (b. 1972) on *Blairaq* (2007) – an exhibition of large wall-mounted newsprint montages comprising pasted and ripped fragments of newspaper coverage of the war being waged by coalition forces in Iraq. Each of the large format montages comprised several layers of tattered and frayed newsprint, a metaphor, perhaps, for the shifting political justifications used by coalition forces to justify the Iraq invasion in 2003. Timed to coincide with Tony Blair's last week as prime minister, Kennard described the exhibition as a comment on 'where the original utopian dreams of the Labour Party have ended up' and as an attack on the British government's intervention in Iraq.[63]

The defining image of the *Blairaq* exhibition was the lightbox-installation

Photo-Op (2005), chosen by the advertising reference publication *Campaign* as one of the iconic images of 2006 (Plate 20). The context of its making is emblematic of the work's meaning and resonance; originally produced on newsprint as a protest poster for the G8 meeting in 2005, it was then made as a pigment print for *Santa's Ghetto* in 2006 and then finally refashioned in 2007 as a lightbox installation and centrepiece for *Blairaq*.[64]

The former British prime minister Tony Blair, one of the principal supporters of the US-led invasion of Iraq in 2003, is shown taking a picture-portrait on his camera phone against an apocalyptic panorama of burning oilfields. The jarring effect of the magnified photograph is compounded by Blair's rictus smile and the sense that the viewer is watching a full colour trophy-snap from Hell. When exhibited as part of *Blairaq*, the light box was framed by simulated boulders and the debris of war, projecting its subject matter into the actual gallery space hung with the ripped newspaper collages which recorded the conflict.

With *Photo-Op*, Kennard and Phillipps adapt the principles of photomontage and photographic projection to critique hubris and political misadventure. Although the ostensible subject is an individual, the work skilfully condenses a broader range of contemporary narratives: neo-imperialism and political hegemony, the pursuit of oil, environmental toxification and foreign policy failure. Describing the careful and deliberate process of adjacent and juxtaposed images as akin to the 'Marxist conception of dialectics', Kennard said of the exhibition's purpose:

> We wanted people to be able to come and find their views echoed and validated by the work. Mainstream politicians and the media have conspired in creating the disaster in Iraq. We wanted to create something that makes people think that they are right to oppose the war, that everything that we said about it was correct. We wanted people to come away from the work with a renewed sense of confidence.[65]

The themes of Kennard's photomontages are noticeably international, reflecting the increasingly globalised repercussions of conflicts, creating migrations and diasporas which extend beyond the regions or countries of their origin. Another ironic design was a 2008 Christmas greeting card which was a colour photomontage of a red metallic Christmas tree decoration which has been magnified into a huge wrecking ball and imposed onto an image of the recently completed security wall which divides the Palestinian enclave from Israeli territory. Punning off the idea of a unified Jerusalem as the Holy City and the birthplace of Christ and the entire Judaic tradition, Kennard's photomontage condenses historic religious traditions with contemporary and seemingly implacable Israeli–Arab conflict.

The collage effect of multiple film narratives has been explored by Alia Syed (b. 1964), who describes herself as an experimental film maker

working within a fine art context who is interested in the 'nature and role of language in intercultural communication'. In practice, this has resulted in film narratives which explore borders, boundaries, the translation of meaning (through culture and location) and the 'trans-cultured self'.[66] Syed has had solo exhibitions at the Gallery of Modern Art, Glasgow (2002), Tate Britain (2003) and the *British Art Show*, Hayward Touring Gallery (2005).

One of Syed's emblematic film pieces is *Eating Grass* (2003), which recounts five narratives, each of which connects to the five daily Muslim prayer times. The short film takes its title from a quote by Zulfikar Ali Bhutto, successively the president and prime minister of Pakistan in the 1970s, who was deposed and sentenced to death in 1979 after a trial for murder. When in power, Ali Bhutto had been a firm supporter of nuclear technology and its deterrent effect, promising to establish such a defence even if it resulted in Pakistan's people facing penury and 'eating grass' as a consequence.

Eating Grass was shot at various public and private locations in Lahore, London and Karachi, with film sequences ranging from a street market in Pakistan to hurrying city commuters on a rainy London evening. The use of film and image fades, double exposures and repetition gives to the people within Sayed's work a spectral and evanescent quality; parallel and fleeting lives are visualised against the politics of diaspora, different time zones and the rhetoric of politicians. The multiple locations used by Sayed emphasise the deterritorialised and decentred condition of contemporary documentary practice within a global modernity.

Technical interventions, defamiliarisation and spectacle

The migration of video and film practice from art cinemas to gallery spaces has provided more flexible spaces for exploration and innovation. This has been paralleled by the increasing miniaturisation and digitisation of production software, enabling practitioners to choreograph special effects by experimenting with scale, play-speeds and spectacle. The popularity of relatively short video and film loops also acknowledges the transient visitor and viewing flows of galleries, rather than the fixed viewing conventions associated with cinema spaces. These shifts in the cultural production of film and video and the contexts of their reception have given further impetus to technical and formal experimentation.

Douglas Gordon (b. 1966) won the Turner Prize in 1996 for an innovative range of work which included practice in film, photography, video and installation. A graduate of Glasgow School of Art (1984–88) and the Slade (1988–90), Gordon's slow-speed adaption of the 1941 film version of *Dr Jekyll and Mr Hyde, Confessions of a Justified Sinner* (1996), featured dual-screened positive and negative images which dramatically evoked the split personae of the film's subject.

Other film interventions by Gordon have included *24 Hour Psycho* (1993), a rendering of Alfred Hitchcock's classic; and *Feature Film* (1999), a re-interpretation of *Vertigo* (1958). *24 Hour Psycho* was a slow-motion rendering of Hitchcock's film, projected onto a large screen at an oblique angle, which ran for an entire day. With each frame slowed down, Gordon challenged the medium's narrative conventions, distorting sound and combining the effect with images which changed so imperceptibly they appeared as static billboard tableaux. As the art historian Joanna Lowry remarked of this and similar works:

> Gordon's ... fragments of film footage are enigmatically decontextualized. They are troublingly unassimilable and are usually presented on video loops which endlessly repeat. In their fragmented form and in their repetition they recall Lacan's definition of trauma as that which cannot be made sense of or be symbolized within representation.[67]

Similar techniques of dissection and repetition were used in *Through the Looking Glass* (1999) in which Gordon replayed a clip from Martin Scorsese's film *Taxi Driver* (1976). The scene selected is that in which the traumatised Vietnam veteran turned yellow cab driver Travis Bickle, played by Robert De Niro, rehearses an encounter with street thugs in front of a mirror. Although the original film scene in which the increasingly alienated Bickle brandishes a gun to unseen assailants, accompanied by the famous line 'You talking to me?' is brief, Gordon extends and repeats the monologue into a continuous loop, its screen repetition projecting and magnifying the psychosis and confinement of the original performance.

Gordon's film and video installations combine iconic and immediately recognisable cinematic images with more abstract considerations of duration, spectacle and cultural memory. By the time of his first solo retrospective at London's Hayward Gallery in 2005 (*what have I done*), and the 2006 show at the Royal Scottish Academy and the Botanical Gardens (*Superhumanatural*), Gordon had established a metaphysical register to concerns which engaged with identity, recognition, recollection and memory; *List of Names* (1990) was an installed text which featured 1,440 names – those of every person he had encountered and whom he could remember.

The repetition and excess of what Lowry describes as Gordon's 'theatre of vision' can be read on one level as a psychological response to forgetting and the erosion of personality and disintegration of self which it heralds. The device of slowing film dialogues defamiliarises the known, forcing re-engagement and reinvestment in ways analogous to the trauma of partial recall. Associated with some of the psychological and perceptual adjustments required by these earlier works is also a tacit theme of dramatised sexual

violence and dissociation. The required duration of our gaze on these vivid tableaux also implies an uncomfortable complicity with what is actually unfolding.[68]

Mark Leckey (b. 1964) came to prominence after winning the Turner Prize in 2009, although he had already received critical recognition for his solo show *Parade* at the Cabinet Gallery, London, in 2003. His video work, *Fiorucci Made Me Hardcore* (1999), was a compilation of found footage based on the British dance and disco scene from the 1970s and 1980s. But rather than keeping to documentary or filmic convention, Leckey remixes and fragments the material; music is interspersed with gaps; the experience is one of disorientation and disconnection. The flashing lights and silences seem to visualise partial memory lapses and the unreliability of recall.

Undermining the assumed referentiality of film and video, and the artifice of cultural production, have remained central concerns of Leckey's practice. In the two-hour film loop of *Made in 'Eaven* (2004), he used the dated medium of 16 mm film to project an image of Jeff Koons's iconic *Rabbit* (1986), a seemingly soft inflatable bunny which is cast in steel. The juxtaposition of cultural periods is deliberately continued through the choice of the antiquated film format. As Rebecca Heald notes of the video piece:

> the outdated medium of 16mm film [is used] to portray the work, evoking an era of artisanal manufacture rather than the slick surfaces of neo-geo, and complimented by the bashed-up door and stripped floorboards by which it is surrounded. Past and present collide to create a disorientating spectacle of nostalgic chaos.[69]

The suspension of overt narrative in favour of recording otherwise overlooked and contingent areas of experience is a characterisation that has been made of work by photographer, video artist and film maker Sam Taylor-Wood (b. 1967). A graduate of Goldsmiths College (1988–90), she had her first solo show at the White Cube Gallery in 1995 and was nominated for the Turner Prize in 1997.

Taylor-Wood works extensively using time-based media, producing tableaux and choreographed scenes which draw both on the photographic performance work of Bruce Nauman and Bill Viola and the psychological intensity associated with the scene direction of film makers and auteurs like Hitchcock, Scorsese, Coppola and Cimino.[70] More recently she has directed and made her own feature film, *Nowhere Boy*, a story of John Lennon, pre-Beatles, which was shown at the 2009 London Film Festival. Unusual subject matter and startling visual juxtapositions displace and unsettle expectations; *Brontosaurus* (1995) was a slow-motion video of a naked man dancing to Samuel Barber's *Adagio for Strings*, the music more widely associated with Oliver Stone's Vietnam war film *Platoon* (1986).

Taylor-Wood's interest in multiple and simultaneous projection, narratives and audio sequences creates an immersive spectacle in which the audience is required to react and respond. In *Five Revolutionary Seconds* (1995–97), a series of five adjacent photographic scenes, people are recorded playing music, talking, looking at views and having sex. The soundtrack, which mixes conversational extracts and background noise, further dislocates the spectacle of the under-seen. The cultural commentator Michael Bracewell has noted the apparent exteriority and precision of Taylor-Woods's settings and subject matter; the human is deflected by surface, harsh lighting, and the opulent and minimalist interiors of industrially sized studios.[71] Describing the piece, Taylor-Wood notes:

> I also think about those photographs as showing different states of being within one room. It was also about all those different ways of isolating yourself from other people … it's a momentary thing, isolated in time.[72]

In *Third Party* (1999), a seven-screen video projection surveys the scene of a cocktail party, with some of the roles acted by celebrities such as Ray Winstone and Marianne Faithfull. In what has become a signature motif of her work, close-up shots explore psychological and emotional states, with the viewer cast as voyeur and spectator in front of an unfolding drama. As Ursula Frohne notes, multiple images of a scene fragment the 'spatial continuity that exists in live television productions' and the conventions of 'axial vision' which we associate with both cinema and television.[73] Instead, the audience are expected to play a more robust and participative part in synthesising meaning and coherence from what is presented to them.

Still Life (2001), a video projection shot on 35 mm film which runs for three minutes and forty-four seconds, combines the conventional vanitas symbolism of still life photography with the liminal – exploring the transitory presence and shifting identities of subjects and objects otherwise beneath notice (Plate 21). Taylor-Wood's image uses time-lapse photography to dramatise decay and entropy through a tabletop arrangement of fruit on a woven platter. We view the accelerating process of decomposition; the spreading and weaving of fungal spores, the growth of mould and the collapse of the distinctness and difference between apples, grapes and pears into an unidentifiable, dessicating mass, a process which is both estranging and compelling.

Still Life combines the accelerated real time of the DVD, and the technical deliberations of lighting, angle and field of vision, with the conventions of 'tableau' photography in which subject matter is arranged in a way suggestive of a carefully composed painting. The inclusion of a biro in the scene's right foreground keys the contemporary, the disposable and the contingency of everything that is being viewed.

Taylor-Wood's use of the single-frame construction of tableaux or 'staged' photography makes explicit reference to the traditions of eighteenth and nineteenth century still-life picture making. Described by the art historian Norman Bryson as the 'overlooked' genre, still life conjures up the work of Chardin, Caravaggio and Zurburán and a range of seventeenth-century Dutch artists whose work objectified, and made permanent, transient but expensive arrangements of flora and fauna.[74] The immobility of their paintings' painted surfaces arrests the patina of decay, which makes the displayed flora and fauna seem all the more theatrical and pristine.

In contrast to the disruption of narrative conventions or the use of speed-lapse photography, Mark Wallinger's *Threshold to the Kingdom* (2000) is a slow-motion video projection set to Gregorio Allegri's distinctive and haunting choral music, *Miserere Mei, Deus* ('God have mercy on me') (Plate 22). It was presented as part of the artist's Tate Liverpool retrospective, *Credo*, and subsequently shown at the 2001 Venice Biennale.

Threshold to the Kingdom was filmed and recorded at the international arrivals gate and lounge of London's City Airport. Over eleven minutes, we view a succession of passengers, tourists and aircrews, walking, rushing and hurrying to their respective destinations; some carry suitcases, bags or push airport trolleys. The video recording was static; people pass in and out of shot and then disappear; there are no tracking scenes, cuts or slow dissolves on the full-length version. Throughout the length of the film, Allegri's music, a hymn of atonement set to the words of Psalm 51, provides a mesmeric and evocative sound landscape, suspending the sense of viewing a banal image airport arrivals lounge, and suggesting, instead, a metaphor for the transcendent and the ephemeral. As one blog suggested, Wallinger's piece was a 'slow motion ode to life, loss and transience'.

The only narrative provided is what can be discerned from the gestures, destination and dress of the filmed participants. The slow-motion spectacle undermines the speed of delivery we associate with other forms of documentary and film footage, prompting comparisons to the visually evocative video-based work of Bill Viola. *Threshold to the Kingdom* retains some of the accepted filmic and documentary conventions, instead presenting meaning symbolically and through metaphor. Although depicting the actual passage into a sovereign State, the scene, enhanced by Allegri's choral music, can been read as an allegory for people entering the Kingdom of Heaven. Wallinger recalled of the work:

> the rigmarole that the State puts one through ... [is] a kind of secular equivalent of the confessional and absolution I thought if we shot this very symmetrically and used slow motion, people's gestures would assume a kind of gravitas and become almost like Renaissance paintings Obviously using *Le Miserere* helps; even the words seem to suit this appeal to a merciful God.[75]

Threshold to the Kingdom evokes the elevated experience of the Sublime, a spectacle which threatens to engulf and dissolve us in the very act of beholding it. Other contemporaries have also broached similar themes, but through the more conventional idiom of landscape. Zarina Bhimji (b. 1963) is a graduate of Goldsmiths College (1983–86) and the Slade School of Fine Art (1987–89), and works in various media including film, photography, sound and installation. She received a Paul Hamlyn Foundation Award in 1999 and has had major exhibitions at Iniva, London (2004) and Leeds City Art Gallery (2004).

Bhimji's single-screen installation *Out of Blue* (2002), commissioned for *Documenta 11* in 2002 and then displayed for the first time at Tate Britain in 2003, shows the haunting landscape vistas and vernacular architecture of Uganda. Filmed in Super 16 mm colour film, *Out of Blue* offers a meditation on time, landscape and memory. An atmospheric soundtrack of murmured voices, birdcalls, the crackle of fire and echoes from the buildings filmed, accompanies panoramic images of lush bush and mist-shrouded forests.

Bhimj's profound sense of place and scene also has a more personal and biographical association. Like many South Asians and Africans, she and her family were expelled from Uganda by the incoming General Idi Amin in 1972. Moving to Britain with her family when she was eight years of age, these haunting images have been described as oblique narratives of loss and mourning. Bhimj's work has prompted comparisons to the British landscape tradition of Turner and the category of the Sublime. Whilst the human is literally absent from *Out of Blue*, the work hints at the 'elimination, extermination and erasure' of those who opposed Amin in the 1970s.[76]

The idea of the Sublime has also been explored in the realm of photographic and photojournalistic images of war and its aftermath. Part of the Brighton Photo Biennale, *The Sublime Image of Destruction* (De La Warr Pavilion, October 2008–January 2009), curated by Julian Stallabrass, featured work by Adam Broomberg and Oliver Chanarin, Simon Norfolk, and Paul Seawright. In an interview transcript which formed the exhibition catalogue, Stallabrass noted the trend towards 'scale and resolution' of most museum photography concerned with the Sublime, which presents viewers with 'more information than they can readily process'. Using a term which has been applied more generally within art practice, Stallabrass characterised the effect as that of the 'data sublime'.[77]

Historically, philosophical and aesthetic categories such as the Sublime and the Picturesque were represented through the genres of history and landscape painting. The technical sophistication allowed by digitisation and refinements in film and camera specifications have enabled contemporary photographers and documentary makers to mediate the idea of the Sublime and visual spectacle in new and different ways, a trend apparent in recent forms of installation practice.

Portraiture, still life and new media art: objectification and reversals

Since the 1960s, photography and film practice have adopted ideas taken from conceptual art and from concerns informed by gender, identity and critical theory. Particularly, the conventions of portraiture and self-presentation have been explored by a post-conceptual generation of artists responsive to the issues of photographic reliability and objectivity.

London-based photographer and performance artist Jemima Stehli (b. 1961) has produced a range of work which explores the provocative intersections between gender, power and objectification, performing both subject and object roles in her photographic work. In the diptych *After Helmut Newton's Here They Come,* (1999), Stehli appropriated work by the late fashion photographer Helmut Newton (1920–2004) by appearing as both the clothed and naked model, walking towards the camera. In the black and white shots, Stehli is seen holding the camera shutter cable and so exercising agency and control, despite her apparent self-objectification in front of the lens.

The themes and inflexions of self-portraiture are further explored in *Strip* (1999–2000), a series of seven colour photographs which Stehli produced in collaboration with selected male critics, curators, writers and dealers – the various valuemakers and intermediaries of the art world. In each image, Stehli is photographed from the back in various stages of undress; the colour shots are taken against different studio backgrounds with the male figure as the seated observer and protagonist in each image. In *Still From Strip (No.4)* (1999), Stehli continues the reversals of fashion and glamour photography with an undressed back shot. Although the viewed object, Stehli is nevertheless the self and culturally empowered auteur – the photographer, choreographer, commissioning agent and director of the image.

Portraiture as a form of social documentation has been associated with the practice of Richard Billingham (b. 1970), who took part in a 1994 group exhibition at the Barbican Art Gallery before achieving wider recognition through the 1997–8 *Sensation* exhibition. Billingham was subsequently shortlisted for the 2001 Turner Prize. His series of colour photographs, *Ray's a Laugh* (previously titled '*Who's Looking at the Family*') were also published as a book of colour plates. The colour photographs depict his parents, Ray and Liz, and his brother Jason, in their Sunderland council flat. The book's minimal preface text reads:

> This book is about my close family. My father is a chronic alcoholic. He doesn't like going outside and mostly drinks homebrew. My mother Elizabeth hardly drinks but she does smoke a lot. She likes pets and things that are decorative. They married in 1970 and I was born soon

after. My younger brother Jason was taken into care when he was 11 but is now back with Ray and Liz again. Recently he became a father. Ray says Jason is unruly. Jason says Ray's a laugh but doesn't want to be like him.[78]

Billingham's photographs, initially taken as studies for paintings, and described as a 'warts-and-all depiction of a disconsolate working class family', offer an affectionate and intimate take on the dynamics and dysfunctions of family life. As David Busell notes:

> They are naïve, humane and beautiful as they are artificial, raw and disconcerting. They lie somewhere between documentary and fiction.[79]

As a family member, Billingham is the auteur and the absent other. Photographs show family members eating, drinking, arguing, or his mother, Liz, piecing together picture puzzles to pass the time (Plate 23). The observation of unfolding family dramas combines close informality with forensic detachment. As a series of images, *Ray's a Laugh* adapts social reportage as an archive of daily family life, but the overall effect is one of repetition and stasis. As Billingham concedes, 'My family always stays the same, they watch the same films, they have the same pattern to their lives, they talk about the same things'.[80]

Social portraiture of a very different kind is appreciable in the work of Tom Hunter (b. 1965), who graduated from the Royal College of Art in 1997 and whose work was among the examples included in the Tate's first major exhibition of photography in 2007. *Woman Reading Possession Order* (1998) is a profile image of its subject which refashions and updates Vermeer's painting *A Girl Reading a Letter by an Open Window* (c. 1654–57). Hunter uncannily recreates a sense of a moment held in time and action suspended.

As the artist and writer Mark Durden has observed of this example, in staging this image as descriptive spectacle, there is the danger that the portrait loses its referentiality as social reportage:

> The real poverty and political struggles which mark life out in a squat are always in danger of becoming mere background to the overridingly visual effects as these alternative lifestyles are glamourised, made fashionable and chic.[81]

Through careful choreography, the actual repercussions for the mother and child suggested by the photograph's title are aestheticised and its immediate context backstaged. These devices result in a decorative tableau which is distanced from its subject – both historically and visually.

A committed feminist, teacher, socialist and publisher, Jo Spence (1934– 1992) initially worked as a commercial studio and portrait photographer

before enrolling for a degree in photographic theory and practice at the Polytechnic of Central London. Following a diagnosis of breast cancer in 1982, Spence increasingly used the photographic and documentary medium to reference and archive issues of class, family and social identity – including her own.

Opting on principle to undertake alternative and holistic treatment, rather than invasive chemotherapy, Spence used a series of still photographs, *The Picture of Heath?* (1982–1991) to document, literally and symbolically, the doctor/patient relationship, and what she perceived as the infantalisation and objectification of the body through medical discourse. Frequently combining text with image, Spence was influenced by Augusto Boal's Theatre of the Oppressed and the ideas of Brecht. Among her professional legacies, with partner and collaborator Terry Dennett, were *Remodelling Photo History* (1982) and establishing the Photography Workshop (1973), an independent organisation dedicated to photographic research, exhibition and publishing.

Spence used and adapted a range of practices in what she termed 'photo therapy'. In addition to techniques of documentary, she staged photographic shots and used old family snaps as found objects and ready-made points of departure for her own work. As she acknowledged in an article authored for the second-wave feminist magazine *Spare Rib*, the technique depended upon using photographs discursively:

> The whole technique depends upon expecting photographs to help us to ask questions, rather than supplying answers. Using this framework … it is possible to transform our imaginary view of the world … trying to change it socially and economically.[82]

Experientially and professionally, Spence's adaption of photographic self-portraiture was a therapeutic response to illness and a powerful means of retaining personal agency. As with Kennard's and Picton Phillipps' collaborative work, Spence used the medium, often with text montage, as part of a dialectic which emphasised the medium's authentic contribution to a dissenting tradition which, in the 1980s, faced being marginalised by authoritarian politics and a centralising State bureaucracy.

Steve McQueen (b. 1969) was born in West London, and studied at the Chelsea College of Art (1989–90) and Goldsmiths College between 1993–94, with a short period at film school in New York. He came to notice with short 16 mm minimalist films such as *Bear* (1993), in which two naked black men (one of them McQueen) square up to each other as if in preparation for some form of encounter or physical contest. Although only a ten-minute film, the close camera angles and shots focus on the changing choreography and facial expressions of the two figures, creating an intense and claustrophobic scenario, the outcome of which is unresolved. *Deadpan* (1997) is a recreation of a slapstick Buster Keaton stunt from the movie,

Steamboat Bill, Jr (1928), in which McQueen emerges unharmed from a collapsing wall of a barn. He won the Turner Prize in 1999 and represented Britain at the 2009 Venice Biennale.

More recently, McQueen has produced work that addresses themes that are more directly social and political in character. The subject of the feature film he directed, *Hunger* (2009), was the last six weeks of the Irish Republican hunger striker Bobby Sands who led the Maze Prison protests in 1981. In character with McQueen's earlier short films, there is no dialogue for the first hour of the film, until a twenty-two minute sequence where Bobby Sands discusses his intention with a Catholic priest.

In 2003 McQueen was sponsored by the Imperial War Museum to cover the conflict in Iraq as a British war artist (as John Keane had been before him). As an 'embedded observer' McQueen spent six days in the southern port of Basra, then remote from the conflict. What little the artist saw was carefully media managed and controlled by the Ministry of Defence (MoD), although what he did witness was the calm professionalism and commitment to duty of the soldiers around him.

What McQueen fashioned from that experience was the powerful and compelling portrait-based memorial *Queen and Country* (2003–) (Plate 24). It comprises a large oak cabinet which contains 155 vertical drawers, each of which holds multiple images of one of the 155 British soldiers killed on active service in the most recent and ongoing Iraq conflict. Arranged chronologically, in the order in which the soldiers were killed, each soldier's photograph is accompanied by details of their regiment and age at date of death.

McQueen was initially refused permission by the MoD to contact the relatives of the dead soldiers, but supported by the Manchester International Festival, he employed a private researcher to make contact with the bereaved families, who were asked to provide their favourite photograph of their late son or daughter, husband or wife, in uniform. The response was overwhelmingly positive. McQueen then made sleeves of facsimile postage stamps from each of the photographic portraits with the intention that the Royal Mail should issue the images as official postage stamps as a public gesture of commemoration and respect. As Julie Maddison, the mother of one of the Royal Marines who died in the initial months of the Iraq War, was quoted as saying:

> A commemorative stamp is a small price to pay for a life, but a respectful way to remind us of those who gave their lives for the war in Iraq, whether we agree with the war or not.[83]

McQueen has refused to be drawn on his private and personal opinion of the most recent war in Iraq, but discussing *Queen and Country* at interview, he recalled the initial suggestion from a senior MoD official that while they

had no objection to the stamps per se, perhaps he could have done 'landscapes' instead. He countered by asking, 'Are you ashamed of these people?' At interview, McQueen continued:

> The whole idea is to give them visibility. This isn't pro-war or anti-war. It's not about Left or Right, or right and wrong. It's about allowing this situation to reach the general public, not through the sensationalism of the media, but by entering the everyday, entering people's lives when they bend down to pick up their mail.[84]

McQueen has made it clear that he considers the work unfinished until the portrait-stamps are officially issued by the Royal Mail. At the time of writing, over 20,000 people have signed the online petition requesting that this be done.[85] As a government-owned organisation, the Royal Mail's decision whether to use the images is ultimately a State-sponsored and politically based one. *Queen and Country* has been purchased for the nation by the Art Fund charity and has since toured the United Kingdom.

While the photographs displayed by McQueen necessarily follow the formal conventions of military portraiture, Anna Barriball (b. 1972) has explored ideas of the 'found' and technically altered or adjusted image. A graduate of Winchester School of Art (1995) and the Chelsea College of Art (2000), Barriball works across media, using photography, drawing, sculpture, installations and light projection. *Untitled III* (2004) is one of a series of found black and white photographs across which ink-based soap bubbles have been blown (Figure 4.9). The resulting forms and patterns are random. As Roger Malbert writes of the series:

> The black, ectoplasmic traces spatter the image, menacing their spectral (because long past), smiling or pensive subjects … . Barriball adds another level of graphic incident, compounding the anecdotal content to the photographs with evidence of an equally fleeting event, captured as the floating bubbles land or explode above the image.[86]

Using a single black and white portrait image as a point of departure, Barriball's *Untitled III* hybridises and combines various traditions and motifs of art-making. The contingent, found object references Duchamp, while the expressionistic ink 'signature' suggests, perhaps, the painterly and free-form gestures of Abstract Expressionism and high Modernism. No context or narrative is given or provided for the boy in the photographic image which Barriball's alchemy renders abstract, even elegiac.

A member of the YBA generation, Gillian Wearing (b. 1963) initially came to prominence in the early 1990s through groups shows like *Brilliant* (1995) and *Sensation* (1997). A graduate of Chelsea College of Art (1985–87) and Goldsmith's College (1987–90), Wearing was given a BT Young

Figure 4.9 Anna Barriball, *Untitled III*, 2004. Ink and bubble mixture on found photograph, 11.9 x 7.9 cm / 34 x 25 cm (framed). Courtesy of Frith Street Gallery.

Contemporaries Award in 1993, the year of her first solo exhibition at the artist-run gallery City Racing, and her video and photographic work was recognised with the award of the Turner Prize in 1997.

Much of Wearing's work explores and visualises human experiences, from the banal to the extreme, and the psychological reactions they provoke. The origin and focus of her work has been characterised as a response to the cultural vogue for the ethnographic – the production of work based on the observation of human behaviour and society. *Mass Observation*, the title of Wearing's 2003 touring exhibition (Chicago and Philadelphia), was a deliberate reference to these concerns, and to the tradition of British social documentary making and the social and ethnographic portrait traditions with which it was associated.

In the series of signature photographs, *Signs that Say What You Want Them to Say and Not Signs that Say What Someone Else Wants You to Say* (1992–3), passers-by on a London street were invited to pen their thoughts on placards which they were then photographed holding. The card held by one well-dressed businessman states 'I'm desperate'; another held by a woman reads 'I don't want to look like a boy'. That held by another man reads quizzically 'What is it?' A simple strategy, the work objectified and displayed the interior world of strangers, marrying public declarations with private introspection.

In a variation of this format, Wearing advertised in papers asking people to contact her and to give video interviews discussing their lives (*Confess All on Video*, 1994). Photography and video cameras are used to explore self-disclosure and the confessional, but in contexts that are public, open and seemingly discursive. In a series of reversals, Wearing appears to exchange agency and authorship, soliciting the thoughts and voices of strangers.

Self-observation of a different kind was the basis for *Dancing in Peckham* (1994), a colour video projection which features Wearing dancing to music in a South London shopping mall. Although clearly staged, from the colour stills of the video, the artist, eyes closed and facing down, is oblivious to, and abstracted from, the milieu of onlookers and passing shoppers. In this image, narrative appears suspended and pared down to the dancer's self-engagement and self-absorption.

Wearing's practice, like that of Sam Taylor-Wood and Douglas Gordon, engages with video principally as a psychological, rather than a technological medium. This follows a characterisation made in the essay 'Video: the aesthetics of narcissism' (1976) by Rosalind Krauss.[87] As one commentator notes of the essay's emphasis:

> The video practices she was concerned with invariably addressed in a self-referential way the relationship between the artist and the image or, in the case of the installation work, the relationship between the spectator and the image.[88]

Wearing's work draws attention to the variability of spectatorship and the narcissistic drives which define the relationship between the artist, the image and their self-representation within practice. Some of these themes are explored in *Sixty Minute Silence* (1996), a colour video projection with sound in which twenty-six members of the public, dressed in police uniforms, sit and stand as if for a formal group portrait (Figure 4.10). Over the course of the sixty minutes, people inevitably cough, fidget, and demonstrate the various tells and tics which index human character pathology.

Discussing this work, Dominic Molon has suggested how it themes a reversal of power. Police officers ordinarily signify visible authority and the formal surveillance of the State. Referencing Michel Foucault's book *Discipline and Punish: The Birth of the Prison* (1977), Molon notes how Wearing's extended photograph overturns the conventional power dynamic, with the police made 'prisoners' – visible as individuals through the levelling and objectifying glance of the viewer.[89] The use of members of the public to 'impersonate' police officers lends ironic duplicity to expectations of appearance and identity.

The idea of portraiture-based reversals has been given a different inflexion in the work of Yinka Shonibare (b. 1962). Born in London and raised in Nigeria, he is a graduate of Byam Shaw School of Art (1984–89) and Goldsmiths College (1989–91). Shonibare was nominated for the Turner Prize in 2004, awarded the Paul Hamlyn Foundation Award for Visual Artists in 1998, and was made a Member of the Order of the British Empire (MBE) in 2005. He works across a range of media including film, photography, sculptural works and painting-based installations.

Shonibare's signature works are tableau scenes in which characters are dressed in period costumes, particularly Indonesian-designed fabrics or batik, historically produced in the Netherlands, but widely worn and used in West Africa. In dramatically realising these fabrics in meticulously arranged figure compositions, typically set in the eighteenth and nineteenth centuries, Shonibare references the formative role of cultural hybridity in colonial and post-colonial history.

Many of the scenes appropriate the choreography and aristocratic subjects taken from canonical western images by Gainsborough, Fragonard and Watteau, in particular *The Swing (after Fragonard)* (2001) and *The Pursuit* (2007). More directly, Shonibare recognises these widely photographed installations as polemical interventions which, in referencing the *ancien régime* of the French aristocracy and their English counterparts, provide analogies to contemporary inequalities and diasporas. Discussing the installations that formed the basis to the *Garden of Love* exhibition at the Musée du quai Branly (2007), Shonibare noted:

> I am deliberately taking this period as a metaphor for a contemporary situation ... people from the Southern Hemisphere, the Third World

Figure 4.10 Gillian Wearing, Sixty Minute Silence, 1996. Colour video projection with sound, 60 minutes. (MP-WEARG-00140). Courtesy Maureen Paley, London.

countries ... are looking at Europe as the rich fruit basket, or if you like the 'rich garden'. It's the garden of Eden for them.[90]

Diary of a Victorian Dandy (1998) (Plate 15) is a series of five photographic tableaux in which Shonibare plays the role of the dandy, variously surrounded by servants, admirers and hangers-on. The carefully choreographed scenes are set in grand Victorian interiors, with the cast wearing period costumes which indicate their social status and relationship to the dandy. The scenes recall Hogarth's allegorical series of paintings *The Rake's Progress*, in which the various fortunes of a naive and impressionable young man, recently in receipt of a considerable inheritance, are depicted.

In Shonibare's narrative, the rest of the Caucasian cast are oblivious to the dandy's skin colour, although difference is coded in more oblique ways. The ambiguous cultural status of the dandy as an outsider is well referenced in the literature and painting of the nineteenth and early twentieth century. It was also the subject of Shonibare's *Dorian Gray* (2001), a series of eleven black and white photographs which took as its subject Oscar Wilde's moralistic novel *A Portrait of Dorian Gray*, with Shonibare portrayed as the narcissistic and ultimately doomed subject.

Diary of a Victorian Dandy was commissioned and produced by the Institute of International Visual Arts (Iniva) and was originally displayed as a series of site-specific posters for the London Underground. As Charlotte Cotton notes, the initial siting of the posters was designed to repeat the commercial and popular contexts of Hogarth's original narrative. His works were widely circulated as prints, the mass media of the time.[91] In Shonibare's carefully choreographed juxtapositions of fabrics and aristocratic characters, the artist plays out the histories and dependencies of empire, class, difference and power.

New media art has been defined as practice that is 'computational and based on algorithms' and may also take ideas and themes from genetic engineering and biotechnology.[92] Continuing its characterisation, Christiane Paul describes it as 'process-oriented, time-based, dynamic, and real-time; participatory, collaborative, and performative; modular, variable, generative, and customizable'.[93]

Digitisation has established computer and internet-based art as a new form of customisable cultural production, examples of which do not necessarily require white cube gallery spaces. It encompasses the full spectrum of audience engagement, from accessing pre-programmed images on a laptop to the use and adaption of virtual reality software, headsets and data gloves. As with installation art, new media practice can combine spectacle with a fully immersive experience which simulates the real. For example, internet technologies have enabled the creation of virtual online communities such as *Second Life* in which participants create their own personas, contexts and narratives.

By definition, online and internet-based art dissolves and circumvents national and international boundaries, although the United Kingdom has hosted early exhibitions devoted to the medium. These have included *Serious Games,* curated by Beryl Graham (Barbican Art Gallery, London and Newcastle's Laing Art Gallery) and *Art and Money Online,* hosted by Tate Britain in 2001. Julian Stallabrass, who curated the Tate's exhibition, also authored the associated text, *Internet Art: The Online Clash of Culture and Commerce* (2003). Discussing the novelty and instability of this new form of cultural production, Stallabrass noted that while internet art demonstrated modernist ideals such as 'openness' and 'radical political engagement', it did so using a technological platform which was itself a contested space:

> It is a vision, though, that must continue to be fought for against those who would turn the Net into a tame, regulated broadcast space, serving as a pervasive and ubiquitous mall.[94]

Several years on, and with increasing State security interest and surveillance of public spaces and forums, both literal and virtual, these concerns remain valid. However, the sheer diffusion and 'decentredness' of new media art and its colonisation of evolving technologies demonstrate a genuine cultural power, largely independent of institutions, patrons or nation states. In this respect the deterritorialisation of internet-based art provides a unifying – and heterogeneous – paradigm which increasingly situates forms of documentary, video and photographic practice.

Notes

1 Maria Lind and Hito Steyerl, 'Introduction: reconsidering the documentary and contemporary art', in Maria Lind and Hito Steyerl (eds), *The Green Room: Reconsidering the Documentary and Contemporary Art #1* (Sternberg Press, 2008), p. 16.
2 Graham Clarke, *The Photograph: A Visual and Cultural History* (Oxford History of Art, 1997), p. 18.
3 Roland Barthes, *Camera Lucida: Reflections on Photography* (Hill and Wang, 1982), p. 30.
4 Charlotte Cotton, *The Photograph as Contemporary Art* (Thames & Hudson, 2004), p. 12.
5 Stefan Jonsson, 'Facts of aesthetics and fictions of journalism: the logic of the media in the age of globalization', in Lind and Steyerl, *Reconsidering the Documentary and Contemporary Art #1*, p. 170.
6 Ibid.
7 Steve Edwards and Jason Gaiger (eds), *Art of the Twentieth Century: A Reader* (Open University and Yale University Press, 2003), p. 109.
8 Walter Benjamin, 'The work of art in the age of mechanical

reproduction', quoted in Charles Harrison and Paul Wood (eds), *Art in Theory: An Anthology of Changing Ideas 1900–2000* (Blackwell, 2002), p. 522.

9 John Berger, *Ways of Seeing* (Penguin, 1985), pp. 129–54.

10 Roland Barthes, *Camera Lucida: Reflections on Photography* (Hill and Wang ,1980), p. 27.

11 See John Tagg, *The Burden of Representation: Essays on Photographies and Histories* (Palgrave Macmillan,1988).

12 Susan Sontag, *On Photography* (Penguin, 1979), p. 6.

13 Clarke, *The Photograph.*

14 Mark Durden and Craig Richardson (eds), 'Introduction', in *Face On: Photography As Social Exchange* (Black Dog, 2000), p. 9.

15 Charles Esche, 'Preface', in Tanya Leighton and Charles Esche, *Art and the Moving Image. A Critical Reader* (Tate Publishing, 2008), p. 5.

16 Emma Dexter, 'Bringing to light: photography in the UK, 1980–2007', in Chris Stephens (ed.), *The History of British Art 1870–Now* (Tate Publishing, 2008), p. 222.

17 Steve Edwards, '"Profane illumination": photography and photomontage in the USSR and Germany', in Steve Edwards and Paul Wood (eds), *Art of the Avant-Gardes* (Yale University Press, 2004), p. 422.

18 Steve Edwards, 'Photography out of Conceptual Art,' in *Themes in Contemporary Art*, Gill Perry and Paul Wood (eds), Yale University Press, New Haven and London, 2004, pp. 137–40.

19 Michael Rush, *New Media in Late 20th-Century Art* (Thames & Hudson, 2003), p. 33.

20 David Metcalfe, quoted by Louise Cohen, 'Under the beady eye of Lord Nelson, video art is going pop', *times/the knowledge*, 1–7 September 2007.

21 Stefan Kalmár, Michael Bracewell, Ian White and Daniel Pies, 'Catalogue Preface', in *The Secret Public/The Last Days of the British Underground 1978–1988* (ICA Publications, 2007).

22 Kalmár et al., 'Catalogue Introduction', in *The Secret Public.*

23 Derek Jarman quoted by Jim Clark. See: http://www.clarkmedia.com/jarman/jarman06england.html (accessed October 2009).

24 See Grant Pooke, 'Pregenitality and the singing sculpture: the anal-sadistic universe of Gilbert & George', in Brandon Taylor (ed.), *Sculpture & Psychoanalysis* (Ashgate Press/Henry Moore Institute, 2006), pp. 139–59.

25 Pil and Galia Kollectiv, biographical and artists' statement, in Anthony Gross and Jen Wu, *Metropolis Rise: New Art from London* (Article Press, Centre for Fine Art Research, UCE, 2006), p. 189.

26 See: http://kollectiv.co.uk/!.html (accessed January 2010).

27 Ibid.

28 Ibid.
29 See Jonathan Griffin, 'Asparagus Ballet: A Horticultural Ballet': http://www.frieze.com/issue/print_back/asparagus_a_horticultural_ballet/ (accessed January 2010).
30 Vicki Kirby, *Judith Butler: Live Theory* (Continuum, 2006), pp. 42–7.
31 John Lechte, *Fifty Contemporary Thinkers: From Structuralism to Postmodernity* (Routledge, 1994), p. 142.
32 Julia Kristeva, 'Powers of horror: an essay on abjection' (1980), reprinted in Harrison and Wood, *Art in Theory*, pp. 1137–9.
33 Kira O'Reilly, email correspondence with the author, 5 March 2010.
34 Göran Sörbom, 'The classical concept of mimesis', in Paul Smith and Carolyn Wilde (eds), *A Companion to Art Theory* (Blackwell, 2002), pp. 19–28 (quote p. 26).
35 Sally O'Reilly, *The Body in Contemporary Art* (Thames & Hudson, 2009), p. 42.
36 Kira O'Reilly, email correspondence with the author, 5 March 2010.
37 See: http://www.tract-liveart.co.uk (accessed November 2009).
38 Ibid.
39 Quoted from Franko B. archive, http://www.bris.ac.uk/theatrecollection/liveart/liveart_FrankoB.html (accessed October 2009).
40 Franko B. quote from http://www.re-title.com/artists/Franko-B.asp (accessed October 2009).
41 Lea Vergine, *Body Art and Performance: The Body as Language* (Skira, 2000), p. 289.
42 Lorna Healy, 'We love you, Tracey: pop-cultural strategies in Tracey Emin's videos', in Mandy Muerk and Chris Townsend (eds), *The Art of Tracey Emin* (Thames & Hudson, 2002), pp. 156–7.
43 Allan Sekula, 'Dismantling modernism, reinventing documentary (notes on the politics of representation)' (1976–8), text sequence reproduced in Gaiger and Wood, *Art of the Twentieth Century*, p. 140.
44 Nicolas Bourriaud, *Altermodern Themes: Docu-fiction*, http://www.tate.org.uk/britain/exhibitions/altermodern/explore.shtm (accessed September 2009).
45 Will Bradley, 'Implicit in this attitude is a belief in freedom?' in *Luke Fowler* (exhibition catalogue, JRP Ringier, 2009), p. 21.
46 In making some of these broad comments and observations, I would like to acknowledge conversations with Elizabeth Tophill and the discussion of her own film-making experience and observations in preparing her Fine Art thesis (August/September 2009).
47 Hito Steyerl, 'A language of practice,' in Lind and Steyerl, *The Green Room*, p. 225.
48 Adam Chodzko, *Pyramid* information panel extract, reprinted in the catalogue, *Folkestone Triennial: Tales of Time and Space* (Cultureshock, 2008), p. 37.

49 *Folkestone Triennial* catalogue, 2008, p. 36.

50 Craig Richardson [with quoted extract from Adam Chodzko], 'Reality gaps, assumed and declared', in *Face On: Photography As Social Exchange* (Black Dog, 2000), p. 51.

51 Quoted in Louisa Buck, *Moving Targets 2: A User's Guide to British Art Now* (Tate Publishing, 2000), p. 122.

52 Willie Doherty quoted in Buck, *Moving Targets 2*, p. 54.

53 Cotton, *The Photograph as Contemporary Art*, p. 168.

54 Willie Doherty, quote on *Somewhere Else* from: http://www.fineaet.ac.uk (accessed September 2009).

55 Information from the press release accompanying the private view of *Road Race*, screened at Platform, Wilkes St. London, 10 December 2004. See: http//www.platformprojects.org.uk/2005/plat46/46info.html (accessed December 2009).

56 Matthias Connor, 'Oliver Payne and Nick Relph,' in Clare Manchester (ed.), *Beck's Futures 2002: Tomorrow's Talent Today* (ICA, 2002), p. 43.

57 Michael Wilson, review, *Frieze*, Issue 63, November–December 2001. See: http://www.frieze.com/issue/review/oliver_payne_and_nick_relph (accessed November 2009).

58 Emma Mahoney, catalogue entry on Paul Rooney for *British Art 6*, p. 212.

59 Robert Graham, 'In search of a revolutionary consciousness: further adventures of the European avant-garde,' in Paul Wood (ed.), *Varieties of Modernism* (Yale University Press/Open University, 2004), p. 385.

60 Steve Edwards, 'Profane illumination: photomontage and photography in the USSR and Germany', in Steve Edwards and Paul Wood (eds), *Art of the Avant-Gardes* (Yale University Press/Open University, 2004), p. 413.

61 Susan Sontag, *On Photography*, p. 51.

62 Steve Beale, exhibition flyer commentary for *Blairaq*, June 2007.

63 Peter Kennard interviewed by Yuri Prasad for *Socialist Worker*, 30 June 2007.

64 My thanks to Cat Picton Phillipps for this information, email 11 March 2010.

65 Kennard, *Socialist Worker*, 30 June 2007.

66 See: http://www.luxonline.org.uk/artists/alia_syed/index.html (accessed November 2009).

67 Joanna Lowry, 'Performing vision in the theatre of the gaze: the work of Douglas Gordon,' in Amelia Jones and Andrew Stephenson (eds), *Performing The Body/Performing The Text* (Routledge, 1999), p. 280.

68 Ibid., p. 275.

69 Rebecca Heald, entry on Mark Leckey, in Alex Farquharson and Andrea Schlieker (eds), *British Art Show 6* (Hayward Gallery Publishing, 2005), p. 84.

70 Buck, *Moving Targets*, p. 91.
71 See Michael Bracewell, 'The art of Sam Taylor-Wood', in *Sam Taylor Wood* (2002).
72 'Sam Taylor-Wood in conversation with Clare Carolin', in *Sam Taylor-Wood* (2002).
73 Ursula Frohne, 'Dissolution of the frame: immersion and participation in video installations,' in Tanya Leighton (ed.), *Art and the Moving Image: A Critical Reader* (Tate Publishing, 2008), p. 369.
74 See Norman Bryson, *Looking at the Overlooked: Four Essays of Still Life Painting* (Reaktion, 1990).
75 See: http://www.tate.org.uk (accessed November 2009).
76 See: http://www.tate.org.uk/britain/exhibitions/artnow/bhimji/default.shtm (accessed November 2009).
77 Julian Stallabrass interviewed by Rohan Jayasekera in *The Sublime Image of Destruction* (Exhibition catalogue, De La Warr Pavilion and Arts Council).
78 Richard Billingham, 'Preface', *Ray's A Laugh* (Scalo, 1996).
79 David Bussel, entry on Richard Billingham, *Sensation* catalogue, 1997, p. 193.
80 James Lingwood, 'Family values' (interview with Richard Billingham), *Tate* (Summer 1998), p. 56.
81 Mark Durden, 'Empathy and engagement: the subjective documentary', in Durden and Richardson, *Face On*, p. 32.
82 Extract submitted to *Spare Rib*, no. 163 (February 1986). See: http//www.hosted.aware.easynet.co.uk/jospence/jotext2.htm (accessed January 2010).
83 Quoted by Richard Morrison, 'McQueen's moving tribute needs the stamp of approval', *The Times*, 11 November 2009.
84 Steve McQueen interviewed by Alastair Sooke, 'Venice's Carnival of the modern', *Telegraph Review*, 30 May 2009.
85 Figure quoted by Richard Morrison, *The Times*, 11 November 2009.
86 Catalogue entry by Robert Malbert in *British Art Show 6*, , p26.
87 Rosalind Krauss, 'Video: The Aesthetics of Narcissism', *October*, no. 1 (Spring 1976), pp. 51–64.
88 See Joanna Lowry, 'Performing Vision in the Theatre of the Gaze: The Work of Douglas Gordon', p. 276.
89 Dominic Molon, 'Observing the Masses', in Gillian Wearing, *Mass Observation*, 2003, p. 14.
90 Yinka Shonibare interviewed by Bernard Müller, for the catalogue, *Jardin d'amour* (Flammarion, 2007), p. 12.
91 Cotton, *The Photograph as Contemporary Art*, p. 57.
92 This characterisation is suggested by Christiane Paul (ed.) in *New Media in the White Cube and Beyond* (University of California Press, 2008), p. 3.

93 Paul, *New Media in the White Cube and Beyond*, p. 4.
94 Julian Stallabrass, *Internet Art. The Online Clash of Culture and Commerce* (Tate Publishing, 2003), p. 155.

Post-Conceptual British Art: New Directions Home

Whilst reviewing the Turner Prize, curator Tom Morton quoted the cryptic response of Zhou Enlai, the first Premier of the People's Republic of China, who, when asked about the consequences of the French Revolution, allegedly replied 'It's too early to tell'.[1] Although the aside is probably apocryphal, it underlines the problems of making assessments when the visual histories in question are still close at hand. Or put another way, how soon is now? How do we situate the art practice and related sensibilities of recent decades when all are in a process of becoming?

However, in sampling some of the critical concerns and idioms suggested by a range of practice, it is possible to make some broader characterisations of British art and to identify several step-changes within recent decades. Across genres – painting, performance, video and installation – there has been, and continues to be, an appreciable and reflexive exploration of the legacy of Modernism. This can be understood as a range of critical precepts associated principally with the thinking of Greenberg and others, which informed the various forms of abstraction – gestural and colourfield – which characterised the hegemonic painting of the 1950s and early 1960s. But the term can also be applied to a pervasive range of stylistic idioms and beliefs which situated the practice and cultural politics of the avant-gardes from the 1920s and 1930s onwards.

As the curators Alex Farquharson and Andrea Schlieker have recently noted, such cultural referencing has not just instanced ironic appropriation and pastiche, tendencies apparent throughout much of the late 1970s and 1980s. Rather, it has involved considered practices of cultural reclamation and visual archaeology in which Modernist ideas have been adapted in relation to more recent concerns and values. As the curators note:

> Unexpected hybrids result from these experiments: fusions of different media; combinations of abstraction and figuration; the eroticisation of the rational … . Often what these have in common is the attempt to translate specific moments of Modernism into individual and private spheres of experience.[2]

Although the social present of late modernity appears fractured and atomised, art practice increasingly accents the discursive and relational, rather than the 'private and symbolic spaces' associated with earlier forms of Modernist practice. Artists from among what might be described as a post-conceptual generation (those typically born from the mid-1950s onwards), have taken the progressive and utopian narratives of earlier avant-gardes as investigative and critical points of departure for their own practice.

In recent British painting, for example, a range of artists have redefined and remixed a Modernist idiom, including Cecily Brown, Gillian Carnegie, Gary Hume and Fiona Rae. The 2006 Tuner Prize winner Tomma Abts (b. 1967) has explored variations of pigment depth, from layering to thin washes, replaying and combining the 'push and pull' of earlier Modernist canvases, but with pragmatic and geometrical calculation. Jenny Saville has used Modernist techniques of impasto to represent the ambiguities of sexual and transgender identity, while referencing iconographical motifs associated with Francis Bacon and Lucian Freud. In contradistinction, canvases by Nigel Cooke and George Shaw explore broader epistemologies: the signification of painting as a discourse and its association with entropy, memory and loss.

The appropriation of modernist iconography and interrogations of its legacy have also been appreciable across the genres of performance, film, installation and sculpture. A range of artists have variously acknowledged and critiqued the progressive social ideals of earlier avant-gardes, while registering a keen awareness of the institutional frameworks and constraints within which the making of art necessarily takes place. The expanded realm of cultural production within late modernity is also apparent in the colonisation of new locations, environments and contexts, virtual and otherwise, for displaying and exhibiting art.

In parallel with wide-ranging experimentation with form and medium, British artists have sustained a tradition of narrative and allegorical practice, a trend which has been particularly apparent within painting, but also evident across film and performance. Wide-ranging themes have included a commitment to place, memory and changing ideas of community and social agency, exampled in particular by the upswing in forms of documentary-fiction and its relocation to white cube gallery spaces.

More recently, commentators have argued that art and aesthetics have witnessed a 'turn to the political' and the affective, claims associated in part with renewed critical interest in the work of Alain Badiou, Ernesto Laclau and Jacques Rancière.[3] But in the United Kingdom at least, dimensions of the political and the social have been recurrent themes across all genres, especially since the 1980s, although the prominence accorded to the robust aesthetic of the YBAs throughout much of the subsequent decade obscured the long-standing continuity of political and allegorical strands within British art practice.

A noticeable shift in the last two decades has been towards a less programmatic sense of the political to its re-definition and mediation through the immediately personal; the idea of the political as a struggle for the recognition and recovery of 'voice' and individual 'agency'. Some immediate examples are suggested by the practice and legacy of the late Derek Jarman and Jo Spence, as well as through practice by Zarina Bhimji, Isaac Julien and Sandra Lahire. The film and video-based work of Clio Barnard and Paul Rooney has, for example, employed and adapted the documentary rubric to explore the marginal practices and perspectives of outsider communities and constituencies. In doing so, the political is defined and inflected through the representation of a plurality of experience, values and in depicting the lives of others.

The emergence of an enterprise culture has been one of the distinctive features of recent decades. Ideologically part of the laissez-faire ethos associated with the Conservative election victory of 1979, the belief in the prevailing virtues of the free market has defined New Labour thinking, providing the broader context in which British art and its infrastructure has developed over the thirty years to 2010.

In the United Kingdon as with much of the rest of the globe, cultural patronage has become increasingly hybridised, with corporate and private interests among the prime drivers of contemporary art sponsorship in recent years. The decision to apply the legal principle of the *droite de suite* to the resale of art concedes the ultimate role of the free market in recognising and regulating the commercial value of cultural production. But the United Kingdom has yet to match the pervasive private philanthropy and endowment culture that characterises the United States, although there are increasing signs that policy makers will consider making changes to British tax and revenue laws in order to encourage such practice.

Where public money is directly used to support the visual arts or in developing associated infrastructure, the justifications remain instrumentally geared to social regeneration and inward investment. The recognition that the cultural industries can make a particular contribution to social, economic and environmental regeneration has provided an impetus for central government funding and corporate giving for larger-scale projects with a civic or public dimension. It remains to be seen what the longer-term consequences will be for the broader trajectory of artistic production and for possibilities of self-censorship. Arguments for the inherent value of the visual arts, if articulated at all, are typically deployed as a default or supplementary position. In the United Kingdom at least, mainstream political approaches to visual culture seem reluctant to concede its intrinsic indispensability.

Paradoxically, such attitudes seem out of step with unprecedented levels of interest in visual culture and contemporary art among the broader British public. For example, footfall to the Tate Modern since it opened in

2000 has massively exceeded expectations, while major galleries and art installations in Gateshead, Liverpool, Middlesbrough, Newcastle and Margate have generated a palpable sense of local and regional ownership. Applications to universities and colleges to study fine art have remained buoyant throughout the years of economic boom, and have been sustained during the more recent downturn.

In the United Kingdom as elsewhere, fine art education, and its supporting infrastructure, has become an increasingly commodified and globally networked industry. In recent years, artists have responded imaginatively and laterally to what has been described as a 'Post-Fordist' cultural environment in which self-motivation, 'brand image' and a networked identity have become professional prerequisites. The doubling of artistic agency through personal and professional partnerships is among the lessons inherited from the modernist avant-garde during earlier times of relative austerity.[4] Similarly, trends towards collectively managed gallery and studio spaces, group shows, self-publishing and self-curation, suggest points of continuity with the earlier experience of YBAs such as Damien Hirst, Tracey Emin and Sarah Lucas at initial stages in their post-art college careers.

As suggested at the start of this book, within a context of global integration (and fracture), cultural production increasingly transcends nation states. Although Bourriaud's concept of the altermodern and the relational has a seductive ambiguity, it remains to be seen whether related characterisations of aesthetic practice in fact conceal altogether harsher and less easily reconcilable realities and conflicts.

The United Kingdom remains a centre and 'switching point' of an enmeshed but frequently oppositional network of cultural production, trends increasingly appreciable since the late 1970s and 1980s. The neo-Marxist aesthetician Theodor Adorno famously characterised modernity as two integral halves which nevertheless do not sustain a whole. If any narrative might be drawn from the British art of recent decades it might be this; one of resolute refusal to be neatly scripted – a space in which a plurality of technique, voice and aspiration has the prospect and possibility of renewal and reinvention.

Notes

1 Tom Morton, 'Tomorrow never knows,' in Katharine Stout with Lizzie Carey-Thomas (eds), *The Turner Prize and British Art* (Tate Publishing, 2007), p. 61.
2 Alex Farquharson and Andrea Schlieker, 'Revisitations: ideology, fiction, style', in *British Art Show 6* (Hayward Gallery Publishing, 2005), p. 54.
3 See for example Slavoj Žižek's 'The lesson of Rancière,' in *The Politics*

of Aesthetics, trans. and intr. by Gabriel Rockhill (Continuum, 2007, pp. 69–79. The ideas of Ernesto Laclau have also informed aspects of Claire Bishop's *Installation Art: A Critical History* (2005). See Chapter 3.

4 See for example Whitney Chadwick and Isabelle de Courtivron (eds), *Significant Others: Creativity and Intimate Partnership* (Thames & Hudson, 1996).

Bibliography

Primary sources

Barnard, Clio, correspondence, December 2009.
Booth, Colin, interviews and studio conversations, November 2008.
Chodzko, Adam, correspondence December 2009, and MA Fine Art lecture presentation, University of Kent, March 2009.
Currie, Ken, correspondence October 2009 and March 2010.
Kennard, Peter, conversation and correspondence, and Private View at Pump House Gallery, Battersea Park, February 2008 and March 2010.
Pil and Galia Kollectiv, correspondence and conversations, January–February 2010 and MA Fine Art lecture presentation, University of Kent, March 2009.
Lingwood, James, interviews 15 September 2009 and March 2010.
O'Reilly, Kira, correspondence November 2009 and March 2010.
Phillipps, Cat Picton, conversation and correspondence, and Private View at Pump House Gallery, Battersea Park, February 2008 and March 2010.
Pryor, Angus, interviews and studio conversations, Canterbury, June–July 2008 and July 2009.
Tophill, Elizabeth, conversations July–September 2009.
Vettriano, Jack, interview 21 September 2007.

Secondary sources

Please note: Newspaper articles are referenced by date of publication and year; books or journals by page and year. Website articles are dated in the month and year of initial usage or reference.

Adam, Georgina, 'Parliamentary report backs "art code"', *The Art Newspaper*, no. 158, May 2005.
Adam, Georgina, 'British government dithers over art levy', *The Art Newspaper*, no. 164, December 2005.
Adam, Georgina, 'How Frieze affected the auctions', *The Art Newspaper*, no. 164, December 2005.
Adam, Georgina, 'Government U-turn shocks art trade', *The Art Newspaper*, no. 166, February 2006.

Adams, Brooks, Lisa Jardine, Martin Maloney, Norman Rosenthal and Richard
Shone, *Sensation, Young British Artists From the Saatchi Collection*, Thames &
Hudson/Royal Academy of Arts, London, 1997.

Aguirre, Peio, 'Elusive social forms', in Monika Szewczyk (ed.), *Meaning Liam
Gillick*, MIT Press, Cambridge, Mass./London, 2009, pp. 1–27.

Alberge, Dalya, 'My art scares you', *The Times*, 15 May 2007.

Alberge, Dalya, Art market report, *The Times*, 22 June 2007.

Alberge, Dalya, 'Tate embroiled in new conflict of interest row', *The Times*, 15
February 2008.

Alberge, Dalya and Jack Malvern, 'Trafalgar Square volunteers will be offered the
chance to put themselves on a pedestal', *The Times*, 24 June 2008.

Allen, Jane, 'Wheelers, dealers and supercollectors: where are they taking the art
market?' *New Art Examiner*, vol. 13, no. 10, June 1986, pp. 22–7.

Araeen, Rasheed, 'Postscript', in Steve Edwards (ed.), *Art and Its Histories: A Reader*,
Yale University Press/Open University, New Haven, Conn./London, 1999.

Archer, Michael, *Installation Art*, Thames & Hudson, London, 1998.

Art Newspaper, The, Editorial, 'Fifteen years reporting the international art world',
no. 164, December 2005.

Art World, interview with Lizzie Neilson, issue 1, October/November 2007.

Arts Council, 'Turning Point', strategy document, www.arts.council.org.uk/
our-work/turning-point-network/ (accessed July 2008).

Bailey, Martin, 'Artists sue Momart for £20 million', *The Art Newspaper*, no. 160,
July–August 2005.

Bailey, Martin, *The Art Newspaper*, no. 163, November 2005.

Banksy, 'Brandalism' in *Wall and Piece*, Century/Random House, London, 2005,
p. 196.

Baracaia, Alexa, 'Prize and prejudice', *thelondonpaper*, 2 December 2008.

Barker, Godfrey, 'From marbles to mazes', *Art Times*, 5 September 2009.

Barker, Simon, 'Preface', in *Revealing Light*, exhibition catalogue, Sassoon Gallery,
Folkestone, 2004.

Barker, Simon, 'Promotional trip to Hell', in Jake and Dinos Chapman (eds),
Fucking Hell, Jay Jopling/White Cube, London, 2008, pp. 6–17.

Barker, Simon, text accompanying exhibition *If Hitler Had Been a Hippy How Happy
Would We Be* (May–July 2008) associated with *Fucking Hell*, Jake and Dinos
Chapman, Jay Jopling/White Cube, London, 2008.

Barrett, Dave, interview with Gary Hume, in *New Art Up-Close 1: Gary Hume*, Royal
Jelly Factory, London, 2004, pp. 2–8.

Barthes, Roland, *Camera Lucida: Reflections on Photography*, Hill and Wang, London,
1982.

Batchelor, David, *Chromophobia*, Reaktion, London, 2000.

Batchelor, David, *Unplugged (remix)* exhibition catalogue, Wilkinson Gallery,
London, 2007.

Baudrillard, Jean, *Simulacra and Simulation*, trans. Sheila Faria Glaser, University of
Michigan, Ann Arbor, Mich., 1994.

Beale, Steve, *Blairaq*, exhibition flyer, June 2007.

Beech, Dave, 'The fall of public art', *Art Monthly*, no. 329, September 2009, pp.
1–4.

Bellingham, David, 'Ethics and the art market', in Iain Robertson and Derrick Chong (eds), *The Art Business*, Routledge, 2008, pp. 176–96.

Benjamin, Walter, 'The work of art in the age of mechanical reproduction' (1936), quoted in Charles Harrison and Paul Wood (eds), *Art in Theory: An Anthology of Changing Ideas 1900–2000*, Blackwell, Oxford, 1992/2003, pp. 520–7.

Berger, John, *Ways of Seeing*, Penguin, London, 1985.

Bhabha, Homi and Sutapa Biswas, 'The wrong story', *New Statesman*, 15 December 1989.

Bickers, Patricia, Editorial, *Art Monthly*, no. 329, September 2009, p. 12.

Billingham, Richard, Preface, *Ray's A Laugh*, Scalo, Zurich, 1996.

Biro, Matthew, 'Allegorical Modernism: Carl Einstein on Otto Dix', *Art Criticism*, vol. 15, no. 1, 2000, pp. 46–70.

Bishop, Claire, 'Antagonism and relational aesthetics', *October*, issue 110, Fall 2004, pp. 31–79.

Bishop, Claire, *Installation Art: A Critical History*, Tate Publishing, London, 2005.

Blackburn, Virginia, 'In search of the next big thing', *The Times*, 19 March 2007.

Blazwick, Iwona and Simon Wilson, *Tate Modern: The Handbook*, Tate Gallery Publishing, 2000.

Bois, Yve-Alain, 'Painting: the task of mourning', in *Painting as Model*, MIT Press, Cambridge, Mass., 1993, pp. 229–244.

Booth, Colin, 'Metropolis and streamline: iconographies of time & light', in Grant Pooke, exhibition catalogue for the Herbert Read Gallery, Canterbury, 2009.

Bourriaud, Nicolas, *Relational Aesthetics*, trans. Simon Pleasance and Fronza Woods, les presses du réel, Paris, 2002.

Bourriaud, Nicolas, *Postproduction: Culture as Screenplay: How Art Reprogrammes the World*, Lukas & Sternberg, New York, 2007.

Bourriaud, Nicolas, *Altermodern Manifesto: Postmodernism is Dead*, http://www.tate.org.uk/britain/exhibitions/altermodern/manifesto.shtm (accessed August 2009).

Bourriaud, Nicolas, *Altermodern Themes: Docu-fiction*, http://www.tate.org.uk/britain/exhibitions/altermodern/explore.shtm (accessed September 2009).

Bracewell, Michael, 'The art of Sam Taylor-Wood', in *Sam Taylor-Wood*, Steidl/Hayward Gallery, London, 2002.

Bradley, Fiona, 'Introduction', in Rachel Whiteread, Rosalind Krauss and Fiona Bradley (eds), *Rachel Whiteread: Shedding Life*, Thames & Hudson, London, 1997.

Bradley, Will, 'Implicit in this attitude is a belief in freedom?' in *Luke Fowler*, exhibition catalogue, JRP Ringier, Zurich, 2009.

Bryson, Norman, *Looking at the Overlooked: Four Essays on Still Life Painting*, Reaktion, London, 1990.

Buck, Louisa, *Moving Targets: A User's Guide to British Art Now*, Tate Publishing, London, 1997.

Buck, Louisa, *Moving Targets 2: A User's Guide to British Art Now*, Tate Publishing, London, 2000.

Buck, Louisa, interview with Cecily Brown, *The Art Newspaper*, no. 159, June 2005.

Buck, Louisa, 'The Turner Prize: a judge's view', *The Art Newspaper*, no. 165, January 2006.

Buck, Louisa, 'The Tate, the Turner Prize and the art world', in Katharine Stout and Lizzie Carey-Thomas (eds), *The Turner Prize and British Art*, 2007, Tate Publishing, London, 2007, pp. 12–25.

Bürger, Peter, *Theory of the Avant-Garde*, University of Minnesota Press, Minneapolis, Minn., 1984.

Burgin, Victor, *Thinking Photography (Communications and Culture)*, Macmillan, London, 1982.

Burn, Gordon, *Sex & Violence, Death & Silence: Encounters with Recent Art*, Faber & Faber, London, 2009.

Burrows, David, 'Beyond belief: Mark Wallinger's *Ecce Homo*', in *Mark Wallinger: Credo*, Tate Liverpool catalogue, 2000, pp. 34–6.

Buskirk, Martha, *The Contingent Object of Contemporary Art*, MIT Press, Cambridge, Mass., 2003.

Bussel, David, entry on Richard Billingham, in Brooks Adams, Lisa Jardine, Martin Maloney, Norman Rosenthal and Richard Shone, *Sensation, Young British Artists From the Saatchi Collection*, Thames & Hudson/Royal Academy of Arts, London, 1997.

Bussel, David, biographical entry for Tracey Emin, in Brooks Adams, Lisa Jardine, Martin Maloney, Norman Rosenthal and Richard Shone, *Sensation: Young British Artists From The Saatchi Collection*, Thames and Hudson/Royal Academy of Arts, London, 1997, pp. 196–7.

Butler, Judith, *Gender Trouble*, Routledge, London, 1990.

Campbell-Johnston, Rachel, 'Sensation! It's paint on canvas', *Times2*, 26 January 2005.

Campbell-Johnston, Rachel, 'Saatchi's old favourites – made in China', *The Times*, 7 October 2008.

Causey, Andrew, *Sculpture Since 1945*, Oxford History of Art, Oxford, 1998.

Causey, Andrew, Richard Cork, David Curtis, Penelope Curtis et al., *Blast to Freeze: British Art in the 20th Century*, Hatje Cantz, Ostfildern, Germany, 2002.

Cave, Joanna, 'Celebrating the artist's resale right', in Iain Robertson and Derrick Chong (eds), *The Art Business*, Routledge, Abingdon/New York, 2008, pp. 154–75.

Chadwick, Whitney and Isabelle de Courtivron (eds), *Significant Others: Creativity and Intimate Partnership*, Thames & Hudson, London, 1996.

Chodzko, Adam, *Pyramid* information panel, repr. in *Folkestone Triennial: Tales of Time and Space*, catalogue, Cultureshock, London, 2008.

Clark, Jim, interview with Derek Jarman, http://www.clarkmedia.com/jarman/ jarman06england.html (accessed October 2009).

Clark, T. J. 'Greenberg on art criticism', Open University (video, A315), 1981 (also in Francis Frascina and Charles Harrison (eds), *Modern Art and Modernism: A Critical Anthology*, Paul Chapman, London, 1982).

Clarke, Graham, *The Photograph: A Visual and Cultural History*, Oxford History of Art, Oxford, 1997.

Claven, Jim, *The Centre is Mine: Tony Blair, New Labour and the Future of Electoral Politics*, Pluto Press Australia, NSW, 2000.

Coggins, Alice, 'Allegory, Repression and a Future for Modernism', http://www. miriad.mmu.ac.uk/ama/modernism/7-alice-coggins.php (accessed June 2008).

Cohen, Louise, 'Under the beady eye of Lord Nelson, video art is going pop', *times/the knowledge*, 1–7 September 2007.

Collings, Matthew, *Blimey! From Bohemia to Britpop: The London Artworld from Francis Bacon to Damien Hirst*, 21 Publishing, London, 1997.

Collings, Matthew, *Art Crazy Nation: The Post-Blimey! Art World*, 21 Publishing, London, 2001.

Collings, Matthew, *Sarah Lucas*, Tate Publishing, 2002.

Colpitt, Frances, *Abstract Art in the Late Twentieth Century*, Cambridge University Press, Cambridge, 2002.

Colpitt, Frances, 'The formalist connection and originary myths of conceptual art', in Michael Corris (ed.), *Conceptual Art: Theory, Myth, and Practice*, Cambridge University Press, Cambridge, 2004, pp. 28–49.

Commissions East, press release, 2 February 2005.

Connor, Matthias, 'Oliver Payne and Nick Relph', in Clare Manchester (ed.), *Beck's Futures 2002: Tomorrow's Talent Today*, ICA, London, 2002, pp. 42–3.

Cooke, Nigel, gallery notes to *New Accursed Art Club*, Stuart Shave/Modern Art, April–May 2008.

Cork, Richard, 'Preface', in *Artists Look at Contemporary Britain*, Hayward Gallery catalogue, London, 1987, p. 5.

Cotter, Suzanne and Caoimhín Mac Giolla Léith, *Cecily Brown: Paintings*, ed. Suzanne Cotter with Miria Swain, Modern Art Oxford, 2005, pp. 37–46.

Cotton, Charlotte, *The Photograph as Contemporary Art*, Thames & Hudson, London, 2004.

Craig-Martin, Michael 'Towards Tate Modern', in Iwona Blazwick and Simon Wilson (eds), *Tate Modern: The Handbook*, Tate Publishing, London, 2000, p. 12–22.

Cumming, Laura, 'Give them some personal space', *Observer*, 15 March 2009.

Cumming, Laura, *Observer*, 10 May 2009.

Cumming, Tim, 'Stuff and nonsense', *Guardian Arts Education*, 13 February 2002.

Danto, Arthur, *Encounters and Reflections: Art in the Historical Present*, University of California Press, Berkeley/Los Angeles/London, 1997.

Danto, Arthur, *The Wake of Art: Criticism, Philosophy and the Ends of Taste*, Routledge, Abingdon/London, 1998.

Davies, Lillian (ed.), *State Britain*, exhibition text, Tate Publishing, London, 2007.

De Oliveira, Nicholas, Nicola Oxley and Michael Petry, *Installation Art*, Thames & Hudson, London, 1998.

Department of Culture, Media and Sport, *Creative Industries: Economic Estimates*, London, 2001, http://www.culture.gov.uk/creative/mapping.html (accessed September 2009).

Dexter, Emma, 'Bringing to light: photography in the UK, 1980–2007', in Chris Stephens (ed.), *The History of British Art 1870–Now*, Tate Publishing, London, 2008, pp. 222–3.

Dickie, George, *Art and the Aesthetic*, Cornell University Press, Ithaca, N.Y., 1974.

Dodd, Philip, 'Preface' to *Beck's Futures 2002 Catalogue*, ICA Publications, London, 2002.

Dorment, Richard, review, *Telegraph*, 20 September 2005.

Drew, Joanna and Catherine Lampert, 'Foreword', in *Art History: Artists Look at Contemporary Britain*, catalogue, Hayward Gallery, London, 1987.

Durden, Mark and Craig Richardson (eds), *Face On: Photography as Social Exchange*, Black Dog, London, 2000.

Eagleton, Terry, *The Ideology of the Aesthetic*, Blackwell, Oxford, 1990.

Edwards, Steve, *Photography: A Very Short Introduction*, Oxford University Press, Oxford, 2006.

Edwards, Steve, 'Photography out of conceptual art', in Gill Perry and Paul Wood (eds), *Themes in Contemporary Art*, Yale University Press, New Haven, Conn./London, 2004, pp. 137–80.

Edwards, Steve and Jason Gaiger (eds), *Art of the Twentieth Century: A Reader*, Open University/Yale University Press, New Haven, Conn./London, 2003.

Edwards, Steve and Paul Wood (eds), *Art of the Avant-Gardes*, Yale University Press, New Haven, Conn./London, 2004.

Ellis, Patricia, *100: The Work that Changed British Art*, Jonathan Cape/Saatchi Gallery, London, 2003.

Enwezor, Okwui, 'Bio-politics, human rights, and the figure of "truth" in contemporary art', in Maria Lind and Hito Steyerl (eds), *The Green Room: Reconsidering the Documentary and Contemporary Art #1*, Sternberg Press, Berlin/ Center for Curatorial Studies, Bard College, New York, 2008, pp. 66–102.

Enwezor, Okwui, 'The black box', extract repr. in Jason Gaiger and Paul Wood (eds), *Art of the Twentieth Century: A Reader*, Yale University Press/Open University, New Haven, Conn./London, 2003, pp. 319–26.

Esche, Charles, 'Preface', in Tanya Leighton (ed.), *Art and the Moving Image. A Critical Reader*, Tate Publishing, London, 2008.

Eshun, Ekow, Francis McKee and Tom Trevor, 'Preface', in *Beck's Futures Catalogue*, ICA Exhibitions, London, 2006.

Evans, Katherine (ed.), *The Stuckists: The First Remodernist Art Group*, Victoria Press, London, 2000.

Farquharson, Alex and Andrea Schlieker, *British Art Show 6*, Hayward Gallery Publishing, London, 2005.

Fleming, Jeff, 'Cecily Brown: living pictures', in *Cecily Brown*, Des Moines Art Center, Iowa, 2006, pp. 47–53.

Foster, Hal, *The Return of the Real: The Avant-Garde at the End of the Century*, MIT Press, Cambridge, Mass./London, 1996.

Foster, Hal, *Recodings: Art, Spectacle, Cultural Politics*, Bay Press, Washington/Port Townsend WA, 1985.

Franko B., quotes on http://www.re-title.com/artists/Franko-B.asp (accessed October 2009).

Fried, Michael, 'Art and objecthood', extracts repr. in Charles Harrison and Paul Wood (eds), *Art in Theory 1900–2000: An Anthology of Changing Ideas*, Blackwell, Oxford, 1992/2003, pp. 835–46.

Frohne, Ursula, 'Dissolution of the frame: immersion and participation in video installations', in Tanya Leighton (ed.), *Art and the Moving Image: A Critical Reader*, Tate Publishing, London, 2008, pp. 355–70.

Furlong, William, interview with Jake and Dinos Chapman, *Audio Arts Magazine*, vol. 15, no. 3, 1996.

Gaiger, Jason, *Aesthetics and Painting*, Continuum, London/New York, 2008.

Gerlis, Melanie and Louisa Buck, 'Zoo's move out of the zoo is a success', *Art Newspaper/Frieze Art Fair Daily*, 12 October 2007.

Giddens, Anthony, *The Third Way: The Renewal of Social Democracy*, Polity Press, London, 1998.

Gillick, Liam, 'Contingent factors: a response to Claire Bishop's 'Antagonism and relational aesthetics'', *October*, issue 115, Winter 2006, pp. 95–106.

Glancey, Jonathan, 'Magic to stir men's blood', *Guardian*, 12 December 2002.

Goetz, Ingvild and Stephan Goetz, discussion with Nigel Cooke, April 2005, in Suhail Malik and Darien Leader, *Nigel Cooke: Paintings 01–06*, Buchhandlung, Walter Konig, London, 2006, pp. 4–21.

Graham, Gordon, *Philosophy of the Arts: An Introduction to Aesthetics*, Routledge, London, 1997.

Graham, Robert, 'In search of a revolutionary consciousness: further adventures of the European avant-garde', in Paul Wood (ed.), *Varieties of Modernism*, Yale University Press/Open University, New Haven, Conn./London, 2004, pp. 363–98.

Graham-Dixon, Andrew, *A History of British Art*, BBC Books, London, 1999.

Gray, John, 'The landscape of the body: Ballard, Bacon, and Saville', in *Saville*, Rizzoli, New York, 2005, pp. 8–10.

Green, David, 'Painting as aporia', in Jonathan Harris (ed.), *Critical Perspectives on Contemporary Painting: Hybridity, Hegemony, Historicism*, Liverpool University Press/Tate Liverpool, 2003, pp. 81–107.

Greenberg, Clement, 'Avant-garde and kitsch' (1939), repr. in Charles Harrison and Paul Wood (eds), *Art in Theory 1900–2000: An Anthology of Changing Ideas*, Blackwell, Oxford, 1992/2003, pp. 539–49.

Greenberg, Clement, 'The decline of Cubism', quoted in Charles Harrison and Paul Wood (eds), *Art in Theory 1900–2000: An Anthology of Changing Ideas*, Blackwell, Oxford, 2003, pp. 577–80.

Greenberg, Clement, 'The pasted-paper revolution' 1958, repr. in Jason Gaiger and Paul Wood (eds), *Art of the Twentieth Century: A Reader*, Open University and Yale University Press, New Haven, Conn./London, 2004, pp.89–94.

Gross, Anthony, 'Index Metropolis' in Anthony Gross and Jen Wu (eds), *Metropolis Rise: New Art From London*, Article Press, Birmingham, 2006, pp. 6–13.

Guerzoni, Guido, 'Analysing the price of art: what the indices do not tell you', *The Art Newspaper*, no. 157, April 2005.

Haacke, Hans, 'All the art that's fit to show' (1974) in John C. Welchman (ed.), *Institutional Critique and After*, JRP Ringier, Zurich, 2006, pp. 53–5.

Hackworth, Nick, 'The art of flogging cars', *Times Review*, 25 June 2005.

Haden-Guest, Anthony, 'Pills and thrills', *Observer Magazine*, 19 September 2004.

Hall, James, 'Jake and Dinos Chapman: collaborating with catastrophe', in *Apocalypse: Beauty and Horror in Contemporary Art*, Royal Academy of Arts, London, 2000, pp. 212–15.

Hall, James, *Hall's Dictionary of Subjects & Symbols in Art*, John Murray, London, 1996.

Hardt, Michael and Antonio Negri, *Empire*, Harvard University Press, Cambridge, Mass., 2000.

Harris, Jonathan (ed.), *Critical Perspectives on Contemporary Painting: Hybridity, Hegemony, Historicism,* Liverpool University Press/Tate Liverpool, Liverpool, 2001.

Harris, Jonathan, *Art History: The Key Concepts,* Routledge, London/New York, 2006.

Harrison, Charles, quoted in Brandon Taylor, *Art Today,* Laurence King, London, 2004.

Harrison, Charles and Wood, Paul, 'The state of painting' in *Modernism in Dispute: Art Since the Forties,* Yale University Press, 1993, pp. 226–236.

Hartley, John, 'Creative industries', in John Hartley (ed.), *Creative Industries,* Blackwell, Oxford, 2005, pp. 1–40.

Hatton, Rita and John A. Walker, *Supercollector. A Critique of Charles Saatchi,* Institute of Artology, 1st edn 1999, rev. 2003.

Heald, Rebecca, entry on Mark Leckey, in Alex Farquharson and Andrea Schlieker (eds), *British Art Show 6,* Hayward Gallery Publishing, London, 2005, p. 84.

Healy, Lorna, 'We love you, Tracey: pop-cultural strategies in Tracey Emin's videos', in Mandy Muerk and Chris Townsend (eds), *The Art of Tracey Emin,* Thames & Hudson, London, 2002, pp. 155–71.

Hirst, Damien and David Peace, 'Foreword', in Gordon Burn, *Sex & Violence, Death & Silence: Encounters with Recent Art,* Faber & Faber, London, 2009, pp. ix–xv.

Hoffmann, Jens, 'Back to the future', in *Beck's Future's 2005,* ICA Publications, London, 2005.

Hoffmann, Jens, 'The curatorialization of institutional critique', in John C. Welchman (ed.), *Institutional Critique and After,* JRP Ringier, Zurich, 2006, pp. 323–35.

Hoggard, Liz, interview with Sally Taylor, *Evening Standard,* 15 October 2009.

Holman, Martin, 'David Batchelor Unplugged', *Art World,* issue 1, October/November 2007, pp. 44–7.

Hopkins, David, *After Modern Art 1945–2000,* Oxford History of Art, Oxford, 2000.

Howkins, John, 'The Mayor's Commission on the Creative Industries', in John Hartley (ed.), *Creative Industries,* Blackwell , Oxford, 2005, pp. 117–25.

Hoyle, Ben, 'Here's the financial picture: the super rich are black', *The Times,* 18 September 2009.

Hoyle, Ben, 'Hirst brings £65m of his wares to market', *The Times,* 29 July 2008.

Hughes, Vicky, 'Foreword', in *Turner Prize 08,* Tate Publishing, London, 2008.

Hunt, Chris, 'Matter & metaphor', unpublished essay, 2008.

Hunt, Ian, 'Protesting innocence', in *Mark Wallinger: Credo,* Tate Liverpool catalogue, Liverpool, 2000, pp. 15–31.

ICA Bulletin, 'Art and Post-Fordism', report on discussion panel at the ICA, 8 December 2009.

Inman, Philip, 'Art syndicate hopes to snare £40m bargain', *Observer,* 17 May 2009.

Jayasekera Rohan, interview with Julian Stallabrass, in *The Sublime Image of Destruction,* exhibition booklet, De La Warr Pavilion, Bexhill (October 2008–January 2009).

Jeffries, Stuart, *Guardian,* 14 November 2006.

Joachimides, Christos, 'A New Spirit in Painting', in Christos Joachimides, Norman Rosenthal and Nicholas Serota, *A New Spirit in Painting,* Royal Academy of Arts, London, 1981.

Johnson, Andrew, *Independent on Sunday*, 15 July 2007.

Johnson, Andrew, 'Is the art market heading for a crash?', *Independent on Sunday*, 11 May 2008.

Jones, Alice, interview with Stanley Donwood, 'Undercover', *Independent*, 14 June 2007.

Jonsson, Stefan 'Facts of aesthetics and fictions of journalism: the logic of the media in the age of globalization', in Maria Lind and Hito Steyerl (eds), *The Green Room: Reconsidering the Documentary and Contemporary Art #1*, 2008, pp. 166–87.

Jury, Louise, *Independent*, 14 October 2006.

Kalmár, Stefan, Michael Bracewell, Ian White and Daniel Pies (eds), *The Secret Public/The Last Days of the British Underground 1978–1988*, ICA Publications, London, 2007.

Kellein, Thomas, *Pictures: Jeff Koons 1980–2002*, Distributed Art, New York, 1998.

Kench, Reuben, ULI Seminar presentation, Chelsea College of Art, 24 June 2008.

Kent, Sarah with Jenny Blyth, *Shark Infested Waters: The Saatchi Collection of British Art in the 1990s*, Zwemmer, London, 1994.

Kernberg, Otto, 'Foreword' to Janine Chasseguet-Smirgel, *Creativity and Perversion*, Reaktion, London, 1992, pp. vi–ix.

Kirby, Vicki, *Judith Butler: Live Theory*, Continuum, London/New York, 2006.

Knabb, K. (ed. and trans.) *Situationist International Anthology*, Bureau of Public Secrets, Berkeley, Calif., 1981.

Krause Knight, Cher, *Public Art: Theory, Practice and Populism*, Wiley Blackwell, Oxford, 2008.

Krauss, Rosalind, 'Sculpture in the expanded field', in Hal Foster (ed.), *Postmodern Culture*, Pluto, London, 1985, pp. 31–42.

Krauss, Rosalind, 'Video: the aesthetics of narcissism', *October*, no. 1, Spring 1976.

Kristeva, Julia, 'Powers of horror: an essay on abjection' (1980), in Charles Harrison and Paul Wood (eds), *Art in Theory: An Anthology of Changing Ideas 1900–2000*, Blackwell, Oxford, 1992, 2003, pp. 1137–9.

Lack, Jessica, 'The great art hunt', *Contemporary Art Norwich Guide*, 2007.

Lacy, Suzanne (ed.) *Mapping The Terrain: New Public Genre Art*, Bay Press, WA, 1995.

Landry, Charles, 'London as a creative city' in John Hartley (ed.), *Creative Industries*, Blackwell, Oxford, 2005, pp. 233–43.

Lawson, Mark, *Conflicts of Interest: John Keane*, Momentum, London, 1995.

Lawson, Thomas, 'Gary Hume: modern painting', in *Gary Hume Door Paintings*, Oxford Museum of Modern Art catalogue, Oxford, 2008, pp. 5–13.

Leader, Darian, 'The information', in Suhail Malik and Darien Leader, *Nigel Cooke Paintings 01–06*, Buchhandlung, Walter Konig, London, 2006, pp. 34–38.

Lechte, John, *Fifty Contemporary Thinkers: From Structuralism to Postmodernity*, Routledge, London/New York, 1994.

Lee, David (ed.) *The Jackdaw: A Newsletter for the Visual Arts*, 2000–ongoing.

Leighton, Tanya and Esche, Charles, *Art and the Moving Image: A Critical Reader*, Tate Publishing, London, 2008.

Leris, Sophie, 'The art of the Tees', *Independent on Sunday*, 28 January 2007.

Lind, Maria and Hito Steyerl (eds) *The Green Room: Reconsidering the Documentary and Contemporary Art #1*, Sternberg Press, Berlin/Center for Curatorial Studies, Bard College, New York, 2008.

Lingwood, James, 'Family values' (interview with Richard Billingham), *Tate*, Summer 1998.

Lippard, Lucy, *Six Years: The Dematerialization of the Art Object from 1966 to 1972*, University of California Press, Berkeley/ Los Angeles/London, 1997.

Lixenberg, Dana, interview with Olafur Eliasson, *Tate Magazine*, September/ October 2003.

Lowry, Joanna, 'Performing vision in the theatre of the gaze: the work of Douglas Gordon', in Amelia Jones and Andrew Stephenson (eds), *Performing The Body/ Performing The Text*, Routledge, London/New York, 1999, pp. 254–62.

Luckett, Helen, *Blind Light*, exhibition guide, Hayward, London, 2007.

Luckett, Helen, entry for Gordon Cheung, in Alex Farquharson and Andrea Schlieker (eds), *British Art Show 6*, Hayward Gallery Publishing, London, 2005, p. 136.

Luckett, Helen, entry for Eva Rothschild, in Alex Farquharson and Andrea Schlieker (eds), *British Art Show 6*, Hayward Gallery Publishing, London, 2005, p. 80.

Macdonald, Murdo, *Scottish Art*, Thames & Hudson, London, 2000.

Macintyre, Ben and Ben Hoyle, 'The super-rich', *The Times*, 23 June 2007.

Macmillan, Duncan, 'A dance with fate', *The Scotsman*, 22 August 1995.

Madelin, Roger, quotes from Julie Maddison, ULI Seminar, Chelsea College of Art, 24 June 2008.

Maharaj, Sarat, 'Perfidious fidelity: the untranslatability of the other', in Jason Gaiger and Paul Wood (eds), *Art of the Twentieth Century: A Reader*, Yale University Press, New Haven, Conn./London, 2003, pp. 297–304.

Mahoney, Emma, entry for Paul Rooney, in Alex Farquharson and Andrea Schlieker (eds), *British Art Show 6*, Hayward Gallery Publishing, London, 2005, p. 212.

Malbert, Robert, entry for Anna Barriball, in Alex Farquharson and Andrea Schlieker (eds), *British Art Show 6*, Hayward Gallery Publishing, London, 2005, p. 26.

Maloney, Martin, 'Everyone a winner! Selected British art from the Saatchi Collection 1987–97', in Brooks Adams, Lisa Jardine, Martin Maloney, Norman Rosenthal and Richard Shone, *Sensation: Young British Artists from the Saatchi Collection*, Thames and Hudson/Royal Academy of Arts, London, 1997, pp. 26–39.

Malvern, Jack, '£50 million for Hirst's diamond geezer', *The Times*, 2 June 2007.

Marsh, Stefanie, 'Painting by numbers', *The Times*, 12 October 2007.

McQueen, Steve, interviewed by Alistair Sooke, 'Venice's Carnival of the modern', *Telegraph Review*, May 30 2009.

Merck, Mandy, 'Bedtime', in Mandy Merck and Chris Townsend (eds), *The Art of Tracey Emin*, Thames & Hudson, London, 2002, pp. 119–33.

Merleau-Ponty, Maurice, *The Phenomenology of Perception*, London, 1998, quoted by Claire Bishop in *Installation Art: A Critical History*, Tate Publishing, London, 2005.

Miles, Malcolm, *Art, Space and the City: Public Art and Urban Futures*, Routledge, London/New York, 1997.

Molon, Dominic, 'Observing the masses', in Dominic Molon and Barry Schwabsky, *Gillian Wearing: Mass Observation*, Museum of Contemporary Art, Chicago, 2002, pp. 11–25.

Molyneux, John, 'State of the art', *International Socialism*, issue 79, July 1998, http//pubs.socialistreviewindex.org.uk/isj79/contents.htm (accessed January 2010).

Montgomery, Hugh and Emily Stokes, 'A Cultural Olympiad? Great idea – now give us the money', *Observer Review*, 5 August 2007.

Morgan, Stuart, 'Rachel Whiteread' in *Rachel Whiteread: Shedding Life*, Tate Gallery Publishing, Liverpool, 1997, pp. 19–28.

Morrison, Richard, 'McQueen's moving tribute needs the stamp of approval', *The Times*, 11 November 2009.

Morrissey, Simon, *Richard Wilson*, Tate Publishing, London, 2005.

Morton, Tom, 'Tomorrow never knows', in Katharine Stout and Lizzie Carey-Thomas (eds), *The Turner Prize and British Art*, Tate Publishing, London, 2007, pp. 60–71.

Muir, Gregor, *Lucky Kunst: The Rise and Fall of Young British Art*, Aurum Press, London, 2009.

Muir, Gregor, and Clarrie Wallis (eds), *In-A-Gadda-Da-Vida*, Tate Publishing, London, 2004.

Müller, Bernard, interview with Yinka Shonibare, *Jardin d'amour*, Flammarion, Paris, 2007, pp. 11–26.

Nairne, David, entry on Tracey Emin, in *This is Another Place* (exhibition booklet), Modern Art Oxford, Oxford, 2002.

Nairne, Sandy, with Geoff Dunlop and John Wyver, *State of the Art: Ideas and Images in the 1980s*, Chatto & Windus, London, 1987.

Nesbitt, Judith (ed.) with Okwui Enwezor, Ekow Eshun, Helen Little and Attillah Springer, *Chris Ofili*, exhibition catalogue, Tate Publishing, London, 2010.

Nesbitt, Judith and John Slyce (eds), *Michael Landy: Semi-detached*, Tate Publishing, London, 2004.

Nesbitt, Judith and Jonathan Watkins (eds), *Days Like These: Tate Triennial Exhibition of Contemporary British Art*, Tate Publishing, London, 2003.

Nochlin, Linda, 'Cecily Brown: the erotics of touch', in *Cecily Brown*, Des Moines Art Center, Iowa, 2006, pp. 55–9.

O'Keeffe, Paul, 'Manifestos from the edge and beyond', in Frank Milner (ed.), *The Stuckists: Punk Victorian*, Bluecoat Press, Liverpool, 2004, pp. 33–48.

O'Reilly, Sally, *The Body in Contemporary Art*, Thames & Hudson, London, 2009.

Parekh, C. Bhikhu, *The Future of Multi-Ethnic Britain: Report of the Commission on the Future of Multi-Ethnic Britain*, Profile Books, 2000.

Paul, Christiane (ed.), *New Media in the White Cube and Beyond*, University of California Press, Berkeley/Los Angeles/ London, 2008.

Peretti, Jacques, 'Burning shame', *Guardian*, 5 June 2004.

Perry, Gill, 'Dream houses: installations and the home', in Gill Perry and Paul Wood (eds), *Themes in Contemporary Art*, Yale University Press/Open University, New Haven, Conn./London, 2004, pp. 231–75.

Phillips, Lisa, et al., *Unmonumental: The Object in the 21st Century*, Phaidon, London, 2007.

Platform, press release for *Road Race*, screened 10 December 2004, www. platformprojects.org.uk/2005/plat46/46info.html (accessed December 2009).

Pollock, Griselda and Alison Rowley, 'Painting in a "hybrid moment"', in Jonathan Harris (ed.), *Critical Perspectives on Contemporary Painting: Hybridity, Hegemony, Historicism*, Liverpool University Press/Tate Liverpool, 2003, pp. 37–79.

Pomery, Victoria, 'Art about life', in Christoph Grunenberg and Victoria Pomery (eds), *Marc Quinn*, Tate Liverpool catalogue, Liverpool, 2002.

Pooke, Grant, 'Culture change', in *Premises and Facilities Management*, IML Group, September 1994, pp. 34–38.

Pooke, Grant, 'Pregenitality and the singing sculpture: the anal-sadistic universe of Gilbert & George', in Brandon Taylor (ed.), *Sculpture and Psychoanalysis*, Ashgate Press/Henry Moore Institute, Aldershot, 2006, pp. 139–59.

Pooke, Grant, 'Colin Booth, *Metropolis* & *Streamline*: iconographies of Time & Light', exhibition catalogue for Herbert Read Gallery, Canterbury, 2009.

Pooke, Grant, 'Post-conceptual art practice: new directions – part one', draft catalogue essay, exhibition of work by Angus Pryor and William Henry, West Wintergarden, Canary Wharf (April 2010), Kent University Fine Art Publications, 2010.

Potts, Alex, entry for 'Maurice Merleau-Ponty (1908–1961)' in Diarmuid Costello and Jonathan Vickery (eds), *Art: Key Contemporary Thinkers*, Berg, Oxford, 2007, pp. 132–6.

Prasad, Yuri, interview with Peter Kennard, *Socialist Worker*, 30 June 2007.

Putnam, James, '*Polymorphous Perverse*', text accompanying the Freud Museum exhibition, 8 November 2006–7 January 2007.

Quinn, Anthony, *Jack Vettriano*, Pavilion, London, 2004.

Quinn, Marc, 'Putting the future on a pedestal', *Times2*, 7 September 2005.

Rancière, Jacques, *The Politics of Aesthetics*, trans. and intr. Gabriel Rockhill, Continuum, London, 2007.

Ratnam, Niru, 'This is I', in Gavin Butt (ed.), *After Criticism: New Responses to Art and Performance*, Blackwell, Oxford, 2005, pp. 65–78.

Reiss, Julie H., *From Margin to Center: The Spaces of Installation Art*, MIT Press, Cambridge, Mass., 2000.

Rentoul, John, 'The end of history man', *Independent on Sunday*, 25 March 2006.

Richardson, Craig, 'Reality gaps, assumed and declared', in *Face On: Photography as Social Exchange*, Black Dog, London, 2000, pp. 39–50.

Roberts, John, 'Warhol's "Factory:" painting and the mass-cultural spectator', in Paul Wood (ed.), *Varieties of Modernism*, Yale University Press/Open University, New Haven, Conn./London, 2004, pp. 339–61.

Rosenthal, Norman and Max Wigram, *Apocalypse: Beauty and Horror in Contemporary Art*, exhibition catalogue, Royal Academy of Arts, 2000.

Ruf, Beatrix and Clarrie Wallis (eds), *Tate Triennial 2006: New British Art*, Tate Publishing, London, 2006.

Rush, Michael, *New Media in Late 20th-Century Art*, Thames & Hudson, London, 2003.

Saatchi, Charles, '30 things about art and life as explained by Charles Saatchi', *Observer Review*, 30 August 2009.

Saatchi, Charles, *My Name is Charles Saatchi and I am an Artaholic*, Phaidon, London, 2009.

Schama, Simon, 'Interview with Jenny Saville' in *Saville*, Rizzoli, New York, 2005, pp. 124–9.

Schlieker, Andrea, 'Tales of time and space', in *Folkestone Triennial: Tales of Time and Space*, Cultureshock, London, 2008, pp. 12–25.

Searle, Adrian, *Arts Guardian*, review, 5 June 2001.

Searle, Adrian, 'The Trophy Room', *Guardian G2*, 15 April 2003.

Searle, Adrian, 'Say it with flowers', *Arts Guardian*, 22 March 2005.

Searle, Adrian, 'Bears against bombs', *Arts Guardian*, 16 January 2007.

Searle, Adrian, 'Preface' to *Unbound: Possibilities in Painting*, exhibition guide, Hayward Gallery Publishing, London.

Sekula, Allan, 'Dismantling modernism, reinventing documentary (notes on the politics of representation)', 1976–8, text sequence reproduced in Jason Gaiger and Paul Wood (eds), *Art of the Twentieth Century: A Reader*, Yale University Press, New Haven, Conn./London, 2003, pp. 139–45.

Serota, Nicholas, 'Foreword', in Katharine Stout and Lizzie Carey-Thomas (eds), *The Turner Prize and British Art*, Tate Publishing, London, 2007, pp. 9–10.

Shaw, George, interview for Channel 4 *The Art Show*, http://www.channel4.com/culture/microsites/A/art_show/george_shaw (accessed December 2009).

Shaw, George, interview with Chris Arnot, *Guardian*, 13 August 2003.

Shepherd, Jessica, 'Paint it black', *Guardian*, 13 January 2009.

Sherman, Jill, 'Stop plundering arts cash to pay for Games, urge MPs', *The Times*, 25 June 2007.

Shone, Richard, 'Freeze and its aftermath', in Andrew Causey, Richard Cork, David Curtis, Penelope Curtis et al. (eds), *Blast to Freeze: British Art in the 20th Century*, Hatje Cantz, Ostfildern, Germany, 2002, pp. 292–5.

Shone, Richard, 'From '*Freeze*' to *House*: 1988–94', in Brooks Adams, Lisa Jardine, Martin Maloney, Norman Rosenthal and Richard Shone, *Sensation, Young British Artists From the Saatchi Collection*, Thames & Hudson/ Royal Academy of Arts, London, 1997, pp. 12–25.

Smith, David, 'Young British talent betrayed', *Observer*, 29 March 2009.

Smith, W. Gordon, *Fallen Angels*, Pavilion, London, 1999.

Sontag, Susan, *On Photography*, Penguin, London, 1979.

Sontag, Susan, *Regarding the Pain of Others*, Penguin, London, 2003.

Sooke, Alastair, 'Venice's Carnival of the modern', *Telegraph Review*, 30 May 2009.

Sörbom, Göran, 'The classical concept of mimesis', in Paul Smith and Carolyn Wilde (eds), *A Companion to Art Theory*, Blackwell, Oxford, 2002, pp. 19–28.

Spence, Jo, extract submitted to *Spare Rib*, no. 163, February 1986, http://www.hosted.aware.easynet.co.uk/jospence/jotext2.htm (accessed January 2010).

Spiegler, Marc, *Art Newspaper*, no. 159, June 2005.

Stallabrass, Julian, 'Economics alone do not explain painting's revival', *The Art Newspaper*, No.159, June 2005.

Stallabrass, Julian, *Contemporary Art: A Very Short Introduction*, Oxford University Press, Oxford, 2006.

Stallabrass, Julian, *High Art Lite: British Art in the 1990s*, Verso, London/New York, 2001.

Stallabrass, Julian, interview with Michael Landy, *Break Down*, Artangel, London, 2001.

Stallabrass, Julian, *Internet Art: The Online Clash of Culture and Commerce*, Tate Publishing, London, 2003.

Staple, Polly, 'The finishing touch', *Frieze 64*, January–February 2002, www.frieze.com/issue/article/the_finishing_touch (accessed November 2009).

Stapleton, Jaime, text commentary on Juan Bolivar, in Ros Carter and Stephen Foster (eds), *New British Painting*, John Hansard Gallery, Southampton, 2004, pp. 15–16.

Stephens, Chris (ed.), *The History of British Art 1870–Now*, Tate Publishing/Yale Center for British Art, London, 2008.

Steyerl, Hito, 'A language of practice', in Maria Lind and Hito Steyerl (eds), *The Green Room: Reconsidering the Documentary and Contemporary Art #1*, Sternberg Press, Berlin/Center for Curatorial Studies, Bard College, New York, 2008, pp. 225–31.

Stott, Laura, 'The fine art of doing it on the cheap,' *Times2*, 5 March 2010.

Stout, Katharine and Lizzie Carey-Thomas, (eds), *The Turner Prize and British Art*, Tate Publishing, London, 2007.

Sudjic, Deyan, *Saatchi: The Definitive Guide to the New Thameside Gallery*, Observer Publications, 2003.

Sweet, David, introductory address, *Allegory, Repression and a Future for Modernism*, 2007, http://www.miriad.mmu.ac.uk/ama/modernism/3-david-sweet.php (accessed June 2008).

Sylvester, David, 'Areas of flesh', in *Saville*, Rizzoli, New York, 2005, pp. 14–15.

Szewczyk, Monika 'Introduction', in *Meaning Liam Gillick*, MIT Press, Cambridge, Mass./London, 2009, pp. xi–xxx.

Tagg, John, *The Burden of Representation: Essays on Photographies and Histories*, Palgrave Macmillan, Basingstoke, 1988.

Tate Modern, *Transforming Tate Modern*, video, Tate Media, 2008.

Tay, Jinna, 'Creative cities', in John Hartley (ed.), *Creative Industries*, Blackwell, Oxford, 2005, pp. 220–32.

Taylor-Wood, Sam, in conversation with Clare Carolin, in *Sam Taylor-Wood*, Steidl/Hayward Gallery, London, 2002.

Teodorczuk, Tom, 'No future for Beck's art prize', *Evening Standard*, 2 February 2007.

Thompson, Charles, 'A Stuckist on Stuckism', in Frank Milner (ed.), *The Stuckists: Punk Victorian* (exhibition catalogue), Bluecoat Press, Liverpool, 2004, pp. 6–30.

Thompson, Don, *The $12 Million Stuffed Shark: The Curious Economics of Contemporary Art and Auction Houses*, Aurum Press, London, 2008.

Thompson, Jon, 'Life after death: the new face of painting', in Ros Carter and Stephen Foster (eds), *New British Painting*, John Hansard Gallery, Southampton, 2004, pp. 5–7.

Tickner, Lisa, 'A strange alchemy', in Gill Perry (ed.), *Difference and Excess in Contemporary Art: The Visibility of Women's Practice*, Blackwell, 2004, pp. 46–73.

Townsend, Chris, *New Art From London*, Thames & Hudson, London, 2006.

Trustees, 'Foreword', in *Aims of The Gallery: The Tate Gallery Biennial Report*, (1988),
 quoted by Louisa Buck in Katharine Stout and Lizzie Carey-Thomas (eds), *The
 Turner Prize and British Art*, Tate Publishing, London, 2007.
Tufnell, Ben, entry on Gillian Carnegie in Judith Nesbitt and Jonathan Watkins
 (eds), *Days Like These: Tate Triennial Exhibition of Contemporary British Art*, Tate
 Publishing, London, 2003, pp. 48–53.
Urban Land Institute (ULI), Seminar, Chelsea College of Art, 24 June 2008.
Van der Zee, Bibi, interview with Chris Ofili, *Guardian*, November 2003.
Velthuis, Olav, *Talking Pictures*, Princeton University Press, Princeton, N. J., 2005.
Vergine, Lea, *Body Art and Performance: The Body as Language*, Skira, Milan, 2000.
Verhagen, Marcus, 'Conceptual Perspex', in Monika Szewczyk (ed.), *Meaning Liam
 Gillick*, MIT Press, Cambridge, Mass./London, 2009, pp. 47–57.
Voltz, Aurelia, Simone Menegoi, Lillian Davies and Cecilia Alemani, *Collecting
 Contemporary Art*, JRP Ringier, Zurich, 2008.
Wakefield, Neville, 'Frieze commissions, talks and film 2007', *Frieze Art Fair Yearbook
 2007/8*, Frieze Publications, London, 2007.
Watson, Peter, *Manet to Manhattan: The Rise of the Modern Art Market*, Vintage/
 Random House, London, 1993.
Welchman, John C. *Art After Appropriation: Essays on Art in the 1990s*, Gordon and
 Breach, Newark, N. J., 2003.
Wells, Liz, *The Photography Reader*, Routledge, London, 2002.
Whitfield, Sarah, interview with Marc Quinn, in Christoph Grunenberg and
 Victoria Pomery (eds), *Marc Quinn*, Tate Liverpool catalogue, Liverpool, 2002.
Wight, Robin, *The Peacock's Tail and the Reputation Reflex: The Neuroscience of Art
 Sponsorship*, Arts & Business Lecture, 2007.
Wilson, John, *Front Row*, BBC Radio 4, 9 September 2009.
Wilson, Michael, *Frieze*, no. 63, November–December 2001 http://www.frieze.
 com/issue/review/oliver_payne_and_nick_relph (accessed November 2009).
Wilson, Richard, *Richard Wilson*, the EYE, Illuminations Video, 2001.
Wilson, Simon, 'A delicate balance', *Royal Academy of Arts Magazine*, no. 103,
 Summer 2009.
Wood, Gaby, 'Going for broke', *Observer Review*, 3 February 2001.
Wood, Paul, 'Inside the Whale: an introduction to postmodernist art', in Gill Perry
 and Paul Wood (eds), *Themes in Contemporary Art*, Yale University Press/Open
 University, New Haven, Conn./London, 2004, pp. 5–43.
Wood, Paul, Francis Frascina, Jonathan Harris and Charles Harrison (eds),
 Modernism in Dispute: Art Since the Forties, Yale University Press, New Haven,
 Conn./London, 1993.
Wu, Chin-tao, *Privatising Culture: Corporate Art Intervention Since the 1980s*, Verso,
 London, 2002.
Young, Robert, *Postcolonialism: A Very Short Introduction*, Oxford University Press,
 Oxford, 2003.
Younge, Gary, 'A bright new wave', *Guardian Weekend*, 16 January 2010.
Žižek, Slavoj, 'The lesson of Rancière', in Jacques Rancière, *The Politics of Aesthetics*,
 trans. and intr. Gabriel Rockhill, Continuum, London, 2007, pp. 69–79.

Websites

Art Fund: http://www.artfund.org (accessed September 2009).

The Art Show: http://www.channel4.com/culture/microsites/A/art_show/ george_shaw (accessed December 2009).

Arts Council: http://www.artscouncil.org.uk (accessed September 2009).

Fourth Plinth : http://www.london.gov.uk/fourthplinth/shonibare.jsp (accessed February 2010).

Franko B. archive: http://www.bris.ac.uk/theatrecollection/liveart/liveart_ FrankoB.html (accessed October 2009).

Journal of the Socialist Workers' Party, London: http://pubs.socialistreviewindex. org.uk/isj79/contents.htm (accessed January 2010).

Gerald Laing: http://www.geraldlaing.com (accessed September 2008).

Luxonline: http://www.luxonline.org.uk/artists/alia_syed/index.html (accessed November 2009).

Margate Renewal Partnership: http://www.margatetownpartnership.org.uk/ margate_regeneration.html (accessed November 2009).

Out of Blue, Zarina Bhimji exhibition at Tate Britain: http://www.tate.org.uk/ britain/exhibitions/artnow/bhimji/default.shtm (accessed November 2009).

Royal Parks: http://www.royalparks.org.uk/learning (accessed September 2009).

Tate: http://www.tate.org.uk (accessed November 2009).

Tract Live Art: http://www.tract-liveart.co.uk (accessed November 2009).

Visual Arts & Galleries Association: http://www.vaga.co.uk (accessed September 2009).

Index

Smith, Terry, 68, 76, 77, 107, 119, 122, 239
Smithson, Robert, 148, 169
Sontag, Susan, 187, 188, 219, 238, 240
 'ethics of looking', 188
 On Photography (1979), 187, 238, 240
 Regarding the Pain of Others (2003), 188
Sotheby's Auction House, 17, 24, 63
South East England Development Agency (SEEDA), 55
South London Gallery, 27, 53
Southwark, 53, 59
Souza, Francis Newton, 82
Soviet Socialist Realism, 87
Soviet Union, 8, 78, 89
Space Studios, 53
Spacey, Kevin, 23
Spence, Jo, 209, 228, 229, 245
 and Terry Dennett, *Remodelling Photo History* (1982), 229
 Spare Rib, 229, 241
 The Picture of Health? (1982–91), 229
 the Photography Workshop (1973), 229
Spencer, Stanley, 96
Spitalfields, 53
St Martins College of Art and Design, 62, 92, 104, 170, 192, 194
 King's Cross site, 62
Stallabrass, Julian, 2, 13, 14, 25, 30, 61, 66–68, 78, 119, 120, 125, 156, 179, 182, 226, 237, 241, 242
 'data sublime', 226
 Art and Money Online (exhibition, 2001), 237
 Art Incorporated: The Story of Contemporary Art (2004), 61

High Art Lite: British Art in the 1990s (1999), 2, 13, 67–68, 120, 182
Internet Art: The Online Clash of Culture and Commerce (2003), 66, 237, 242
The Sublime Image of Destruction (exhibition, 2008–9), 226, 241
Staple, Polly, 110, 122
Stapleton, Jaime, 74, 119
Stehli, Jemima, 227
 After Helmut Newton's Here They Come (1999), 227
 Still From Strip (No. 4) (1999), 227
 Strip (1999–2000), 227
Steinbach, Haim, 116, 171
 'shopping sculptures', 171
Stephen Friedman Gallery, 160
Stephens, Chris, 3, 13, 238
 The History of British Art 1870 – Now (editor, 2008), 13
Stewart, Dave, 23
Steyerl, Hito (see Maria Lind), 14, 184, 188, 205, 237, 239
Stokes, Matt, 50
 Long After Tonight (2006), 50
Stoner, Tim, 50
Stratford, 53, 104
Stuart Shave/Modern Art, 121
Stuckists, 104, 105, 106, 109, 122
 'Remodernism', 104, 122
 Stuck! Stuck! Stuck! (1999), 105
 The Resignation of Sir Nicholas Serota (2000), 105
 The Stuckists Punk Victorian (2004), 105, 121, 122
Sublime, (the), 98, 100, 143, 226
Surfacing (exhibition, 1998), 109
Surrealism, 29, 75, 136, 189
Sutherland, Graham, 96
Sweet, David, 117, 123
Swinton, Tilda, 149
 The Maybe (1995), 149, 151